Refugee Nuns, the French Revolution, and British Literature and Culture

In eighteenth-century literature, negative representations of Catholic nuns and convents were pervasive. Yet, during the politico-religious crises initiated by the French Revolution, a striking literary shift took place as British writers championed the cause of nuns, lauded their socially relevant work, and addressed the attraction of the convent for British women. Interactions with Catholic religious, including priests and nuns, Tonya J. Moutray argues, motivated writers, including Hester Thrale Piozzi, Helen Maria Williams, and Charlotte Smith, to revaluate the historical and contemporary utility of religious refugees. Beyond an analysis of literary texts, Moutray's study also examines nuns' personal and collective narratives, as well as news coverage of their arrival to England, enabling a nuanced investigation of a range of issues, including nuns' displacement and imprisonment in France, their rhetorical and practical strategies to resist authorities, representations of refugee migration to and resettlement in England, relationships with benefactors and locals, and the legal status of "English" nuns and convents in England, including their work in recruitment and education. Moutray shows how writers and the media negotiated the multivalent figure of the nun during the 1790s, shaping British perceptions of nuns and convents during a time critical to their survival.

Tonya J. Moutray is an Associate Professor of English at Russell Sage College, Troy, NY.

Refugee Nuns, the French Revolution, and British Literature and Culture

Tonya J. Moutray

LONDON AND NEW YORK

First published 2016
by Routledge
2 Park Square, Milton Park, Abingdon, Oxon OX14 4RN

and by Routledge
711 Third Avenue, New York, NY 10017

Routledge is an imprint of the Taylor & Francis Group, an informa business

© 2016 Tonya J. Moutray

The right of Tonya J. Moutray to be identified as author of this work has been asserted by her in accordance with sections 77 and 78 of the Copyright, Designs and Patents Act 1988.

All rights reserved. No part of this book may be reprinted or reproduced or utilised in any form or by any electronic, mechanical, or other means, now known or hereafter invented, including photocopying and recording, or in any information storage or retrieval system, without permission in writing from the publishers.

Trademark notice: Product or corporate names may be trademarks or registered trademarks, and are used only for identification and explanation without intent to infringe.

British Library Cataloguing in Publication Data
A catalogue record for this book is available from the British Library

Library of Congress Cataloging-in-Publication Data
Names: Moutray, Tonya, author.
Title: Refugee nuns, the French Revolution, and British literature and
 culture / by Tonya J. Moutray.
Description: Farnham, Surrey, England: Ashgate Publishing Limited;
 Burlington, VT: Ashgate Publishing Company, 2016. | Includes
 bibliographical references and index.
Identifiers: LCCN 2015039368 | ISBN 9781409435907 (hardcover: alk.
 paper) | ISBN 9781409435914 (ebook) | ISBN 9781472405760 (epub)
Subjects: LCSH: Travelers' writings, English–18th century–History and
 criticism. | English prose literature–18th century–History and criticism. |
 Monasticism and religious orders for women–France–History–
 18th century–Public opinion. | Monasticism and religious orders for
 women–England–History–18th century–Public opinion. | British–Public
 opinion–History–18th century. | British–Attitudes–History–18th century. |
 Protestants–England–Attitudes–History–18th century. | Literature and
 society–England–History–18th century.
Classification: LCC PR769 .M68 2016 | DDC 820.9/382719–dc23
LC record available at http://lccn.loc.gov/2015039368

ISBN: 9781409435907 (hbk)
ISBN: 9781315604343 (ebk)

Typeset in Times New Roman
by Apex CoVantage, LLC

Printed in the United Kingdom
by Henry Ling Limited

To my grandmothers—
Mavis Naomi Reeves (1926–2010)
Darlene Sylvia Reile (1926–2015)

Contents

List of Illustrations	viii
Preface and Acknowledgements	ix
Introduction	1
1 Encountering Convents Abroad: Hester Thrale Piozzi, Ann Radcliffe, William Cole, Samuel Paterson, and Philip Thicknesse	36
2 Spoiled Economies and Violated Virgins: The Benedictines of Montargis, Abbé Augustin Barruel, and the French Emigration	60
3 Resistant Virtue in Flight: The Blue Nuns, Helen Maria Williams, and Reluctant Returns	90
4 Refugee Resources and Competitive Curricula: Frances Burney, Charlotte Smith, and the Augustinians of Bruges	126
Epilogue	159
Bibliography	175
Index	190

Illustrations

Figures

	Cover: *Salford Hall* (1813), Alicia Gorman, *Salford Hall, Warwickshire, "The Residence of the English Benedictine Dames Late of Cambray,"* watercolor with pen and ink, 1813, Stanbrook Abbey, Wass	
I.1	*A Scene in a Nunnery Garden* (1782)	23
3.1	*A Blue Nun Teaching a Pupil* (c. late 18th-c)	95
3.2	*Helen Maria Williams* (c. 1780–1800)	99
3.3	*A representation of the horrid barbarities practised upon the nuns by the fish-women, on breaking into the Nunneries in France* (Gillray, 1792)	101
3.4	*Decret de l'assemblee national qui supprime les ordres religieux et religieuses* (1790)	104
3.5	*Mrs. Jerningham as Hebe* (1809)	113
4.1	*Madame d'Arblay* (1840)	129
4.2	*Mrs. Charlotte Smith* (1808)	135
4.3	*Mother Mary Augustina More* (1772)	143
E.1	*Abbey of Our Lady of Consolation, Stanbrook 1838*	167

Table

I.1	Nuns' Migrations to England during the French Revolution	9

Preface and Acknowledgements

My interest in nuns in Britain during the Revolutionary Wars, and the ways in which they were represented and received in literary and popular culture, evolved over many years. Significant shifts in my understanding of religious life took place after visiting the Carmelite convent in St Denis, France, the Community of St Mary in Greenwich, NY (the first Anglican religious order in the U.S. founded in 1865 in New York City), and the Convent of Our Lady of Consolation, also known as Stanbrook Abbey, in Wass, North Yorkshire. The latter two communities, and many others around the world, are putting sustainable practices into place and continuing the tradition of monasticism at a time when recruits are few and the future of women's religious life is uncertain.

The survival of religious communities has been at risk for centuries. The heart-rending story of the martyrdom of the Carmelites of Compiègne in 1794 is perhaps the most well-known story of the struggle for survival that nuns in revolutionary France faced, a story made famous by Francis Poulenc's 1956 operatic adaptation of Georges Bernanos's screenplay, *Dialogues des Carmélites* (1949), itself a libretto adaptation of Gertrud von Le Fort's *Song at the Scaffold* (1933).

This book attempts to explicate some of the factors that threatened Catholic women's religious life in the 1790s. It also looks at the ways in which English nuns negotiated the traumatic and tenuous situations in which they found themselves, both on the Continent and after migrating to Britain. British Romantic writers introduced me to these women. The research of historians and the histories of religious communities have deepened my understanding of the interplay between literary representations and lived experience. This work would not be possible without the scholarly contributions of Margaret J. Mason, Dominic Aidan Bellenger, Carmen M. Mangion, Caroline Bowden, Elizabeth Rapley, Claire Walker, Janet Hollinshead, and Susan O'Brien. The *Who Were the Nuns?* database through Queen Mary University of London and the Arts and Humanities Research Council has also been a major resource.

Many individuals have helped me in large and small ways, offering encouragement, substantive feedback, information on artwork, and editing assistance, as well as suggesting published and unpublished materials for consideration. Aparna Gollapudi, Jean Marsden, Carmen M. Mangion, Anna Battigelli, Pamela Cheek, Sister Scholastica Jacob, Anita Duneer, and the reviewer who read the manuscript

x *Preface and Acknowledgements*

for Ashgate Press, worked with me on various chapters of the manuscript, providing historical corrections, adding clarity to the arguments, and helping me to further articulate the relationships between historical realities and literary representations. Jean Marsden has looked at much of my work over the years, including the initial proposal for this book and a draft of the Introduction. Many others also gave valuable feedback on portions of the manuscript, including Victoria Van Hyning, Geoffrey Ross, David Baecker, Sister Mary Aline, Scott Winters, Jessica Zeccardi, Elijah Grey, Chris Vestuto, David Salomon, Jackie Redick, and Gladys Craig. Jayne Ritchie Boisvert provided the splendid translation of the ferocious speech of Madame de Lèvi de Mirepoix that begins Chapter 2. Chris Vestuto and Jackie Redick copy-edited various portions of the manuscript. My editor at Ashgate Press, Ann Donahue, was particularly helpful in guiding me through the process of publication.

This research would not have been possible without additional funding. Conference travel funds through the Dean's Office at Russell Sage College, as well as the Harder-McClellan Endowed Chair that I was awarded in 2013, enabled me to conduct research and present my work at conferences hosted by the History of Women Religious of Britain and Ireland (H-WRBI), and the American Society for Eighteenth-Century Studies (ASECS).

In 2011, and funded by a Schacht Fine Arts Grant through the Sage Colleges, I visited Stanbrook Abbey. Sister Scholastica Jacob was my host, sharing archival materials and articles, and deepening my understanding of the difficulties faced by the English Benedictines of Cambrai (as they were formerly known) both in France and Britain. Viewing the relics of the Carmelites of Compiègne, now housed there, took me out of the present and made the English Benedictines' story come alive. The Carmelites were lodged in the same prison as the Benedictine community. When their death orders came in 1794, the Carmelites dressed in their full habits, sparking the fascination with their story that continues to this day. The English Benedictines were given the simple peasant dress discarded by the Carmelites and humbly bedecked themselves in the garments for their journey to England. One set of these garments and a pair of shoes are housed in an exquisitely designed ark painted with scenes from the French Revolution.[1]

Resources at multiple institutions have made this research possible, including the British Library, British Museum, Cambridge University Library, Guildhall Library, John Carter Brown Library at Brown University, Homer Babbidge Library at the University of Connecticut, Russell Sage College Library, and Vassar College Library. The staff at the Sage Colleges Library deserve a special thank-you, particularly Andrea Pike, who has located obscure items for me over the years and been infinitely patient with my requests to renew materials. I also want to thank the Trustees of the British Museum, Abbott Geoffrey Scott at Douai Abbey, Sister Mary Aline at the Convent of Nazareth in Bruges, and Abbess Andrea Savage at Stanbrook Abbey for granting permission to use the images in this book.

Finally, I am grateful for the support of friends, family, and colleagues, particularly Caroline Bowden, Carole Statham-Fletcher, Robin Moutray, Rebecca Moutray, Shealeen Meaney, David Baecker, Andor Skotnes, Sandra Schwab, Miranda

Preface and Acknowledgements xi

Simon, Nancy Cumo, Scott Winters, and Cheryl Derby. Though some have already been mentioned, I want to thank my colleagues at the Sage Colleges whose kind interest in and support of my research has been invaluable.

Tonya J. Moutray
Russell Sage College
Troy, NY

Note

1 The ark, *Shrine for the Relics of the Carmelite Martyrs*, was hand-painted on wood by Dame Catherine Warner and the Sisters at the Community of Sainte Cécile, Solesmes, c. 1897. It is currently housed at Stanbrook Abbey, Wass, Yorkshire.

Introduction

And Twilight to my lonely house a silent guest is come
In mask of gloom through every room she passes dusk & dumb
Her veil is spread, her shadow shed o'er stair and chamber void
And now I feel her presence steal even to my lone fireside.
Sit silent Nun—sit there and be
Comrade and Confidant to me.

> Charlotte Brontë, "The Autumn Day its Course Has Run," 1843, Brussels

For what training is there compared to that of the Catholic nun? . . . There is nothing like the training which the Sacred Heart or the Order of St. Vincent gives to women.

> Florence Nightingale to Henry Manning, 1853

A highly contested figure in Victorian society, the nun was at once fascinating and threatening, a relic from another world and an agent in the contemporary one. Brontë's verse and Nightingale's letter evoke just a few of the many contradictions that nuns embodied in nineteenth-century literature and culture.[1] Brontë personifies "Twilight" as a nun, a shadowed presence arriving "in mask of gloom." By the end of the poem, the speaker welcomes and invites the figure to inhabit the privileged position of "Comrade and Confidant." Yet, her very silence and status as a "guest" marginalizes and alienates her from closer intimacy. If the nun functioned as a literary trope for Brontë, however, nuns were very real individuals for Nightingale. She had experience working alongside and supervising Anglican and Catholic nuns at the Scutari military hospital during the Crimean War (1853–1856). She lamented the fact that secular women did not have similar opportunities for professional training and public work.[2] These contrasting characterizations of the nun, as both the mysterious outsider and the active professional, illuminate the divide between fictional and historical representations. They also point to the uncomfortable position of women religious who were breaking social norms in the Victorian era just as Catholic and Anglican women's orders in England were undergoing a period of significant growth.[3] Nuns' material presence in England was a powerful

2 *Introduction*

reminder of the reemergence of Catholic monasticism after three centuries of suppression in Great Britain, motivating the virulent anti-Catholic backlash against nuns that historians and literary critics have so frequently discussed.[4] Yet, in spite of anti-Catholic sentiment, more than 10,000 women choose some form of religious life over the course of the nineteenth-century. By 1900, England and Wales alone boasted some 80 religious congregations and 513 convents.[5]

The exponential growth of religious communities during this period and the attention that the figure of the nun elicited in nineteenth-century literature and culture are well known, but neither the Romantic origins of the trope nor the historical conditions that helped to make this cultural transformation possible for so many women in England have been fully examined. This study illuminates the significance of the nun in Romantic literature and culture and, in particular, the cultural impact of the return to England of women's monasticism during the French Revolution. Past studies of the French emigration to England have focused primarily on the material lives of aristocratic, working class, and ecclesiastical refugees, but largely neglect nuns' experiences, as well as the impact they had on the surrounding culture.[6] For example, historian Susan O'Brien notes that the migrations of nuns at the end of the eighteenth century "mark[ed] a new phase in the history of religious life in Britain."[7] Yet these women's experiences *during* the Revolution, including their travels to and reception in England, and the ways in which their views and survival strategies were shaped by the popular literary and cultural discourses of the period have not been studied in concert with the works of Romantic-era writers who championed their cause.

Nuns arrived on English shores in the final decade of the eighteenth century because of the displacement of Catholic religious during the French Revolution and the Revolutionary Wars. The new French government had begun dismantling religious life as early as 1789; by 1792 conventual practice was illegal and most convents were closed.[8] Throughout France, approximately 55,000 women religious, including 44,000 Catholic nuns, were expelled from their homes, becoming part of the larger Catholic diaspora that the Revolution initiated.[9] By 1809, around 400 English nuns who belonged to 19 religious houses that had been founded in exile on the Continent, as well as several French religious groups, had migrated to England, seeking political asylum and sharing the émigré experience with other refugees.[10]

This study considers how British writers perceived refugee nuns before and after they were forced to leave their Continental homes in the 1790s. However, in addition to analyzing the ways that writers saw nuns and represented their struggles to readers, I also examine nuns' own perceptions of Revolution, displacement, and migration, drawing on their rich histories to address unanswered questions about Romantic-era women religious, who, like the palimpsest of the nun lurking behind the twilight in Brontë's epigraph, are often shadowed in silence. For instance, who were the individual women behind the corporate identity of nuns? How did forces within and outside of the community shape nuns' choices during the Revolutionary period? How did British writers construct women religious and for what purposes? Did nuns conform to or challenge cultural, national, and gendered stereotypes? What discourses did their often anxious English hosts invent

Introduction 3

to normalize and valorize nuns' everyday presence? Did writers see religious communities as fragmented and vulnerable or as resilient and socially resourceful? What strategies did nuns use to build and consolidate their assets, as well as strengthen their social networks after displacement from the Continent? What part did writers and benefactors play in assisting them? This book endeavors to fill some of the gaps in the hitherto incomplete pre-history of the nineteenth-century nun by putting into dialogue literary texts, writings by nuns, and historical scholarship about them.

Literary scholarship has focused primarily on representations of nuns in British literature and culture, whereas analyses of the socio-political contexts that shaped real nuns' lives or written narratives from within the cloister have been largely left to historians.[11] For instance, in the eighteenth century, utopian fiction, which idealized life in a women's community, gained popularity, but literary studies of this fiction have made few connections to the real lives of women religious.[12] Literary scholars have also explored the ways in which eighteenth- and nineteenth-century writers drew on images of nuns as incarcerated victims and eroticized objects forced into sexual and theological deviance, tropes that hark back to centuries of anti-Catholic propaganda.[13] The actual historical agency of nuns in the eighteenth and nineteenth centuries, on the other hand, has been recounted primarily by historians, such as Elizabeth Rapley, Susan O'Brien, and others, who have uncovered the various roles that women religious played in education and social services, as well as the opportunities for personal development afforded them by religious life.[14]

This study, in contrast, uses a synthetic approach, analyzing a variety of literary representations of nuns in genres such as travel writing, young adult literature, political pamphlets, literary reviews, poetry, journalism, and historical writings alongside nuns' own narratives in letters (written for private or public audiences outside of the community), corporate diaries and chronicles (written for members within the community), and documents addressed to the French government. This research strategy enables a nuanced exploration of the interplay between the perceptions of writers within the convent and those without. Outsiders, including Hester Thrale Piozzi, Augustin Barruel, Helen Maria Williams, Frances Burney, and the British press, provide fascinating insight into how political forces shaped late eighteenth-century writers' cultural attitudes towards women's monasticism. In fact, nuns' own narratives suggest that they often adroitly adapted to their hosts' views of them. The core methodology of this book is thus dialectical, putting nuns' voices into conversation with those of the Romantic writers who represented nuns' experiences to the wider reading public. Thus, my work explores the complex interface that took place between women religious and British society during a time critical to the survival of women's religious life.

Foregrounding a tradition of national hospitality to religious refugees was a central project of the British Romantic literature discussed here. Within this broader agenda, writers sought to honor and preserve in narrative form the memory of specific religious groups whose survival was highly uncertain. During the last decade of the eighteenth century, the figure of the nun became a highly politicized and

4 *Introduction*

feminized icon, personifying the dire effects that the Revolution had upon women religious after their mostly unsuccessful attempts at resistance. In some ways, the nun became a symbol of the vulnerability of the British nation itself. Thus Britons rallied from across the political spectrum to support religious refugees in opposition to the Revolution. Nuns' contemporary writings reveal their acute awareness of this political construction and show them grappling with the dual challenge of maintaining some semblance of communal integrity while simultaneously performing the collective role of grateful recipient on local and national levels. The various and even contradictory representations of nuns by Catholic and Protestant supporters, the British Press, and the government highlight the diverse ways in which different writers appropriated the figure of the nun to bolster individual and group agendas within the larger national project of countering the Revolution.

Toby Benis argues that emigrants in Romantic literature stood "helpless" amid a variety of political allegiances. They were "Hamlet-like figures who [had] no clear path laid out before them," their agency disabled in both France and England.[15] Benis's statement may be true, in the sense that the figure of the nun could be manipulated to serve a myriad of literary and political ends, but real nuns defied stereotypes and challenged easy assumptions. English nuns, in particular, did not fit neatly into gothic, nationalist, foreign, or anti-Jacobin frameworks. Moreover, although writers interpreted monastic culture in the service of a variety of personal and political agendas, nuns' own writings illuminate the very real practical—rather than ideological—concerns that lay at the core of their struggles. Their stories of survival, produced for both internal and external audiences, were influenced by subjective experience and memory, as well as a sensitivity to these audiences, who were often powerful patrons and allies.[16] Finally, their narratives offer further insights into the ways in which an elite English Catholic minority shouldered the burden of taking care of cloistered family members and friends, who were returning not as isolated refugees, but in groups of various sizes and as members of even larger communities.

This analysis of multiple narratives from within and outside of the cloister emphasizes the permeable nature of monastic enclosure, as well as the importance of social networks, both of which allowed nuns to participate more fully in the public sphere than is generally assumed. Nuns were often active agents in determining courses of action for their communities. And beyond simply resisting and responding to the intrusions of the outside world, nuns also acted in response to occurrences *within* the cloister, such as the death of a revered member, in ways that could lead to a series of profound changes for their communities.

Such an analysis debunks the tendency, as common today as it was in the late eighteenth century, to assume that nuns' corporate identities define them and that distinctions between groups of nuns are minimal. On the contrary, collective narratives from within communities of women religious, as well as nuns' individual stories during the Revolution, reveal a wide variety of experiences of displacement and resettlement. Because real nuns defied outsiders' preconceived ideas about their nationality, age, politics, and sensibilities, contemporary writers' direct

Introduction 5

engagement with them was central to the task of making their lives comprehensible and sympathetic to readers, thus enabling both a cultural exchange and a reevaluation of stereotypes. Though they did not all support nuns in the financial and practical ways that on-the-ground Protestant and Catholic benefactors could, writers participated in refugee assistance by becoming literary benefactors, using their rhetorical skills to mitigate potentially negative public sentiments towards nuns at a time when they desperately needed public assistance. Thus, this research endeavors to deepen our understanding of the "complex ways to emplacement," in England and beyond that refugee nuns undertook after their expulsion from the Continent, as well as the ways in which a diverse literary culture assisted and complicated their transition.[17]

In order to familiarize the reader with some of the key points along the trajectory that nuns followed and that this book will trace—from settled pre-Revolution monastic life to displacement, migration, and resettlement in England—it will be useful to offer a broad overview of the socio-political contexts that framed this extraordinary odyssey. In the next two sections of this Introduction, therefore, I will briefly outline English nuns' histories after the English Reformation, the impact of the French Revolution on women's monasticism, and the reception and challenges faced by religious refugees in Britain.

Women's Monasticism: The English Reformation to the French Revolution

Until recently, histories of Catholic monasticism have not focused exclusively on nuns, though their inclusion at all suggests a long-standing fascination with their culture among readers.[18] O'Brien contends that the "historical invisibility" of nuns, like that of other groups of women, has been intensified because "a spirit of humility and self-forgetfulness" has long been a major objective within women's religious culture.[19] Despite this tendency, however, recent works, such as Claire Walker's *Gender and Politics in Early Modern Europe*, Nicky Hallett's *The Senses in Religious Communities 1600–1800*, Elizabeth Rapley's *A Social History of the Cloister*, and Jo Ann Kay McNamara's *Sisters in Arms: Catholic Nuns through Two Millennia*, have brought attention to nuns' lives and experiences.[20]

Narratives and other documents written by nuns have not always been available to mainstream audiences, and many remain that way. During the Revolution, a number of convent libraries and archives were destroyed, lost, or scattered across France, Belgium, England, and elsewhere. Most of the documents that do survive are sequestered in local record offices, libraries, private collections, and conventual archives not readily accessible to the public. Nevertheless, some communities of nuns have published their own histories, making them available to a general readership, and increasingly nuns are responsive to researchers who wish to study and present women's monastic culture to audiences outside of the convent.[21] The Catholic Record Society has published both historical research on English nuns, as well as narrative histories from within their communities.[22] Research emerging from the *Who Were the Nuns?* database, hosted by Queen Mary University of

6 *Introduction*

London and the Arts and Humanities Research Council, has revitalized scholarly investigation into the lives of exiled English nuns, and many examples of nuns' own writings can be found in the six-volume *English Nuns in Exile, 1600–1800*, as well as in other sources.[23] The examination of how British history and literature have been shaped by Catholic women is thus becoming an increasingly exciting arena for scholarly investigation.[24]

The history of English exiled nuns begins with the dissolution of the monasteries in 1536, two years after Parliament pronounced Henry VIII to be the Supreme Head of the Church of England. This process continued through 1539; as McNamara explains, "monasteries represented an untapped and virtually undefended source of wealth waiting to be exploited."[25] Dispossessed religious regrouped on the Continent; some joined foreign establishments, while others waited until more permanent settlement was possible. By 1600, the English Bridgettines were settled in Lisbon and there was an English Benedictine abbey in Brussels. Over the course of the seventeenth century, across the Continent, 22 contemplative English convents were founded, managed, and inhabited by Catholic women, primarily English and aristocratic.[26]

The majority of nuns in these exiled convents claimed English descent, as Walker's research demonstrates, yet women from across the British archipelago and beyond, including those with Welsh, Scotch, Irish, French, Belgian, and American origins, participated in the formation and maintenance of communities based upon shared religious, political, national, and geographical ties. In addition, women from Belgium and France joined exiled English communities, usually as lay sisters.[27] Each English convent maintained a distinct English identity throughout the seventeenth-century, which connected it to its founder's original mission, countered British perceptions that nuns on the Continent were necessarily "foreign," and kept alive nuns' determination to return home. Yet, according to historian Caroline Bowden, the "identities of the convents were subject to competing influences which might modify [their] original identities."[28] Hence, although national ties remained important to the long-term success and broader agenda of English convents abroad, international and local connections made their survival possible and inflected convent culture in unique ways. Nuns managed a variety of social networks that ran across national, gendered, and ethnic lines. English convent schools educated local elites, while the practice of taking in distinguished lay women as boarders increased the social visibility of convents and attracted potential novices. Convents also forged ties with local governments, as well as with English royalty.[29]

In spite of the deeply patriarchal nature of the Catholic Church, many nuns experienced much more autonomy than would have been possible in secular society. As revisionist historian Silvia Evangelisti argues, "monastic communities were places for female agency."[30] The convent allowed many women in early modern Europe to experience levels of education and political, social, religious, and literary influence typically unavailable outside of the cloister. Walker makes the case that in the seventeenth and eighteenth centuries, English convents provided "an alternative to marriage and domestic religion, a place to educate the next

Introduction 7

generation of Catholic wives and mothers . . . The religious houses represented their determination to develop non-conformity outside the dimension of the gentry household."[31] By eschewing matrimony and motherhood, nuns could "dedicate themselves to the creation of a better society," according to French Revolution historian, Olwen H. Hufton.[32]

Neither was religious life monolithic: it took various forms, providing diverse opportunities for women. For example, active congregations and *beguinages* were organizations that did not require solemn vows or enclosure and this elicited admiration from tourists such as Ann Radcliffe and Samuel Patterson.[33] Though diverse, eighteenth-century religious communities composed of women united by a shared mission fits Jane Rendall's definition of "feminist practice," as "the organization of a range of activities . . . around the claims of women to determine different areas of their lives."[34]

While it imposed certain restrictions, the convent was also a space in which women could avoid the more pervasive patriarchal institution of marriage and its concomitant calls to domesticity and motherhood. Furthermore, women in convents could pursue the life of the mind; they conducted scholarship, transcribed manuscripts, and composed and published verse, drama, music, and devotional writings. Nuns were responsible for recording their communities' own histories in convent annals, diaries, and chronicles.[35] Nuns were women of influence: they ran infirmaries, boarded girls and lay women, and provided elite—in some cases free—education for girls while building and maintaining highly complex political, religious, and familial networks.[36]

Life within Continental contemplative houses replicated external social class structures. Both Hester Thrale Piozzi and Helen Maria Williams purposefully downplay class differences in their writings about nuns, but a nun's status within the community mattered and it almost always depended on her origins: choir nuns were middle- or upper-class women who came with competitive dowries; lay sisters, women from the laboring classes, were essentially the equivalent of domestic servants. Thrale Piozzi and Williams provide evidence that class lines were occasionally crossed.[37] Nevertheless, class structures within eighteenth-century Continental convents were similar to those in the convents of nineteenth-century England and Wales, where, according to Barbara Walsh, "a convent household was no different from a large country house or a middle-class villa" in which there was an "endless round of chores performed by servants."[38]

Neither were cloisters insulated from external economic and political forces. For example, French nuns saw their communities downsized over the course of the eighteenth century as King and Church worked hand-in-hand to streamline and economize existent women's monastic communities.[39] Few French nunneries were wealthy; many more were moderately poor. Yet because women's convents, unlike male monasteries, were far more embedded in and dependent upon regional economics and the local community, they displayed a surprising diversity in their practices and composition.[40] By the eighteenth century, the British had become eager tourists of this diversity, visiting a range of foreign and "native" convents.

8 *Introduction*

Initially, upper-class British men began visiting convents during their Grand Tours; by the mid-eighteenth century, tourists of various rank could investigate monastic practice through travel.[41]

The Revolution would soon disrupt monastic culture so dramatically that nuns no longer had to be visited to be seen, either in print media or in person: they were big news. Hufton articulates the "stock image" of the nun propagated by revolutionary culture: she was "beautiful, fragile, abused, and in search of a man to solve her predicament."[42] In the early years of the Revolution, political rhetoric positioned concepts such as citizenship, liberty, and the "natural" family unit in opposition to monasticism. By October of 1789, religious candidates were not allowed to take vows and convents could not admit new entrants. In 1790, nuns were given the option to accept a pension, renounce their vows, and enter into secular society; most did not budge. The Assembly issued a decree dissolving convents and monasteries in February of 1791, although teaching and hospital congregations, as well as lay confraternities devoted to charitable works, were not banned until 1792.[43]

Despite these legal restrictions, Gemma Betros points out that nuns in France made the "outright suppression" of religious groups difficult for authorities to effect because nuns "capitalized on the newly open political culture": they put to use the rhetoric of liberty and utility to justify their claims to maintain their religious practices. Indeed, in this respect they were similar to women outside of the cloister, who also used revolutionary terminology to engage in political resistance when women were denied citizenship in June of 1793. Joan Landes reveals that revolutionary politics and philosophy circumvented French women's demands for political representation, which had swelled in the eighteenth century, effectively relegating them to the domestic realm, all the while projecting a feminized image of "Liberty" in popular culture. What was at stake was a struggle over the very vocabulary of the Revolution and who had a right to claim it.[44] Through writing and activism, nuns also defended their culture from further encroachments; they exploited the perceptions that others had of them and employed the rhetoric of their erstwhile political opponents.

The petitions nuns wrote are among the surviving *cahiers de doléance*, the lists of grievances compiled by the *Estates–General,* which convened on May 5, 1789. These documents prove that nuns proactively defended their way of life.[45] Both English and French nuns petitioned the government in the early 1790s, using the rhetoric of citizenship and loyalty to the nation in order to remain in community on French soil.[46] According to Hufton, the Revolution threatened the "destruction or jeopardy of an entire set of highly complex networks" between various groups of women religious.[47] That nuns so actively defended themselves, through writing and direct contact with officials, reveals not only their commitment to religious life, but also their conviction that their voices should be heard.

Nuns' efforts were hardly a match for the brutal force of the new French government though, and nuns would soon be forced to abandon their monastic homes in fear for their lives. Although English communities had been exempt from the legislation forcing them to disband until 1793—the year France declared war on

Introduction 9

England—within the next 12 months, multiple groups of English nuns migrated to England. At first some remained on the Continent, attempting to recoup losses and wait out the political turmoil, even though staying behind resulted in imprisonment. By 1795, however, regulations were loosened and English nuns remaining in France were set free, initiating another round of migrations to England (see Table I.1).[48]

Traveling across a war-torn Continent, in small or large cohorts, nuns sought political asylum in countries willing to host them. Nuns' tales of dispersal and escape from France appealed strongly to British readers because their stories included violence, plunder, imprisonment, starvation, and journeys that could well prove fatal, particularly to the sick and elderly. Non-fictional and fictional accounts of dispossessed religious were also ideologically attractive since monastic orders were predicated on the notion of corporate and individual inviolability. Anti-Catholic literary fantasies of women religious imagined revolutionary invasions of sacred spaces as liberating for the women within. However, the displacements nuns underwent during this period were not journeys of escape from conventual incarceration, but forced removals, threatening the integrity of both individual and collective bodies by stripping away the protection of the convent's walls.[49]

Table I.1 Nuns' Migrations to England during the French Revolution

Location/Date Founded	Institute	Migration to England
Montargis/1630	French Benedictines	1792
Bruges/1629	English Augustinians	1794
Louvain/1609	English Augustinians	1794
Brussels/c. 1597–1599	English Benedictines	1794
Cambrai/1623	English Benedictines	1795
Dunkirk/1662	English Benedictines	1795
Ghent/1624	English Benedictines	1794
Paris/c. 1651–1653	English Benedictines	1795
Lisbon/1594	English Bridgettines	1809
Antwerp/c. 1618–1619	English Carmelites	1794
Hoogstraten/1678	English Carmelites	1795
Lierre/1648	English Carmelites	1794
Paris/1658–1660	English Conceptionists/Blue Nuns	1800
Brussels/c. 1660–1661	English Dominicans	1794
Brussels/1619	English Franciscans	1794
Aire/1629	English Poor Clares	1799
Dunkirk/1625	English Poor Clares	1795
Gravelines/c. 1609	English Poor Clares	1795
Rouen/1644	English Poor Clares	1795
Liege/1642	English Sepulchrines	1794
Douai	French Bernardines	1795
Cambrai	French Salesians	unknown
Cambrai	French Hospitalières	unknown

Source: Adapted from *English Convents in Exile*, vol. 6, p. xvii and *Who Were the Nuns?* database, <http://wwtn.history.qmul.ac.uk/> accessed Feb. 9, 2016.

10 *Introduction*

Outside of the safety of the convent lay a world of trouble for nuns. Migration at least offered some chance of survival, but the politics of being welcomed by a society with a long anti-Catholic history were highly problematic. Forced to invent new discourses to deal with the influx of celibate nuns, the British rallied around the concept of the nun as a striking example of the Revolution's evils, particularly its trespasses against women. As the following section—on the migration of religious groups to England and their complex reception there—demonstrates, how well refugee nuns fared often depended on a plethora of shifting and unpredictable circumstances over which they had minimal control.

Refugee Migration, Reception, and Prospects of Permanent Settlement

In 1793, with thousands of French exiles seeking political asylum on the shores of England, Frances Burney invited British women to collaborate in the project of émigré aid. Her tract, *Brief Reflections Relative to the Emigrant French Clergy*, called particular attention to the plight of nuns who had spent their lives "exercising a charity as decisive for life or death as that which the females of Great Britain are now conjured to perform." Burney saw in this tragedy a ripe opportunity for women of various means to emulate the work of social aid executed by Catholic women religious for centuries.[50] Making no specific mention of English nuns returning to England, however, Burney's reference demonstrates just how invisible these particular refugees could be in popular culture. Perhaps one reason for this invisibility was that in their economic and physical condition, as well as in religious ideology, English nuns from the Continent had far more in common with the French clerical refugees they had accompanied than they did with the average Briton.

Nuns in England shared refugee status with other groups. According to Kirsty Carpenter, although French émigrés had begun arriving steadily by 1791, it was not until after the September Massacres of 1792—when over 200 French clergy became victims of the brutal Jacobin campaign to root out Catholicism—that the many people who migrated to England can really be termed "refugees." Bernard Ward's assertion that "suffering communities were received with every mark of popular sympathy" is supported by contemporary news coverage in the British press. Peter F. Anson reveals that Catholic religious, "these 'displaced persons' from overseas[,] were treated like heroes by 'John Bull.' Their Popery was either ignored or forgotten."[51] Public attention was riveted by the large numbers of destitute men, women, and children from all walks of life, arriving with sometimes only the clothes on their backs. The *Public Advertiser* of September 17, 1792, relayed part of a letter written seven days earlier in Dover: "not a day or night passes without the arrival of hundreds of all ages, either driven forcibly from their home or voluntarily flying from those scenes of horror, to which they were obliged to be the unavailing witness." The letter writer and the *Public Advertiser* were figuring refugees as helpless: their desperate condition making transparent the destructive political forces in France.[52]

Historians agree that the influx of over ten thousand émigrés before 1794 galvanized a conservative shift in British public opinion in opposition to the French

Introduction 11

Revolution. Thus, according to Carmen M. Mangion, the "tolerance of catholicity may have reflected more an antipathy for the French government and the revolutions in France than an acceptance for Catholicism or religious life."[53] Even so, religious refugees benefited from the organized efforts of the Emigrant Relief Committee, also known in its early years as the Wilmot Committee, which was founded by John Wilmot in September of 1792 to assist with the needs of the French clerical populations. The committee's supporters had status, including 14 members of Parliament, 12 Anglican ministers, the president of the Royal College of Physicians, a doctor servicing the King, and prominent bankers and lawyers. Through the committee, led by the Duke of Portland, the Marquis of Buckingham, Earl Fitzwilliam, and the Earl of Radnor, these prominent middle- and upper-class men of differing religious persuasions formalized their commitment to aiding clerical refugees. In turn, the 1793 decline in donations to the Wilmot Committee sparked a national collection by Anglican parishes and dissenting congregations. In total, Carpenter estimates that £70,000 were raised on behalf of the French clergy alone. Refugee nuns who arrived before November of 1794 were given an annual grant of £10 by the British government. Nuns who migrated later were awarded a slightly larger pension, amounting to one guinea per month, which continued until death.[54]

English nuns brought with them social histories recorded in several languages and French refugees, such as Augustin Barruel, published in English. The visibility of this "channel literature" challenges the notion of a fixed national identity during the period. The migrant herself was "a work in progress," according to Michael Wiley. The claiming of a particular national identity may reveal more about political strategies of the time than it does about the real national allegiance of an individual or community. Wiley observes: "As the literature of Romantic migration shows, the minds and bodies forever turning inward—toward nation state, toward locality, and toward mental interiors—extended also outward into international and global spaces that shook and transformed the Romantic self."[55] The very notion of national identity was still developing in nineteenth-century Europe and the geographical borders of the British nation had been in flux for some time: the 1707 Act of Union had brought Scotland and England together, but the Union with Ireland Act was only passed in 1800.[56]

English nuns' identities were shaped by family origins, religious upbringing, shared narratives of religious exile from Great Britain, and the local communities on the Continent where they ran their lives for two centuries.[57] In revolutionary France they protested their oppression by claiming loyalty to the French nation, deploying a kind of double identity.[58] Upon relocation in England, they drew upon their British national origins, as well as their extensive familial and religious networks. However, the national identities of refugee nuns were often oversimplified by outsiders. For example, the French Benedictines of Montargis, who arrived in 1792, had members with English origins and significant English connections; they also regularly taught girls from the English Catholic aristocracy.[59] While these facts were well known among Catholics, newspaper coverage emphasized the nuns' foreignness, constructing a more unified narrative within the tale of France's expulsion of its convents and thus diverting attention away from the fact that

12 *Introduction*

English nuns had not, until now, been able to practice their vocations legally in Britain.

Misrepresentations were the least of nuns' troubles, however. Communities arrived, as did the English Blue Nuns of Paris and English Benedictines of Cambrai, "ragged and penniless."[60] Many nuns were already advanced in age. Almost completely dependent upon wealthy benefactors who provided primary initial funding, they were also recovering from the psychological and physical trauma of war, described by the poet Amelia Opie as their "weary wakeful wanderings."[61] Resuming communal integrity was difficult with members dispersed sometimes across several countries.[62] Proper housing depended largely upon others' generosity and even though most groups remained in England, many communities remained in transit for decades.[63] Because English convents abroad had played a significant role in the education of the next generation of English Catholics for almost two centuries, some groups returned to teaching, seeking economic stability and demonstrating to the nation their social utility. For many nuns, however, England provided little more than a grave, figured by well-wishers as a space of final rest.[64]

Religious had to deal not only with the demands of patrons, but also with curious locals to whom they must have seemed anachronisms.[65] Misguided ideas about monasticism were superimposed upon religious by both patrons and the local public, as Dominic Aidan Bellenger has shown.[66] Trappist monks in Dorset, for example, attracted visitors eager to retrace a British medieval past. As one visitor reported, "we fancied ourselves in former days, when the Monastick orders flourished; so strange seemed the appearance of the Monks in the full habit of their order."[67] T.D. Fosbroke, who discussed his visit to Lulworth, the Trappists' monastery, in his best-selling *British Monachism: or, Manners and Customs of the Monks and Nuns in England* (1802), reassured readers that although "mere *automata* . . . these noble-minded Asceticks maintained 80 orphan children of the murdered French Noblesse."[68] Drawing on charitable sentiments, Fosbroke was assuaging concerns that monks and nuns might pose a threat in England.

Suspicions that migrants were bringing dangerous French ideas with them, whether Catholic or Jacobin, were reflected in the 1793 Aliens Act, which enabled the government to control the numbers of migrating French, monitor their movements, and impose delays and bureaucratic difficulties on the émigrés.[69] Though English nuns were not subject to the Aliens Act, they were easily mistaken for foreigners and because they were Catholic nuns, the government could and did keep tabs on them.[70] Ultimately, nuns were not easily categorized as native or foreign. Having fostered an English Catholic diasporic identity on the Continent, English nuns found themselves in a space tense with contradictions: they had voluntarily participated in an expatriate religious community but now sought political asylum; they had returned before the purpose of their exile—to effect the conversion of England—had been fulfilled; they were dependent upon the British government and its tolerance of religious orders; they had to please patrons and a general public who initially saw them as "other." Fortunately, this perception tended to change as contact between nuns and the public increased.

Introduction 13

In the case of the English Benedictine nuns from Cambrai, the historian Janet Hollinshead asserts that they were given only a "cautious welcome" when they arrived in Woolton, a dissenting village. Yet Dame Ann Teresa Partington wrote three years later that "we have found no abatement in the kindness and charitable attention show'd to the community, not by our friends and relatives only, but by our country folks at large."[71] Dependence upon others' patronage and the goodwill of locals also made religious cautious when writing about their experiences in the community. While the overall reception of Catholic nuns in England was positive at the height of their arrivals (1793–1795), their specific experiences of migration to and settlement in England reveal nuanced and difficult journeys through the uncertain political climates of France, Belgium, and England. Nuns' own stories show how unstable their lives were during these years; perceptions of these women in popular culture and local communities could shift just as quickly.

Nuns' precarious position—physical, psychological, and economic—caused anxieties among the English Catholic elite, who had recently gained political ground: how should they respond to the return of entire communities when the toleration of the government towards permanent settlement of convents was contingent at best? English Catholics, such as Lord Robert Petre, worried that returning religious would worsen relationships between Catholics and the government.[72] Nuns were entering a tense political situation. According to historian M.D.R. Leys, by the mid-eighteenth century, "papists formed a permanent element in English society."[73] The Gordon Riots in 1780, which had resulted in 300 deaths and many injuries, were a backlash against more tolerant legislative policies for both native and foreign Catholics. The 1778 Catholic Relief Act had lifted some of the restrictions on property inheritance, repealed penalties against Catholic priests, and lessened penalties for teaching Catholic children in Catholic schools. The 1791 Relief Act went even further, lifting almost every restriction on Catholics, enabling them to worship freely, profess membership in a community, and educate their children in Catholic schools. Although facilitating the social integration of lay Catholics in England to some extent, these measures had a limited impact on nuns. Surviving restrictions directly targeted religious orders: nuns and monks could not wear their distinctive habits in public, profess new members, establish any religious houses, teach children with Protestant fathers, or mount steeples or bells on their churches.[74] Thus, their prospects of successful resettlement were highly uncertain. Hence, as Ward notes, "nothing short of absolute necessity would have supplied the requisite stimulus to induce the religious to break up their foreign establishments, and face the difficult task of refounding them in England."[75]

For most returning nuns the concept of social integration was already counterintuitive to the enclosed nature of their communities, and legal strictures undoubtedly made Catholic religious and cultural practices seem even more taboo to outsiders. Nuns were seeking contemplative spiritual spaces closed off and protected from the general populace and they typically kept a low profile, working outside of national institutions, social norms, and even, at times, the law. The wearing of religious habits had been outlawed since penal times. Though many

14 *Introduction*

nuns chose to relinquish religious dress, others were encouraged, even granted permission from clergy and the government, to wear them, despite the law.[76]

In this uncertain political environment, nuns understood that they would have to adapt their contemplative communities, if only temporarily, to a more active orientation with a focus on public service. One way they achieved this end was by opening schools: teaching was an acceptable role for women in British society and the schools benefited Catholics in England by educating their children without having to send them abroad. That this shift in emphasis was difficult for the Benedictines of Cambrai and other groups to undertake is evident in the community's own assertion that the nuns "obediently bent themselves to the highly uncongenial task of educating young ladies."[77] Nuns needed to appear harmless to the Protestant majority, working only within a carefully delineated Catholic world. Nonetheless, the proposal of the Monastic Institutions Bill in Parliament in 1800, after the vast majority of nuns had already arrived, reveals concerns among politicians about nuns' permanent settlement, the regulation of convents, the recruitment of novices, and nuns' roles in teaching Protestant children. Though the Bill was defeated, these issues remained just beneath the surface of local and national politics for decades.[78]

However, the political situation in Britain was only one of many challenges faced by nuns in the early years of the nineteenth century: women religious were busy rebuilding their lives, forging ties within local communities, and even reclaiming and returning to their convents on the Continent. For example, the English Augustinians from Bruges returned to their original convent in 1802 after eight years in England. The English Augustinians in Paris, the only English community to remain in their convent throughout the Revolution, provided schooling well into the nineteenth-century to both French and British students, including the future author George Sand.[79] While some repatriated religious anticipated a return to the Continent, for most, the French wars made the likelihood of such an enterprise impossible.[80] In the absence of any easy assimilationist or integrative topos to provide a "happy ending" for these women, the experience of settlement brought with it a number of serious challenges, several of which I will discuss in detail within this book's individual chapters.

Literary and Historical Encounters with Refugee Nuns: Organization of the Book

Romantic-era writings about and by nuns must be considered in the context of the pivotal historical events that shaped them. This framework implies an experiential chronology and imposes a pattern of sorts on nuns' otherwise seemingly chaotic movements from France and Belgium to England. The main body of this book traces that trajectory: I begin with nuns' pre-Revolution lives; follow the attacks perpetrated by the new French government on their homes, ways of life, and very identities; move on to their flight from the Continent and their arrivals and receptions in England; and finally consider their efforts to settle permanently in this new and, at times, hostile land.

Introduction 15

My exploration, then, starts before the Revolution, when convents thrived and attracted a wide array of British travelers. Travel narratives depicted women's monastic culture to British readers who did not imagine that they would soon be receiving actual nuns in their midst. As I examine in Chapter 1, the discourses about nuns contained in these travel narratives indicate that the British view of celibate cloistered women was actually far more complex and fluid than that found in the anti-Catholic texts of the period. Nuns, in turn, relied on their interactions with tourists to form alliances, gain recruits (students and novices), and maintain their British social networks. The chapter also explores the ways in which British Protestants functioned as consumers of Catholicism—using Catholic educational facilities, traveling on the Continent, and taking advantage of Catholic systems of patronage—until the Revolutionary Wars rendered travel to the Continent impractical.[81]

British travel writers exhibited a sustained fascination with Catholic nuns, as well as surprising degrees of access to and engagement with them. Hester Thrale Piozzi and Ann Radcliffe, writing 20 years apart, each visited several convents and recounted a variety of conventual practices among German, French, and English houses in Germany and France.[82] Thrale Piozzi in particular, whose 1775 travel journal shows French and English enjoying literary and leisured pursuits in the convents of the *ancien régime* (as of yet unmolested by the Revolution), reveals the high level of access to cloistered culture available to some Protestant women. Both writers initially interpret the lives of nuns through the reductionist motif of the incarcerated young woman, but further contact with women religious eventually allows both writers to critically reflect upon the advantages of conventual life over the economic and social instability that single women faced in England.

The second half of Chapter 1 examines the travel writings of William Cole, William Thicknesse, and Samuel Paterson. These male tourists had various motives for encountering women religious, ranging from a fascination with their culture to a desire to visit a daughter or friend.[83] Because they had far less access to nuns than did female tourists, it is surprising that these Protestant men legitimized celibate vocation at all, but they did. The travel narratives of Cole and Thicknesse, in particular, display a surprising degree of acceptance of and interest in Catholic institutions. These narratives also evince the popularity of French and English convents as educational institutions catering to British children.

Both male and female Protestant writers discuss their social and familial connections with nuns and their students, which indicates that the boundaries between Catholic and Protestant must have been far less rigid than we might assume. In summary, travel writers of both genders expressed an openness to Catholic religious traditions and an intense curiosity that compelled them to more deeply examine and comment upon women's monastic culture, its different forms, and its relevance to women in England.

Leaving behind these vignettes of calm conventual life, Chapters 2 and 3 turn to the upheaval brought about by the Revolution. When the French government seized French convents in 1791, many nuns found themselves uprooted and distressed. External narratives about nuns, as well as those written by nuns

16 *Introduction*

themselves, demonstrate that though they were indeed victims of the French government's agenda to root out Catholic monasticism, they were also agents: they resisted on multiple levels the laws that essentially dissolved their communities.[84] Writers who focused on the Revolution and its direct impacts on groups of nuns in France and Belgium, including their struggles with authorities ending in displacement or imprisonment, situated nuns as iconic counter-Revolutionaries who were both victims and heroes. Augustin Barruel, a French émigré priest who wrote for eager British audiences, depicted nuns at the center of the revolutionary action, highlighting their vulnerability and bravery in the face of violent expulsion from France. Helen Maria Williams, in her journalistic *Letters Containing a Sketch of the Politics of France* (1795), portrayed the English Blue nuns in France as national and international icons of women's political resistance to a new order that did not give women political representation.[85] Though they came from very different perspectives and backgrounds, both Barruel and Williams confronted British readers with the overwhelming difficulties experienced by women religious, while simultaneously emphasizing nuns' agency in defending their physical integrity, properties, and cultural practices.

Chapter 2 specifically examines the lives of nuns in France during the Revolution and the reception of the first group of nuns to migrate, the French Benedictines of Montargis. Compared to other disadvantaged groups, these exiles, according to Carpenter, "had far greater access to men of influence," and it should be added, women of influence as well.[86] Barruel's portrayal of nuns in France as national heroes legitimized England's generous reception of French religious refugees, as well as the nation's provision of safe havens where dispersed communities could reassemble. When the 37 French Benedictines arrived at Shoreham on October 17, 1792, Barruel reported that a "mass" of spectators gathered and the nuns were greeted by the Prince of Wales himself. They were far from helpless, as Barruel explains: "Englishmen admired their courage and resolution. They were everywhere treated with that regard which respect inspires, they everywhere met with the most generous support." Indeed, subsequent news coverage reported that the nuns benefited from the use of the Prince's carriage and their journey was arranged by his Catholic mistress, Mrs Fitzherbert, who, along with their other Catholic benefactors, William and Frances Jerningham, continued to assist the group.[87] French refugees also received support from other Catholic and Protestant benefactors, the Anglican Church, and the British government. The outpouring of assistance for these early religious refugees was no accident: Carpenter notes that religious exiles, "because of their background, understood the workings of pressure and patronage," which enabled a smoother transition than is often the case when groups are forced to relocate.[88]

On the other hand, according to Bellenger, most migrating religious did not have quite the "ready-made set of benefactors," as enjoyed by the French Benedictines of Montargis; even this group's reception in the local community was, at times, uneasy.[89] In fact, the vulnerability of women religious marked them as fodder for political propaganda, prompting journalists, historians, and cultural

Introduction 17

critics to magnify and valorize the English nation's role in providing refuge to political outcasts.[90] The popular press, such as the *St James's Chronicle, Public Advertiser, General Evening Post*, and *Gazetteer*, furnished the public with tabloid versions of nuns' lives: they were transformed from incarcerated virgins in the early years of the Revolution, to exotic refugees in need of the nation's protection by 1792. As Chapter 2 demonstrates, contemporary news coverage also reinforced a model of the generous reception of refugee nuns by the wealthy and blurred the distinctive national identities of nuns. Newspaper coverage tracked nuns' movements, lampooned and lauded the popular figures who supported and courted them, and published their locations, gratifying both potential benefactors and community members eager to spot newly arrived religious groups.

As the fragmentation and dispersal of religious communities continued abroad, English nuns remaining on the Continent were forced to travel to England. Their arrival and reception on English shores, captured in the print media of the time, were crucial aspects of nuns' emigration experience. Chapter 3 examines the harsh realities that English nuns endured during the French Revolution, focusing specifically on the English Conceptionists or Blue Nuns of Paris and the English Benedictines of Cambrai, as discussed in contemporary documents. For example, the account books of the English Benedictines of Cambrai, after they settled in Woolton, disclose the types and amounts of aid provided by the local community and other benefactors. And, letters from nuns to other religious, friends, and family detail the interactions that nuns had with locals and patrons as they attempted to create new homes and sources of income.[91]

Chapter 3 also analyzes women writers who brought nuns' stories into line with these writers' own national, personal, and religious agendas. Helen Maria Williams, normally a fierce critic of women's religious enclosure, saw the English Blue Nuns as models of affective and effective reception because of the hospitality they had displayed towards British nationals incarcerated in their Parisian convent years before; unsurprisingly, Williams herself had been one of those prisoners.[92] Reimagining conventual space as a potent expression of social efficacy and sororal equality, Williams's *Letters Containing a Sketch of the Politics of France* attracted a wide readership in 1795, just as the majority of English nuns were returning to England. That the remaining six Blue Nuns reluctantly returned to England as late as 1800, and that their group dispersed soon afterwards, highlights the difficulties of psychological and physical recovery, social integration, and economic sustainability that migrating nuns faced, even when backed by Catholic elites.

The role that the Blue Nuns' chief benefactor, Lady Frances Jerningham, played in preserving their written legacy is a striking example of the access that some lay Catholics had to archival documents. Her revisions to the community's *Diary* puts as positive a spin as possible upon the Blue Nuns' final years, revealing in her personal support of their enterprise very different motivations than those of Williams. Jerningham's additions to the *Diary* emphasize corporate integrity rather than fragmentation and cover up the group's dispersal that took place five years

18 *Introduction*

into the Blue Nuns' sojourn in England.[93] With her family's reputation at stake, Jerningham kept a tight hold on the Blue Nuns' history.

Nuns' fates were thus as varied as their receptions as they sought to begin new lives on British soil. Some groups found new homes and eventually thrived, while others, despite valiant efforts by nuns and their Protestant and Catholic supporters, did not even survive. The final chapter of this book deals with the outcomes of migration and the challenges of permanent settlement. Chapter 4 examines the tense politics surrounding the development of Catholic schools and refugees' consolidation of resources, focusing specifically on émigré priests who began arriving *en masse* in 1793 and the English Augustinians from Bruges who migrated in 1795. I look at this history in the particular context of women writers' use of the refugee crisis to supplement educational opportunities for young women. While Charlotte Smith in *Rural Walks* (1795) figures émigré priests as collaborative and socially useful individuals with marketable skills in teaching, Frances Burney in *Brief Reflections* (1793) argues that the survival of these migrants depends upon charitable practices by British women and girls patterned after the temporarily defunct Daughters of Charity.[94] Smith also proposes a model curriculum for girls that moves beyond charitable giving, encouraging them to reflect critically upon national and international political history. Both writers acknowledge their nation's complicity in the dispersal and dispossession of nuns and monks during the English Reformation. Perhaps this is due to the fact, as Wiley contends, that France's break with the *ancien régime* gave British writers an opportunity to "retrace [Britain's] migratory past."[95]

As a re-membered body of women, in the process of transposing the past into the present, English nuns were both historical relics and contemporary agents. Having escaped the severe restrictions imposed by the French government, they arrived directly into another patriarchal culture, which was, ironically, figured maternally by some women writers.[96] Indeed, Burney's work emphasizes a distinctly feminine form of national benevolence that also constructs refugees as dependents. Smith, in contrast, advocates practical measures to ameliorate migrants' financial burdens and integrate them into the work force. It should also be noted that fiscal relationships between refugees and locals, such as those Smith describes, promoted business in England.[97]

Nuns in England also recouped financial ground through teaching and managing schools for girls amidst intense competition for students in an era when a plethora of educational facilities and various curricular experiments were emerging. Nuns' progress, though halting at times, clearly belied the dire predictions of monastic dissolution that had been made by Burney. The fear that refugee Catholic nuns were recruiting high numbers of students and new members provoked Parliamentary debates in 1800 about the status of convents on English soil. Though such debates suggest that the national romance of playing savior to women in distress was wearing thin, in reality, the very rhetoric of paternal and national care of nuns was used to defend their current status. Because it was assumed that French communities would return to France, and that English groups were of little threat, the government continued to grant them

Introduction 19

safe asylum and pay subsidies to each nun until her death.[98] The fragile position of nuns during this time also contributed to the public perception that they were harmless, even as print culture had celebrated their heroism nearly a decade earlier. Poignant motifs of nuns' diminution, dismemberment, death, and even extinction were threaded through the literature of the times and were reflected in the political debates,[99] reminding everyone of the human and cultural costs of the Revolution.

Texts written by nuns show them undergoing and negotiating political and personal turmoil and also expose how some of their choices were shaped by others. Their accounts paint more detailed pictures of their lives than we can find anywhere else and offer unique insights into the multi-faceted cultural exchanges that occurred between nuns and the outside world during the 1790s. For example, although all of the writers explored here—Catholic and Protestant alike—praise the benevolence of the English nation, only nuns can inform us that they understood their position on British soil was very tenuous. Only by listening to nuns' voices can we discover that they found entertaining patrons and pandering to the demands of benefactors a tricky and potentially annoying business. Benefactors and patrons supplied women religious with financing, housing, and even students, and thus they sometimes asserted a "right of entry" into the community, in spite of the privacy nuns wished to maintain.[100] According to Sister Scholastica Jacob, an archivist at the English Benedictine convent in Wass, North Yorkshire, refugee nuns recovering from the trauma of war had a strong interest in maintaining religious enclosure.[101] Yet, financially dependent, facing the challenge of social and professional survival in what Mangion has called, "a homeland that was not Catholic," where their very loyalty to the nation was suspect, nuns were often forced to bow to the desires of others.[102] In the end, therefore, I examine some of the ways that systems of charity and patronage benefited nuns, while potentially compromising the traditions that made their cultures distinct.

Although this book discusses the shared experiences of many groups of migrating nuns—drawing parallels and making connections between them—it centers particularly on four monastic communities along with the writers who encountered them. These communities are the French Benedictines of Montargis in Loiret, the first migrant community to arrive in 1792 and which was active in England until the early 2000s; the English Conceptionists or Blue Nuns in Paris, a group that did not relocate until 1800 and was essentially defunct by 1805; the English Augustinians of Bruges, who stayed in England for eight years but returned to their Belgian convent in 1802 where an active community remains today; and the English Benedictines of Cambrai, who arrived in 1795 and currently reside at Stanbrook Abbey in Wass, North Yorkshire.[103]

Through the lens that these communities' histories provide, I examine the varying ways that writers perceived the impact of the French Revolution on monastic culture, as well as the varied fortunes of each community of nuns. Their stories typify the wide range of experiences of women religious during this time, including fierce conflicts with revolutionary authorities, imprisonment, financial gains and losses, deaths of community members, dispersal and reunion, exile and relocation. Three

20 *Introduction*

of these groups—the French Benedictines of Montargis, the English Blue Nuns, and the English Augustinians of Bruges—shared the same primary Catholic benefactor, Lady Frances Jerningham, a woman who had numerous cloistered relatives and strong connections to the exiled English convents. In spite of this shared source of support, however, the three groups did not share similar fates. The fourth group, the English Benedictines of Cambrai, is discussed throughout the book. Their story provides extensive evidence of how nuns negotiated their struggles and adapted to a new way of life in England. It is worth noting here that the English Benedictines came to England disguised in perhaps the most famous of all religious relics from France, the peasant clothing once worn by the now beatified French Carmelites of Compiègne who had been beheaded on the scaffold in 1794.[104]

In order to better understand the British cultural reaction to nuns' traumatic dispossession, flight, and resettlement, it is necessary to examine the dominant motifs of cloistered experience found in seventeenth- and eighteenth-century literature. For example, the early figure of the eroticized and sex-starved nun trapped in a repressive and corrupt convent overlaps with later images of nuns, convents, and monasteries popularized in gothic fiction: the gothic nun brings an exoticism to the supposed terror, superstition, and deviant sexuality found within the cloister. On the other hand, an entirely different sort of representation of the cloister in eighteenth-century literature positions women's monastic orders as models of alternative, even utopian, female communities. These texts emphasize women's agency in creating distinct spaces for self-determination. The next section of this Introduction comprises a general map of these often contrasting literary and cultural constructions of women religious in the seventeenth and eighteenth centuries, providing an important foundation for a dialectic exploration of nuns' emigration experience alongside contemporary writers' responses to their material presence in England.

Nuns and Convents: A Complex History of Representation

Anti-Catholic polemic shaped perceptions of women religious in seventeenth- and eighteenth-century British culture, affecting the ways in which both writers and readers viewed them. Anti-Catholic discourse in Britain constructed the convent as "an obviously odious alternative to marriage . . . it typified the oppression of women which prevailed in Roman Catholic Europe."[105] In fact, the Rule of the Clausura, which restricted nuns to an enclosed existence of prayer, had been reaffirmed by the Council of Trent in 1563 and continued to be enforced. It was implemented architecturally by means of barred windows, curtains obscuring outside views, walls around the cloister, locks, and grates.[106] These regulations were just some of many moves made by the Catholic church to further consolidate the cloister and control the individuals within its structure. Incarceration was necessary, the anti-Catholic argument ran, to keep women from leaving.

Though many women choose religious lives for themselves, they were also guided by the desires of others. Some parents were motivated to send a daughter to the convent because entry into a religious community was less expensive than

Introduction 21

a marriage dowry. As John Milton sarcastically described them, nunneries constituted "convenient stowage for withered daughters."[107] Nonetheless, the practice of arranged marriage, and the domestication of women through the institution of marriage in general, call into question the notion that convent life was any more restrictive for women than marriage. As Jenny Franchot argues, "[c]onvent interiors then, registered the tensions of Protestant familial interiors while thwarting domesticity's hegemonic claims."[108]

While nuns fought to maintain their communally oriented lives during the Revolution, several centuries of anti-monastic propaganda had already framed them as frustrated young women waiting for release from incarceration in Continental cloisters. The variety of narrative tensions implicit in this imprisonment motif helps to explain not only what made it so appealing, but also its frequent deployment in literature. The French epistolary collection, *Les Lettres portugaises* (1669), is a notable early example that was widely available, translated, and spoofed. Supposedly based on the true story of the nun Marianna Alcoforado and her French beau, Chamilly, the letters are not unlike Alexander Pope's poem "Eloisa to Abelard" (1717) in their depiction of the emotional fluctuations—passion, ecstasy, rage, sadness, frustration—experienced by the cloistered Marianna, who refuses to repent of her desires even after Chamilly has abandoned her.[109] British travel writing from the seventeenth and eighteenth centuries also frequently includes this incarceration trope.[110]

Restoration drama and British amatory fiction employed the convent as a recurrent plot device in the service of a variety of ends: enclosure is used as a threat against young women who refuse to capitulate to the demands of parents, an escape from undesirable marriages, a barrier that ultimately facilitates romance, a last resort for women recouping their reputation, and a temporary refuge for characters in transit. Eliza Haywood's *Love in Excess* (1719–1720), for example, positions the convent as both a convenient repository for female characters and an exciting site for their subsequent rescue by men. *Fantomina* (1725), also by Haywood, is a story about a curious and independent young woman who is sent to a French convent by her mother after giving birth to a child. Conventual enclosure in *Fantomina* has the power to both restore the eponymous heroine's reputation and punish her for transgressing sexual norms.[111] *The Convent of Pleasure* (1668), by Margaret Cavendish, Duchess of Newcastle, depicts a cultured, courtly, and leisured female community, although heterosexual love pairings ultimately transform the convent into a courting space.[112] In Aphra Behn's *The Rover* (1677), Hellena barely escapes her family's plans to relinquish her to a libidinous mother superior. Likewise, in Susanna Centlivre's, *The Wonder: A Woman Keeps a Secret* (1714), Violante frustrates her father's design to commit her to a cloister, whereas Isabella threatens religious profession if her father forces her hand in marriage.[113] As a narrative device lurking in the periphery of these tales, the convent registers tensions regarding the limits and privileges of paternal authority over the marrying, punishing, and disposing of daughters.

John Dryden's *The Assignation: Or, Love in a Nunnery* (London, 1673), goes even further, drawing upon the hackneyed but entertaining trope of sexually

22 *Introduction*

voracious nuns. According to Ana M. Acosta, "[T]he combination of titillation and religious ideology was frequently exploited for its ability to increase theatre attendance and book circulation."[114] In the anonymously penned *Vénus dans le cloître, ou la Religieuse en chemise* (1683), the young Sister Angélique personally initiates the newest member of the convent, the sixteen-year-old Agnes, into sexual experience, opening conventual interiors to eager readers of pornographic fantasy. This work was translated and circulated widely in England by 1725.[115]

Late eighteenth-century fiction enlisted Enlightenment criticism of monastic orders through two primary genres: the French libertine novel, widely read in England, and the English gothic novel. French libertine fiction frequently played upon reversals: sacred spaces become undisciplined playgrounds in order to question the motives of and satirize nuns, monks, and clergy. Denis Diderot's *La Religieuse* (1796) comes out of this tradition, presenting the cloister as a perverse and dangerous location for women because of its supposed despotic political structure, its denial of healthy heterosexual sexuality, and its propagation of anti-rationalism and superstition. Although Diderot had worked on *La Religieuse* for several decades, by the time it was released in 1796 (printed in English in 1797), Diderot had died and French convents had been dispersed. As Russell Goulbourne observes, by that time the nun was "less a figure of sexual fun and more a figure to be pitied."[116] From this vantage point, Diderot's text feels outdated; though his criticisms of women's monasticism were shared by many, the spectacle of displaced nuns had already changed public sympathies.

In British gothic novels, such as Horace Walpole's *The Castle of Otranto* (1765), Ann Radcliffe's *Mysteries of Udolpho* (1794), and *The Italian* (1797), the convent functions as a sublime architectural monument that facilitates plot intrigues through the power it affords a foreign Catholic patriarchy. Katherine points out that women gothic novelists, such as Radcliffe, tended to romanticize the convent more than did male authors, a trend that indicates "some sentimental sympathy" with conventual life. Indeed, Radcliffe is far more sympathetic in her depiction of the cloister in her post-revolutionary novel *The Italian* than in her earlier fictions. However, even in the works of women authors, the convent's anti-intellectual representation makes it more useful as a disguise or cover for female characters than it is for their spiritual enlightenment.[117] The convent as safe haven also appears in François-René Chateaubriand's *René* (1802). Yet here religious space provides a respite from life's vicissitudes, as well as a place for the morally weak (René has fallen victim to the charms of his own sister). Imlac's comments on religious vocation, in Samuel Johnson's *Rasselas* (1759), work in the same vein: "In monasteries the weak and timorous may be happily sheltered, the weary may repose, and the penitent may meditate."[118]

Other gothic novels portray morally weak individuals whose *amours* are acted upon—even made possible—within the monastery. Matthew Lewis's *The Monk* (1795), for instance, offers a lurid portrait of convents in which nuns who transgress sexual boundaries are either agents of the devil or sacrificial victims of ecclesiastical tyranny.[119] Lewis's depiction draws upon a long-standing association of nuns with prostitutes, as well as with witches. Ever since the medieval

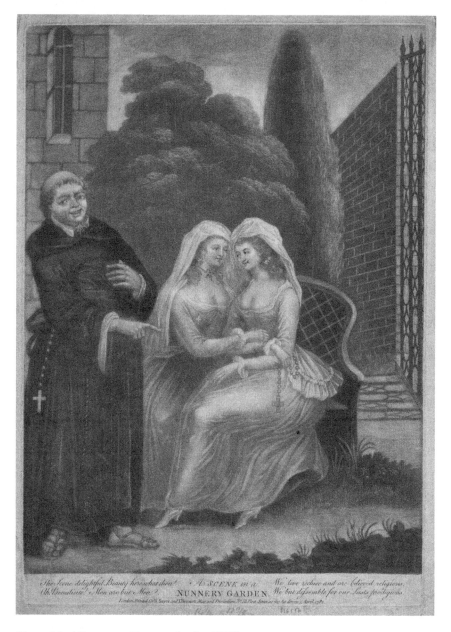

Figure I.1 A Scene in a Nunnery Garden (1782).

Source: The Trustees of the British Museum.

Anonymous, *A Scene in a Nunnery Garden*, 35.3 × 25 cm, mezzotint on paper, 1782, British Museum, London.

24 Introduction

period, some had believed that women were especially susceptible to the machinations of the devil; thus nuns who received divine messages that opposed male clergy were vulnerable to accusations not only of heresy, but also of demonic possession or witchcraft. Prostitutes and nuns also shared an "economic and social independence" from "parental and conjugal discipline" and therefore were often conflated in sensational literature.[120]

The surprising similarities between French and English representations of convents, says Rogers, imply that "Enlightenment secularism conditioned everyone's thinking, regardless of nationality," and that "[h]ostility to monastic ideals caused both [sets of] writers to distort their pictures of the convent by overemphasizing its austere and extreme aspects."[121] Moreover, eighteenth-century texts could play both sides of this field. For example, Adelaïde de Sousa-Botelho's *Adèle de Sénage* (1794) details Sister Eugénie's discontent in the convent, while at the same time describing its important social contributions as a hostel and respectable school.[122] Johnson's *Rasselas* also simultaneously critiques and complements the monastic ideal: not only does Pekuah return to St Anthony's convent where she wishes to "be made prioress of the order" and "be fixed in some invariable state," but also Imlac, while associating monasteries with the morally weak, declares that "retreats of prayer and contemplation have something so congenial to the mind of man."[123]

Indeed, British writers who explored the lives of Catholics on the Continent—whether through travel, personal encounters, or simply imagination—demonstrated a capacity to understand, sympathize with, and even long for a religious vocation. Many literary and historical examples attest to the ongoing interest that many Protestants had in recreating a monastic model in England. Bridget Hill, in her examination of British writers who promoted the establishment of Protestant nunneries in the eighteenth and nineteenth centuries, comments that this multiplicity of "backward glances" at pre-Reformation monasticism occurred too often to be "easily dismissed." Citing examples that date back to the years following the dissolution of the monasteries in the sixteenth century—including Little Gidding (1625–1657), established by the Anglican deacon Nicholas Ferrars as a liturgically high lay monastery for his friends and family—Hill makes a strong case for the persistent interest among British writers in promoting a Protestantized version of community for women in England.[124] Perhaps the most famous and frequently cited proposal for such a community is Mary Astell's *A Serious Proposal to the Ladies* (1694), a scheme which offered an English audience the vision of a Protestant female community in which women could be educated properly and live apart from secular society. As Hill notes, Astell's proposal "suggests that nunneries and the role they had played—or rather . . . the role they were thought to have played—before the Reformation were not far from her mind."[125] Although her plan never materialized as an actual community, *A Serious Proposal* went through four editions by 1701, a fact that bespeaks the continuing popularity of Astell's idea.

Tract writers such as Sir George Wheeler and Edward Stephens proposed societies similar to Astell's in 1698 and circa 1700, respectively, while some

Introduction 25

English women living singly and in small groups undertook self-imposed religious vocations before the turn of the eighteenth century.[126] That these communal possibilities were independently explored by Protestants indicates, in Anson's opinion, that the exiled English Catholic communities were "a constant reminder that ... the *Ecclesia Anglicana* ... had not managed to provide similar opportunities for men and women."[127] Jane Barker, an English Catholic novelist and poet who followed James II into French exile, suggests throughout her writings that women's investment in religious vocation was prompted by a confluence of religious, political, and feminist agendas: within a convent, a woman might avoid both marital and political problems while pursuing a religious vocation within an all-female community.[128]

Sarah Scott projects just such an ideal in *Millenium Hall* (1762). Promoting education through an "invented society" of women, Scott's fiction, as described by Alessa Johns, presents a "viable mode of group life involving friends, family, neighborhood, and community," and "a world that offers satisfactions in many areas and for whole groups of people." Johns terms works like Scott's "generic hybrids," which pose the development of an institution or group rather than that of the individual. As one might expect, then, such utopian and reformist fictions often include the creation of institutions, such as schools, hospitals, and almshouses, adjacent to women's communities.[129]

In some cases men actively collaborated with women's communal proposals. A decade earlier than Scott, in the novel *Sir Charles Grandison* (1753), Samuel Richardson voiced concerns very similar to hers. In this novel, worries about the livelihoods of unmarried and impoverished gentlewomen induce Sir Charles to propose the foundation of a Protestant nunnery in every county in England. Living in groups, he envisions, the women could "maintain themselves genteelly on their own income; though each singly in the world, would be distressed." Even earlier, Richardson's title character *Clarissa* (1748) declares that if only her family were Catholic, she might happily join a convent, rather than marry without love.[130] More ambitiously, in a work by Thomas Amory, a woman of means founds an all-female Protestant nunnery in Yorkshire, modeling her retreat on Catholic convents inspired by her Continental travels.[131] And 80 years later, in *Sir Thomas More: or, Colloquies on the Progress and Prospects of Society* (1829), Robert Southey made his own plea for female communities.[132]

Eighteenth-century Dissenters and Unitarians were likewise interested in developing religious communities. In the nineteenth century, Shakers and Millenarians would practice forms of lay monasticism comprising communities of celibate men and women withdrawn from secular society.[133] The earlier dissenting and Anglican-based projects "anticipated [these] nineteenth-century experimental communities ... as they leaned on Enlightenment concepts."[134] In particular, Franchot maintains that nineteenth-century American experiments, such as Bronson Alcott's Brook Farm in Massachusetts, can be directly connected to the "communitarian ideals" of Catholic monasticism: both projects explore alternatives to and contest domesticity.[135]

26 *Introduction*

Much like their realized counterparts, fictional utopias, "attempt to secure economic and legal independence for their members by favoring homosocial relationships over heterosexual family structures—clearly an indication of women's persisting unequal position in the so-called companionate marriage, according to Nicole Pohl and Rebecca D'Monté."[136] As Christine Rees asserts, eighteenth-century utopian fictions can be seen "as a mirror tilted by the author to catch new angles on familiar aspects of his or her society."[137] Using Michel de Certeau's notion of the *bricoleur*—a cultural consumer who takes advantage of existing resources to build sites of resistance to a hegemonic power structure—Johns proposes that we think of women utopian writers as female consumers, or *bricoleuses*, whose reformist projects create the possibility of female agency through limited collaborations with patriarchal society.[138]

Just as women writers explored their interest in monastic life through fiction, they also used non-fiction to advocate for refugee assistance during the Revolution. Catholic nuns and British women writers collaborated in this regard across both religious and secular lines. Williams's narrative contains a first-hand account of imprisoned nuns and British nationals working together to resist government authorities and offer mutual support. Burney, although not as directly involved in the conflict as Williams, validates and recommends to British women the service roles of religious sisters in caring for émigré priests.[139] Her championing of nuns' efforts represents not only an act of solidarity with displaced religious, but also a means of justifying women's public work in philanthropy and education.

Linda Colley and Anne K. Mellor have shown that, as time went on, women in England became increasingly visible and public in their responses to the Revolution, something that Burney's contributions also demonstrate. They administrated philanthropic organizations, engaged in political activities, such as electioneering and canvassing, and used their rhetorical skills to actively involve readers in their concerns. Mellor states that "insofar as [writers] represented the interests of women, children, and the family, they also saw themselves as peculiarly responsible for defining the future direction of public policy and social reform."[140] The year after the French Benedictines of Montargis arrived in Dover, Burney was busy refashioning the legacies of women religious for those outside of the cloister. She argued that British women must now engage in the public work of social aid that had been executed by women religious for hundreds of years.

As this study illuminates, secular women and Catholic nuns each contributed significantly to the projects of social transformation and religious liberalization, which were central movements in the Romantic period, according to Robert M. Ryan.[141] On the eve of the Victorian age, refugee nuns had worked quietly and diligently for almost 40 years since their displacement from the Continent, employing innovative strategies to achieve solvency and consolidate their assets. By this time, anti-Catholic sentiment had intensified because of the passing of the Catholic Emancipation Act of 1829 and the influx of Irish Catholic immigrants to England in the 1830s and 1840s.[142] To address the new social

Introduction 27

problems that these changes caused, Catholic clergy reached out to women religious from Ireland, France, and Belgium, initiating another wave of migrations to England. By mid-century, the contemplative English communities attracted Irish and middle-class English entrants, and women's institutes, devoted to serving the poor, appealed to a variety of women, including aristocratic English Catholics.[143] The stories of earlier religious migrants began to fade into popular memory and local lore. Not even the nuns themselves, much less the public who had been fascinated by their travails at home and abroad, could have anticipated that a "second spring" of religious life in England was around the corner and that 300 convents would dot the landscape by 1880. Nor could they anticipate that these diverse convents would be populated with thousands of women, adeptly founding, managing, and developing schools, orphanages, nursing homes, and other infrastructures, providing much-needed services to the public well into the twentieth century.[144]

Notes

1 Charlotte Brontë, The Poems of Charlotte Brontë, ed. Victor A. Neufeldt (New York, 1985), p. 277; Florence Nightingale, *Ever Yours, Florence Nightingale Selected Letters*, eds Martha Vicinus and Bea Nergaard (Cambridge, 1990), p. 59.
2 Val Web, *Florence Nightingale: The Making of a Radical Theologian* (St Louis, 2002), pp. 13, 130–32.
3 Carmen M. Mangion, "Women, Religious Ministry, and Female Institution-Building," in Sue Morgan and Jacqueline deVries (eds), *Women, Gender and Religious Cultures in Britain, 1800–1940* (London, 2010), p. 72. The term "nun" is often used in place of "sister" in common usage and this research follows this convention. "Women religious" is a broad term that refers not only to contemplative choir nuns and lay sisters, but also enclosed and unenclosed active sisters, as well as laywomen who took simple vows in a women's congregation. This research primarily focuses on contemplative communities.
4 For popular reactions to Catholic convents and Anglican Sisterhoods in Victorian culture see Michael Wheeler, *The Old Enemies: Catholic and Protestant in Nineteenth-Century English Culture* (Cambridge, 2006), pp. 213–44; John Shelton Reed, *The Glorious Battle: The Cultural Politics of Victorian Anglo-Catholicism* (Nashville, 1996), pp. 186–209; Susan Mumm, *Stolen Daughters, Virgin Mothers: Anglican Sisterhoods in Victorian Britain* (London, 1999), pp. 166–206; Dennis G. Paz, *Popular Anti-Catholicism in Mid-Victorian England* (Stanford, 1992).
5 Carmen M. Mangion, "The 'Mixed Life': Challenging Understandings of Religious Life in Victorian England," in Laurence Lux-Sterritt and Carmen M. Mangion (eds), *Gender, Catholicism, and Spirituality* (New York, 2011), p. 168.
6 For example, see Toby Benis, *Romantic Diasporas: French Emigrés, British Convicts, and Jews* (New York, 2009); Kirsty Carpenter, *Refugees of the French Revolution: Emigrés in London, 1789–1802* (New York, 1999); Dominic Aidan Bellenger, *The French Exiled Clergy* (Bath, 1986); Margery Weiner, *The French Exiles 1789–1815* (London, 1960).
7 Susan O'Brien, "A Survey of Research and Writing about Roman Catholic Women's Congregations in Great Britain and Ireland (1800–1950)," in Jan DeMaeyer, Sophie LaPlae, and Joachim Schmiedl (eds), *Religious Institutes in Western Europe in the Nineteenth and Twentieth Centuries* (Belgium, 2004), p. 93.

28 *Introduction*

8 Nigel Aston, *Religion and Revolution in France 1780–1804* (Washington D.C., 2000), pp. 134, 182, 232–3; Elizabeth Rapley, *A Social History of the Cloister: Daily Life in the Teaching Monasteries of the Old Regime* (Montreal, 2001), pp. 100–105.

9 Elizabeth Rapley and Robert Rapley, "An Image of Religious Women in the *Ancien Régime*: The *Etats de religieuses* of 1790–91," *French History*, 11 (1997): p. 389. Rapley and Rapley state that 8,000 secular sisters and "a thousand or so" canonesses have been documented. Claude Langlois estimates that by 1790, there were 44,000 nuns, 1,000 canonesses, 7,500 secular sisters, and 3,000 nursing sisters. Claude Langlois, *Le catholicisme au feminine: les congrégations françaises à supérieure générale au XIXe siècle* (Paris, 1984), p. 78. A total of 55,000 women religious is cited in Olwen H. Hufton, *Women and the Limits of Citizenship in the French Revolution* (Toronto, 1999), p. 57; and Derek Beales, *Prosperity and Plunder: European Catholic Monasteries in the Age of Revolution, 1650–1815* (Cambridge, 2003), p. 86.

10 Carmen M. Mangion, *Contested Identities: Catholic Women Religious in Nineteenth-Century England and Wales* (New York, 2008), p. 35; An estimated 340 French nuns were in England by 1800. John Adolphus, *The History of England from the Accession to the Decease of George the Third* (7 vols, London, 1845) vol. 7, pg. 273. Estimates of English nuns who migrated to England are from the *Who Were the Nuns?* database, <http://wwtn.history.qmul.ac.uk/>, accessed Feb. 9, 2016. The number of nuns who arrived in smaller groups or did not live in community formations is unknown.

11 For nuns' reception in England, see Callum Whittaker "La Généreuse Nation!" Britain and the French Emigration 1792–1802," M.A. Dissertation (York, 2012); Dominic Aidan Bellenger, "The Brussels Nuns at Winchester 1794–1857," English Benedictine Congregation History Commission Symposium (1999), pp. 1–7; Peter F. Anson, *Building up the Waste Places* (Leighton Buzzard, 1973), pp. 13–40; Carpenter. Exceptions include historians who have examined representations of nuns, including Mita Choudhury, *Convents and Nuns In Eighteenth-Century French Politics and Culture* (Ithaca, 2004); and Mumm, pp. 166–206.

12 For discussions of eighteenth-century utopian women's fiction see Christine Rees, *Utopian Imagination and Eighteenth-Century Fiction* (New York, 1995); Nicole Pohl and Rebecca D'Monté (eds), *Female Communities, 1600–1800* (New York, 2000); Nicole Pohl and Brenda Tooley (eds), *Gender and Utopia in the Eighteenth Century: Essays in English and French Utopian Writing* (Burlington, 2007); Bridget Hill, "A Refuge from Men: The Idea of a Protestant Nunnery," *Past and Present*, 117 (1987): pp. 107–30.

13 See Susan P. Casteras, "Virgin Vows: The Early Victorian Artists' Portrayal of Nuns and Novices," *Victorian Studies*, 24/2 (1980–81): pp. 157–84; Wheeler, pp. 213–44; Mumm, pp. 166–206. For eighteenth-century literary representations of nuns, see Ana M. Acosta, "Hotbeds of Popery: Convents in the English Literary Imagination," *Eighteenth-Century Fiction*, 15 (2003): pp. 615–42; Christopher Rivers, "Safe Sex: The Prophylactic Walls of the Cloister in the French Libertine Convent Novel of the Eighteenth Century," *Journal of the History of Sexuality*, 5/3 (1995): pp. 381–402; Katherine Rogers, "Fantasy and Reality in Fictional Convents of the Eighteenth Century," *Comparative Literature Studies*, 22 (1985): pp. 297–316; Barbara Woshinsky, *Imagining Women's Conventual Spaces in France*, 1600–1800 (Aldershot, 2010).

14 Mumm; Susan O'Brien, "French Nuns in Nineteenth-Century England," *Past and Present*, 154 (1997): pp. 142–80; O'Brien, "Terra Incognita: The Nun in Nineteenth-Century England," *Past and Present*, 121 (1988): pp. 110–40; Barbara Walsh, *Roman Catholic Nuns in England and Wales, 1800–1937* (Dublin, 2002); Mangion, *Contested Identities* and "The 'Mixed Life,'" pp. 165–79; Martha Vicinus, *Independent Women: Work and Community for Single Women, 1850–1920* (Chicago, 1985), pp. 46–84.

Introduction 29

15 Benis, p. 14.

16 Carmen M. Mangion, "Avoiding 'rash and imprudent measures': English Nuns in Revolutionary Paris, 1789–1801," in Caroline Bowden and James E. Kelly (eds), *Communities, Culture and Identity: The English Convents in Exile, 1600–1800* (Aldershot, 2013), p. 252.

17 Michael Wiley, *Romantic Migrations: Local, National, and Transnational Dispositions* (New York, 2008), p. 5. Wiley uses this phrase to describe broadly French emigrants' struggles to integrate socially.

18 See M.D.R. Leys, *Catholics in England 1559–1829: A Social History* (New York, 1961); Bernard Ward, *The Dawn of the Catholic Revival in England, 1791–1803* (2 vols, London, 1909); Bellenger, *French Exiled Clergy*; E.R. Norman, *The English Catholic Church in the Nineteenth Century* (Oxford, 1985); Peter Guilday, *The English Catholic Refugees on the Continent, 1558–1795* (New York, 1914).

19 O'Brien, "Terra Incognita," p. 118.

20 Claire Walker, *Gender and Politics in Early Modern Europe: English Convents in France and the Low Countries* (New York, 2003); Nicky Hallett, *The Senses in Religious Communities 1600–1800* (Aldershot, 2013); Jo Ann Kay McNamara, *Sisters in Arms: Catholic Nuns through Two Millennia* (Cambridge, 1996), and Rapley, *A Social History of the Cloister*. See also Rapley, *The Lord as Their Portion: The Story of the Religious Orders and How They Shaped Our World* (Cambridge, 2011).

21 See *In a Great Tradition: The Life of Dame Laurentia McLachlan, Abbess of Stanbrook by the Benedictines of Stanbrook* (New York, 1956); *A History of the Benedictine Nuns of Dunkirk*, ed. by the Community (London, 1958); Frideswide Stapleton, *The History of the Benedictines of St Mary's Priory, Princethorpe* (Hinckley, 1930).

22 For example, Margaret J. Mason, "The Blue Nuns in Norwich: 1800–1805," *Recusant History*, 24/1 (1998): pp. 89–122; and Mason, "Nuns of the Jerningham Letters: Elizabeth Jerningham (1727–1807) and Frances Henrietta Jerningham (1745–1824), Augustinian Canonesses of Bruges," *Recusant History*, 22/3 (1995): pp. 350–69. To avoid confusion, the last article is cited in future references as "Augustinian Canonesses of Bruges." Cecilia Heywood, "Records of the Abbey of our Lady of Consolation at Cambrai 1620–1793," in Joseph Gillow (ed.), *Miscellanea*, 8 (London, 1913), pp. 20–35.

23 *Who Were the Nuns? A Prosopographical Study of the English Convents in Exile 1600–1800*, Queen Mary University of London and the Arts and Humanities Research Council, http://wwtn.history.qmul.ac.uk/; *The English Convents in Exile, 1600–1800*, eds Caroline Bowden, Carmen M. Mangion, Michael Questier, et al. (6 vols, London, 2012–2013). See also Isobel Grundy, "Women's History? Writings by English Nuns," in Isobel Grundy and Susan Wiseman (eds), *Women, Writing, History: 1640–1740* (Athens, 1992); Dorothy L. Latz, *Neglected English Literature: Recusant Writings of the 16th–17th Centuries* (Salzburg, 1997). As Walker articulates, "emerging interest in the post-Reformation cloisters has yet to match the attention received by the medieval English nunneries, and the fate of their inmates after the Dissolution," *Gender and Politics*, p. 4.

24 Alison Shell states, "Historians have become familiar with the idea that, in late sixteenth-century and early seventeenth-century England, Catholicism was the enemy against which an emergent Protestant nationalism defined itself, and which shaped English allegiances within Europe." Shell, *Catholicism, Controversy and the English Imagination* (Cambridge, 1999), p. 109. Walker makes similar claims in her article, "Prayer, Patronage, and Political Conspiracy: English Nuns and the Restoration," *Historical Journal*, 43/1 (2000): pp. 1–23. She states: "Restoration historiography has remained strongly Protestant in tone and silent on gender," p. 22. See also Gabriel Glickman, *The English Catholic Community, 1688–1745: Politics, Culture, Ideology* (Rochester, 2009); Anna Battigelli and Laura M. Stevens (eds), "Eighteenth-Century

30 *Introduction*

Women and English Catholicism," *Tulsa Studies in Women's Literature*, 31/1–2 (2012): pp. 1–26.

25 McNamara, pp. 422–3. In addition, monies were regularly given by English orders to their motherhouses on the Continent, furthering the English Crown's frustration with the exportation of financial resources to enemy countries.

26 Walker, *Gender and Politics*, pp. 13–29.

27 Walker, *Gender and Politics*, p. 39, reveals that the majority of women were of English descent, although Irish, Scottish, Welsh, and local women were occasionally recorded in conventual archives. See also *English Convents in Exile*, vol. 1, p. xvi. I have made all attempts to clarify nuns' ethnic and national origins—as well as their perceived origins—since these factors played a key role in writers' portrayals of nuns in popular literature.

28 Caroline Bowden, "The English Convents in Exile and Questions of National Identity C. 1600–1688," in David Worthington (ed.), *British and Irish Migrants and Exiles in Europe, 1603–1688* (Leiden, 2010), pp. 289, 298, 302–3, 308; Liesbeth Corens, "Catholic Nuns and English Identities. English Protestant Travellers on the English Convents in the Low Countries, 1660–1703," *Recusant History* 30 (2011): pp. 441–59.

29 Bowden, "English Convents in Exile," pp. 298, 307, 312–13; Walker, *Gender and Politics*, pp. 6–7; Walker, "Prayer, Patronage, and Political Conspiracy," pp. 1–23. In the seventeenth century, the English convents catered to English royalty so as to keep the "claims of convents to return to England in front of those at the English court," according to Bowden, "English Convents in Exile," p. 307.

30 Silvia Evangelisti, *Nuns: A History of Convent Life* (New York, 2007), p. 65. See McNamara; Rapley, *A Social History of the Cloister*; Walker, *Gender and Politics*. Critics of women's monasticism have downplayed the opportunities for women's self-determination in the cloister. For example, Rogers states of eighteenth-century Catholic convents: "though [nuns] may have found satisfaction in running their own affairs, [it] was a male-dominated institution, offering little scope for individual development," p. 312.

31 Walker, *Gender and Politics*, p. 12.

32 Hufton, p. 147.

33 Ann Radcliffe, *A Journey Made in the Summer of 1794, through Holland and the Western Frontier of Germany, with a return down the Rhine*, 2nd edn (2 vols, London, 1795), vol. 1, p. 195; Samuel Paterson, *Another Traveller!: or, Cursory Remarks and Tritical* [sic] *Observations made upon a Journey through part of the Netherlands in the latter end of the year 1766 by Coriat Junior* (London, 1767–69), vol. 1.2, p. 80.

34 Jane Rendall, *The Origins of Modern Feminism: Women in Britain, France, and the United States 1780–1860* (London, 1985), pp. 1–2.

35 Latz; Evangelisti, pp. 91–124; Elissa B. Weaver, *Convent Theatre in Early Modern Italy: Spiritual Fun and Learning* (Cambridge, 2007); *In a Great Tradition*, pp. 21–2.

36 For further reading see Rapley, *A Social History of the Cloister*; Walker, *Gender and Politics*; Evangelisti; McNamara.

37 Hester Thrale Piozzi, *Mrs Thrale's French Journal, 1775*, in Moses Tyson and Henry Guppy (eds), *The French Journals of Mrs Thrale and Doctor Johnson* (Manchester, 1932), pp. 136–7; Helen Maria Williams, *Letters Containing a Sketch of the Politics of France, from the Thirty-first of May 1793, till the Twenty-eighth of July 1794, and of the Scenes which have passed in the Prisons of Paris* (4 vols, London, 1795), vol. 1, pp. 185–6. Class differences were also apparent in ceremonial rituals; for example, the English Blue Nuns in Paris gave 90 masses for reposed abbesses, 30 for choir nuns, and 15 for lay sisters. Walker, *Gender and Politics*, p. 61.

38 Walsh, p. 8.

39 Rapley, *A Social History of the Cloister*, pp. 82–7.

40 Rapley and Rapley, pp. 398, 409.

Introduction 31

41 See C.D. Van Strien, "Recusant Houses in the Southern Netherlands as Seen by British Tourists, c. 1650–1720," *Recusant History*, 20 (1991): pp. 495–511; Jeremy Black, *The British Abroad: The Grand Tour in the Eighteenth Century* (New York, 1992); Chloe Chard, *Pleasure and Guilt on the Grand Tour: Travel Writing and Imaginative Geography, 1600–1830* (New York, 1999), p. 35.

42 Hufton, p. 56. Hufton uses Diderot's Suzanne in *La Religieuse* as the emblem of this image of women religious, although Diderot's work was not published until 1796, well after nuns' initial conflicts with authorities. Denis Diderot, *The Nun*, trans. Russell Goulbourne (Oxford, 2005).

43 Aston, *Religion and Revolution in France 1780–1804*, pp. 134, 182, 232–3; Mangion, "Avoiding 'rash and imprudent measures,'" pp. 248–9. For the continuing work of nursing sisters, see Hufton, pp. 81–2. The National Constituent Assembly was formed on July 9, 1789 and was replaced by the Legislative Assembly on October 1, 1791.

44 For nuns' use of political rhetoric, see Gemma Betros, "Liberty, Citizenship and the Suppression of Female Religious Communities in France, 1789–90," *Women's History Review*, 18/2 (2006): pp. 315–16. For French women's defense of their rights see Joan Landes, *Women and the Public Sphere in the Age of the French Revolution* (Ithaca, 1988); Harriet B. Applewhite and Darline G. Levy (eds), *Women and Politics in the Age of the Democratic Revolution* (Ann Arbor, 1993); and Sara E. Melzer and Leslie W. Rabine (eds), *Rebel Daughters: Women and the French Revolution* (New York, 1992).

45 Landes, p. 107.

46 Choudhury, pp. 167–8; Betros, p. 312; Betros states that "several hundred" petitions were written by French nuns. Mangion discusses English nuns' petitioning in "Avoiding 'rash and imprudent measures,'" pp. 260–62.

47 Hufton, p. 70.

48 *English Convents in Exile*, vol. 6, p. 293.

49 Bellenger, "The Brussels Nuns at Winchester," p. 4; Ward, vol. 2, pp. 69–70. For French propaganda against nuns see Beales, p. 238.

50 Frances Burney, *Brief Reflections Relative to the Emigrant French Clergy* (London, 1793), p. 8.

51 Carpenter, p. 29; Ward, vol. 2, p. 70; Anson, *Building up the Waste Places*, p. 14.

52 *Public Advertiser*, September 17, 1792. Letter dated from Dover September 10, 1792. Reprinted in Carpenter, p. 30.

53 Carpenter, p. 23; Benis, p. 8; Ward, vol. 2, p. 70; Mangion, *Contested Identities*, p. 34; Bellenger, "The French Revolution and the Religious Orders. Three Communities 1789–1815," *Downside Review*, 98/330 (1980): pp. 42–3. For more on numbers of émigrés, see Carpenter, pp. 39–44.

54 Carpenter, pp. 44–7; Mangion, *Contested Identities*, p. 34; Mason, "Blue Nuns in Norwich," p. 96. Carpenter clarifies that the Benedictines of Montargis initially received 20 guineas from the Wilmot Committee. Later, they agreed to £35 per month until their school had more students. Carpenter, p. 214. Leigh states that members of communities who arrived in 1795 received one guinea a month. George Frederick Leigh, "The French Clergy Exiles in England, A.D. 1792–1797," *National Review*, 12/69 (London, 1888): p. 358; The English Benedictines of Cambrai received a guinea and a half per month. *In a Great Tradition*, p. 43.

55 Wiley, p. 8, xiii.

56 Franco Moretti, *Atlas of the European Novel 1800–1900* (London, 1998), p. 37; The idea that a British national identity was emerging at the turn of the century, as argued by Colley, has initiated more broadly-based scholarly inquiries into transnational networks and cultural transfer. Linda Colley, *Britons: Forging the Nation 1707–1837* (New Haven, 1992). See also Wiley, *Romantic Migrations*; Leanne Maunu, *Women Writing the Nation: National Identity, Female Community and the British-French Connection, 1770–1820* (Lewisburg, 2007).

32 Introduction

57 For more on English convent identities, see Bowden, "English Convents in Exile," pp. 297–314.

58 Mangion, "Avoiding 'rash and imprudent measures,'" pp. 260–62. For example, see "Memorial of the English Nuns, Settled at Paris, in the Rue des Fossés, Saint Victor," in *Extract from the Proceedings of the Board of Administration of the District of Douay on the Fourteenth of December, 1791. Trans. from the French.* (London, n.d.). Betros, p. 315, uses the term "double identity" to characterize the ways in which French nuns in revolutionary France identified themselves as both citizens and "members of the religious state."

59 Margaret J. Mason, "Nuns of the Jerningham Letters, The Hon. Catherine Dillon (1752–1787) and Anne Nevill (1754–1824), Benedictines at Bodney Hall," *Recusant History*, 23/1 (1996): p. 35. To avoid confusion, this article is cited in future references as "Benedictines at Bodney Hall."

60 *In a Great Tradition*, p. 45; Ward, vol. 2, p. 116.

61 *In a Great Tradition*, pp. 40–41; Bellenger, *The French Exiled Clergy*, p. 91; Amelia Opie, "Lines for the Album at Cossey," in *Poems by Mrs Opie*, 3rd edn (London, 1804), pp. 77–84. For statistics on nuns' increasing age in French houses, see Rapley and Rapley, p. 409; O'Brien, "Religious Life for Women," pp. 118–20.

62 Anson, *Building up the Waste Places*, p. 14; Mason, "Blue Nuns in Norwich," pp. 89–91. The Blue Nuns, for example, had sent three members to England in 1795 after their release from imprisonment in France. *The Diary of the Blue Nuns: An Order of the Immaculate Conception of our Lady at Paris, 1688–1810*, eds Joseph Gillow and Richard Trappes-Lomax (London, 1910), p. xv. The French Benedictines of Montargis also sent women ahead to secure lodgings with the English Benedictines of Brussels in 1792, although the community settled in England instead. Mason, "Benedictines at Bodney Hall," p. 38. The Augustinians of Bruges left a small cohort of nuns at the Bruges convent and sent the rest ahead; the community returned in several cohorts in 1802. Francis Young, "Mother Mary Moore and the Exile of the Augustinian Canonesses of Bruges in England 1794–1802," *Recusant History*, 27/1 (2005): pp. 88–9, 94–6.

63 Mangion, *Contested Identities*, pp. 34–5; *In a Great Tradition*, pp. 42–54.

64 Bellenger, "The Brussels Nuns at Winchester," p. 5; *In A Great Tradition*, pp. 42–4.

65 Anson, *Building up the Waste Places*, pp. 14–15.

66 Bellenger, *French Exiled Clergy*, p. 90.

67 Anson, *Building up the Waste Places*, p. 15; Quotation reprinted in T.D. Fosbroke, *British Monachism: or, Manners and Customs of the Monks and Nuns of England* (London, 1816), p. 302. Monks were also subjects of wide speculation in England. See Anson, *Building Up the Waste Places*, pp. 13–40; Bellenger, *French Exiled Clergy*, pp. 83–96. Fosbroke's antiquarian work attempted to recover the histories and cultures of the English monks.

68 Fosbroke, p. 301.

69 Michael Tomko, *British Romanticism and the Catholic Question: Religion, History and National Identity, 1778–1829* (New York, 2011), pp. 16–22; Carpenter, pp. 36–7. The Aliens Act was updated twice: once in 1798, which further defined the original Act, and again in 1802, to allow migrants to move more freely after the peace. Carpenter, p. 39.

70 See *The Parliamentary History of England from the Earliest Period to the Year 1803* (London, 1819), vol. 35, pp. 340–86.

71 Janet E. Hollinshead, "From Cambrai to Woolton: Lancashire's First Female Religious House," *Recusant History*, 25 (2001): p. 461; Heywood, p. 35.

72 Bellenger, *French Exiled Clergy*, p. 92.

73 Leys, p. 124.

74 Tomko, pp. 16–22; Ward, vol. 2, pp. 69–70. It would not be until the Catholic Relief Act of 1829 that Catholics could assume positions in Parliament or vote, although this

Introduction 33

privilege was granted only to property owners with rents of at least ten pounds per annum.

75 Ward, vol. 2, pp. 69–70.

76 Ward, vol. 2, pp. 118, 123–6. The Benedictines of Louvain, who settled first in Hammersmith and then Amesbury, wore their habits, as did the Sepulchrines from Liège who settled at Holme Hall in Yorkshire. The English Benedictines of Ghent wore secular attire upon arrival, "yet caused some attention, and led to inquiries which were at times disquieting to the nuns." According to Mason, the French Benedictines at Bodney Hall resumed their habits upon arrival in London in 1792. Mason, "Benedictines at Bodney Hall," p. 38. Lacking proper habits until 1823, the English Benedictines of Cambrai created simple black cloth dresses with white hoods and collars. *In a Great Tradition*, p. 42.

77 *In a Great Tradition*, p. 42.

78 *The Parliamentary History of England*, vol. 35, pp. 340–86. Local disturbances impacted perceptions of nuns, such as the runaway Lulworth Trappist monk whose reports in 1815 resulted in an order from the House of Commons that the prior leave Britain. Bellenger, *French Exiled Clergy*, pp. 83–90.

79 Young, pp. 94–5; George Sand, *The Convent Life of George Sand*, trans. Maria Ellery McKay (Chicago, 1977). The Augustinians in Paris relocated to Ealing, London in 1911. The convent closed in 1996.

80 Bellenger, "The Brussels Nuns at Winchester," p. 5.

81 O'Brien, "French Nuns," p. 179, uses the term "consumers of . . . Catholic subculture" to describe the ways in which French Catholic convents were utilized for the education of Protestant children in nineteenth-century England. Zoe Kinsley, *Women Writing the Home Tour, 1682–1812* (Burlington, 2008), p. 7.

82 Thrale Piozzi; Radcliffe, *A Journey Made in the Summer of 1794*.

83 William Cole, *A Journal of my Journey to Paris in the year 1765* (New York, 1931); Philip Thicknesse, *A Year's Journey through France, and part of Spain* (2 vols, Bath, 1777); and Thicknesse, *Observations on the Customs and Manner of the French Nation: In a Series of letters in which that Nation is vindicated from the misrepresentation of some late Writers* (London, 1766); Paterson.

84 Mangion, "Avoiding 'rash and imprudent measures,'" pp. 247–63; Betros, pp. 311–36.

85 Augustin Barruel, *The History of the Clergy during the French Revolution* (3 vols, London, 1794); Williams, vol. 1, pp. 182–93.

86 Carpenter, p. 48.

87 Barruel, vol. 3, p. 233; *Public Advertiser*, September 17, 1792.

88 Carpenter, p. 48.

89 Bellenger, "The French Revolution," p. 35.

90 Loyalist propaganda played up British women's vulnerability with the threat of French invasion. Colley, pp. 254–6.

91 Account Book, Stanbrook Abbey Archives, 1795–1803. Stanbrook Abbey. Wass, Yorkshire; Young, pp. 86–102. See also Mason, "Blue Nuns in Norwich" and Hollinshead. Mangion estimates that about 400 English nuns were in France during the Revolution. See "Avoiding 'rash and imprudent measures,'" p. 250.

92 Williams, vol. 1, pp. 182–93.

93 Mason, "Blue Nuns in Norwich," pp. 110–11; *The Diary of the Blue Nuns*.

94 Burney, pp. 7–8; Smith, *Rural Walks: In Dialogues. Intended for the use of Young Persons* (Dublin, 1795), pp. 65–72.

95 Wiley, p. xiii.

96 For the feminization of the nation in British literature, see Angela Keane, *Women Writers and the English Nation in the 1790s* (Cambridge, 2000), p. 3.

97 Bellenger, *French Exiled Clergy*, pp. 73–8.

98 Bellenger, "The French Revolution," pp. 37, 41–2; Carpenter, pp. 44–7; Leigh, p. 358; *In a Great Tradition*, p. 43.

34 *Introduction*

99 *The Parliamentary History of England*, vol. 35, pp. 356–60.

100 *In a Great Tradition*, p. 48; Mangion, *Contested Identities*, p. 35.

101 Sister Scholastica Jacob, Personal Communication, Stanbrook Abbey. Wass, York-shire. June 29–30, 2011.

102 Mangion, *Contested Identities*, pp. 33, 35

103 Mason, "Blue Nuns in Norwich"; Mason, "Benedictines at Bodney Hall," pp. 34–78; Mason, "Augustinian Canonesses of Bruges," pp. 350–69; Hollinshead. The Benedictines formerly of Montargis moved to Fernham Priory in Oxfordshire after leaving Princethorpe Priory in 1966. They began dispersing in the early 2000s, with some members joining the Benedictines at Oulton Abbey in Staffordshire.

104 William Bush, *To Quell the Terror: The True Story of Carmelite Martyrs of Compiègne* (Washington, D.C., 1999).

105 Rogers, p. 297.

106 Rapley, *A Social History of the Cloister*, pp. 112–13.

107 Evangelisti, p. 20; John Milton, *Animadversions* in Don M. Wolf (ed.), *Complete Prose Works* (8 vols, New Haven, 1953–82), vol. 1, p. 718.

108 Jenny Franchot, *Roads to Rome: The Antebellum Protestant Encounter with Catholicism* (Berkeley, 1994), p. 126. See also Acosta, pp. 633–4; Rogers, p. 311. Though Franchot is discussing nineteenth-century anti-Catholicism in the U.S., her comments apply to perceptions of eighteenth- and nineteenth-century British perceptions of convents as well.

109 *Les Lettres portugaises, Lettres d'une péruvienne, et autres romans d'amour par lettres*, eds Bernard Bray and Isabelle Landy-Houillon (Paris, 1983); Alexander Pope, "Eloisa to Abelard," in Aubrey L. Williams (ed.), *Poetry and Prose of Alexander Pope* (Boston, 1969), pp. 104–13.

110 See Chapters 1 and 3 for further analysis of this trope in travel narratives.

111 Eliza Haywood, *Love in Excess*, 2nd edn, ed. David Oakleaf (Toronto, 2000); and *Fantomina* in Paula R. Backscheider and John J. Richetti (eds), *Popular Fiction by Women 1660–1730* (Oxford, 1996), pp. 226–48.

112 Margaret Cavendish, *The Convent of Pleasure and Other Plays*, ed. Anne Shaver (Baltimore, 1999), pp. 217–47.

113 Aphra Behn, *The Rover* (London, *1677*); Susanna Centlivre's, *The Wonder: A Woman keeps a Secret: A Comedy* (London, 1714). See also Behn, *The History of the Nun: Or, The Fair Vow-Breaker* (London, 1689).

114 John Dryden, *The Assignation: Or, Love in a Nunnery* (London, 1673); Acosta, p. 618.

115 *Venus in the Cloister; Or, the Nun in her Smock* (London, 1725). The original French novel is attributed to Jean Barrin or François de Chavigny de la Bretonnière. The Marquis de Sade's *Juliette* (1798), depicts Juliette's sexual education within the convent by means of both a student and the abbess. Marquis de Sade, *Juliette*, trans. Austryn Wainhouse (New York, 1968).

116 Diderot, p. xiii.

117 Ann Radcliffe, *The Mysteries of Udolpho* (Oxford, 1998); *The Italian* (London, 2000); Horace Walpole, *The Castle of Otranto* (Oxford, 1998); Rogers, p. 302.

118 François-René Chateaubriand, *Atala/René*, trans. Irving Putter (Berkeley, 1952); Samuel Johnson, *Rasselas* in Bertrand H. Bronson (ed.), *Poems, and Selected Prose*, 3rd edn (New York, 1971), p. 704.

119 Matthew Lewis, *The Monk*, ed. Christopher Maclachlan (London, 1998).

120 McNamara, pp. 372–82.

121 Rogers, p. 313.

122 Adélaïde de Sousa-Botelho, *Oeuvres de Madame de Souza* (Paris, 1845). As Rogers reveals, Sister Eugénie's discontent was not only due to the restrictive life in the convent, but also to her own neurosis that is manifested even after she leaves the convent, p. 315, note 27.

123 Johnson, *Rasselas*, pp. 704, 708.

124 Hill, p. 110. Anson also traces this history in *The Call of the Cloister: Religious Communities and Kindred Bodies in the Anglican Communion* (1964), pp. 1–27; and *Building up the Waste Places*, pp. 1–40.

125 Hill, p. 109; Mary Astell, *A Serious Proposal to the Ladies,* 4th edn, (New York, 1970).

126 See Anson, *Call of the Cloister*, pp. 16–19, for a discussion of the tracts of Edward Stephens, Sir George Wheeler, and others, as well as information on Mary and Anne Kemys, and Margaret Blagge, examples of women who lived in semi-cloistered retirement.

127 Anson, *Call of the Cloister*, p. 15.

128 Tonya Moutray McArthur, "Jane Barker and the Politics of Catholic Celibacy," *Studies in English Literature 1500–1900*, 47/3 (2007): pp. 595–618. For Jane Barker's biography, see Kathryn King, *Jane Barker, Exile: A Literary Career, 1675–1725* (Oxford, 2000); Jane Barker, *The Galesia Trilogy and Selected Manuscript Poems*, ed. Carol Shiner Wilson (New York, 1997).

129 Alessa Johns, *Women's Utopias of the Eighteenth Century* (Urbana, 2003), pp. 4, 10. For a discussion of Scott's novel in terms of its feminist impulses, see also Gary Kelly's "Introduction" to Sarah Scott's *Millenium Hall* (Ontario, 2001), pp. 11–43.

130 Samuel Richardson, *The Works of Samuel Richardson* (19 vols, London, 1825), vol. 16, pp. 155–6; vol. 5, p. 92.

131 Thomas Amory, *Memoirs: Containing the Lives of Several Ladies of Great Britain* (London, 1755).

132 Robert Southey, *Sir Thomas More: or, Colloquies on the Progress and Prospects of Society* (2 vols, London, 1831), vol. 2, p. 214

133 Hill, pp. 125–7. The term "lay monasticism" comes from J.F.C. Harrison's *The Second Coming: Popular Millenarianism, 1780–1850* (London, 1979), pp. 165, 173.

134 Johns, p. 3.

135 Franchot, p. 120.

136 Pohl and D'Monté, p. 2.

137 Rees, pp. 2–5.

138 Johns, p. 2. For more on *bricoleurs*, see Michel de Certeau, *The Practice of Everyday Living*, trans. Steven Rendall (Berkeley, 1984).

139 Williams, vol. 1, pp. 182–93; Burney, pp. 7–8.

140 Anne K. Mellor, *Mothers of the Nation: Women's Political Writing in England, 1780–1830* (Bloomington, 2000), p. 9; Colley, p. 250.

141 Robert M. Ryan, *The Romantic Reformation: Religious Politics in English Literature, 1789–1824* (Cambridge, 1997).

142 O'Brien, "French Nuns," p. 174; Walter L. Arnstein, *Protestant versus Catholic in Mid-Victorian England: Mr Newdegate and the Nuns* (Columbia, 1982), p. 50.

143 Susan O'Brien, "Religious Life for Women," in V. Alan McClelland and Michael Hodgetts (eds), *From Without the Flaminian Gate: 150 Years of Roman Catholicism in England and Wales 1850–2000* (London, 1999), pp. 113–14; O'Brien, "Terra Incognita," pp. 134–5.

144 O'Brien, "Religious Life," p. 112; O'Brien, "Terra Incognita," p. 120.

1 Encountering Convents Abroad

Hester Thrale Piozzi, Ann Radcliffe, William Cole, Samuel Paterson, and Philip Thicknesse

> The Streets of Paris are very entertaining to drive through; I had a long Prance over them this Morning—Coxcombs, Religious Habits, Wenches with Umbrellas, Workmen with Muffs, fine Fellows cover'd with Lace, & Old Men with Woollen Wigs make a Contrast & Variety inconceivable to a Londoner, who thinks all Monks & Nuns are shut up in Convents.
>
> Hester Thrale Piozzi, *Mrs Thrale's French Journal, 1775*

In 1775, Hester Thrale Piozzi, her then husband Henry Thrale, daughter Queeney, female companion and Roman Catholic Mrs Cecilia Strickland, and Samuel Johnson, arrived in France for a seven-week tour of the country. During the course of the trip, Thrale Piozzi visited a handful of Catholic convents and occupied much of her journal with descriptions, observations, and interpretations of women's religious life. After one of her first encounters with a community of Poor Clares, Thrale Piozzi declares: "these Austerities are never chosen by any Women who have the least Experience of any other Mode of Life . . . Can such blind Superstition be pleasing to God?" A few weeks later, after paying a final call to a community of English Augustinians in Paris, Thrale Piozzi writes: "I shall surely lose my heart among these Friars & Nuns" and "Miss Canning promised me her Correspondence . . . I kissed ['em] through the Wicket, and wished them most sincerely well. Miss Fitzherbert has promised to send me a Pair of Ruffles to take Care of for her Mama."[1] So what happened in the span of a few weeks to effect such a transformation in Thrale Piozzi's relationship to nuns on the Continent from that of a shocked and critical spectator to a pen pal and postal agent?

Examining late eighteenth-century travel narratives reveals that British responses to convents in France, Belgium, and Germany were far less uniform than is generally assumed in scholarship.[2] Some tourists invest considerable portions of their journals, and indeed their travels, in describing various monastic cultures for women, such as is seen in the travel writings of Hester Thrale Piozzi (1741–1821), Ann Radcliffe (1764–1823), William Cole (1714–1782), Samuel Paterson (1728–1802) and Philip Thicknesse (1719–1792).[3] These writings demonstrate a range of positive responses to convents and nuns, a feature that makes them not only interpretively rich, but also surprisingly diverse in treatment and

approach. Protestant travelers, it seems, desired at least a glimpse of, if not a full-fledged education in, a mode of living that had not been available in England since the early-sixteenth century.[4]

Foreign cloisters, sensationalized in novels such as Denis Diderot's *La Religieuse* (1796) and Matthew Lewis's *The Monk* (1795), were depicted as sites of sexual and theological deviance, as well as oppressive extensions of the State.[5] Even now, our historical and literary understanding of the cultural dynamics between British Protestants and Continental Catholics in the eighteenth century has been largely shaped by the same gothic fiction popular in Thrale Piozzi's day, rather than by travel narratives, which show that travelers had various levels of access to the cloister and differing agendas when visiting. For example, with the increased popularity of Continental convents for the education of girls in the mid to late eighteenth-century, parents and family friends on tour sought out young scholars to assess their educational development in a Catholic cloister. With exposure to nuns and the young women under their care, the writers discussed here develop arguments in favor of women's monasticism, highlighting the positive gains for women such as education, community, industry, and protection.

Thrale Piozzi's *French Journal,* a work that has recently been of interest to scholars, provides the overarching framework for this chapter because of the remarkable level of contact and engagement with women's monastic culture that it records. While a more mainstream anti-conventual critique peppers the first section of the work, its tone changes midway, endorsing positive features of these women's lives, a narrative pattern that Radcliffe, Thicknesse, and Paterson follow as well.[6] Thrale Piozzi discovers in monasticism a viable alternative to the isolation experienced by unmarried, abandoned, or widowed women in British society.[7] Thus, her journal not only furthers our understanding of the ways in which some Protestants expressed concern over the legal and economic situation of English Catholics; it also demonstrates that some tourists appreciated the alternative to the domestic template that the convent presented for other kinds of women's corporate endeavors.[8]

A major rhetorical device employed by Protestant travelers is the use of contrast: in drawing a line between communities that deploy more severe forms of contemplative practice and those that more closely resemble a comfortable and convivial retreat, Thrale Piozzi can endorse the positive gains for women in the convent without seeming overly biased. Radcliffe, Cole, and Paterson also criticize monastic groups that make unreasonable physical demands on women yet endorse those which preserve women's mobility in the community, allow access to their families, and provide them with a respectable haven.

The multiple spaces within the convent to which Thrale Piozzi is privy suggests that in some cases extended contact between nuns and Protestant British women tourists was possible. This level of access would have been unthinkable for male tourists, although plenty of them visited convents in spite of the drawback of remaining on the other side of the grate: typically men's encounters with nuns were not only brief, but also supervised and restrictive.[9] Yet, even with such limited interactions, it is possible to trace changes in male tourists' attitudes. For

38 *Encountering Convents Abroad*

example, Paterson depicts his first encounter with nuns in the sensational terms of gothic fiction; however, like Thrale Piozzi, his narrative shifts into realism as he endorses the cloister for older unmarried women. Thicknesse and Cole are even less judgmental, downplaying readers' possible objections to the education of British children in convents abroad. In fact, Catholic and Protestant parents placed a high value on a foreign-based education that was thought to develop a cosmopolitan frame of reference in middle- and upper-class British youth.[10]

It is perhaps no surprise that British travelers were enthralled by the expatriate English convents. Not only did these communities provide tourists with an "English" encounter, convents also housed individuals who were known to visitors through their various social networks. For historians today, the culture cultivated within exiled English convents represents the epitome of nonconformity in its "overt rejection of English religion, law, and society."[11] Travel writers, on the other hand, sought to familiarize Catholic religious by situating them in terms of their aristocratic lineages, and foregrounding their national, ethnic, and class identities. In addition, British tourists took pains to normalize monastic life and its various functions in part because some of them had relatives, friends, and children boarding in English and French convents on the Continent.[12] Gabriel Glickman explains that for English Catholic children, "foreign schooling would become a natural extension of family life." Furthermore, these institutions generated "a sense of national community . . . in a world constructed as much to keep recusants thoroughly English when they moved through Europe, as it was to keep them Catholic when they returned across the Channel."[13] That the young women being educated in convents were in such close contact with nuns was registered with varying degrees of comfort in the travel narratives discussed here. For example, while Thicknesse is unconcerned over the Catholic inclinations of his convent-educated daughter, Paterson worries that too many viable and attractive young women will take the veil and forgo lives in the world altogether. Radcliffe, on the other hand, finds evidence that some convents offered a flexible approach to managing a daughter's social position during the critical time between the onset of puberty and marriage.

Convent visiting went beyond educational purposes: foreign travel itself became one of the most popular pastimes for the eighteenth-century upper and middle classes, so popular, in fact, that from 1760 to 1780, the numbers of published travel narratives exceed those of any other genre.[14] It is no wonder that the highly popular gothic novel utilized the topos of foreign travel, particularly Continental, as one of its primary plot devices. For upper-class men, the Grand Tour provided ample opportunities for convent visiting. Alison Shell points out that the first recorded uses of the term "Grand Tour" come from seventeenth-century writings of Catholic priests who assisted Royalist exiles on their Continental travels during the tumultuous years of the English Civil Wars and the Interregnum. Thus, the very concept of the Grand Tour is rooted in the displacements of English Catholics.[15] Travel narratives from the seventeenth and eighteenth centuries reveal that visiting nunneries was not only appealing to British tourists, but also a mainstay of travel itineraries.[16] Francis Bacon, as early as 1625, prescribes "churches and

Encountering Convents Abroad 39

monasteries" as "things to be seen and observed" second only to courts of law and royalty in his essay "Of Travel."[17]

Women's communities elicited more attention than did men's.[18] While tourists were eager to visit the convents that dotted rural France, Belgium, and Germany, once they arrived in cultural centers, such as Paris, it is curious that many typically continued their exploration of French and English convents in the metropolis rather than moving onto other tourist sites. Travellers' keen interest in the expatriate English convents may account for tourists' continued pursuit of cohabiting women in urban centers. English Catholic religious life for women was revived in the late sixteenth century when the first English Benedictine convent was founded in Brussels and an English Bridgettine convent was established in Lisbon; 20 more houses followed in the next century. English Catholic women were responsible for reestablishing abroad religious communities under the auspices of foreign governments.[19] The English origins of these exiled women, their Catholic status, and Continental location appealed to British tourists desiring a "native" and "foreign" encounter at once.

Anti-monastic portrayals had been a part of British culture since before the English Reformation. In propaganda, nuns were seen as misguided, repressed, or sexually deviant women whose vulnerability made them victims and vehicles of the Church-run State.[20] This picture is evident in scholarship as well. Jeremy Black, whose research on travel narratives explores various reoccurring motifs, states that for male tourists the "fascination that nunneries excited was speedily quenched. Those who visited nunneries discovered that most nuns were not beautiful, sensual women held against their will, and many were disappointed by their looks." His argument is simple: because nuns did not live up to the sensational expectations of Protestant visitors, interest in nunneries waned quickly on a given trip.[21] Black does not examine narratives that take a different direction, that move beyond the disappointment that nuns did not live up to the propaganda about them. Black's research, while debunking some myths, plays into the stereotype that nuns were not generally marriageable. The fascination that seventeenth-century Protestant travelers express in regards to nuns, their beauty, and missionary zeal suggests differently. Nuns entertained travelers not only to establish new patrons and promote their community through social networking, but also in the hopes of effecting visitors' conversion to Catholicism.[22]

In the late eighteenth century, an emerging understanding of British nationalism was figured in terms of ethnic and religious differences from Continental culture.[23] This ideological strain is apparent in travel narratives that frame Catholicism and its institutions as negative reminders of Britain's own philosophical and political progress. Johannes Fabian, in his discussion of anthropological methodologies, argues that anthropology's central difficulty lies in its tendency to deny coevalness to the culture it is studying. Instead, the studied culture is figured in terms of its distance, in the past tense, from the anthropologist's own culture. As the historian Jenny Franchot puts it, "the stagnant terrain of the past belonged to Catholics. The New Testament, Protestant history . . . moved jointly forward; Catholicism, divorced from time and Scripture, stood still." Accessible to the gaze of the British tourist, English Catholic monastic groups exported to foreign soil

40 *Encountering Convents Abroad*

were remnants from Britain's past, and as such, induced some Protestant tourists to spend significant time there.[24] Some found the monastic an admirable, even appealing, configuration for unmarried women, which could be used to address a variety of needs in British culture. As Katherine Turner argues of travel literature:

> The possibilities offered by the genre for the articulation of views shaped as much by specificities of gender, class, profession, religion, and region as by national consensus present more unexpected perspectives on "abroad," and frequently provide a critique of the illusory domestic coherence which the mythical evils of the "Other" served to create.[25]

That British writers became acquainted with and drew upon international social models as a means of exploring practical correctives to local and national concerns suggests that we question Black's assertion that anti-Catholic sentiment was the "prime ideological commitment" in British eighteenth-century culture.[26] Focusing on self versus other dichotomies, the language of nationalism "obscures" other simultaneous drives towards internationalism, according to Alessa Johns. As Zoe Kinsley asserts, British women travelers discuss the women they encounter in order to "establish a continuum of female experience which enables them to turn an explicit consideration of the lives of women in other locations and social groups, into an implicit reflection upon the position of women in their own home environment."[27] This mode of reflection through travel is apparent in men's travel narratives as well, revealing tourists' exploration of the space of the cloister in terms of its ongoing cultural and institutional value.

Visiting Nuns in France and Germany: Thrale Piozzi and Radcliffe

Thrale Piozzi's interest in English and French Catholic nuns occupied the majority of her time during her seven-week tour of France in 1775. Turner indicates that women's travel writings were quite popular "in some cases because of the woman traveler's access to areas of experience . . . closed to their male counterparts." Just as Lady Wortley Montagu's *Letters* from 1717 to 1718 detail her visit to a Turkish harem, a closed community for most tourists, so does Thrale Piozzi's travel narrative reveal the surprising degree of conventual access she was granted.[28] Because she penetrated religious spaces both intriguing and off limits to many tourists, it is likely that had she tried to publish her journal, it would have met with interest by publishers.[29]

Thrale Piozzi emphasizes and outlines two of the primary issues that reoccur in her journal: the connection between English nuns and their families back home, and the comfortable, social, and even literary environment of the cloister. Her first encounter with nuns takes place in Calais at a Dominican convent of English nuns. Miss Gray, a nun, chats with Thrale Piozzi about the arts in London, controversial literature, and Miss Gray's aristocratic relations. Thrale Piozzi agrees to take a letter to Miss Gray's family back to England.[30] Thrale Piozzi's exploration

Encountering Convents Abroad 41

of the culture within convents provides an example of Turner's sense that women's travel writing moves "away from erudite classical traditions in favor of more sociological, affective, and miscellaneous preoccupations. Women travel writers often provide less hostile accounts of Europe . . . than some of their male counterparts."[31] Because of her access to nuns, Thrale Piozzi can claim "the authority of the eye-witness," which also gains her entry into a traditionally male "discourse of European travel."[32]

Yet, in spite of Thrale Piozzi's sympathetic descriptions of her first encounter with nuns in Calais, her second—this time with the English Poor Clares at Gravelines—results in a far more critical appraisal of certain forms of monastic practice. In drawing distinctions between various types of monastic orders, Thrale Piozzi shares a common rhetorical strategy employed in British Protestant travel narratives: writers compliment and approve of some types of communal practices for women, while deriding more extreme forms of contemplative monasticism. As Chloe Chard explains, "this device of constructing binary, symmetrical oppositions between the familiar and the foreign constitutes one of the most common strategies for translating foreignness into discourse."[33] For example, Thrale Piozzi documents the Poor Clares's coarse habits, bare legs and feet, lack of cleanliness, and thin figures.[34] Claire Walker's research on the Gravelines Poor Clares suggests that the group had a difficult time sustaining itself throughout the seventeenth century. A fire in 1626 destroyed a large portion of the convent, and later in 1654, an explosion of the powder arsenal in Gravelines leveled the church. As one nun described the event: "the whole House shatter'd in Pieces." The convent was rebuilt with funding from Louis XIV, but Walker points out that "the numbers of women taking the veil at Gravelines never again reached the heady days of the 1610s." In spite of this convent's tumultuous history, Thrale Piozzi noted that there were "43 in Number," not an insubstantial number, considering the requirements of their challenging way of life.[35]

Thrale Piozzi's visit, directly afterwards, to the French Benedictine priory of Saint-Louis in Gravelines, presents an immediate contrast to the cloister of the Poor Clares. She explains that "Mrs. Strickland carried me from this Scene of Misery to a Convent of the highest Order, where there is a Royal Abbess—so they call those whom the King chuses." Unlike the convent of the Poor Clares in which the visitors are not allowed beyond the grate, the Benedictines conduct a tour of the "Refectory, Cells, Garden & all Curiosities of the Place," as well as the Lady Abbess's own apartment. With such access, Thrale Piozzi explores the culture within, an examination that she could not perform in the convent of the Poor Clares, rendering the stricter order suspicious by virtue of its exclusionary nature. In contrast to the Poor Clares's deprivation, these nuns exhibit their dress, "a light Black Stuff turned back with fine Cambrick at the Cuffs," and their linens, which are changed daily and "most delicately clean." Their "Table Cloths were of good Diaper and perfectly net."[36] Unlike fictional depictions of nuns as shut off from the secular world, the Lady Abbess is very up-to-date: "We talked of Literature, of Politicks, of Fashions, of everything." In addition, the abbess "was particularly curious to have me explain to her the Nature & Cause of the Rebellion

42 *Encountering Convents Abroad*

in America." Interestingly, the American Revolution, a precursor to the French Revolution, would indirectly affect the fate of cloistered women in France in the years to come. The Lady Abbess's desire to understand the situation in America underscores her engagement in and concern with current politics. Thrale Piozzi promised to send her a French version of Johnson's *Rasselas*, another indication that women within the convent participated in and had access to secular literary culture.[37]

Although she witnessed two very different groups of cloistered women, Thrale Piozzi outlines the impact of her visit to the Poor Clares in her initial appraisal of monastic culture:

> [T]hese Austerities are never chosen by any Women who have the least Experience of any other Mode of Life: but Parents who want to be rid of their poor Girls send them at the Age of ten or eleven to these Convents where they—seeing these Nuns perpetually & seeing nothing else—fall into the Snare, & profess Poverty, Misery & all which the rest of the World unite to avoid—much less from Religion than Stupidity. However some of them must absolutely be taken, ... & forced to warm themselves in Winter, or they would kill themselves by using Severities on their wretched Persons to distinguish themselves by Sanctity from the rest. Can such blind Superstition be pleasing to God? Surely not, it can only be pardoned I think as involuntary Error.[38]

Thrale Piozzi outlines differences articulated by other British writers. For instance, John Andrews, in *Remarks on the French and English Ladies, in a Series of Letters* (1783), replicates Thrale Piozzi's contrast between the Benedictines, "who enjoy large revenues, and live in much elegance" and the Poor Clares who "are denied every convenience and comfort of life."[39] Elizabeth Rapley in her discussion of French nuns in *A Social History of the Cloister*, confirms that, indeed, some women engaged in severe forms of mortification, but that these practices were discouraged by their superiors since they weakened the body and left a nun unfit to perform her duties.[40] Walker argues that English nuns in the seventeenth century considered mortification as the vehicle of spiritual transformation, "an intrinsic feature of female convent culture, advanced by ready access to devotional literature."[41]

In fact, the Poor Clares at Gravelines had a legacy of extreme female devotion. Founded by Mary Ward in 1609, the active rather than contemplative orientation of the community came out of Ward's desire to pursue more aggressively the Catholic mission in the world. Yet active convents were still subject to the rule of enclosure, the Clausura, to which nuns were bound. In addition, active work did not negate but could even aggravate physical deprivation. Elizabeth Thwaites, who was made vicaress of the convent in 1654, was noted by her community for "her peace and constant union with God," evident physically "in her exterior." The Poor Clares' annals from the seventeenth century describe "severall holy Religious ... conspicuous for sanctity."[42] While it is difficult to conclude to what

Encountering Convents Abroad 43

degree Thrale Piozzi's comments on self-mortification were based upon actual practices in the Gravelines community in the late eighteenth century, her further encounters with English nuns confirmed that the Poor Clares were the strictest in practice that Thrale Piozzi visited. Her initial commentary on female monasticism most likely reflected her shock or discomfort at their lifestyle.

Thrale Piozzi's next encounter with nuns occurred at the Order of the Immaculate Conception of Our Lady of Paris. Also known as the English Blue Nuns, the Conceptionists had originally branched off from a group of English Franciscans from Nieuport, leaving for Paris before that filiation dissolved in 1662 and changing their affiliation in 1658.[43] These nuns, too, discussed political affairs with Strickland and Thrale Piozzi, informing the travelers of the current health of an English woman who had married a Jacobite supporter. From here, Thrale Piozzi visited the English Augustinian Nuns in Paris, noting that the Prioress is the niece of Arabella Fermor, Alexander Pope's famed Belinda in "The Rape of the Lock." Other nuns impressed Thrale Piozzi with their traveling, reading, studying of music and language, and beauty—one nun in particular "has been a Beauty about London since my Time, & is now eminently handsome."[44]

Beyond their hospitality to British tourists, the English Augustinian Nuns in Paris ran a boarding house for gentlewomen and a popular school attended by both English and French children; George Sand would become one such student in the nineteenth century.[45] Thrale Piozzi toured not only the nuns' cells, kitchen, garden, and vineyard, but also the abbess's private "Dressing Room" where they took tea and discussed "the Hardships suffered by the Claires." Speaking from the same perspective, Thrale Piozzi and the abbess criticized the strict practices of the Poor Clares. Having gained more evidence for her own views on the unnecessary "Hardships" undertaken by more penitential groups, Thrale Piozzi seems to have identified with this English Augustinian community in which ties of nationality and culture trump religious differences. Strickland's interactions with the nuns were even more intimate; as Thrale Piozzi noted, "they are most of them her Friends, either Schoolfellows or Instructresses. It was in this Convent She was bred."[46] As a former student at the convent, Strickland was already a part of the cloistered circle, a connection that allowed Thrale Piozzi to engage these nuns as acquaintances, not as pathetic or misguided figures.

By the end of her visit, Thrale Piozzi considered herself an extended member of the English Augustinian family. Desiring to prolong the visit, she sent the confessor to detain Dr. Johnson when he arrived to pick them up. Her effusive goodbye, quoted at the beginning of this essay, follows: "I shall surely lose my heart among these Friars & Nuns: there is something so caressive in their Manner, so Singular in their Profession, which at once inspires Compassion and Respect, that one must love them . . . I left these Ladies a *Louis D'Or* for Wine, and we parted liking each other quite well I believe." Paying yet another final call before returning to England, she recorded that "Miss Canning promised me her Correspondence, & thanked me a thousand Times for my little present of Books—. . . . I kissed ['em] through the Wicket, and wished them most sincerely well. Miss Fitzherbert has promised to send me a Pair of Ruffles to take Care of for her Mama."[47] Acting as

44 *Encountering Convents Abroad*

postal agent between France and England, Thrale Piozzi solidified ties between herself and the nuns, as well as between the nuns and their own families back in England. In a similar mode, she explains that Johnson delivered a letter from "Father Prior at Paris to the Confessor of the English Benedictine Nuns at Cambray," a detail that highlights a Protestant male traveler's participation in the social networking between Catholics. The confessor of the English nuns joined the traveling party for dinner at their inn, another of Thrale Piozzi's narrative details that reveals the variety of interactions between British travelers and the English Catholics abroad. The Confessor, a "Mr. Welch from Westmorland . . . knew Mrs. Strickland's name & Family full well as all the Roman Catholicks do."[48] Thus Thrale Piozzi's narrative highlights the connections between Catholics, signaling her understanding of the social and religious networks that stretched across the Channel.

During the latter portion of her trip, Thrale Piozzi revises her initial criticisms of conventual life. Addressing the three vows of chastity, poverty, and obedience, she finds reasonable arguments in support of them, tracing out the differences between the state of single women in England and nuns:

> A Well endowed Convent is of all others the most perfect Refuge from Poverty. With regard to Celibacy—it is for the [most part] uncomfortable in the World [only] because it is a Disgrace, which Objection is lost in a Convent; with Regard to Solitude—few Women live in so much Society as four and twenty or thirty [female] Acquaintance—I mean of People in a little way who pass their Time in Prayer, Cards & Prattle just as these do, only going to one anothers Houses instead of all living in one. Obedience is the most objectible of all the Vows, & that too seems to be made very easy; their Abbess is of their own chusing, & they elect a new one or the same over again every three Years: the Lady I saw Yesterday had been 13 Years Superior.[49]

Refiguring the three vows of chastity, obedience, and poverty into respectability, democracy, and sororal community, Thrale Piozzi presents a positive reading of monastic rule that serves women's interest. In contrast to single women's position in England, cloistered women have the advantages of a larger community of like-minded celibate women and of a democratically appointed female leader. As Fabian argues, "for human communication to occur, coevalness has to be *created*. Communication is, ultimately, about creating shared Time."[50] Because she cements real friendships with nuns, experiencing "shared Time" with them, she is thus able to further understand and promote the benefits of their communal culture, benefits that include egalitarian governance, education, and community service.

Thrale Piozzi's narrative remained unpublished until the twentieth century so contemporary responses to its content and style do not exist. Ann Radcliffe, known for her impact on the development of the gothic novel and the translation of picturesque and sublime landscapes into descriptive prose, was reviewed extensively after the publication of her *A Journey Made in the Summer of 1794*, which detailed

Encountering Convents Abroad 45

her trip to Germany with her husband, William Radcliffe, and which they finished with a tour of English lakes in Lancashire, Westmoreland, and Cumberland. Reviewers disagreed about Radcliffe's literary merit as a travel writer. While the *European Magazine* praised Radcliffe's descriptive powers, her "elegant and fertile pen," the *British Critic* warned readers of incorrect typography that "betrays frequent marks of carelessness," repetitive word usage, and an "enthusiasm" in descriptive passages "dipped in colours beyond the glow of nature."[51] Substantial portions of the narrative were reprinted in reviews, a testament to the interest that it elicited as a new genre within which Radcliffe could explore her descriptive powers; the *Critical Review*, for example, praised Radcliffe's "happiest selection of words and significant epithets," and the mixed nature of her language, part poetry and part painting.[52]

Radcliffe's travel narrative also addressed conventual culture, although her access was far more restricted than Thrale Piozzi's. Also dismayed after her encounter with Poor Clares in Cologne, Radcliffe prefaced her experience and her description with the warning: "Of the severe rules of this society we had been told in the morning."[53] The "severe rules" of which Radcliffe speaks, however, are not those of bodily discipline, but of seclusion from family members on the outside:

> The members take a vow, not only to renounce the world, but their dearest friends, and are never permitted to see even their fathers or mothers, though they may sometimes converse with the latter from behind a curtain. And, lest some lingering filial affection should tempt an unhappy nun to lift the veil of separation between herself and her mother, she is not allowed to speak even with her, but in the presence of the abbess. Accounts of such horrible perversions of human reason make the blood thrill and the teeth chatter. Their fathers they can never speak to, for no man is suffered to be in any part of the convent used by the sisterhood, nor, indeed, is admitted beyond the gate, except when there is a necessity for repairs.

The cutting off of filial connections is akin to death, according to Radcliffe: "It is not easily that a cautious mind becomes convinced of the existence of such severe orders; . . . the poor nuns, thus nearly entombed during their lives, are, after death, tied upon a board, in the clothes they die in, and, with only their veils thrown over the face, are buried in the garden."[54] In her critiques, Radcliffe outlines the primary features implicit in anti-conventual discourse: a group of women without the healthy influence of family members, particularly fathers, is subject to irrational religious practices, the tyrannical rule of the abbess, and the loss of connection with the outside world. Interestingly, Thrale Piozzi, while surprised at the severity of the lifestyle in the house of Poor Clares in Gravelines, alerts the reader that the Mother Superior and one of the choir nuns are sisters by blood, and provides their family name, narrative details that situate them as English gentlewomen, providing class and national markers which familiarize and domesticate nuns to British readers.[55] Radcliffe is unable to do this at the German nunnery, and thus her portrayal

46 *Encountering Convents Abroad*

of the Poor Clares takes on a gothic flavor with the "thrill" of "blood" and the "chatter" of "teeth."[56] The *Monthly Review* reprinted Radcliffe's commentary on the Poor Clares, representing only the first half of her depiction of monastic culture for women, enticing readers with the gothic bias that pervades her fiction.[57]

With her second exposure to conventual culture, Radcliffe contrasts the Poor Clares in Cologne with richer chapters whose rules were less strict and whose members lived in more luxury, allowing her to refigure the modes of community available to women. Radcliffe points out that these nuns "are little more confined than if they were with their own families, being permitted to visit their friends, to appear at balls and promenades, to wear what dresses they please, except when they chaunt in the choir, and to quit the chapter, if the offer of an acceptable marriage induces their families to authorise it." Radcliffe describes this German cloister as a potentially temporary, yet respectable and secure repository, for single women of high standing. Radcliffe notes that "they sung their responses with a kind of plaintive tenderness, that was extremely interesting."[58] It is possible that this unidentified group of nuns became Radcliffe's inspiration for her sympathetic depiction of the sisters in the convent of the Santa della Pieta in *The Italian*, a novel written three years after her tour.[59] Radcliffe also describes nuns who work "by rotation, in teaching children and attending the sick."[60] Performing important public offices, the nuns are actively working within society, while maintaining a social mobility that allows them to negotiate family contact.

With increased time with nuns abroad, Thrale Piozzi and, to a lesser degree, Radcliffe, reevaluate women's monasticism in terms of the privileges it affords for single women. Both writers use contrast in their depictions of various groups as a means of criticizing what they considered the problems of enclosed life for women, whilst admiring and even recommending the advantages of communities whose rules appeared more congenial. Thus, these experiences abroad not only facilitated the traveler's engagement in Catholic social networks, but also opened up a discursive space through travel writing to better understand conventual culture and its advantages for single women.

Encountering French and English Nuns: Cole, Thicknesse, and Paterson

Although women had more access to the convent, male travelers also sought out women's convents abroad. One admirer of monasticism, William Cole, a rector of Bletchley in Buckinghamshire, recorded his observations in *A Journal of my Journey to Paris in the Year 1765*. Cole does not hide his sentiments, declaring that he might have been "fixed . . . [at the monastery] for Life, as I never had any other Views in Life, than to live retiredly & quietly, & pretty much to myself, after the Monkish Manner."[61] Cole's descriptions of religious houses detail structural and architectural features, important works of art and literature that the convent holds, and noteworthy individuals within the house, as well as their lines of descent. Cole's journal does not record many personal interactions with actual

Encountering Convents Abroad 47

monks or nuns, suggesting that, like other male tourists, Cole had limited access to cloistered space.[62] Yet, in spite of Cole's differing focus, his travel journal, like Thrale Piozzi's, demonstrates an overt interest in monasticism throughout.[63]

Tracing the lines of descent from Catholic family in England to Catholic exile or convert abroad is a narrative device that connects the traveler's national history to the identity of the religious subject being discussed, thus grounding the common origins shared by the traveler, the religious, and the reader. As one example of this, after Cole's visit to the English Benedictine monks in Paris, he delineates the men's families and their former stations in England. It is here where the coffin of James II lies, and Cole's narrative praises this Catholic King and laments the shabbiness of his resting place. Disappointed that none of the priests greeted him upon his arrival, Cole confesses his fondness for the Benedictines, "formerly so flourishing in England," and his attempts, before his departure, to secure lodging at this monastery.[64]

While Cole's desire to explore monasticism on a personal level is not realized, his visits to convents strengthen his social ties to English Catholics abroad. One such connection is with the Throckmorton family. Cole records his attempts at tracking down a daughter of Cole's deceased friend, George Throckmorton. Mrs Throckmorton had urged Cole's visit to her daughter who was being schooled at a convent in France. At first unsuccessful in finding Miss Throckmorton, Cole eventually discovered her at the English Augustinian Convent in Paris, the same convent where Thrale Piozzi and Strickland spent much of their time. Meeting her in the parlor on the opposite side of the grate, Cole notes:

> [She] seemed delighted to see a Person she had known in England, & expressed herself very happy in her present Situation with these English Ladies; but seemed to dread very much her approaching Leave of them for the French Nunnery of Port Royal, where her Grandfather Sir Robert Throckmorton was desirous she should go for a Time in order to perfect herself in the French language, as none but ladies of the best Families in France were educated in that Monastery.[65]

Later on, Cole tracked Miss Throckmorton to her new location at the French Nunnery of Port Royal. As Miss Throckmorton had anticipated, her new situation proved difficult: "As soon as . . . she was alone with me, she began to let her Tears fall in abundance: she said, that she hoped her Mama would not let her remain in the Convent for a long Time, where she had not one Mortal to speak to in her own Language." Though presented with this opportunity to critique the potential misery of English children in French convents, Cole instead consoled Miss Throckmorton, reassuring her to "make herself as easy as the awkward Situation of being a Stranger in the midst of Foreigners would admit: that it was upon this very Account of being bred up with Persons of the Distinction, who consequently spoke their Language in its Purity, that she was placed there." Cole reassures the reader that Miss Throckmorton, although lamenting the length of her stay at the French convent, had been there for a mere week.[66]

48 Encountering Convents Abroad

Cole relates that Miss Throckmorton's oldest sister died three or four years previously in the English Augustinian convent in which she was educated and then buried. Cole does not indicate whether this Throckmorton daughter was professed or simply attending school. However, he does divulge that "this young Lady was a great Favourite of mine, & promised fairly to be very gentile & handsome." Cole had given her a small gold cross with pearls before she departed for France, a cross given to him by his own sister. Cole's bestowal of his sister's gift to Miss Throckmorton exposes a former intimacy cut short by her untimely death. Cole's melancholy narrative of this deceased Miss Throckmorton abruptly changes tone as Cole reassures readers that the Throckmortons have plenty of heirs left, praying that they may "never want Heirs to inherit their noble Fortune 'till the latest Generations!'"[67]

Cole's connection to this Catholic family, like Thrale Piozzi's relationship to the Stricklands, underscores the reality that many Protestant and Catholic families met on friendly, if not intimate, terms. These connections existed and were maintained in spite of geographical constraints and the restrictions placed on convent visitors, particularly men. To illustrate this last point, while Thrale Piozzi was let into two abbesses' dressing rooms, Cole remained behind the grate, even whilst speaking with his acquaintance. After Cole's visit to a Carmelite Nunnery, he noted that "it is difficult to see any of this Order of Nuns, who are very rigid & recluse," echoing Radcliffe's and Thrale Piozzi's criticisms of the physical restrictions practiced by the Poor Clares. Yet, it should be noted that even when Cole visited more lenient groups, he was only allowed entrance into the church and courts open to the laity and visitors.[68]

Historians have documented the popularity of English and French convents abroad for the education of English Catholic children. The *Gentleman's Magazine* asserted in 1766 that 350 boys and 300 girls from English Catholic families were attending Catholic boarding schools in the Low Countries. As Rapley's research on French education notes, "*pensionnats* for girls became the rage in the seventeenth [century]."[69] How popular were such schools within British Protestant circles? Philip Thicknesse recorded moving his fifteen-year-old daughter Charlotte to a French Benedictine convent in Ardres from a Benedictine convent in Calais, where she had been for the past six months in his *Observations on the Customs and Manners of the French Nation* (1766). Thicknesse, a columnist for the *Gentleman's Magazine*, had lived as a colonist in Georgia, served as a Captain first for an independent company in Jamaica and then for a regiment of the Marines; he finally became the governor of Landguard Fort, Suffolk. He was not only well-traveled but also tolerant of diverse religious practices.[70] Informing Protestant parents that they ought not send their children abroad if they are "terrified at the thoughts of a child's conversion to the Catholic religion," Thicknesse also documented his daughter's assertion that "I like the religion very well . . . and so does every English lady in our convent, who would all change if they durst."[71] Indeed, the 1766 "Copy of a Letter from an English Gentleman on his Travels" noted that a French convent in Calais, likely the same that Thicknesse's daughter attended, had "no less than seven and forty Boarders, Girls; all of them

Encountering Convents Abroad 49

the Children of Protestant parents."[72] The surprising popularity of this particular convent for the education of Protestant young women suggests both its affordability and an increasingly tolerant attitude towards Catholic education as the century progressed.[73]

Thicknesse's final comments to his correspondent both warn him of the potential conversion of children educated abroad and Thicknesse's own tolerance of his daughter's situation: "you seemed inclined to have sent your daughter over, and therefore I thought myself bound to say no less, and leave you to be guided by your own good judgment, assuring you, at the same time, that I am under no great concern about the fate of my own children."[74] Tobias Smollett's review of *Observations* in the *Critical Review* reprinted this section, outing Thicknesse for his lackadaisical perspective towards religion and, according to Amy Elizabeth Smith, suggesting that he was "a Francophile disloyal to his homeland." The fact that Thicknesse's *Observations* was a spoof of Smollett's epistolary *Travels through France and Italy* (1766), and was highly popular with over 430 subscribers, was no doubt a sore spot for Smollett.[75]

Thicknesse's daughter did indeed take the veil, following her disfigurement from smallpox, as discussed in his *A Year's Journey through France, and part of Spain* (1777), which details a tour he took with wife Ann, their two youngest daughters, and a "favorite monkey." "She assured me she is happy," Thicknesse testified, impressed that she had matured into a "sensible woman, full of affection and duty." More concerning are the "English ladies of very suspicious characters" boarding at the convent who "may paint the pleasures of this world in such gaudy and bewitching colours to a poor innocent Nun."[76] Indeed, boarders could impact a convent's reputation for good or ill.[77] On that same trip, the Thicknesse family left their daughters, aged 11 and 13, at a convent outside of Auxerre to perfect their French, after haggling over the price of boarding and tuition with the 24-year-old abbess: Thicknesse offered not half of the convent's regular fees and after an evening's deliberation, the nuns accepted his offer. "Upon this occasion we were all admitted within the walls of the convent," Thicknesse recorded, suggesting that enclosure was, at times, relinquished to "oblige" parents or other patrons.[78] The *Monthly Review* reprinted Thicknesse's travels to the convent and hermitages occupying Montserrat's mountain caves in Spain, revealing Thicknesse's broad fascination with Catholic religious life. The reviewer exclaimed that we "shall be exceeding glad to attend him in his journey to Rome," implying that Thicknesse himself was in danger of conversion, as well as the reader.[79]

Under the pseudonym "Coriat Junior," Samuel Paterson in his Sterne-inspired and audience-directed travel narrative, *Another Traveller!* (1767–1769), voiced a more clichéd concern than Thicknesse: young women educated in the convent might enter the novitiate, become nuns, and lose their place in the marriage market: "buried alive, they grow and wither in obscurity—they may not be touched, scarce looked upon, their fragrancy never once to be tasted!—their sweat breath serving only to bedew and perfume the hallowed walls." Coriat worries about the flattering fit of the habit, "enough to make any girl enamoured with a cloyster." His description of the charms of the habit—and its ability to charm the male

50 *Encountering Convents Abroad*

gazer—has a definite erotic undertone. His depiction of the veil provides a noteworthy example: "the thin, transparent, black veil adown the face, contrasts the red and white—which, from its gentle waving, still opens new beauties, still conceals what may be better imagined:—the most loosely-attired coquet cannot display the thousandth part of them."[80] Other male tourists, such as Patrick Brydone in his *Tour through Sicily and Malta* (1773), registered an attraction to the figure of the habited and veiled nun. Brydone states: "there is no artificial ornament . . . that can produce half so strong an effect, as the modest and simple attire of a pretty young nun, placed behind a double iron grate."[81] The nun's sexual power is amplified because of her relative inaccessibility to the male traveler whose gaze remains restricted, even as he attempts to transgress architectural and sartorial limitations.

The habit calls attention not only to a nun's withdrawal from the realm of sexuality, but also to the body itself. For example, prior to lamenting the loss of attractive women from the marriage market, Coriat outs a convert, Grace Fox, "who tho' born and bred a protestant of the church of England, had been soothed, or tempted, or some how or other constrained to take the habit," a mode of dress "most bewitching" to young women and, by implication, the male tourist.[82] Underneath his anxiety around her conversion lurks an overt erotic fascination with nuns in general, quite distant from the more personal interactions with daughters and friends recorded by Cole and Thicknesse. Exploiting the reader's desire to pay visual homage to young fertile women immuring themselves behind bars, an anonymous male travel writer also promises visual access in the revised title of his narrative. Originally, *A Tour through part of France and Flanders, the whole intended as a guide to the curious travellers, and an instructive amusement to those who have no opportunity of visiting the places mentioned in this work* (1768), in the second edition, the author emphasizes his proximity to nuns and his work in translating their celibate culture: *The Gentleman's Guide, in a tour through part of France and Flanders; containing a particular description of Calais, Ardres, Boulogne, St Omers, Aire, Mardyke, and Dunkirk: wherein is described the particular Ceremonies of the Nuns taking the Veil; Copies of their Vows, their Times of Prayer, Form of their electing a Superiour; Manner of celebrating particular Days* (1776).[83] Using nuns to market his work, this travel writer, like Coriat, promises readers access to these women and their rituals.

Similarly, in his depiction of the English Benedictines at Ghent, Coriat unveils both the women and their cloister for the consumption of his readers: "The curtain is drawn back, and behold the prioress and her nuns!—She appears like the goddess, or the priestess of this temple; and they as her attendant nymphs, or vestals!" As in his earlier depiction of the habit worn by young nuns, this portrait of the Prioress as goddess with her virgin vestals borders on idolatry, as Coriat declares they are "sexual angels!"[84] Like convent pornography, which juxtaposes monasticism with uncontrolled sexuality, Paterson's text fetishizes conventual culture, emphasizing its erotic appeal. As Christopher Rivers argues: "the convent is by definition the locus of a collective secret that must be penetrated; by the very fact of pretending to shut sexuality out, it effectively shuts it in."[85] Perhaps Coriat

Encountering Convents Abroad 51

Junior's comments are part of the self-construction of the character as the "sentimental" tourist, one that is "preoccupied with the meanings of sensibility for manhood," according to G.J. Barker-Benfield.[86]

In spite of his earlier rejoinders against young women's conventual education and the loss of fertile young women to an enclosed life, Paterson humanizes and admires the English nuns. Their community poses an alternative to the loneliness of widowhood and domestic isolation:

> After having tasted life's fancied sweets and real sorrow, and experienced some of her numberless cares and calamities, they may well be thankful that they are over ... after the loss of husbands, who were their partners, or their plagues; of children, who might have been their comforts, or their curses—after the unkindness of some relations and the ingratitude of others, whom can we love? ... With all my heart, ladies, if it is your pleasure—I see no reason why you may not retire, and carry some of your unprovided nieces along with you ...[87]

Coriat's realistic outlook on marriage and childbearing in this passage undercuts his sentimental regret at the loss of his friend, Grace Fox, to a Conceptionist convent in Ostend. However, Coriat recognizes the social utility of the convent in providing resources for what society terms "useless" women. For example, Coriat and the prioress, Elizabeth Philips, discuss the convent's industry of silk flower making: "We touched sometimes upon the world; but more upon the sweets of virtuous retirement—The Arachnean arts of the fair sisterhood, and their beautiful imitations of Flora's choicest gifts, engaged our attention."[88]

In an attempt to come to grips with Paterson's "ambivalent assessment of Catholicism," Turner concludes that, "nuns, certainly as Coriat sees it, play no part in the socially virtuous practices of hospitality and charity which are evident in the many [male] monastic institutions visited."[89] Yet Paterson's description of life within a Brussels beguinage—a more relaxed version of female monasticism—directly extols these features. Unlike enclosed nuns, beguines did not take solemn vows and worked together corporately; they also had more accessibility to the outside world.[90] James Essex, in his *Journal of a Tour through part of Flanders and France in August 1773*, describes beguines as "a particular sort of Nuns ... they are not confined like those in other Convents but may leave it when they please and marry when they can."[91] While Essex emphasizes the flexible parameters for beguines, Coriat applauds the integrity of such institutions in a panegyric to St Bega, from which the term "beguines" is derived: "thousands of thy loved sex have been sheltered from want, and shielded from prostitution; millions of thanks we owe to thy memory!" As Rapley points out: "The cloister was a defense against ill repute and a haven of respectability for unmarried daughters of 'good' family—but only if it remained a true cloister. The women within had to be safe in the one respect that really mattered: their chastity."[92] Instead of worrying about how to survive like some of her worldly counterparts, a beguine, "by sober industry ...

52 *Encountering Convents Abroad*

employ[s] her talent towards her own support" through the production of textiles and fancy forms of needlework that are sold. Because the "gentle rule" of St Bega has "cut off [women] from the corruptions, but not from the commerce of flesh," Coriat makes an allowance: "this seems to be no absurd institution—and something like it might admitted into any corporation, whether popish, or protestant.—I will subscribe to it with all my heart."[93] Coriat's travel journal articulates not merely "a sentimental agenda of broader tolerance" towards Catholicism but a positive approval of some forms of religious practice for women.[94]

Coriat's visit to St Monica's Convent of the English Canonesses in Louvain elicits further consideration of contemplative monasticism for women: "[I] am now fully perswaded that by custom and society we may overcome many difficulties, which at first sight appear to be insuperable. Confinement, which is certainly among the greatest, wears off of itself; and to the habit of women, which is more sedentary than ours, not so irreconcilable as we may imagine." Like his contemporaries, Paterson legitimizes the pedigree of this "opulent English house" in Louvain: "some of the first English Catholic families have been of their order, or nearly allied to those who were." By means of contrast, he decries the English Carmelites: "what could tempt the unerring virgin to associate with such melancholy spectres as these poor *Theresians*?"[95] Coriat's categorization of healthy and unhealthy examples of religious life thus allows him to simultaneously critique and condone monastic groups based upon their practices rather than their religious affiliation.

Coriat immediately follows his approval of the English Canonesses with his own vow never to "make a wilful sacrifice of a daughter, a sister, or a niece, in the prime of life, to such unnatural love," making a distinction between women who are necessary in society and those who are not.[96] Paterson's text works to justify his views that women, specifically young women, are not made to take vows to God, but to man: "upon sound protestant principles, I cannot for the soul, or for the body of me, or both united, consider a woman, but as a woman."[97] However, though he is constrained by his rigid definition of gender, Paterson manages to move beyond the personal in his commendation of flexible communal models for women.

Reviews of the first volume of *Another Traveller!* reproduced Coriat's fascination with the subject, suggesting that the critics knew that readers would want access to nuns as well. The *Monthly Review* reprinted the section on Grace Fox's conversion, as well as the visual unveiling of the English Benedictines at Ghent, while the *London Magazine* shared Coriat's musings on beguines in Brussels. The *Critical Review* stated that Coriat's "reflections upon nuns and nunneries are affecting," while the *Monthly Review* affirmed his "natural and sentimental observations on nunneries."[98] Indeed, critics focused much of their reviews on Coriat's encounters with nuns and convents. That the reviews of Radcliffe's, Thicknesse's, and Paterson's travel narratives widely comment on and reprint sections from these travellers' experiences with nuns is further evidence that readers of travel narratives were highly interested in monastic life for women.

For Radcliffe and Paterson, the cloister poses a set of restrictions primarily to those young women who take the veil; on the other hand, for older women, the conventual template is a potentially liberating and protective structure in contrast to society proper as Thrale Piozzi's and Paterson's narratives argue. Indeed, the cloister becomes a space of freedom for women to pursue their own interests, secured from the dangers of the outside.

To conclude, I want to turn briefly to Thrale Piozzi's later travel writings. Her visit to the Continent in 1784, after the death of Henry Thrale and her marriage to Gabriel Piozzi, was published in 1789 as *Observations and Reflections Made in the Course of a Journey Through France, Italy, and Germany*. Interestingly, she revised the original narrative before publication, incorporating more explicit support for monastic enclosure for women. Upon revisiting the English Augustinian nuns in Paris, all of whom were still alive and remembered her visit from years before, she drew another practical comparison between nuns' lives and those of single English women in society:

> These ladies really live here as comfortably for aught I see as peace, quietness, and the certainty of a good dinner every day can make them. Just so much happier than as many old maids who inhabit Milman Street and Chapel row, as they are sure not to be robbed by a treacherous, or insulted by a favoured, servant in the decline of life, when protection is grown hopeless and resistance vain; and as they enjoy at least a moral certainty of never living worse than they do to-day: while the little knot of unmarried females turned fifty round Red Lion Square may always be ruined by a runaway agent, a bankrupted banker, or a roguish steward.[99]

Thrale Piozzi's commentary reveals the sad truth that common law denied married women legal status and typically deprived women of their rights over their own money; thus, joining a religious community was one way to secure economic and legal independence.[100] Because of the criticism Thrale Piozzi suffered at this time for marrying Piozzi, an Italian and a Catholic, it is not surprising that in her published work she spends little time in overt praise of Italy or its Catholic practices. Yet the inclusion of this commentary on the single life of older women in England indicates that she had a positive view of religious communities, such as she witnessed at the English Augustinian convent.

The travel narratives discussed here represent only a handful of those that find and extol the social utility of the cloister. Without a more thorough examination of extant travel narratives, it is easy to overlook the powerful effect that monastic communities had upon British tourists in the late eighteenth century, as well as the continuing impact of those experiences during the French Revolution and emigration. Alongside French Royalists, bishops, and priests, 23 known communities of Catholic nuns came to England by 1809, inspiring British writers to continue to re-examine a way of life which had been previously unavailable in England since the Reformation.[101] With English, French, and Belgian nuns seeking asylum

54 *Encountering Convents Abroad*

in Great Britain in the last decade of the eighteenth century, different kinds of interchanges became possible. The convents of the Poor Clares in Gravelines, the English Blue Nuns, and the English Augustinians in Paris would all serve as prisons for British Nationals during the Revolution. While the Poor Clares of Gravelines and the Blue Nuns returned to England, neither group successfully relocated.[102] Surprisingly, the English Augustinians in Paris, Thrale-Piozzi's especial friends, remained in France, becoming the only English community that was not displaced by the Revolution.[103]

Notes

1 Hester Thrale Piozzi, *Mrs Thrale's French Journal, 1775*, in Moses Tyson and Henry Guppy (eds), *The French Journals of Mrs Thrale and Doctor Johnson* (Manchester, 1932), pp. 83, 121, 144. A version of the first half of this Chapter was published as "Peregrinations to the Convent: Hester Thrale Piozzi and Ann Radcliffe," in Dorothy Medlin and Katherine Doig (eds), *British-French Exchanges in the Eighteenth Century* (Cambridge, 2007), pp. 116–30.
2 See Jeremy Black, *The British Abroad: The Grand Tour in the Eighteenth Century* (New York, 1992), pp. 238–51; Chloe Chard, *Pleasure and Guilt on the Grand Tour: Travel Writing and Imaginative Geography, 1600–1830* (New York, 1999), pp. 91–2, 128. Chard focuses on the representation of "improper restraint" that nuns symbolized to tourists.
3 Ann Radcliffe, *A Journey Made in the Summer of 1794, through Holland and the Western Frontier of Germany, with a return down the Rhine: to which are added Observations during a Tour to the Lakes of Lancashire, Westmoreland, and Cumberland*, 2nd edn (2 vols, London, 1795); William Cole, *A Journal of my Journey to Paris in the year 1765* (New York, 1931); Samuel Paterson, *Another Traveller!: or, Cursory Remarks and Tritical* [sic] *Observations made upon a Journey through part of the Netherlands in the latter end of the year 1766. By Coriat Junior* (2 vols, London, 1767–1769); Philip Thicknesse, *Observations on the Customs and Manners of the French Nation: in a Series of Letters, in which that Nation is Vindicated from the Misrepresentation of some Late Writers* (London, 1766); and *A Year's Journey through France, and part of Spain* (2 vols, Bath, 1777).
4 English Catholic tourists overtly supported the English convents, which depended upon English Catholic patronage and also housed the friends, relatives, and children of English Catholic visitors. Gabriel Glickman, *The English Catholic Community, 1688–1745: Politics, Culture, Ideology* (Rochester, 2009), pp. 76–7.
5 Matthew Lewis, *The Monk*, ed. Christopher Maclachlan (London, 1998); Denis Diderot, *The Nun*, trans. Russell Goulbourne (Oxford, 2005).
6 Radcliffe's journal has been cited as an example of British anti-monastic sentiment. See Katherine Rogers, "Fantasy and Reality in Fictional Convents of the Eighteenth Century," *Comparative Literature Studies*, 22 (1985): p. 313. For work on Thrale Piozzi's journal see Rogers, pp. 310–11; Susan Lamb, *Bringing Travel Home to England: Tourism, Gender, and Imaginative Literature in the Eighteenth Century* (Newark, 2009), pp. 229–31; Lamb's claims are in line with my own in "Peregrinations to the Convent."
7 Rogers also points out this shift, stating that Thrale Piozzi's "thoughtful observation of a community of English Augustinians in Paris broke down her British prejudices," p. 310.
8 The passing of the Catholic Relief Acts of 1788 and 1791 demonstrates England's more tolerant legal and economic response to English Catholics. Carla Gardina Pestana points out that the Pope's refusal in 1766 to acknowledge the descendants of

James II as the rightful heir to the English throne allowed for "ameliorating legislation" in 1778 and 1782, although the Gordon Riots of 1780 make clear that anti-Catholic sentiment was still strong; in *Protestant Empire: Religion and the Making of the British Atlantic World* (Philadelphia, 2009), p. 233.

9 C. D. Van Strien, "Recusant Houses in the Southern Netherlands as Seen by British Tourists, c. 1650–1720," *Recusant History*, 20 (1991): p. 501; Black, *British Abroad*, pp. 238–51.

10 Glickman discusses the "cosmopolitan spirit" infused in recusant circles abroad, p. 77.

11 Claire Walker, *Gender and Politics in Early Modern Europe: English Convents in France and the Low Countries* (New York, 2003), pp. 2, 12, 38; Isobel Grundy, "Women's History? Writings by English Nuns," in Isobel Grundy and Susan Wiseman (eds), *Women, Writing, History: 1640–1740* (Athens, 1992), pp. 126–38. As Walker states, "taking vows in an expatriate house constituted an act of religious and political disobedience against the English Church and State," p. 35.

12 *The English Convents in Exile, 1600–1800*, eds Caroline Bowden, Carmen M. Mangion, Michael Questier, et al (6 vols, London, 2012–13), vol. 1, pp. xxv.

13 Glickman, p. 76.

14 Katherine Turner, *British Travel Writers in Europe 1750–1800: Authorship, Gender, and National Identity* (Aldershot, 2001), p.11.

15 Alison Shell, *Catholicism, Controversy and the English Imagination* (Cambridge, 1999), p. 171. Glickman describes English recusants as "early exponents of the Grand Tour," p. 77.

16 Liesbeth Corens, "Catholic Nuns and English Identities. English Protestant Travellers on the English Convents in the Low Countries, 1660–1703," *Recusant History* 30 (2011): p. 442; Van Strien.

17 Francis Bacon, "Of Travel," in *Bacon's Essays* (New York, 1930s), p. 133.

18 Van Strien, p. 501; Chard, p. 91.

19 Walker, pp. 8–17.

20 For example, see Ana M. Acosta, "Hotbeds of Popery: Convents in the English Literary Imagination," *Eighteenth-Century Fiction* 15 (2003): pp. 615–42; Rogers, "Fantasy and Reality." For a literary portrait of these anti-monastic critiques, see Lewis, *The Monk*.

21 Black, *British Abroad*, p. 240. In the same vein as Black, Van Strien says of early eighteenth-century narratives: "The average traveler did not come to make a serious study of life inside the convents. They were tourists, satisfied with a general impression of the house and a conversation with a countrywoman," p. 507.

22 Walker, p. 121.

23 See Linda Colley, *Britons: Forging the Nation 1707–1837* (New Haven, 1992).

24 Johannes Fabian, *Time and the Other: How Anthropology Makes its Object* (New York, 1983), pp. 30–31; Jenny Franchot, *Roads to Rome: The Antebellum Protestant Encounter with Catholicism* (Berkeley, 1994), p. 23. Franchot addresses specifically nineteenth-century American tourists' concept of Catholic Italy as representative of the past. Yet, her description of the strategy that many tourists used to categorize Catholicism as a relic of their own history, a relic to be observed, commented upon, and left behind, is common to some American and British travelers in both the eighteenth and the nineteenth centuries. Dennis Porter argues that travel writing often carries with it "a sense of the return of the past [such as] the reemergence of a previously abandoned system of belief" in *Haunted Journeys: Desire and Transgression in European Travel Writing* (Princeton, 1991), p. 12.

25 Turner, p. 7.

26 Jeremy Black, *Natural and Necessary Enemies: Anglo-French Relations in the Eighteenth Century* (Athens, 1987), p. 161. For more on this anti-Catholic perspective, see Colin Haydon, *Anti-Catholicism in Eighteenth-Century England, 1714–80: A Political and Social Study* (New York, 1993).

56 *Encountering Convents Abroad*

27 Alessa Johns, *Women's Utopias of the Eighteenth Century* (Urbana, 2003), p. 4; Zoe Kinsley, *Women Writing the Home Tour, 1682–1812* (Burlington, VT, 2008), p. 122.
28 Turner, p. 128. As Turner points out: "women's travel writings were generally welcomed by the reviewers . . . for the novel perspectives they offered," p. 129; Mary Wortley Montagu, *Letters* (New York, 1992), pp. 130–34.
29 Thrale Piozzi may have opted not to publish this narrative after her marriage to Gabriel Piozzi, since her social circle criticized her decision to marry an Italian Roman Catholic. Although the conventual depictions in her *French Journal* all take place in Flanders and France, she may have wished to minimize the public perception that she leaned towards Catholicism. Further evidence for this position exists in the manuscript and published versions of her journal of 1784 in which outright discussions of Catholicism are limited. See her *Observations and Reflections Made in the Course of a Journey Through France, Italy, and Germany*, ed. Herbert Barrows (Ann Arbor, 1967).
30 Thrale Piozzi, *French Journal*, pp. 72–3.
31 Turner, p. 128. For discussions of gendered differences in travel writing see also Gary Kelly, *Women, Writing, and Revolution 1790–1827* (Oxford, 1993), p. 69. For an alternative to this notion of difference in male and female journals, see Felicity A. Nussbaum, *The Autobiographical Subject: Gender and Ideology in Eighteenth-Century England* (Baltimore, 1989).
32 Chard, p. 35.
33 Chard, p. 40.
34 Thrale Piozzi, *French Journal*, pp. 79–80.
35 Walker, pp. 23–4; Thrale Piozzi, *French Journal*, p. 80. See also M.W. Sturman, "Gravelines and the English Poor Clares," *London Recusant*, 7 (1977): pp. 1–8.
36 Thrale Piozzi, *French Journal*, pp. 80–81.
37 Thrale Piozzi, *French Journal*, p. 81.
38 Thrale Piozzi, *French Journal*, p. 83.
39 John Andrews, *Remarks on the French and English Ladies, in a Series of Letters; Interspersed with Various Anecdotes* (Dublin, 1783), p. 117.
40 Elizabeth Rapley, *A Social History of the Cloister: Daily Life in the Teaching Monasteries of the Old Regime* (Montreal, 2001), p. 144.
41 Walker, p. 151.
42 Quoted in Walker, pp. 153, 157.
43 Walker, pp. 18–19.
44 Thrale Piozzi, *French Journal*, p. 120.
45 Walker, pp. 93, 95, 99; George Sand, *The Convent Life of George Sand*, trans. Maria Ellery McKay (Chicago, 1977).
46 Thrale Piozzi, *French Journal*, p. 121.
47 Thrale Piozzi, *French Journal*, pp. 121–2, 144.
48 Thrale Piozzi, *French Journal*, pp. 153–4.
49 Thrale Piozzi, *French Journal*, p. 122.
50 Fabian, pp. 30–31, emphasis his.
51 *European Magazine and London Review*, ed. John Bannister, 28 (1795): pp. 98–9; *British Critic and Quarterly Theological Review*, 6 (1795): pp. 363, 366.
52 The *Critical Review* suggests that "genius and taste" counterbalance "indolence, habits of inattention, and ignorance of language." *Critical Review*, ed. Tobias Smollett, 14 (1795): p. 241. See also *English Review* 26 (1795): pp. 1–5; *Monthly Review*, ed. Ralph Griffins, 18 (1795): pp. 241–6; *European Magazine and London Review*, ed. John Barrister, 28 (1795): pp. 257–61.
53 Radcliffe, *A Journey Made in the Summer of 1794*, vol. 1, p. 188.
54 Radcliffe, *A Journey Made in the Summer of 1794*, vol. 1, pp. 188–9.
55 Thrale Piozzi, *French Journal*, p. 80.

Encountering Convents Abroad 57

56 Radcliffe, *A Journey Made in the Summer of 1794*, vol. 1, p. 188.
57 *Monthly Review*, 18 (1795), pp. 242–3.
58 Radcliffe, *A Journey Made in the Summer of 1794*, vol. 1, pp. 195–6.
59 Turner, p. 217, reads Radcliffe's comments on evicted nuns in Flanders as the possible origin of the convent she depicts in *The Italian*. Brenda Tooley discusses the positive portrayal of the nuns of Santa della Pieta in "Gothic Utopia: Heretical Sanctuary in Ann Radcliffe's *The Italian*," in Nicole Pohl and Brenda Tooley (eds), *Gender and Utopia in the Eighteenth Century: Essays in English and French Utopian Writing* (Burlington, 2007), pp. 53–68. See also Rogers, pp. 301–2. Ann Radcliffe, *The Italian, or, the Confessional of the Black Penitents*, ed. Robert Miles (London, 2000).
60 Radcliffe, *A Journey Made in the Summer of 1794*, vol. 1, p. 195.
61 Cole, pp. 140–42; For more on Cole's pro-Catholic sentiments see M.D.R. Leys, *Catholics in England 1559–1829: A Social History* (New York, 1961), pp. 122–3.
62 For other examples of this kind of travel writing, see Annibale Antonini's *A View of Paris: Describing all the Churches, Palaces, Publick Buildings, Libraries, Manufactures, and Fine Paintings; Necessary for the Observation of Strangers: by the Abbot Antonini* (London, 1749); *A Tour of Spa, through the Austrian Netherlands, and French Flanders* (London, 1774); Antonio Monsanto's *A Tour from England, thro' part of France, Flanders, Brabant, and Holland* (London, 1752); and Thomas Nugent's *The Grand Tour; or, a Journey through the Netherlands, Germany, Italy, and France* (4 vols, London, 1778). The first edition of this text was published in 1756.
63 The women's communities Cole visited include the convent of the *Petits Augustins*, the Benedictine nunnery of Val de Grace, the Convent of the Carmelites, the English Augustinians and Benedictines in Paris, the Bernardine Convent of Port-Royal, and the Ursuline Convent in Boulogne.
64 Cole, pp. 140–42.
65 Cole, pp. 145, 201.
66 Cole, pp. 286–7.
67 Cole, p. 202.
68 Cole, p. 135. For another response to the Carmelites, see *An Accurate Description of the Principal Beauties, in Painting and Sculpture, belonging to the several Churches, Convents, &c. in and about Antwerp* (London, 1765). The anonymous male narrator describes the English Carmelites in Antwerp as leading "a very austere life, eating no flesh, lying upon straw, wearing no linen, and performing many other acts of abstinence and mortification. Without, their nunnery has the appearance of a prison, its gates, bars, &c. looking very dreadful," p. vi.
69 *Gentleman's Magazine* (1766): p. 206; Rapley, p. 235.
70 For Thicknesse's biography, see Philip Gosse, *Dr. Viper: The Querulous Life of Philip Thicknesse* (London, 1952).
71 Thicknesse, *Observations*, p. 11–12.
72 Qtd. in Black, "Foreign Education," p. 310. Both Protestant and Catholic girls were educated at the English exiled convents. *English Convents in Exile*, vol. 1, p. xxv.
73 As Black qualifies, "There are some signs that religious antagonism became less of a theme in the accounts of many tourists in the second half of the century, but it is important not to exaggerate the scale of any change that took place," in *British Abroad*, p. 247.
74 Thicknesse, *Observations*, p. 12.
75 *Critical Review*, ed. Tobias Smollett, 22 (1766): pp. 430–34; Amy Elizabeth Smith, "Tobias Smollett and the Malevolent Philip Thicknesse: Travel Narratives, Public Rhetoric, and Private Matters," *Huntington Library Quarterly*, 66/3–4 (2003): pp. 349–72, p. 360; Gosse, p. 175. See also the *Monthly Review*, eds Ralph Griffiths and G.E. Griffiths, 35 (1766): p. 471, where the reviewer states that Thicknesse "gives

58 *Encountering Convents Abroad*

a much more favourable account of [France], than Dr. Smollett and other writers of our country have done."

76 Thicknesse, *A Year's Journey through France,* vol. 1, pp. 11–13.
77 Caroline Bowden, "The English Convents in Exile and Questions of National Identity C. 1600–1688," in David Worthington (ed.), *British and Irish Migrants and Exiles in Europe, 1603–1688* (Leiden, 2010), p. 307.
78 Thicknesse, *A Year's Journey through France,* vol. 2, pp. 140–41.
79 *Monthly Review or Literary Journal,* ed. Ralph Griffiths and G.E. Griffiths, 57 (1777): pp. 207–21; see also the *Critical Review,* 43 (1777): pp. 449–52.
80 Paterson, vol. 1.1, pp. 92, 89–90. Turner, p. 101, asserts that Paterson's narrative is the most sophisticated and the first to appear after Sterne's *A Sentimental Journey* (1768).
81 Qtd. in Chard, *Pleasure and Guilt,* p. 128.
82 Paterson, vol. 1.1, p. 89.
83 *A Tour through part of France and Flanders* (London, 1768); *The Gentleman's Guide, in a Tour through part of France and Flanders* (London, 1776).
84 Paterson, vol. 1.1, pp. 181, 185.
85 Christopher Rivers, "Safe Sex: The Prophylactic Walls of the Cloister in the French Libertine Convent Novel of the Eighteenth Century," *Journal of the History of Sexuality,* 5/3 (1995): p. 387. Chard also addresses this issue, stating that the habit functions as a disguise that signifies nuns' restrictive culture, making the male gaze an act of "erotic transgression," p. 128.
86 G.J. Barker-Benfield, *The Culture of Sensibility: Sex and Society in Eighteenth-Century Britain* (Urbana, 1992), p. 142.
87 Paterson, vol. 1.1, pp. 182, 184.
88 Paterson, vol. 1.1, p. 186. Silk flower making was a common industry among enclosed nuns, especially the Benedictines. Walker, pp. 97–8.
89 Turner, p. 108.
90 Silvia Evangelisti notes that "By engaging in social work and education, the women who joined these active orders fulfilled social roles outside the cloister that Trent had reserved for married women only." Evangelisti, *Nuns: A History of Convent Life* (New York, 2007), p. 202. For more on beguines, see pp. 201–4.
91 James Essex, *Journal of a Tour through part of Flanders and France in August, 1773,* ed. W.M. Fawcett (Cambridge, 1888), p. 29.
92 Paterson, vol. 1.2, p. 80; Rapley, p. 117. For praise of the convent's role in aiding fallen women, see Andrews, *Remarks,* p. 120.
93 Paterson, vol. 1.2, pp. 80–81.
94 Turner makes this claim of Paterson's journal and also confirms that Paterson is interested in Catholic institutions; in *British Travel Writing,* pp. 108–9. In *Remarks,* p. 199, Andrews supports forms of monasticism that render service to the public. He cites specifically the French "Charitable Sisters" whose lives are devoted to work in the hospital, and the Ursulines who teach young women free of charge. See also his positive depiction of "female canonesses," p. 123.
95 Paterson, vol. 1.2, p. 149, emphasis his. See note 68 above for an anonymous male traveler's view of Carmelites, as well as Cole's commentary.
96 Paterson, vol. 1.2, pp. 148–9.
97 Paterson, vol. 1.1, p. 94.
98 *Monthly Review,* 39 (1768): pp. 441–2; *London Magazine or Gentlemen's Monthly Intelligencer,* 37 (1768), pp. 664–5; *Critical Review,* ed. Tobias Smollett, 26 (1768): p. 348.
99 [Thrale] Piozzi, *Observations and Reflections,* p. 13.
100 Rebecca D'Monté and Nicole Pohl, *Female Communities, 1600–1800* (New York, 2000), p. 8.
101 *English Convents in Exile,* vol. 6, p. xvii.

102 Sturman, pp. 6–7. The Poor Clares of Gravelines returned to their Continental convent, but had only two members by 1837. They opted to give their estate to the Ursulines of Bologne. The Blue Nuns were essentially defunct by 1805. Margaret J. Mason, "The Blue Nuns in Norwich: 1800–1805," *Recusant History*, 24/1 (1998): p. 89.

103 Carmen Mangion, *Contested Identities: Catholic Women Religious in Nineteenth-Century England and Wales* (New York, 2008), p. 35. The Augustinians in Paris relocated to Ealing, London in 1911. The convent closed in 1996.

2 Spoiled Economies and Violated Virgins

The Benedictines of Montargis, Abbé Augustin Barruel, and the French Emigration

> Thousands of other respectable religious women, mostly engaged in the education of persons of their own sex, and other laudable occupations, have been deprived of their estates, and expelled from their houses, in which they had purchased a property by the portions given to them by their parents . . . [They are] obliged to fly their country, or are reduced to almost an equal degree of penury with those they had been accustomed to relieve.
>
> Edmund Burke, *Evening Mail*, September 17–19, 1792

In a fierce face-off with local officials ordering her to open the convent's doors, Madame de Lèvi de Mirepoix, prioress of the Benedictines of Montargis in Loiret, rebuffed their demands by challenging: "Ferocious souls, drink our blood; and at that price the favorable heavens will quell in your guts the rage to spill it again."[1] This was in 1791. By October of 1792 the community of 41, including two servants and two chaplains, was in transit: at the head was the tenacious prioress, who agreed to settle the community in England upon the request of the Prince of Wales after their arrival at Shoreham.[2] The first intact group of nuns to immigrate to England, the Benedictines of Montargis became the subject of eyewitness accounts and multiple British press releases; they depended upon supportive benefactors, as well as the charity of strangers, in order to survive the turbulent 1790s.

With the French government's systematic dismantling of Catholic monasteries and convents in the early years of the Revolution, nuns increasingly became public figures as they underwent forced evacuation, assault, emigration, and in rare cases, execution. By August of 1792, many French nuns were, effectively, "deprived of their estates, and expelled from their houses," leaving them with few options but dispersal or "to fly their country."[3] Edmund Burke's entry in the *Evening Mail*, published just after the spectacularly bloody September massacres, in which approximately 230 clergy and two bishops were murdered, draws attention to key debates about the value of women religious in society. In the seventeenth and eighteenth centuries nuns had been responsible for providing both charity and elite educations for girls, as well as other social services. French nuns were now without work and those who chose to remain in community were homeless. Nuns were initially framed by the National Assembly as victims of Catholic indoctrination,

Spoiled Economies and Violated Virgins 61

whose individual liberty was at stake, and then as counter-revolutionaries threatening the integrity of the French state.[4] On the other hand, British readers were presented with a compelling portrait of nuns' resistant virtue under assault, a motif that enabled writers to argue against Revolutionary policies while advocating on behalf of religious refugees. Reduced to refugee status, the imperiled nun became an icon of violated womanhood in British popular culture, no longer protected by the walls of the convent or the social status that religious profession conferred.

This chapter examines literary representations of nuns during the Revolution and emigration, with a particular focus on the first English edition in 1794 of Abbé Augustin Barruel's *Histoire du clergé pendant la Révolution françoise* (1793), a book regarded by nineteenth-century historians of the Revolution as the authoritative work on its subject.[5] A Jesuit priest, Barruel immigrated to England in 1792 and within a year published *Histoire du clergé* with J.P. Coghlan in London. An English translation followed in 1794. Like the nuns he wrote about, Barruel experienced a loss of station and exploited his social networks, especially his Bourbon connections, in order to adapt to temporary dislocation during his 10 years in England.

Concerned with the economic position of religious groups and their reception in England, Barruel accused the French government of depriving society of the vital contributions of priests and nuns in order to enrich government coffers. In revealing the invasive procedures by which the authorities and the revolutionary mob gained access not only to nuns' property but also their persons, Barruel's narrative shifted the focus from a long-standing anti-monastic polemic that argued that religious orders were economic drains on their local communities. By contrast, he portrayed nuns as active civic participants, whether they teach young women or defy government officials. Though Barruel lamented the victimization of nuns in revolutionary France, he emphasized their bravery in actively resisting mandates and those who enforce them, whether in maintaining their religious dress, surreptitiously aiding priests, or refusing to obey orders to disperse. Such defiance is supported by accounts written by and about women religious. Both heroes and martyrs, nuns in Barruel's narrative provide incontestable evidence of the French government's systematic and widespread abuse of power, while involving readers in the realities faced by these groups.

In British print culture the jeopardized position of women in France, and women religious in particular, became a gauge of the British nation's vulnerability to the violent invasions of revolutionary ideology. If the physical and spiritual integrity of a body consecrated to God was at stake, so was social order itself. That conventual social management could be said to put into practice some of the very terms of the Revolution, such as "equality" and "fraternity," was emphasized by nuns themselves in response to anti-monastic legislation.[6] This idea is also threaded throughout various literary genres, including British journalism, poetry, and political histories, such as Barruel produced.

In addition, Barruel's depiction of the French Benedictines of Montargis, as well as other women religious, registers concerns shared by British journalists and travel writers, such as Ann Radcliffe, who witnessed and described the economic

62 *Spoiled Economies and Violated Virgins*

and physical conditions of nuns in the process of relocation. Newspaper accounts drew attention to emigrating nuns' fragility—foreign victims in need of the nation's safety. With the arrival of the Benedictines of Montargis, the press highlighted their reception by the Prince of Wales, while obscuring their English connections within and outside of the community, connections that made the transition possible. Even so, the writings inspired by the spectacle of displaced nuns enabled cultural exchange and unintentional collaboration among writers and readers with different religious and political agendas, prompting a broad reconsideration of the economic viability and social value of women's work within a corporate model.

Eighteenth-Century Monastic Economics and Women Religious in France

Before examining the literary portrayals of Revolutionary-era women religious, it is important to review the historical debates regarding the economic viability and social utility of the monastic model, as well as the position of women religious and their orders in France over the course of the eighteenth century. Arguments waged against the monastic vocation by both British and French critics were broadly applied to both male and female orders, yet when these cultural representations of religious life are contextualized by the political and material realities faced by nuns, the differences between propagandist rhetoric and the real lives of cloistered women become visible. Any discussion of French religious life for women must take into account the regional diversity of cloisters, as well as the various economic and cultural milieus in which they were situated. Furthermore, distinctions must be made between the very different economic positions inhabited by men and women within religious orders, as well as those between different women's orders and individual communities so as not to further the scholarly tendency towards creating "an elitist concentration that so distorts church history," according to Elizabeth Rapley.[7]

Enlightenment criticism of monasticism questioned the social, civic, and economic productivity of religious orders in Catholic countries. The textbook of Enlightenment philosophy, Denis Diderot's and Jean le Rond D'Alembert's *Encyclopédie*, published in France between 1751 and 1772, and available in England as early as 1752 (the same year in which a project to translate the tome into English began), was circulated widely in British and French reading circles. Chevalier Louis de Jaucourt, a contributor to the *Encyclopédie*, wrote the entry for "Monks": "The prodigious numbers of monasteries, which has continued to subsist in the Catholic Church, has become a charge on the public, oppressive and manifestly promoting depopulation."[8] De Jaucourt voices the "populationist" argument against celibacy, which unintentionally obscures the more concerning features of monasticism in eighteenth-century France, such as its doubtful economics and its gaping gender disparities.[9] For example, why were there 750 large revenue-bearing male monasteries and only 250 comparable women's institutions even though there were two to three times more women than men per house during the *ancien régime*?[10] The newer teaching congregations, such as the Visitandines and

Spoiled Economies and Violated Virgins 63

Ursulines, purchased their own property, largely in urban areas. Barbara Woshinsky observes that "because of the disparities in wealth and power between men's and women's orders, women often occupied, and made do with, buildings not designed for their use."[11] Although nuns had to contend with a range of economic issues, typically overlooked in anti-Catholic discourses, the fact that all monastic properties were exempted from the *taille*, the primary tax imposed by the King, as well as feudal dues, contributed to the notion that religious orders were social parasites, leeching the wealth of surrounding parishes without putting this money back into circulation. As Rapley explains, "populationist theories lent weight to the out-and-out resentment that many felt towards monasteries, over what was perceived as their unfair share of the country's wealth."[12]

Even earlier critiques of monastic celibacy conflated procreative with economic productivity. Joseph Addison in his *Remarks on Several Parts of Italy, &c.*, published in 1705, argued: "to find a Country half unpeopled" is the natural result when "so great a proportion of the Inhabitants of both Sexes is ty'd under Vows of Chastity."[13] Addison's use of the verb "ty'd" to describe monastic profession highlights the idea that monks and nuns, bound to vows, cannot be socially-useful, income-producing, and child-bearing citizens. In his *Persian Letters* (1721), Montesquieu raised a similar concern: "The career of chastity has annihilated more men than plagues or the most savage wars. In every monastic institution is an everlasting family to which no children are born, and which maintains itself at the expense of all other families."[14] Children represented the natural inheritors of a family's wealth; since monastic communities did not produce children, they recruited members instead, thus taking potential wives and husbands out of the social realm and into the cloister. To make matters worse, since the income of the regular clergy was partially derived from tithing, Montesquieu's assertion that "every monastic institution" depends upon "other families" makes reference to the economic advantages of the large revenue-bearing male monasteries, the *gros décimateurs*, over their tenant sharecroppers, while failing to recognize the economic disadvantages of women's houses.[15]

Rhetoric charging religious orders with the burdening of the French economy only became increasingly virulent as the century progressed. Mary Wollstonecraft, in *An Historical and Moral View of the Origin and Progress of the French Revolution* (1794), rearticulates this broad critique: "sixty thousand persons, who by renouncing the world cut the thread of nature, served as a prop to the priesthood that enjoyed more than a fourth of the produce of all France; independent of the estates it possessed, which were immense." Consuming more than they produce, the regular clergy were considered "leeches of the kingdom," sucking local and national economies dry without rendering useful public services. In addition, Wollstonecraft described taking the vow of chastity as a "cut to the thread of nature," an act which eliminated the possibility of monks becoming husbands and fathers.[16] Yet Wollstonecraft's description is written in past tense: by the time she was writing, the National Assembly had not only singled out monastic estates for seizure, but also the entire Church's "extensive property portfolio," which comprised 6 to 10 percent of the total landholdings in France.[17]

64 *Spoiled Economies and Violated Virgins*

In anti-monastic propaganda, nuns were seen as victims of a system that rendered them useless members of society since their vow of celibacy removed their bodies from reproductive circulation, an act that represents the "usurpation of male prerogatives."[18] On the one hand, fathers and potential husbands lost control over the transmission of family wealth to future heirs when women chose to join religious orders. That Louis XV's youngest daughter, Louise-Marie, had secretly joined the Carmelites in Saint Denis in 1771 suggested that women had a right to determine their own outcome. Her act of defiance influenced at least two women to join the Carmelite community in Compiègne, a group that would be publicly executed in 1794.[19] On the other hand, propaganda asserted that young women were forced into taking vows by parents attempting to consolidate family wealth and that convents were simply "dumping grounds for surplus or unloved children."[20] To be sure, the cost of joining a religious community, or the convent dowry, was less expensive than a marriage, making the convent a cost-effective method for parents to dispose of unmarried or unmarriageable daughters. Yet it is important to remember that the majority of young novices had been educated within convent walls since early adolescence and in some cases much earlier; thus they had been naturalized to convent norms and saw their entrance into the novitiate as the next step, which nuns' first-person accounts reveal.[21] Though narratives of forced vocations permeate fictional anti-Catholic depictions of the cloister, between 1731 and 1789 only two nuns made formal complaints to the *officialité* to renounce their vows. Mita Choudhury notes: "the process through which a woman entered the convent was designed to prevent families from exerting force over daughters and sisters." However, abuses to the system did occur in allowing fathers or husbands to utilize conventual space for the management of problematic female family members.[22]

Thus, anti-monastic discourse did not recognize that "monastic wealth was male wealth," and contributed to the public perception that women's communities were making money at society's expense.[23] As "small-business enterprises," many communities of women religious struggled to keep afloat financially since they did not receive the same monetary benefits as monks. The fact is that the majority of French nuns during the eighteenth century were "bedevilled by poverty" and this is due to several factors.[24] In 1689, the French monarchy demanded that all religious communities pay dues of *amortissement*, or a percentage of the sale price on all investment properties bought since 1641. By 1704 even investments in the stock market, common economic practice within convents, were subject to this tax. Convents used dowries and other disposable income to loan lump sums of money to individuals and the government, termed *rentes constituées*, in exchange for a yearly payment with interest. Having to pay dues on these investments alongside their land and building purchases plunged many women's communities, particularly the newer teaching orders without inherited land, into utter ruin. To compound the situation, the Law Crash of 1720 plunged the nation into debt, resulting in a sharp decrease in numbers of cloistered nuns and students, which forced teaching orders to ask for governmental assistance, decrease their fees for day students, and accept adult female pensioners as paying members of

Spoiled Economies and Violated Virgins 65

the community in order to keep afloat. Nuns were ordered to turn in their gold and silver, as well as their governmental *rentes*, to the Treasury in return for paper money. In some cases nuns were able to use the money to pay off convent debts or purchase additional property; in others, borrowers paid communities back with the inflated paper currency, including some families that had not paid their daughters' dowries in full yet. Convents continued to feel the effects of these economic setbacks well into the middle of the eighteenth century.[25]

In order to assess and give funding to needy nuns during the turbulent decades following the Law Crash, a *Commission des secours* was set up by the Crown in 1727, providing pensions to 558 communities within the first five years. The *Commission des secours* was also established in order to reduce the total number of nuns so that a community's revenue could reasonably support its members. Thus it made strategic decisions to close communities perceived as socially useless, those without resources such as royal patronage or other influential social ties, or which were not submissive enough to the authority of bishops. Religious houses were combined to increase cumulative incomes. New entrants were also banned, negatively impacting a system dependent upon dowries as income. Finally, the lifting of this restriction depended upon nuns' willing compliance with bishops and male clergy. By 1788, the last year of the *Commission*'s work, around 244 female convents had been suppressed, making the total population of French nuns one-third less than it was in 1720.[26] Thus, at the onset of the Revolution, women's convents had already felt the impact of compression, reorganization, and an Enlightenment ethos in which a community's perceived social utility determined its survival.

In the early years of the Revolution, political rhetoric positioned concepts such as citizenship, liberty, and the "natural" family unit in opposition to monasticism. As Olwen H. Hufton asserts, the "stock image" of the nun propagated in revolutionary culture was that she was "beautiful, fragile, abused, and in search of a man to solve her predicament."[27] By 1789, no new religious candidates were allowed to take vows, and in 1790, nuns were given the option to accept a pension, renounce their vows and enter into secular society.[28] M. Garat-l'Ainé expressed the National Assembly's prevailing attitude towards religious orders in his speech delivered on February 13:

> The rights of man will they thus be won? This is the real question. Religious orders are the most scandalous violation of them. In a moment of fleeting fervor, a young adolescent pronounces an oath to recognize henceforth neither father nor family, never to be a spouse, never a citizen; he submits his will to the will of another, his soul to the soul of another; he renounces all liberty at an age when he could not relinquish the most modest possessions; his oath is a civil suicide.[29]

Revolutionary politicians thus justified the suppression of religious houses in France on the basis that the rights of man were irreconcilable with the vow of celibacy. Useful female citizens, revolutionaries argued, produce children not more nuns. Just as priests and monks were pressured by revolutionary writers to "prove

66 *Spoiled Economies and Violated Virgins*

their worth as citizens in biological terms," so were nuns supposed to embrace women's procreative maternal role as their civic obligation, a role that largely marginalized women from the public sphere.[30] French and English nuns' socially useful work in the education of young women was not a point emphasized by politicians eager to dismantle monastic estates. Instead, society commonly criticized religious orders for not providing sufficient preparation for young girls entering the world and using their schools as engines to recruit novices. Cecile Volanges in Choderlos de Laclos's *Les Liaisons Dangereuses* (1782) is a well-known fictional example of this critique; her conventual education has not taught her how to successfully maneuver within the social circles she inhabits without becoming prey to the sadistic manipulations of others.[31]

While society criticized women religious for failing to embrace marriage and motherhood, their work both inside and outside of the convent was socially significant. Since the seventeenth century, a shift in women's orders from contemplative to active (whose focus was on nursing and teaching) took place. The *institut*, or founding mission of the teaching congregations, for example, was "[t]o devote oneself entirely to the free instruction of young girls," a service that dramatically increased standards of education for women in France.[32] Thus, in the years leading to the Revolution, the extensive work of women's congregrations, whose numbers rose significantly over the course of the eighteenth century, reveals that ideas of social utility provided a framework for alternative forms of religious communities. Women's management of social services, such as education, the care of children and the sick, and support of other women, attest to the degree of civic engagement that the Church made available to women. If non-cloistered orders in which women did not take vows or live together, such as the Daughters of Charity, are taken into account, then women religious outnumbered the regular clergy three to one by the 1770s. These confraternities, such as the Daughters of Charity, Daughters of the Holy Virgin, and Daughters of Wisdom, provided a laicized version of religious vocation (members did not take vows and typically maintained separate households), and allowed women an unprecedented level of public agency. In fact, some pamphleteers suggested that contemplative nuns should move from enclosed orders to these "free congregations" or confraternities to increase their social utility and economic sustainability in the wider community. Nuns working primarily as educators and nurses, as well as women religious within confraternities, were initially exempt from legislative pressure to disband on the basis of their social contributions. On the other hand, revolutionary propaganda asserted that nuns in contemplative orders, whose primary "work" was to pray and sing the divine offices, had "no public value."[33]

Many nuns actively retained the cohesion of their communities in the face of legislative pressure to disperse. Nuns benefited from the "openness of revolutionary political culture of 1789 and 1790," according to Choudhury, strategically employing the rhetoric of social utility and patriotism to promote their positions in France. The National Assembly had promised to protect the citizens of the nation and nuns readily applied this promise to themselves in their appeals to officials. Engaging in public debates through pamphlet writing and submitting

Spoiled Economies and Violated Virgins 67

several hundred petitions to the National Assembly, as well as "voluminous correspondence" with the *Comité Ecclésiastique*, nuns understood that the survival of their communities depended upon an active defense.[34] Nuns from the order of the Assumption appealed to the Assembly stating, "You have solemnly promised liberty to all the French; we only ask you to give us ours to be as we are." Focusing on their relationship to the nation over the Church, nuns appealed to the government as protectors of their liberty. As Visitandine nuns exclaimed, "We ask to live and die in the holy and blissful state that we have freely embraced."[35]

While some communities directly addressed the false stereotypes about women's enslavement in the cloister, others emphasized their social productivity through care of the sick and education of children: "communities appreciated the importance of the new public sphere and its role in their preservation," according to Gemma Betros.[36] These women could be quite bold: in one example, a mother superior charged the "caprice" of legislators as disruptive to their work serving the poor; in another, sixteen nuns asked the Assembly to help them obtain work if they choose to disperse, highlighting men's usurpation of even "sedentary" jobs more appropriate for "the most delicate sex."[37] This example indicates that one primary motivation behind a religious vocation was the opportunity for viable work in the community.

In the changing political climate of the early 1790s, nuns found their communities in grave danger as Revolutionary authorities realized women's potential for collective resistance. No longer playing the role of vulnerable daughter to the benevolent paternalism of the nation, nuns became subject to harsher measures, particularly with increased fears of counter-revolutionary conspiracies against the government after Louis XVI's attempted escape to Austria in June of 1791. In August of 1792, all remaining French nuns and monks were ordered to relinquish their religious garb, disband, and leave their convents. The day the monarchy fell, August 10, 1792, teaching orders were abolished.[38] From this point, French nuns had few options besides imprisonment, dispersal, or emigration.

Issuing a "virulent" pamphlet against local administrators attempting to enter their property, the Benedictines of Montargis's prioress, Madame de Lévi de Mirepoix, argued that "our consciences, stronger than death, only obey God alone . . . Ferocious souls, you drink our blood."[39] Local officials had ordered her to turn over the convent's title deeds. In addition, the convent's church had been invaded by a "screaming mob" threatening to dismantle the grille designed to separate or enclose nuns from the rest of the congregation. Searches by authorities for wheat, weapons, and their Jesuit confessor were also performed and the nuns were interviewed multiple times by officials who could not understand their refusal to disperse. Turning revolutionary rhetoric against the authorities, the prioress's pamphlet further singled her community out.[40] In September 1792, the prioress was deposed by the government and the women were ordered to evacuate the convent. Leaving France that year, the Benedictines of Montargis were the first community of nuns to immigrate to England.[41]

Upon arrival in England, the British popular press focused almost exclusively on the Benedictines' vulnerability rather than their recalcitrance. On the other

68 *Spoiled Economies and Violated Virgins*

hand, Barruel and other writers honed in on the courageous roles that women religious played in defending their positions in France. Ultimately, the key to survival resided in nuns' ability to adapt to changing circumstances in host countries willing to offer them support. However, representations of their dual courage and victimization in British texts contributed significantly to this process, enabling a diverse audience to gain awareness of the struggles of religious refugees.

Spoiled Economies and Violated Virgins: Abbé Augustin Barruel

Already a well-known Jesuit polemicist by 1790, Abbé Augustin Barruel joined French emigrant culture in Great Britain in 1792, serving as almoner to the refugee seventh Prince de Conti, a member of a cadet branch of the Bourbons, but eventually returning to France after the fall of the Directory in 1802.[42] Barruel became best known in England after the publication of his *Memoirs, Illustrating the History of Jacobinism* (1797–1798), a text read enthusiastically by Edmund Burke and admired by Percy Bysshe Shelley for its emphatic style.[43] A theory of conspiracy and considered one of the "founding documents of the right-wing interpretation of the French Revolution," according to Amos Hoffman, the *Memoirs* accused the French philosophers, Freemasons, and German Illuminati of turning public opinion against the monarchy and the Catholic Church.[44] Yet his earlier work, *History of the Clergy*, published only one year after Barruel's emigration, established his reputation in conservative reading circles in Great Britain.[45] This work examined the relationship between the rise of the new government and the demise of the Catholic Church. Essentially a critique of the crimes against religious groups during the early years of the Revolution, *History of the Clergy* went through multiple English editions beginning in 1794 and was published in Dublin, London, the United States, Brussels, Paris, and even Mexico.[46]

In *History of the Clergy*, Barruel starkly portrays the Revolutionary Army's brutal treatment of French religious groups, in particular nuns and refractory priests, from the confiscation of clerical and monastic property in 1790 to the September Massacres of 1792 and their aftermath. Barruel represents the Revolutionary Army as a highly disruptive force, desecrating a way of life that priests and religious had been called by God to execute since early Christianity.[47] Figuring this disruption as a multi-tiered rape, Barruel depicts the revolutionary army as not only breaching the boundaries that separate religious from secular by storming conventual spaces, plundering valuables, and vandalizing property, but also violating holy bodies in acts of rape and murder. Ultimately forced to leave France, nuns and priests in Barruel's narrative have already arrived in England; their physical presence serves as both testimony and warning regarding the devastating impact of revolutionary ideology upon Catholic religious and religion itself.

Scholars have more recently considered the impact of the French Catholic diaspora upon host countries, their religious cultures, and cultural discourses concerning religion and the Revolution.[48] Barruel's text, published in England and circulated widely while he lived there, must be seen within this context. Although

Spoiled Economies and Violated Virgins 69

historian Nigel Aston does not discuss women religious refugees specifically, he explains that exiled French clergy were "scattered around Europe by 1795, pushed out of France, as they never hesitated to aver, by a hostile republican state. Their pathetically reduced status spoke as loudly as any preaching about what was going on in France." Since most German states were closed to the refugees and only higher clergy and bishops were admitted into Naples, the rest "were often forced to keep on the move." French priests and bishops spoke out against Jacobinism, finding audiences among conservatives, such as Edmund Burke, who had influence in Pitt's government through Lord Grenville, the Foreign Secretary. As Kirsty Carpenter reveals, the émigrés "had the sympathy of the British elite," a real advantage in the political tumult of the Revolution.[49]

French Catholic priests made up the majority of emigrants in England: current estimates calculate that by the end of 1792, 3,000 priests were in England while 3,400 were in the Channel Islands and Jersey.[50] Although Barruel states that his explicit purpose is to expose the crimes committed by the French government, implicitly his work is designed to bring order to "a collection of accounts, which have been communicated to us by our dispersed brethren." Just as Britain, "a nation rich in the treasures of unaffected benevolence," provides the physical space for the reordering of religious life among French refugees, so does Barruel's text assemble evidence or "facts which carried on the face of them marks of the most atrocious ferocity," responsible for dispersal in the first place.[51] As a Catholic insider, Barruel renders into public discourse for an international readership a sequence of episodes that record the destabilization of religious communities.

Barruel's dedication in *History of the Clergy* to the British for their support of French refugees constructs the nation's role in émigré aid as that of parent to child, host country to "colonist," affirming that "the history of [our] misfortunes is intimately connected with that of your benevolence." Not only does Barruel convey a feeling of safety, since he writes "under the protection of the English nation," he also figures the nation as both feminine and masculine, maternal and paternal. England is not only a safe parent to orphaned French émigrés, it is also a benevolent "bosom" for those in need of aid. While priests' status as refugees might constitute their demasculinization, Barruel terms his community a colony, its members as "colonists," affirming their active role in choosing a place of refuge rather than drawing attention to their forced exile.[52] In using such motifs, parent to child, host country to colonist, Barruel regains control of a narrative in which communal and physical integrity is at stake.

Such stories of violence against Catholic clergy and religious, public knowledge in France, were disseminated in England by the British press, travelers, relatives and friends living abroad, and the growing émigré population in London. The first violent act against religious groups widely discussed in the British press involved the usurpation of the Catholic Church's property by the Assembly. Barruel's text examines the political maneuvering that led to the government's seizure of Church lands on November 2, 1789, an act that dispossessed French clergy of their livelihoods as they knew them. Traditionally exempt from property taxes, since these sites were considered "God's portion" and thus dedicated to

70 *Spoiled Economies and Violated Virgins*

the service of the poor, Church property comprised 6 to 10 percent of the total land holdings in France. This issue became the focus of debate as the Assembly searched for additional sources of revenue to fund the Revolution. While the Declaration of Rights defined property as a sacred right in article 17, Charles Maurice de Talleyrand-Périgord, Bishop of Autun, argued that Church property was different from privately owned property in that it was "held in trust" for "public purposes." If the government provided public services in the Church's stead, the intentions of the original benefactors would still be fulfilled.[53] Therefore, the Assembly questioned whether the Church was tying up potential national wealth in its perpetual ownership of ecclesiastical lands. This rhetoric would be used to support the Assembly's decision in December of 1789 to authorize the sale of Church properties so as to secure the financial stability of the state and cripple the Gallican Church's "political power base" grounded, literally, in its land holdings. Furthermore, in 1791 monastic properties were officially claimed by the state, although thorough evacuations did not occur for another year.[54]

The seizure of Church properties by the Assembly signaled the imminent crises ahead; not only would the Gallican Church be divided between those who supported the new government-backed Constitutional clergy and those who did not, but also the very basis of Judeo-Christian culture would be challenged in the decade to follow. Conservative critics of the Revolution, including refractory clergymen such as Barruel, employed Enlightenment rhetoric in their defense. Claiming that the usurpation of Church property contradicted the "rights of men," Barruel charged the Jacobins with promoting "a general apostasy" to carry off a "speedy sale of [religious] houses and estates."[55] His point of view aligned with Burke's in his *Reflections on the Revolution in France* (1790), in which the French government's confiscation of Church property is portrayed as an act of outright robbery: "Who but a tyrant ... could think of seizing on the property of men?" Constructing Catholic clergy and religious as hereditary landowners, Burke accused the French government of "open violence and rapine" in its seizure of clerical and monastic property.[56]

The *London Chronicle* voiced the dilemma that this new social order posed: if clergy and religious were no longer property holders and had, upon profession, relinquished their rights to familial inheritance, "it was referred to the Committee of Legislations, to consider how far it might be proper to restore them to those rights, not retrospectively, for that would disturb the whole property of many families, but prospectively."[57] These concerns were rooted in the fact that monks and nuns resigned any legal rights upon profession; they became, according to Rapley, "non-persons in secular society." This tradition provided assurance, particularly to aristocratic families, that daughters would not embroil the family in legal complications if they left the cloister to return home or marry. If inheritance laws in France were updated to include all of the children within a family regardless of sex or birth order, as politicians in the early 1790s had suggested, the logic ran that there would be little economic necessity for anyone in the future to join a religious order.[58] How families would refigure the legal rights and economic positions of returning family members from the convent was up for debate. How ex-nuns

Spoiled Economies and Violated Virgins 71

without family would support themselves and be reintegrated into society were questions to consider as well.

In hopes of remaining in their communities, nuns emphasized their current social utility and service to the nation. In a similar vein, Barruel's text looks back to the key role that monastic orders played in the economic development of local communities in Europe. Rather than sapping the wealth of surrounding communities as anti-monastic propaganda asserted, these regions owe their "state of cultivation to the foundation of monasteries." Barruel asserts that the work of clearing and cultivating the land, of assisting regional municipalities in rendering aid, of educating men and women since the Middle Ages, constitutes "considerable service to the state." Furthermore, Barruel points to the monetary value of churches and monastic estates as a primary motivation behind the National Assembly's dismantling of the Catholic religion.[59] Unlike Henry VIII, who "acted like a gentleman" when he dismantled monastic institutions in sixteenth-century Great Britain, France's "reformation" was "effected by a mob of ruffians," a point that suggests Barruel's class bias.[60] Barruel's description of the behavior of the revolutionaries as "ungentlemanly" connects their violation of boundaries between self and other, secular and religious, to their questionable class standing.

Barruel's text focuses explicitly on these "ungentlemanly" violations, registering the ways in which women religious were both victims and heroes. Barruel's depiction of the evacuation of convents by commissioners emphasizes the invasive manner in which they proceeded:

> [They were] pitilessly compelling tender and forlorn virgins, expiring with grief and alarms, to quit the abodes of their family asylums, and to exchange their habits for a secular dress: . . . There were cannons pointed against the monasteries to frighten those religious women, who might refuse to quit their house. Many of them were expiring with old age, others with sickness, many distracted through fear wandered up and down the streets, and others were dragged out by the ferocious national guards, and abandoned to the mercy of less insensible citizens.[61]

Barruel constructs the nuns as courageous victims "who might refuse to quit their house." After the commissioners disband them, they become victims of the revolutionary mob. A tactic used to remind nuns of their ultimate vulnerability to the demands of the army, the positioning of cannons at the entrance of convents occurred not only in Paris but also in Holland during the French army's invasion.[62] Barruel describes the commissioners' inquest as a figurative rape of the cloister and a literal rape of the nuns: "The ruffians spread themselves about the town, break open the doors of the convents, call on the nuns to take the civic oath, scourge and beat them for refusing; call upon them again to swear; as they persist in their refusal, to a repetition of the same cruelties, are added the most shocking outrages against modesty."[63] Women's virtue, endangered and, in some cases, already lost, became a central trope in propaganda against the Revolution. Furthermore, the threat to nuns' physical integrity only further exemplified the

72 *Spoiled Economies and Violated Virgins*

possibility that the Jacobin faction would lead France to penetrate not only other nations, but also the very idea of God to the core. An attack on female modesty and virtue, the violation of holy women was evidence that atheism could dismantle a Christian-based social order.

Importantly, Barruel's anecdote unveils not only the sadistic cruelty of the revolutionary faction, but also nuns' resistance to authorities. Indeed, "they persist in their refusal" to take the Civic Oath, which signified allegiance to the new Constitutional Church. Barruel's assertion that nuns refused to hear mass from "usurping clergy," or Constitutional clergy, was true of the majority of nuns and which further points to the active role they played in defending their communities. Some nuns did comply with the authorities in hopes that by doing so, they would be able to stay in France; their compliance, however, was strategy rather than agreement.[64]

Barruel points out that nuns went so far as to relinquish the sacraments, their "only remaining comfort," and "opposed an invincible fortitude to the solicitations of the usurping clergy."[65] Many nuns did go without the sacrament of Holy Communion, unless delivered by a non-juring priest, and their refusal to participate in mass led by Constitutional Priests initiated the April Riots in which the Sisters of Charity in Paris were caned, stripped naked, and flogged by market women, known as *les dames de la Halle*. This event was illustrated in satirical works such as the semi-pornographic *La Discipline patriotique ou le fanatisme corrigé*, published in *Le Père Duchesne* and termed by Michel Vovelle an example of "*la caricature incendiaire*," or incendiary political satire that depicts the corporeal punishment of women.[66] Barruel describes the perpetrators' actions:

> These monsters of ingratitude did not even refrain their barbarous hands from the holy women belonging to the charity-houses, devout persons, whose only care was to attend on the sick, relieve the poor, and comfort the afflicted. Three of this venerable sisterhood in the parish of St. Marguerite died in Paris under the rod of these horrible flagellations.

In addition, Barruel claims that even students educated through charity schools were also cruelly handled. Alongside nuns, "two women are trampled under foot and suffocated; young girls and their mothers [are] whipped."[67] Barruel conflates cruelty exercised by the market women with that of the government, indicating the sharp lines of demarcation he is drawing between revolutionaries and Christian citizens.

Although the market women took a particularly active role "to bring other women into line to ensure the patriotism of the sex," according to Hufton, such measures only furthered the devotion of women religious to their respective communities. In response to the legislation forcing cloistered women to return to the world, Barruel asserts that "they remained sequestered in their cells, their fervor redoubled" to remain in their chosen spiritual world. Inspiring the "admiration of mankind" because of their "fortitude," French nuns' determination to retain cohesion is "striking" in Barruel's estimation, particularly given the contrasting

high defection rates among monks.[68] The expulsion of the Jesuits from France in 1764 "had removed the most dynamic force from the male religious life," Hufton asserts, and numbers of monks over the course of the eighteenth century had been in decline. Though some monks integrated into other communities, the difficulty of maintaining traditions when different groups were forced into the same space became one primary reason for male defection. In contrast to monks among whom "the number of apostates . . . was great," nuns were "servant[s] of angels, pure as the heavenly lamb," according to Barruel. Indeed, monks defected at a rate of at least 50 percent, while many women religious stubbornly refused to leave their communities and their professions, even after they were forced to evacuate their convents in 1792.[69]

Nuns' active roles in resisting dispersal and the authorities are not the only examples of their agency in Barruel's text. They also work tirelessly on behalf of and in conjunction with refractory priests. Barruel praises the perseverance of the Nuns of the Visitation and of the Ave who, he claims, were the only individuals to relieve the wants of priests who had been arrested and transported.[70] Indeed, organizations founded and organized by both lay and cloistered women, such as confraternities and other innovative versions of active religious life, served as unofficial convent houses and centers to help aid priests in parish duties and hospital work during the Revolution. Another notable incident in which nuns and priests colluded occurred at Avrillé in Anjou where priests and the Daughters of Charity joined forces and cohabited. The fate of priests, "expelled [from] their houses, and unmercifully driven out from the town," is synonymous with the cruelties practiced upon religious women after they were forced out of their homes. In the Vendée, while priests were drowned with chains in the Loire river, nuns in surrounding villages were executed. Barruel underscores that the army had the power to subdue not only women religious but also male regular and secular clergy in his depiction of the September Massacres of 1792, which resulted in the deaths of approximately 230 priests held in Parisian and other detention facilities.[71] Barruel describes the massacre of five male Capuchins inside their own chapel in terms of "assassins" and "victims," revealing the sharp difference in power between two different groups of men.[72]

Barruel's portrayal of the conflicts between the revolutionaries and nuns does not overdramatize the violence, but affirms what historians consider nuns' "fervent and stolid support of the nonjuring priesthood." That Barruel emphasizes their resistance rather than their compliance suggests his investment in defending women religious, in unifying the narratives between nuns and priests since both populations required support in host countries. For French nuns, such support was needed once political propaganda framed them as counter-revolutionaries, particularly after the April Riots of 1791.[73] The rhetorical framing of women religious ultimately justified further legislation against them. Now considered France's internal enemies, *contre-révolutionnaires*, in league with refractory priests thought to be complicit with the advancing Prussian Army, nuns would have hard choices to make, if any, and emigration seemed increasingly necessary. Ann Radcliffe, in *A Journey Made in the summer of 1794*, encountering

74 *Spoiled Economies and Violated Virgins*

Flemish nuns seeking political asylum during her trip to Holland in 1794, suspected that "these societies had probably their misfortunes increased by the artifices of a political rumour."[74]

Contemporary reviews of Barruel's *History of the Clergy* in British periodicals, although not all positive, reveal the impact of the Revolution and emigration upon British culture. The book was widely reviewed and this attention no doubt swelled the work's already significant readership. Most of the reviews emphasize Barruel's Catholic bias. For example, Tobias Smollett, editor of the *Critical Review*, warns readers that the work "bears evident marks of exaggeration and prejudice," a critique also echoed in several other reviews of the work, including the *Analytical Review*, *Monthly Review*, and the *New Annual Register*.[75] As an almost necessary rhetorical gesture, Smollett acknowledges Barruel's Catholic perspective. Other reviewers less favorable towards the work dismiss it simply on the basis of its "marks of credulity or misrepresentation," as in the politically radical *Analytical Review*, or cast doubt on the probability of such "wonderful and extraordinary" stories "unsupported by any shadow of rational proof," as voiced in the *New Annual Register*. With over half of the reviews speaking openly against the work's Catholic bias, it is apparent that critics from both ends of the political spectrum were concerned that French Catholic émigré accounts could not entirely be trusted. On the other hand, even sympathetic reviewers, such as Smollett, felt it necessary to call out Barruel's Catholicism if only to satisfy an audience expecting such a move before asserting the work's claims to historicity and human interest.

Even though anti-Catholic prejudice inflects most reviewers' perspectives, all of the critics condemn the extreme violence exerted by the Jacobin faction, in some cases virulently, in others, as an almost expected political positioning. *The Monthly Review*, while advising that readers approach Barruel's work with "caution," affirms that "the horrid massacres . . . have disgraced the French Revolution," just as Smollett considers such violence "that indelible stain in the page of French history."[76] By distancing themselves politically from revolutionary violence, reviewers sought common ground with the reading public, while framing Barruel's text in critical and sympathetic terms, sometimes within the same review. In another example, a sympathetic review in the conservative *British Critic* recommends Barruel's book as a "salutary employment" and "a very affecting history," which should be used as a warning to the British regarding the dangers of revolutionary ideology: "Shocking as this spectacle is, it is obvious that a like Revolution in Great Britain would be . . . far more calamitous; as it would involve in its consequences the wives and children of the clergy."[77]

These fears were voiced openly in the 1801 anonymous *Complete History of the Invasions of England*, which included Barruel's *Abstract of the History of the Clergy During the Revolution*, a shortened version and commentary to accompany the full-scale work. *The Complete History of the Invasions of England* warned British women that it was their duty to refute and repel revolutionary sentiments echoed by lovers, fathers, or children; otherwise they would have to "bid adieu to that sacred inviolability of your persons, upon which alone your true felicity depends." Images of the French and their nation where "female delicacy, modesty,

Spoiled Economies and Violated Virgins 75

and virtue are almost extinguished" continued to shape British responses to the French Revolution in the nineteenth-century, reinforcing strict gender roles for women in Britain in contrast to French "equality."[78] This text reflects anxieties voiced much earlier. Burke had argued that the Revolution threatened to invade England and would thus destroy social order, while Barruel positioned the economic and physical vulnerability of religious refugees on British soil as evidence further backing such claims. As the British government, the Church of England, and English Catholics grappled with the task of providing the necessary social aid that destitute French émigrés required, Barruel's text reassured readers that their corporate and individual efforts to aid refugees were not misguided but necessary to the survival of Christianity itself.

Although the reviews registered a distrust of tales imported by the French about the French, the actual presence of refugees, including Barruel himself, testified to the truth of such narratives and the ongoing cultural impact of the French Catholic diaspora in England. Smollett asserts that Barruel's text "cannot fail of being interesting and particularly to us of this island, who have before our eyes so many of the unfortunate victims to the new order of things" and that the work "has been much read here, especially by the friends of the royalist party." In the *Gentleman's Magazine*, the reviewer describes clerical émigrés as "innocent" and "exposed to a thousand dangers and hardships" in their journey "to the ports and frontiers, seeking, over mountains and through storms, some hospitable region to shelter." In these reviews, Barruel's writing is notable because it is not "affected" but "affecting"; in the *Gentleman's Magazine,* Barruel's narrative is "sublimely pathetic"; Smollett writes that "there is a lively and feeling description of the humane reception the banished priests met with in this country, which certainly deserves the praise of having acted on this occasion the part of the good Samaritan."[79] Self-congratulatory in its finale, Smollett's review suggests that the nation's benevolent reception of French émigrés has made possible their current political and literary contributions. Likewise, Barruel also praises the British nation for its "sound policy" and its people who are "without pride . . . active, calm, serene, and collected," as well as "peaceable, unsuspecting and secure."[80]

Barruel's flattery of the British nation and its people moves beyond mere abstract compliments, detailing the reception of French émigrés from their perspective: "by my own experience, and by that of my fellow exiles," the arrival "into the peaceful abode of personal security under a legal government" has produced "exquisite sensations." Barruel goes even further, attesting that "when no interpreter could be found," British spectators expressed sympathy through tears and gestures. Support does not end here. Barruel expresses amazement that "every vessel that arrived with a cargo of these exiles, seemed to have been foreseen by the English through an instinct of benevolence. They flocked to the landing place to offer us lodging or refreshments." Barruel's 20 pages detailing the various sources of aid offered to the refugees, including the Wilmot Committee, reinforce for British readers a sense of patriotic comraderie that extends across class, religious, and ethnic lines. "The English clergy, the peers, the commoners have all contributed to lodge, to feed, to cloth these unfortunate colonists,"

76 *Spoiled Economies and Violated Virgins*

Barruel observes. Several pages later he asserts that members from a variety of professions and social classes actively aided the refugees, including "a green-grocer," a "semstress" [sic], doctors, milkmen, and schoolboys."[81]

Not until the final pages of his tribute to British generosity does Barruel discuss the reception of the first community of nuns in England, the Benedictines of Montargis. Rapley observes that most church histories have been "overwhelmingly male," a statement generally true of Barruel's history as well: "suddenly, in a discussion about men and their problems, women are included."[82] British journalism and travel writing do, however, show a simultaneous interest in nuns, their experiences of Revolution and migration, and their successes and struggles within local communities.

Refugee Nuns in Transition: Ann Radcliffe, the British Press, and the French Benedictines of Montargis

Commentary on migrating women religious is found in a variety of genres in the 1790s, including travel narratives, the British press, poetry, and works such as Barruel's *History of the Clergy*. Writers, far from invested in the Catholic cause, also noted the ways in which women's religious communities were stripped of their resources and left literally stranded. Radcliffe, who was returning from Holland in 1794, encountered several groups of nuns displaced from their convents, seeking temporary refuge in Dutch towns.[83] In Nimeguen, Radcliffe sighted nuns subsisting on a boat in the city's port and attracting considerable notice from spectators:

> [T]he company in all were objects of curiousity to the Dutch, being no less than the sisterhood of several Flemish convents, in their proper dresses, and under the care of their respective abbesses. These ladies had been thus situated, for several days and nights, which they had passed on board their vessels. They were attended by their usual servants, and remained together, without going on shore, being in expectation, as we were told, of invitations to suitable residences in Germany.

Far from employing gothic stereotypes, Radcliffe was concerned with the altered position of these very real nuns: "We could not learn, as we wished, that they had brought away many effects. Their plate it was needless to enquire about; the contributions of the preceding spring had no doubt swallowed up that."[84] Indeed, contemporary accounts concur that the French army, as it advanced from France into the Netherlands, was responsible for lifting silver and other valuables from convents as religious orders were discharged from their communities. An English Carmelite nun in Hoogstraten wrote to her brother that upon the approach of the French Army, the confessor of the nuns managed to protect some of their valuables by means of bribery. In other cases, treasured objects were removed and hidden by the nuns before the approach of the army. Getting caught could result in death, as was the case for the Bragelongne sisters of the Argenteuil Ursulines:

they were found with "incendiary" literature, as well as silver and linens from their convent.[85]

Beyond losing the material objects within convents, the loss of the safety of enclosure meant that nuns were increasingly vulnerable, as well as subject to the gaze of spectators.[86] When Radcliffe was in Dort, she encountered more displaced nuns open to public view. Her description takes on an even more pronounced sympathetic tone as she addresses their general loss of fortune and support:

> A little further on . . . was the melancholy reverse of nearly an hundred ladies, driven from some convent in Flanders, now residing . . . in bilanders moored to the bank. . . . [W]e caught as full a view of them as could be had, without disrespect; and saw they still wore their conventual dresses, and were seated, apparently according to their ages, at some sort of needle-work. It might have been censured, a few years since, that mistakes, or deceptions, as to religious duties, should have driven them from the world; but it was certainly now only to be lamented, that any thing short of the gradual and peaceful progress of reason should have expelled them from their retirement.[87]

Although Radcliffe did not endorse female enclosure, she expressed regret at the manner in which these women had been forced into the world. Radcliffe constructs "reason" as "gradual and peaceful progress," not an abrupt and cruel shift. In this manner, Radcliffe critiques the use of Enlightened "reason" to justify invasions that cause harm to individuals. Many French citizens felt the same way, as Aston articulates: "They had been ready enough, as their parents and grandparents before them, to enjoy a joke about monastic lifestyles and cloistered self-indulgence, but such banter was articulated within a familiar social order in the countryside, one whose endurance seemed axiomatic." The result then of the forceful employment of troops to close nunneries without providing nuns adequate support and compensation created fierce resentment among the laity, resentment that would fuel the revitalization of Catholic monastic culture in France in a few years.[88]

While France's convents were emptied, England was playing host to nuns looking for new homes. Not only of interest to travelers, the evacuation of convents and monasteries was also front-page news. As *St James's Chronicle* lamented on the first page of the first September edition of 1792, "The convents at Calais are totally deserted, and converted into receptacles for lumber—the Nuns are pensioned—the Friars turned adrift over the face of the globe!"[89] The month before, French nuns had been forced to evacuate their convents and some of them were en route to England. The September 22, 1792 edition of *Woodfall's Register* documented that in Brighton, "Two Nuns were landed here today among the eight Emigrants, who report that the Nuns in Paris, have leave to come to this country, or liberty given them."[90] In October of 1792, readers of *St James's Chronicle* learned that in Calais, "They have just turned out the Nuns of the Annunciade. They stood their ground as long as possible—the bubble, however, has burst which promised them a clear continuance, and the people are going through the apartments." Stories

78 *Spoiled Economies and Violated Virgins*

of resistance followed by plunder and dispersal created a melancholy scene of "nuns . . . all departing," where nuns were both victims and heroes, enabling readers to see nuns in more active roles, defending their choices.[91]

Alongside press accounts of confiscated convents, which were used as prisons, storage facilities for lumber and grain, and for housing the sick and wounded, were announcements of British estates being renovated for nuns on their way to or lately arrived in England.[92] The press also lampooned male patrons, suggesting that their attentions towards nuns were motivated by prurient motives. The November 3, 1792 edition of the *World* reported: "Lord Cholmondeley, Earl Grosvenor, Old Q. and Johnny Wilkes, whose actions are ever beaming with benevolence, have provided a permanent settlement for the numerous Nuns who have fled from France to Britain for Safety."[93] Most of the migrating nuns who arrived between 1794 and 1795 were English natives from English convents.[94] In 1795, the *St James's Chronicle* noted: "Amesbury, the seat of the Duke of Queensbury, in Wiltshire, has been formally converted into a Convent; a society of English Nuns from the Continent having leased it of his Grace, at the rent of 300 l. a year." These stories are laced with curiosity so that readers might imagine even English nuns as exotic new neighbors.[95] For example, the *Public Advertiser*, in its September 25, 1792 edition listed "Nuns" as a topic heading, catching the attention of readers interested in nuns' fates: "The last arrival from Dieppe to Brighton, brought several Nuns. The news instantly raised the curiosity of Old Q. He went express to put his gallantry in force!"[96] The Duke of Queensbury was a particular target in the press; as reported in the July 20, 1793 edition of the *Gazetteer*, "enchanted with the beauty of *French Nuns* in the Neighbourhood [of] Richmond," he "does not intend a visit to Scotland this season."[97] In italicizing "French Nuns," the editor emphasizes their religious and national differences, drawing on the more tabloid version of nuns as exotic objects now open to the gaze of the British male patron. Before the Revolution it was necessary to travel to the Continent to view convents or interact with nuns; now, imported into British society, nuns became fodder for journalists and writers.

The first full community of nuns to arrive in Brighton, the French Benedictines of Montargis, received the most extensive news coverage, although references to migrating nuns are peppered throughout newspapers in 1792 and 1793. Perhaps because they were the first intact group of nuns to arrive safely, their sympathetic reception by the British was lauded both in news sources and Barruel's *History of the Clergy*. The prioress's pamphlet had positioned the French authorities as "vampiric" in their dealings with the community and was "one of the most direct public statements of the growing hostility many nuns felt toward the Revolution by 1791," writes Choudhury.[98] The *General Evening Post*, alongside seven other news sources in October 1792, reported on their reception by the British:

> Last Wednesday morning were landed at Black Rock, near Shoreham, from the Prince of Wales packet, Captain Burton, thirty-seven Nuns. They were all from one Convent, and most of them elderly Ladies.

The packet lay some time off Brighton, with a view to land them there, but the roughness of the sea prevented it; and it was no sooner known that they were to land at or near Shoreham, than almost every carriage in Brighton repaired thither to be present at their debarkation, and to assist in conveying them to Brighton.[99]

The front-page news story in the *General Evening Post*, the write-up also appeared in *Woodfall's Register*, *Lloyd's Evening Post*, and the *Star*.[100] Clearly readers wanted to know every detail about these women and the material conditions in which they arrived. *St James's Chronicle* reported: "at the time of their debarkation [they] had only . . . thirty pounds of specie remaining, all the valuables of their Convent having been seized." Receiving "Prince and Mrs. Fitzherbert" who "paid them a very long visit," the nuns were also given "a subscription for their relief" by the King, amounting to £50. Following these women's movements from Brighton to London, the *Public Advertiser* documented that "the thirty-two Nuns that came from Montorges [sic], near Orleans, are at present in two houses in the neighbourhood of Grosvenor Square."[101]

Interestingly, the news coverage did not report that the nuns had not originally intended to settle in England; in fact, they were planning to temporarily lodge with the English Benedictines in Brussels while waiting for the situation in France to change so that they could return to their convent in France. Because the nuns' convent school in France had catered to the English Catholic aristocracy, its members now included women from both France and the British Isles, including both the sister and cousin of Lady Frances Jerningham. As the group's history in England makes clear, these connections enabled their successful emigration in spite of the difficulties of finding proper accommodations, dealing with locals, and recouping financially after their multiple losses.

Catherine Dillon, known as Sister François in religious life and the youngest sister of Lady Jerningham, had been sent ahead in 1792 to prepare the way for the entire community in Brussels, first arriving in England with three nuns, visiting family and the Catholic companion of the Prince of Wales, Mrs Fitzherbert, who became a "constant benefactor" to the group, and then sailing on to Belgium. The rest of the nuns, prior to their London arrival, had been "lodging uncomfortably" with the English Poor Clares at Rouen, awaiting word that the Benedictines in Brussels were ready for them.[102] The sources of discomfort for the second party of Benedictines may have included cramped living quarters or internal dissension, though the *Public Advertiser* reported that "by order of the Convention," the abbess of the Poor Clares, had altogether "refused to admit them into her Convent."[103] This example illuminates the ways in which rumor and fact could easily comingle in news reports. The historical record indicates that the two groups lived together, if only for a short period. Forced or asked to move out of the convent in Rouen, this second Benedictine cohort traveled on to England, initially relying on the support given to

80 *Spoiled Economies and Violated Virgins*

them by the open-handed generosity of the Prince of Wales and Mrs Fitzherbert. The prioress was duly convinced that they were safer in England since France would likely invade Austrian Flanders.[104] At least as independent as the prioress herself, Sr. François initially refused to return from Belgium to England, believing that "the project of settling a monastic community in England was unrealistic." However, with the sympathy of British nobility, the women had advantages in England from the start. Later, when the Princesse de Condé, sister of the last Duc de Bourbon, lived as a lady boarder with the community from 1805 to 1814, the status of the establishment was once again elevated.[105]

Just as news coverage portrays an ideal reception of refugee French nuns, Barruel's account of the arrival of the French Benedictines of Montargis underscores England's benevolence towards the group after its conflicts with the French government:

> Faithful to their God, to their vows, they set at defiance the projects of the legislature, the threats of the Jacobins, the delusive arts of the apostates, and the dangers of a long journey. At their head was their superior, Madam Levis de Merepoix. . . . England proved that virtue and piety oppressed will ever have a claim on her benevolence. The Prince of Wales was at Brighton when these fugitive virgins arrived. His Royal Highness's clemency and bounty were the first pledge of the protection they were to meet with in their retreat. Englishmen admired their courage and resolution. They were every where treated with the regard which respect inspires; they were every where met with the most generous support. The murmur of prejudice was not heard among the acclamations of beneficence. They found a peaceable retreat.[106]

While Barruel's work was not available in French until 1793 and in English until 1794, well after the arrival of these "fugitive virgins," his depiction reframed more popular notions of their victimization, portraying them as defiant towards revolutionary dictates and courageous in their determination. Because they had mechanisms of assistance in place upon their arrival, the French Benedictines experienced a "soft landing," according to Dominic Aidan Bellenger.[107] However, as the first visible émigré community of nuns in England, their story could be used to support a variety of representations of nuns. By turns, they were constructed as French, elderly, noble, courageous, and victimized.[108]

As forerunners of multiple communities of nuns, which would relocate to England in the next few years, the Benedictines of Montargis drew the attention of writers, spectators, the nobility, and journalists, eager to follow them as they set up new lives for themselves. Though neither Barruel nor the popular press acknowledged the extensive British networks vital to their survival or the English nuns within the community, writings about them influenced public opinion, recasting nuns as both heroines and victims of France's destructive political regime. Upon their arrival, the press downplayed the French Benedictines' connections in England, focusing instead on these women as French refugees in need

Spoiled Economies and Violated Virgins 81

of direct assistance. Although Benis observes that discourses "of and about the émigrés grappled with [their] multiple identities,"[109] in media coverage about the Benedictines of Montargis, the community's French identity occludes from view its English members and the British connections important to their successful transplantation.

British newspapers traced the Benedictines' movements within England and praised mostly male benefactors, setting forth a model of paternal reception and immediate aid for future refugee nuns. Press releases constructed them as elegant old women who retained a tenacious hold on tradition. After their sojourns through Brighton and London, the nuns settled in Bodney Hall, a "surprisingly Catholic quarter" of Norfolk, which would become their home for 19 years. This update was relayed by the press in tones of delicate assurance. For example, the July 21, 1793 edition of the *Observer* stated that "Rodney [sic] Hall has been appropriated by the noble owner for the reception of refugee nuns from France, where they meet an honourable and elegant asylum." One of the community's English members had obtained Bodney Hall from her nephew, Lord Tasburgh,[110] making media depictions of their national origins misleading. Their movements had been traced earlier in the *Public Advertiser* on February 14, 1793, several months after their arrival the year before: "The French Ladies, Nuns from Mortarges [sic], near Orleans, have quitted their houses in Duke-street, and are now at a large house in the neighbourhood of Thetford, Tom Paine's natal place; they are treated by the Corporation and the gentlemen of the neighbourhood with that respect and humanity to which their situation and their calamities entitle them."[111] Though Paine's *Rights of Man* articulated the principles behind both the American and French Revolutions, nuns and their supporters used the rhetoric of "rights" to argue on behalf of women religious and their freely chosen communal structure. That the Benedictines of Montargis have finally had their rights restored in England signals the appropriate placement of their residence near the birthplace of Paine.

Yet the Benedictines of Montargis also contended with "local resistance" from Thetford, whose mayor argued against their move to Norfolk to the Secretary for the Home Department, Henry Dundas. The mayor was responding to the concerns of Lord Petre, a prominent Catholic living nearby Bodney Hall, who thought that the arrival of the nuns would only further raise the profile of Catholics in the area. Dundas allowed the nuns to settle in Norfolk and they were quickly greeted by Lord Petre who, in spite of his fears, "behaved very kindly to the ladies." Supported by both Protestant and Catholic benefactors, the nuns focused on recruiting students to their school, and catering to British and Irish children, including Lady Charlotte Bedingfeld's daughter, Matilda. By 1806, five of Lady Jerningham's granddaughters were at Bodney Hall.[112] Between 1793 and 1811, at which time the nuns left Bodney Hall, they had admitted some 166 students.[113]

Their losses were also great. During their 19 years at Bodney Hall, they buried 18 nuns, including Sr. François on May 23, 1797. Lady Bedingfeld, the daughter of Lady Jerningham, wrote to the poet Matilda Betham about her late aunt: "the misfortunes of France, [had] thrown her back (though unwillingly) to her native

82 *Spoiled Economies and Violated Virgins*

land."[114] A poet with ties to Mary and Charles Lamb, as well as Samuel Taylor Coleridge, Betham displayed a "notable antiquarian and historical bent." Her first collection of poetry, *Elegies and Other Poems* (1797) was dedicated to Lady Jerningham with "wishes" that she "may long, very long, continue to bless your family, to adorn your rank, and console the unhappy," the latter a reference to Lady Jerningham's work on behalf of religious refugees. "To The Nuns at Bodney," a discreetly positioned poem near the end of the collection, memorialized Sr. François, Catherine Dillon.[115]

In the poem, Betham recounts the nuns' escape from France, approaching their story as a tourist gazing upon an endangered species. Betham begins by distinguishing herself as a "Stranger" to these "holy women," even as she shares their "zeal": "Which warm'd your bosoms in Religion's cause./When impious men commanded you to break/The vow which bound your souls, and which in youth/Warm Piety's emphatic lips had made" (4–8). Drawing on stories of "impious men," who perpetrate the "ungentlemanly acts" discussed by Barruel, Betham also suggests that religious profession is an "emphatic" choice because young women make it. While an implicit critique of young women taking lifelong vows peppers British writing on nuns, Betham shifts the focus to "Ambition's scowling eye" that forces "meek-ey'd Quiet quit her last abode/Ere he can pause to look upon the wreck,/And rue the wild impatience of his hand" (25–8). Male violence forces "Quiet" from her conventual safety into the rough terrain of migration and forced repatriation.

The poet asks permission to "shed a tear" on Sr. François' grave, in tones reminiscent of Thomas Gray's "Elegy Written in a Country Churchyard." In this, Betham follows Bedingfeld's lead, integrating the unsung hero motif to draw attention to the death of a noble woman who chose obscurity. Bedingfeld's letter to Betham exclaims: "I could have stood for hours musing over these simple memorials of those who were born to riches and grandeur, but who preferred a life of meek retirement, and now sleep in peace under the green sod surrounded by lowly peasants. 'How the rank grass waves o'er the cheerless ground."[116] Like Bedingfeld, Betham reworks Gray's trope to emphasize the family name: "No marble monument to speak her praise,/And tell the world that here a DILLON rests" (18–19). On the one hand, Betham flatters Lady Jerningham by drawing attention to her family in the poem. On the other, she suggests that Dillon's grave, since unmarked, relies upon the poet's elegy to signal the location of this "majestic" woman's place of rest.

Although the poem suggests Dillon's legacy is in some danger of dropping out of the cultural memory, obituaries suggest differently. Unlike the media coverage in 1792 and 1793, in which the group's British members and relations were invisible, the earliest of Dillon's obituaries makes no reference at all to the Benedictine order or to her professed name, calling attention to her British noble connections entirely. She is described as having died, "A few days since, at Bodney Hall, in Norfolk, the Hon. Mrs Catherine Dillon, sister to the present Viscount Dillon, of Ireland," in both the *Morning Post* and the *London Packet* obituary notices. Indeed, "Bodney Hall" remains the only clue for readers who are outside of family and

Spoiled Economies and Violated Virgins 83

religious networks in identifying Dillon's position within a religious community. The *Evening Mail*'s notice uses more detail, resembling in some ways Betham's elegy. Repeating the same information as above, the rest of the obituary reads:

> This Lady, though born with beauty, and endowed with many accomplishments and talents, secluded herself at a very early age from the world, wishing at her entry into life to prepare for the moment she has now passed. She dwelt in a Monastery at Montargis, till the unhappy Revolution in France compelled her to return in 1793. She has since resided in Norfolk with the original companions of her retreat, and has been an example to the few who were acquainted with her of what true Philosophy is capable—that Philosophy which has Religion for its foundation, and which is alone the science of wisdom.[117]

Couching "true Philosophy" within "Religion" cleverly distracts attention away from Dillon's Catholic and French leanings, bringing her point of view in line with the reader's. Shared politics squelch religious confrontations here, similarly to the reviews of Barruel's *History of the Clergy*. In both, the "unhappy Revolution" is responsible for the disruption of religious communities; "compelled to return," Dillon's repatriation is not a personal choice but a forced removal.

England's role in providing safe asylum to nuns extends even unto death. Betham's final lines emphasize, similarly to the obituary above, the nuns' resistance in returning to England. Betham encourages the wandering "stranger" to feel pride "Whene'er he hears the tale," not of the nuns rebuilding their lives at Bodney Hall, but "[t]hat England's hospitable land should yield/All that you could accept, *an humble grave*" (33–6). Betham's finale praises her country's hospitality, while ironically conceding that Dillon's repatriation also signals her demise. That the earth is "All that you could accept" speaks to Sr. François's stubbornness, her attempts to lead the community on to Belgium, her initial refusal to reroute her entourage to England, and her final surrender in the end. Yet she would not be the only nun in the group to resist change. Thomas Penswick, Vicar Apostolic, visited the Benedictines in their next home in Orrel Mount, near Wigan, and observed that "although they had now been away from Montargis for many years, they still seemed to look upon themselves as birds of passage." They maintained many aspects of their French heritage throughout the nineteenth century, including the election of French prioresses, direction by French priests, and the use of French in the convent's annals, daily life, and liturgies.[118] The community finally settled at St Mary's Priory in Fernham, Oxfordshire in 1966, though due to low numbers they began dispersing in the early 2000s. In spite of the losses the women sustained during their first 20 years in England, the community remained more robust than smaller groups such as the English Blue Nuns who were also supported by Lady Jerningham. As the story of the Blue Nuns reveals, surviving and adapting to British culture was a challenge not only for French communities, but also English groups coming "home" after working abroad for nearly two centuries.

84 *Spoiled Economies and Violated Virgins*

Notes

1 Pierre d'Hesmivy d'Auribeau, *Extraits de quelques écrits de l'auteur des Mémoires pour servir à la histoire de la persécution françoise* (1814), p. 270. I want to thank Jayne Ritchie Boisvert for her translation of the prioress's statement.

2 Dominic Aidan Bellenger, "The French Revolution and the Religious Orders. Three Communities 1789–1815," *Downside Review*, 98/330 (1980): pp. 34–5; Carmen M. Mangion, *Contested Identities: Catholic Women Religious in Nineteenth-Century England and Wales* (New York, 2008), p. 33. The Prince even sent his own doctor to care for the women. Elphege Hind, "Princethorpe Priory," *Ampleforth Journal*, 11 (1905): pp. 192–204.

3 Edmund Burke, "The Case of the Suffering Clergy of France," *Evening Mail*, September 17–19, 1792, p.1. For further discussion on Burke's criticism of monastic dissolution in France, see Derek Beales, "Edmund Burke and the Monasteries of France," *Historical Journal*, 48/2 (2005): pp. 415–36.

4 Nigel Aston, *Religion and Revolution in France 1780–1804* (Washington, D.C., 2000), p. 183; Mita Choudhury, *Convents and Nuns In Eighteenth-Century French Politics and Culture* (Ithaca, 2004), p. 170.

5 Abbé Augustin Barruel, *Histoire du clergé pendant la Révolution françoise; oubrage dédié à la nation angloise* (3 vols, London, 1793); *The History of the Clergy During the French Revolution* (3 vols, London, 1794). From here on footnotes will refer to the English edition. For references to the significance of Barruel's work see Hannah Adams, *A History of Religion in Two Parts* (2 vols, Boston, 1801), vol. 1, p. 359; *A Complete History of the Invasions of England* (London, 1801), pp. 87–94; Charles Buck, *A Theological Dictionary* (Philadelphia, 1818), p. 83; Bela Bates Edwards and George Palmer Tyler, *An Encyclopedia of Religious Knowledge*, ed. John Newton Brown (Brattleboro, 1844), p. 368.

6 Gemma Betros, "Liberty, Citizenship and the Suppression of Female Religious Communities in France, 1789–90," *Women's History Review*, 18/2 (2006): p. 315.

7 Elizabeth Rapley and Robert Rapley, "An Image of Religious Women in the *Ancien Régime*: The *Etats de religieuses* of 1790–91," *French History*, 11 (Fall 1997): p. 398; Elizabeth Rapley, *A Social History of the Cloister: Daily Life in the Teaching Monasteries of the Old Regime* (Montreal, 2001), p. 81. Aston, for example, pays little attention to women's monastic groups although he credits French women with the re-catholicization of France after the Revolution. Aston, *Religion and Revolution in France*, pp. 286–7, 350–51.

8 John Lough, *The Encyclopédie in Eighteenth-Century England* (Newcastle upon Tyne, 1970), pp. 3, 13–23; *The Encyclopédie of Diderot and D'Alembert: Selected Articles*, ed. John Lough (Cambridge, 1954), p. 175.

9 Rapley clarifies that "populationist" arguments came into currency during the administration of the royal minister Colbert in the 1660s and responded to concerns about the lack of available options—beyond religious profession—for younger sons and daughters, which would preserve their procreative potential. Rapley, *The Lord as Their Portion: The Story of the Religious Orders and How They Shaped Our World* (Cambridge, 2011), p. 214.

10 Rapley, *A Social History of the Cloister*, p. 80–82.

11 Barbara Woshinsky, *Imagining Women's Conventual Spaces in France, 1600–1800* (Aldershot, 2010), p. xiv. Woshinsky discusses a community of Poor Clares in Paris whose living arrangements "upset my preconceived ideas" about conventual space, p. xii.

12 Rapley, *A Social History of the Cloister*, p. 20. Aston explains that "There was nothing like a large land-owning monastery in the neighborhood to guarantee a persistent anticlerical tradition among French tithe payers, especially if their *curé* was diligently

Spoiled Economies and Violated Virgins 85

going about his duties while living on the breadline." Nigel Aston, *Christianity and Revolutionary Europe c. 1750–1830* (Cambridge, 2002), p. 126.

13 Joseph Addison, *Remarks on Several Parts of Italy, &c. In the Years 1701, 1702, 1703* (Hague, 1718), p. 122.

14 Charles-Louis de Secondat de Montesquieu, *Persian Letters*, trans. C.J. Betts (London, 1993), pp. 211–12.

15 Rapley, *The Lord is Their Portion*, p. 215; Aston, *Religion and Revolution*, pp. 28, 117.

16 Mary Wollstonecraft, *An Historical and Moral View of the Origin and Progress of the French Revolution* (2 vols, London, 1794), vol. 1, pp. 79–80. Furthermore, like other Enlightenment writers, Wollstonecraft does not take into account the ways in which monasteries and convents provided generous support within communities, such as during the harsh winter of 1788–1789, or the concerns of citizens that without the support of monks, they would be in a far more precarious economic situation. See Aston, *Religion and Revolution* p. 136.

17 Aston, *Religion and Revolution*, pp. 10–11.

18 Valerie Traub, *The Renaissance of Lesbianism in Early Modern England* (Cambridge, 2002), p. 181. While Traub is outlining the patriarchal response to women's resistance to heteronormativity in the Renaissance period, her discussion can be applied to women's same-sex religious communities.

19 William Bush, *To Quell the Terror: The Mystery of the Vocation of the Sixteen Carmelites of Compiègne* (Washington, D.C., 1999), pp. 19–30; Choudhury, p. 21.

20 Choudhury, p. 19; Rapley, *A Social History of the Cloister*, p. 151.

21 Rapley, *A Social History of the Cloister*, pp. 165–6. For a study that compares the cost effectiveness of a religious versus a marriage dowry, see Marie-Thérèse Notter, "*Les contrats de dot des religieuses à Blois* (1580–1670)," *Revue Mabillon*, 63 (1991): pp. 241–66. Cited in Rapley, p. 151.

22 Choudhury, pp. 19, 99–100. For example, to curb monastic incomes and keep families from wielding a particular influence upon a community, the amount that could be required for the conventual dowry had been restricted in a 1693 edict by Louis XIV. See François Isambert, *Recueil général des anciennes lois françaises depuis l'an 420 jusqu'à la révolution de 1789* (29 vols, Paris, n.d.), vol. 20, p. 179. For a discussion of forced vocation narratives see Choudhury, pp. 98–128. For women's incarceration in convents, see Rapley, *A Social History of the Cloister*, pp. 248–52.

23 Rapley and Rapley, p. 398.

24 Rapley, *A Social History of the Cloister*, pp. 33, 81; Rapley and Rapley, pp. 392–3.

25 Rapley, *A Social History of the Cloister*, pp. 20–22, 39–48, 81, 93.

26 Rapley, *A Social History of the Cloister*, pp. 23–41; Rapley, *The Lord is Their Portion*, p. 219.

27 Olwen H. Hufton, *Women and the Limits of Citizenship in the French Revolution* (Toronto, 1999), p. 56. Hufton uses Diderot's Suzanne in *La Religieuse* as the emblem of this image of women religious, although Diderot's work was not published until 1796, well after nuns' initial conflicts with authorities.

28 Mangion, p. 33.

29 Terrye Newkirk, "The Mantle of Elijah: The Martyrs of Compiègne as Prophets of Modern Age" (Washington, D.C., 1995).

30 Choudhury, pp. 164–5. Madelyn Gutwirth, "*Citoyens, Citoyennes*: Cultural Regression and the Subversion of Female Citizenship in the French Revolution," in Renée Waldinger, Philip Dawson, and Isser Woloch (eds), *French Revolution and the Meaning of Citizenship* (Westport, CT, 1993), pp. 22–6.

31 Rapley estimates that at the beginning of the Revolution, the convent's *pensionnat*, which included both female students and adult women, provided one-third or more of the convent's total income. Rapley, *A Social History of the Cloister*, p. 254. Pierre

86 *Spoiled Economies and Violated Virgins*

Ambroise François Choderlos de Laclos, *Les Dangerous Liaisons*, trans. and ed. Helen Constantine (London, 2007).

32 Hufton, pp. 57–8; Rapley, *A Social History of the Cloister*, p. 219.

33 Rapley, *A Social History of the Cloister*, pp. 14, 104, 219–20; Rapley and Rapley, pp. 392–3; Aston, *Religion and Revolution*, pp. 22, 46; Choudhury, p. 163; Rapley, *The Lord is Their Portion*, p. 219.

34 Choudhury, pp. 167–8; Betros, pp. 312–13. Betros reminds us that petitions represent a primarily "institutional response to suppression." Though most were written by contemplative nuns, Betros states that they are representative of a variety of women in terms of background, social class, and age.

35 Assumption nuns are quoted in Choudhury, p. 168; Visitandine nun is quoted in H. Daniel-Rops, *The Church in an Age of Revolution, 1789–1870*, trans. John Warrington (London, 1965), p. 7.

36 Betros, p. 315, 317–19; Choudhury, pp. 166–7.

37 Emmet Kennedy, *A Cultural History of the French Revolution* (New Haven, 1989), p. 149; Choudhury, p. 168.

38 Barruel, *History of the Clergy*, vol. 2, p. 59, 112; Aston, *Religion and Revolution*, p. 232.

39 Choudhury, p. 176. *Discours de Madame de Lévi de Mirepoix, abbesse des religieuses bénédictines de Montargis, âgée de vingt-sept ans; en réponse aux officiers du district de cette ville, entrant par force dans sa maison* (1791).

40 Margaret J. Mason, "Nuns of the Jerningham Letters: The Hon. Catherine Dillon (1752–1787) and Anne Nevill (1754–1824), Benedictines at Bodney Hall," *Recusant History*, 23/1 (1996): p. 37. The group, derived from the Benedictines of Montmartre in Paris in 1630, boasted a "tradition of independence," refusing to comply with the system of *commende* in which the Crown appointed abbesses rather than the community. Dominic Aidan Bellenger, *The French Exiled Clergy* (Bath, 1986), p. 90.

41 Mangion, p. 33.

42 William Fanning, "Augustin Barruel," *The Catholic Encyclopedia* (2 vols, New York, 1907), vol. 2. Retrieved 29 July 2014. For more on Barruel's biography, see Fernand Baldensperger, *Le Mouvement des idées dans l'émigration française, 1789–1815* (2 vols, Paris, 1924), vol. 2, pp. 19–24; Michel Riquet, "*Un Jesuit Franc-Maçon, historien du jacobinisme*," *Archivum Historicum Societatis Iesu*, 43 (1974): pp. 157–61; Christian Lagrave, "*La Vie et l'oeuvre du R.P. Augustin Barruel de la Compagnie de Jésus*," in Barruel's *Mémoires pour servir à l'histoire du jacobinisme* (4 vols, Vouille, 1973), vol. 1, pp. 9–25.

43 Walter Edwin Peck, "Shelley and the Abbé Barruel," *PMLA* 36/3 (Sep., 1921): pp. 347–53. Barruel, *Memoirs, Illustrating the History of Jacobinism* (4 vols, London, 1797–1798).

44 Amos Hofman, "Opinion, Illusion, and the Illusion of Opinion: Barruel's Theory of Conspiracy," *Eighteenth-Century Studies*, 27/1 (Fall, 1993): pp. 28–9. See also J.M. Roberts, *The Mythology of the Secret Societies*, 2nd edn (St Albans, 1974), pp. 199–213; Bernard N. Schilling, *Conservative England and the Case Against Voltaire* (New York, 1950), pp. 227–31.

45 David Simpson, *Romanticism, Nationalism, and the Revolt Against Theory* (Chicago, 1993), p. 88–9.

46 Barruel's *History of the Clergy* would become an authoritative "history" of these events in the nineteenth century, as the work is referred to in multiple nineteenth-century political and historical works on the French Revolution. See footnote 5, above. In 1794, Barruel also published a shortened commentary on the work, *Abstract of the History of the Clergy During the Revolution* (London, 1794). For more on the impact of *History of the Clergy* on emigrant ecclesiastical circles, see Bellenger, *French Exiled Clergy*, pp. 112–13.

Spoiled Economies and Violated Virgins 87

47 As Bellenger asserts, Barruel "reflected and strengthened the French exiled clergy's belief that they were the 'faithful remnant' of a dislocated society whose vocation was to proclaim the old ways as the true ways." *French Exiled Clergy*, p. 113.

48 For works on migration and Romantic diasporas, see Kirsty Carpenter, *Refugees of the French Revolution: Emigrés in London, 1789–1802* (New York, 1999); Toby Benis, *Romantic Diasporas: French Emigrés, British Convicts, and Jews* (New York, 2009); Michael Wiley, *Romantic Migrations: Local, National, and Transnational Dispositions* (New York, 2008).

49 Aston, *Religion and Revolution in France*, pp. 194–5; Kirsty Carpenter, "London: Capital of Emigration," in Kirsty Carpenter and Philip Mansel (eds), *The French Emigrés in Europe and the Struggle against Revolution, 1789–1814* (New York, 1999), p. 60.

50 Dominic Aidan Bellenger, 'Fearless Resting Place': the Exiled French Clergy in Great Britain, 1789–1815," in Kirsty Carpenter and Philip Mansel (eds), *The French Emigrés in Europe and the Struggle against Revolution, 1789–1814* (New York, 1999), pp. 214–15; Barruel, *History of the Clergy*, vol.1, pp. iii–iv. Bellenger states that "as many as 7,000 at one time or another, were in the holy orders of the Roman Catholic Church," in *French Exiled Clergy*, p. 1. Barruel gives a more exaggerated figure, citing the arrival of eight thousand refugees by 1792 in *History of the Clergy*, vol. 3, p. 233.

51 Barruel, *History of the Clergy*, vol. 1, pp. iii–iv.

52 Barruel, *History of the Clergy*, vol. 1, pp. iv, vii.

53 Kennedy, p. 146; Rapley, *A Social History of the Cloister*, p. 19; Aston, *Religion and Revolution in France*, p. 10.

54 Aston, *Religion and Revolution in France*, pp. 127, 133; Mangion, p. 33.

55 Barruel, *History of the Clergy*, vol. 1, p. 29.

56 Burke, *Reflections on the Revolution in France*, 5th ed. (London, 1790), p. 157. "Rapine" is used multiple times in Burke's text to describe the Catholic clergy's loss of their property, pp. 157, 171, 174, 350.

57 *London Chronicle*, August 11–14, 1792, p. 4.

58 Elizabeth Rapley, *The Dévotes: Women and Church in Seventeenth-Century Convents* (Montreal, 1990), p. 39; Woshinsky, p. 4 n. 12; Hufton, p. 56.

59 Barruel, *History of the Clergy*, vol. 1, pp. 29, 25, 24.

60 Barruel, *Abstract*, p. 22.

61 Barruel, *History of the Clergy*, vol. 3, p. 20.

62 An English Carmelite from Hoogstraten wrote about this tactic in a letter to her brother, Bishop Douglas. See Bernard Ward, *The Dawn of the Catholic Revival in England, 1791–1803* (2 vols, London, 1909), vol. 2, p. 87.

63 Barruel, *History of the Clergy*, vol. 2, p. 52.

64 Choudhury, pp. 171–2. The French Carmelites of Compiégne was one community that took the Liberty-Equality oath of 1792. The nuns nonetheless were guillotined on July 1794. Choudhury, p. 178. Aston discusses the opposition expressed by wives and mothers to constitutional priests which led to criticisms against women's supposed usurpation of authority within the family; *Religion and Revolution in France*, p. 207.

65 Barruel, *History of the Clergy*, vol. 2, p. 59.

66 Mary Jacobus, "Incorruptible Milk: Breast-Feeding and the French Revolution," in Sara E. Melzer and Leslie W. Rabine (eds), *Rebel Daughters: Women and the French Revolution* (New York, 1992), pp. 63, 74, n. 33; Michelle Vovelle, *La Révolution Française: Images et Récit 1789–1799* (5 vols, Paris, 1986), vol. 2, p. 268, fig. 4.

67 Choudhury, p. 172–3; Barruel, *History of the Clergy*, vol. 2, p. 52.

68 Hufton, pp. 73–8; Barruel, *History of the Clergy*, vol. 1, pp. 29–30.

69 Hufton, p. 57; Aston, *Religion and Revolution in France*, pp. 136–7. Cholvy dispels the myth that nuns wished to marry; only 0.6 percent of all nuns did so (318 out of 55,000). Gérard Cholvy, "Revolution and the Church: Breaks and Continuity," *Concilium*, 201/1 (1989): p. 53.

88 *Spoiled Economies and Violated Virgins*

70 For more on this topic, see Hufton, p. 71; Barruel, *History of the Clergy*, vol. 3, pp. 200–202.

71 Aston, *Christianity and Revolutionary Europe*, pp. 220, 209; Aston, *Religion and Revolution in France*, p. 183.

72 Barruel, *History of the Clergy*, vol. 1, p. 89.

73 Choudhury, p. 170.

74 Ann Radcliffe, *A Journey Made in the Summer of 1794 through Holland to the Western Frontier of Germany* (2 vols, London, 1795), vol. 1, p. 140. All citations are taken from this edition.

75 *Critical Review*, ed. Tobias Smollett, 16 (1796): p. 60; *Analytical Review*, ed. Thomas Christie, 18 (1794): p. 513; *Monthly Review or Literary Journal*, eds Ralph and G.E. Griffiths, 14 (1794): pp. 458–9; *New Annual Register*, eds Andrew Kippis and William Godwin, 15 (1795): p. 222.

76 *Monthly Review or Literary Journal*, 14 (1794): p. 459; *Critical Review*, 16 (1796): p. 61.

77 *British Critic and Quarterly Theological Review*, 5 (1795): pp. 471–2.

78 *A Complete History of the Invasions of England* (London, 1801), p. 201.

79 *Gentleman's Magazine and Historical Chronicle*, ed. Sylvanus Urban, 64/1 (1794): pp. 244–6. *Critical Review*, 16 (1796): pp. 60–61, 66.

80 Barruel, *History of the Clergy*, vol. 3, p. 215.

81 Barruel, *History of the Clergy*, vol. 3, pp. 218, 212–13.

82 Rapley, *A Social History of the Cloister*, p. 81.

83 Radcliffe's account indicates that she did not directly communicate with the nuns she saw although she may have gained information from other bystanders. Ward describes the migration of English communities from the Netherlands to coastal towns and finally to the English Channel. See vol. 2, pp. 86–94, for English nuns' movements from their convents in Holland to England.

84 Radcliffe, vol. 2, pp. 139–40.

85 Ward, vol. 2, pp. 87–9; Choudhury, pp. 176–7.

86 Woshinsky discusses enclosure as a means for women to experience freedom "from the male gaze and male control," even while remaining "penetrable" to other men such as priests and confessors. See pp. 2, 17. Certainly, without protection, nuns outside of enclosure were far more physically vulnerable.

87 Radcliffe, vol. 2, pp. 155–6.

88 Aston, *Christianity and Revolutionary Europe,* p. 284. Laywomen, in particular, were central in resisting the de-Christianization of their parishes, harboring clergy, teaching children the Bible and lives of the Saints, hiding sacred objects, and even performing services themselves. Aston, p. 244.

89 *St James's Chronicle*, September 1–4, 1792, p. 1.

90 *Diary or Woodfall's Register*, September 22, 1792, p. 2.

91 *St James's Chronicle*, October 9–11, 1792, p. 1; *World*, September 27, 1792, p. 1, reports that the "nuns are all departing" the Ostrobert convent in Montreuil.

92 For coverage on the military or government use of convents see *St James's Chronicle*, September 1–4, 1792, p. 1; *St James's Chronicle*, August 28–30, 1792, p. 3; *Public Advertiser*, February 13, 1790, p. 6. Woshinsky discusses the multiple uses of convents during the Revolution, including prisons, police headquarters, public assemblies, barracks, hospitals, and granaries. Other buildings were sold at auction to raise funds for the government. See p. 291.

93 *World*, November 3, 1792, p. 2.

94 Only a handful of French communities arrived, including the French Benedictines of Montargis, the Bernardines of Douay in 1795, and the Salesians and Hospitalières of Cambrai. Mangion, p. 35. See Dominic Aidan Bellenger, "France and England: The English Female Religious Reformation to World War," in Frank Tallett and Nicholas Atkin (eds), *Catholicism in Britain and France Since 1789* (London, 1996), p. 6.

Spoiled Economies and Violated Virgins 89

95 *St James's Chronicle,* December 26–29, 1795, p. 1; Bellenger, "France and England," p. 6.
96 *Public Advertiser,* September 25, 1792, p. 2.
97 *Gazetteer,* July 20, 1793, p. 3.
98 Choudhury, p. 176.
99 *General Evening Post,* October 23–25, 1792, p. 1
100 *Woodfall's Register,* October 25, 1792, p. 2; *Star,* October 25, 1792, p. 4; *Lloyd's Evening Post,* October 29–31, 1792, p. 424.
101 *St James's Chronicle,* October 30–November 1, 1792, p. 3. The same story is reported in the *London Chronicle,* October 30–November 1, 1792, p. 417; and the *Gazetteer* and *New Daily Advertiser,* October 31, 1792, p. 2. The news articles state that the community received £100. Carpenter states that they received 20 guineas from the Wilmot Committee. Later, they agreed to £35 per month until their school had more students. Carpenter, *Refugees of the French Revolution,* p. 214. Other sources state that the women received an immediate £50 from the Prince of Wales alongside other assistance from locals. See Bellenger, *French Exiled Clergy,* p. 91; George Frederick Leigh, "The French Clergy Exiles in England, A.D. 1792–1797," *National Review,* 12/69 (London, 1888): p. 358.
102 Mason, pp. 34–40. See also Bellenger, *French Exiled Clergy,* pp. 91–2.
103 Mason, p. 38; *Public Advertiser,* November 3, 1792, p. 3.
104 Ward, vol. 2, p. 32.
105 Mason, pp. 34–40, 66.
106 Barruel, *History of the Clergy,* vol. 3, pp. 233–4.
107 Bellenger uses the term "soft landing" to describe the reception of the British Benedictine nuns in Brussels and the French Benedictines of Montargis. Bellenger, "The Brussels Nuns at Winchester 1794–1857," English Benedictine Congregation History Commission Symposium (1999), p. 4.
108 The fact that many migrating nuns were elderly contributed to Burke's construction of them in *The Evening Mail* as victims in need of immediate assistance from multiple sources. Burke, "Case of the Suffering Clergy," p.1. Bellenger's study of the archives of St Mary's Priory, Fernham, reveals that many of the women were elderly. *French Exiled Clergy,* p. 91.
109 Benis, p. 11.
110 Bellenger, *French Exiled Clergy,* p. 91; *Observer,* July 21, 1793, p. 3. The *Morning Post* has a slightly different write-up: "Bodney-hall, in Norfolk, is now completely occupied by Refugee Nuns from France, who have been afforded an asylum in that venerable mansion." *Morning Post,* July 22, 1793, p. 3. Some of the nuns were in Bodney Hall as early as December of 1792. Frideswide Stapleton, *The History of the Benedictines of St Mary's Priory, Princethorpe* (Hinckley, 1930), p. 93.
111 *Public Advertiser,* February 14, 1793, p. 2.
112 Mason, p. 68.
113 Ward, vol. 2, pp. 32–3; Hind, p. 204. They also had encountered local resistance to their settling outside of London under the auspices of Lord Onslow, a Protestant. This plan was abandoned. Mason, pp. 55–6; Bellenger, *French Exiled Clergy,* p. 92.
114 Mason, p. 47.
115 Matilda Betham, *Poems and Elegies,* ed. Donald H. Reiman (New York, 1978), p. v. Betham's "Dedication" and "To the Nuns of Bodney" are found in *Elegies,* pp. v–vii, 116–17. For more on Betham's biography, see Reiman's "Introduction," pp. v–x.
116 Mason, p. 47.
117 *Morning Post and Fashionable World,* June 2, 1797, p. 4; *London Packet or New Lloyd's Evening Post,* May 26–29, 1797; *Evening Mail,* May 3–June 2, 1797.
118 Bellenger, *French Exiled Clergy,* pp. 92–3.

3 Resistant Virtue in Flight
The Blue Nuns, Helen Maria Williams, and Reluctant Returns

> And she, the cloistered virgin, forced to fly
> The fatal blaze of Irreligion's eye,
> Forced unprotected amidst foes to roam,
> Profaned her altars, and laid waste her home,
> Here finds, her weary wakeful wanderings o'er,
> A sure asylum from destructive power . . .
>
> Amelia Opie, "Lines for the Album at Cossey," 1802

In the "cold month of January 1800," as recorded in the community diary of the order of the Immaculate Conception of our Lady at Paris, six women boarded a steamship and sailed for England after a decade of resisting French authorities. Known as the "Blue Nuns" for their distinctive sky blue mantle, the Conceptionists had once boasted a handsome convent, four acres of land in Paris, and an elite boarding school for girls in the eighteenth-century. Reduced significantly in size and strength by the end of the Revolution, the remnant was "forced to fly" the nation that "laid waste to her home," as poet Amelia Opie depicted the situation of the Blue Nuns a few months after their destitute arrival in England in 1800. Yet England would not be a "sure asylum" for the women's "weary wakeful wanderings": in 1805 the final members were dispersing and by 1810 the community was no more.[1]

The story of the Blue Nuns and their struggles in France and England reveal the varied and complex strategies for resistance women religious used to maintain autonomy and agency in the midst of horrific political crises. English nuns, who were leveraging their ambiguous position in Revolutionary France, managed to survive through engaging in political discourse, defying or conforming to stereotypes of nuns, and actively resisting authorities. Although the Blue Nuns did not have the resources to sustain their community upon their return to England, the successes of other repatriated women religious, such as the English Benedictines of Cambrai, highlight the ways in which English nuns negotiated their uncertain position in Britain to their advantage when possible, even though their national identities were not easily categorized and their political views were suspect.[2]

Having embraced an English Catholic diasporic identity on the Continent, English nuns could not always balance their own corporate identities with the

expectations of benefactors and other supporters. Beyond the uncertainty surrounding their political and national alliances, as well as their ethnic origins, migrating nuns did not satisfy the stereotype of young women forced into conventual incarceration seeking freedom in a host country; on the contrary, many nuns were well advanced in age and their appearances bespoke their experiences of imprisonment, hunger, and displacement. Dominic Aidan Bellenger tells us that the English Sepulchrines from Liège were mistaken in York for Frenchmen wearing women's clothes, so strange was their appearance.[3]

Sentimental literary depictions of nuns played a significant though under-explored role in preparing the British public for the reception of migrating religious in the 1790s. Just as nuns were fleeing France in 1793, Helen Maria Williams spent two months of incarceration with the "Blues" (as they were affectionately nicknamed by their Catholic friends), while their convent in Paris was serving as a temporary prison for British nationals. Although her earlier writings demonstrate that Williams supported the illegalization of monastic orders in France, her experience of imprisonment with "English nuns" (she obscured the Blue Nuns' identity), prompted her to write an alternative representation of conventual life. Writing from within the convent, Williams made her struggles—and those of the nuns in France—public in *Letters Containing a Sketch of the Politics of France* (1795).[4] Widely read in England, though criticized for its radicalism, the work engaged readers directly in the plight of refugee nuns during the height of their migrations. Universalizing the harrowing experiences of the 19 English groups that relocated to Britain, Williams's portrait allowed readers to encounter religious refugees, finessing public opinion in their favor when they stood in the greatest need of that public's assistance.

Using the trope of domestic virtue under assault, Williams's nuns are not a kind of exotic species clouded in mystery, but rather British gentlewomen whose sororal community provides a more effective model of social productivity than the violent methods employed by the Revolutionary commissioners. The "English Nuns," as Williams refers to them, are models of benevolent "native" hospitality in their positive reception of British prisoners, although through the course of the narrative they become refugees themselves in need of safe asylum. Yet beyond recuperating nuns primarily for a liberal readership, Williams strikingly links them with all women resisting political tyranny and, in so doing, positions them as icons of women's political agency and heroism. Williams lionizes nuns' resistance to authority and their struggles to retain cohesion in spite of the various intrusive measures undertaken by the Revolutionary army, including forced evacuation, desecration and plundering of sacred spaces, and physical assault. Positioned next to the stories of two well-known French political figures, Madame Roland and Charlotte Corday, the Blue Nuns are left in mid-flight in Williams's narrative, suggesting that they may survive unlike their secular counterparts. Valorizing their Enlightened ethos and collective endeavors in the community, Williams argues that these English Catholic women, although resistant to the Revolution, embody the very principles of the New Republic.

English religious groups were averse to leaving France after working and living there since the seventeenth century. It should not be assumed that English nuns

92 *Resistant Virtue in Flight*

desired to permanently return to a "place of origin," as discussed by post-colonial theorist Avtar Brah: "diasporas are places of long-term, if not permanent, community formations, even if some . . . members move on."[5] The Blue Nuns' refusal to relocate to England until 1799, well after the majority of English nuns' reluctant migrations in 1795, demonstrates their strong resistance to becoming refugees in a non-Catholic country. Bellenger asserts that: "it is impossible to recreate the dislocation and psychological impact of forced repatriation."[6] As the Blue Nuns' *Diary* depicts, the dissolving of women's monastic communities in France augured over a decade of agonizing struggle, as well as the steady attrition of the community to death and defection. Williams could not have known that her quaint portrait of the Blue Nuns during the Terror would become a kind of epitaph, like Opie's "Lines for the Album at Cossey," above, published in 1802 after Opie visited the nuns at their final home in Norwich. "Forced unprotected," the nuns had been assaulted by the "destructive power" of the Jacobin faction. Though the poem suggests that England provided safe cover for the Blue Nuns, it could not, in the end, offer them a viable future.[7]

The preservation of the community's legacy was not left to chance: Lady Frances Jerningham, who almost single-handedly assisted the Blue Nuns upon their arrival, took an active role in not only their welfare, but also their written history. Finalizing the obituary entries in their *Diary*, Jerningham left out evidence of the community's dispersal in 1805, post-dating their demise to 1810 so as to better reflect a legacy of coherence rather than fragmentation.[8] Her efforts indicate the high level of involvement that a benefactor might have in the construction of a community's history and the ways that multiple stakeholders were invested in refugee communities' survival.

In contrast to the outcome of the Blue Nuns, the histories of the English Benedictines of Cambrai and Dunkirk, both in transit in 1795, the year Williams's *Letters Containing a Sketch* was published, reveal a bumpy but ultimately successful transition. The Blue Nuns arrived just months before the Monastic Institutions Bill was proposed in the House of Commons in the summer of 1800, which brought nuns' work in teaching and recruiting novices to national debate.[9] Inserted into this uncertain political climate, the Blue Nuns were at a distinct disadvantage when compared with the English Benedictines who had been growing student bodies in Hammersmith and Woolton as early as 1795.[10] Yet the resourcefulness and regrowth of women's monastic communities in England suggest that worries regarding convents and—worse yet—converts had at least some basis in reality.

English Convents and the French Revolution

The Blue Nuns' history highlights how English communities on the Continent survived apart from their homeland and, in particular, how they negotiated the turmoil of the Revolution. The ambiguous and independent position of English nuns in France inflected their experience of the Terror in unique ways, enabling them to resist political authority—to survive—by employing patriotic discourse,

Resistant Virtue in Flight 93

subverting stereotypes, and conforming to them. English nuns were property owners whose communities were integrated into "existing networks of local lay piety," according to Claire Walker. These convents were affected by the local politics in their "adopted country," as the Benedictines from Dunkirk considered France, as well as the political and religious changes in England as quantitative analyses of their numbers of recruits demonstrate. English convents relied upon support from patrons both abroad and at home, the dowries that women brought with them, and the money that pensioners and boarders paid to the establishment. As part of the English Catholic diaspora, English houses served the interests of the Catholic elite by providing a distinctly "English" space for the education of the next generation.[11]

The history of the Blue Nuns provides insight into the multiple challenges faced by English convents abroad and the ways they were sustained during the seventeenth and eighteenth centuries. Without the ability to support the 48 English nuns of the Third Order of St Francis at Nieuport, Flanders, the community decided to create another branch. They had already discharged three members in 1639, "for the setting up of a Seminary in our native Soyle of England, of Yong Gentlewomen." Over a two-year period (1658–1660), seven professed nuns from that community established themselves in a suitable dwelling in the rue de Charenton, Faubourg St Antoine, Paris, which contained a "fair garden with a pretty little wood." According to Walker, the nuns "relied heavily upon the charity of both English exiles and pious French gentlewomen."[12] The property also boasted a spring that Jane Widdrington, maid of honor to Queen Catherine, paid to have opened up in 1694 with the hope that the mineral properties of the water would provide a source of income for the community, although this plan was never realized.[13]

From the beginning, the Blue Nuns' corporate identity was uniquely Continental. With pressures from the archbishop of Paris to place the group under his jurisdiction, the provincial of the English Franciscans petitioned the Pope to change the community's affiliation from the English Franciscans to that of the Immaculate Conception of our Lady, an order introduced from Spain and Italy into France by Marie Therése, Queen of Louis XIV. The petition was granted. The convent had royal support: Mary of Modena, Queen of James II, awarded it an income of £40 per year in 1687, having already given them 40 *pistoles* in 1673 to pray for her and the conversion of England. She also helped to secure the convent's "letters of establishment" from the *Parlement de Paris*. The nuns opened a school in 1660 but a series of unsuccessful expansion efforts ensued. Meanwhile, the Duchess of Cleveland paid for major alterations in the convent and donated £1,000 for the construction of a new church, placing her daughter, Lady Barbara Fitzroy, in the convent school, a move that served as a powerful recruiting tool for students.[14] The history of the Blue Nuns disrupts preconceived notions of the inviolability of religious enclosure, revealing that various cultural influences moved in and outside of cloistered space. Some members, including Abbess Anne Timperley, even left the convent for months at a time to conduct business, usually recruiting novices and students.[15]

94 *Resistant Virtue in Flight*

The Blue Nuns became increasingly cosmopolitan over the course of the eighteenth century and were, in some ways, more highly integrated into the local community than other English groups. The Blue Nuns received financial support from both the French King and clergy, and admitted French girls into their school.[16] Other benefactors ranged from the English families of Howard and Stafford to a Sorbonne doctor, Monsieur du Vivier, who bequeathed the income from multiple properties to the convent in the early eighteenth century.[17] Relying on female boarders and benefactors after 1690, in 1731 the nuns were "advised by all their friends" to reopen the school, due to their "dwindling state, and the absence of prospect of increase." By 1733, the school was successful. The convent's supporters enabled a sometimes floundering enterprise to survive the economic and political shifts that endangered individual houses throughout the long eighteenth-century. With a public relations team that included the Duchess of Norfolk, the convent took between 15 and 30 students and represented "for English Catholics very much what the *Abbaye-aux-Bois* was for the French Nobility—the most fashionable as well as the best organized place of education for girls"; it really functioned as a short-term "finishing school."[18] Furthermore, Caroline Bowden notes that eighteenth-century English convents in Paris and Bruges provided education and boarding for local elite, not just English students.[19]

While the school went through periods of popularity with British parents, it lost numbers after mid-century to the French Ursulines, whose curriculum in French became fashionable. For example, Lady Jerningham, a former student of the Blue Nuns, sent her daughter Charlotte to the Ursulines but arranged for her to spend some holidays with the Blue Nuns for "a bit of England."[20] Yet with inconsistent numbers of students, professed nuns, and lay sisters, the convent was "frequently in embarrassed circumstances." In passages in the community's *Diary*, there is also evidence of economic disputes and nuns who gained permission to leave the cloister "to take the waters." As Walker reveals, rumors of dissention could prove "fatal" to a convent's ability to recruit students and novices.[21]

The Blue Nuns' experience during the Revolution follows a similar trajectory to that of other English houses and illuminates how English nuns found varied modes of resistance to political authority. Their uncertain status in France and property ownership gave them some advantages; so did their convents' roles as centers of English Catholic piety. For example, Williams informs readers that at the time of her imprisonment in the *Convent Les Anglaises* in November of 1793, English nuns had retained cohesion unlike French nuns who "for more than a year before this period [had] been driven from their retreats."[22] Because they owned their own property and had the support of benefactors and patrons, English nuns were able to maintain themselves longer than contemplative French communities, which had been dispersed by August of 1792.[23] There were around 400 nuns from English convents in France at the onset of the Revolution.[24] Because of their undetermined status in France, English convents were permitted as legal spaces for refractory priests to perform mass through February of 1794.[25] Thus, in some ways, the English Catholic presence in France enabled counter-revolutionary activity to continue, if even on a limited basis.

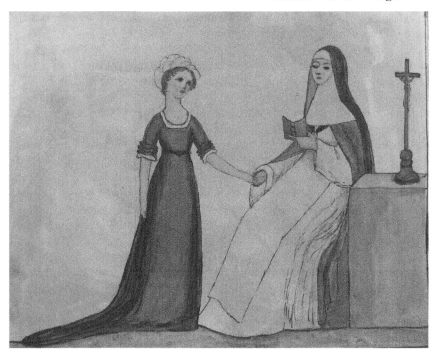

Figure 3.1 A Blue Nun Teaching a Pupil (c. late 18th-c).
Source: Douai Abbey Archives.

Anonymous, *A Blue Nun Teaching a Pupil*, watercolor on paper, late eighteenth century, Douai Abbey, Berkshire.

English nuns, like their French counterparts, manipulated patriotic rhetoric. In 1791, the English Augustinians in Paris defended their estate and position in France by reminding the National Assembly that they had purchased the property with their own money, recruited only English women, and remained economically self-sufficient.[26] Engaging in political discourse at a time when the "very language of rights and liberties was in flux," according to historian Joan Landes, the Blue Nuns wrote to the Convention after their release from imprisonment in 1795: "Our property is not restored; we are despoiled of everything. We have no family and shall have no country if the Republic abandons us . . . Grant us temporary shelter and succour until you have decided whether our property shall be restored. We shall not cease to bless your justice and to cry '*Vive la République Française, vive la Convention Nationale!*'" English nuns advocated for their positions by utilizing Enlightenment rhetoric and professing loyalty to the French nation, even claiming the nation as their country. This strategy worked: the Blue Nuns' petition resulted in the conferral of two francs per nun per day.[27] At first, communities resisted the possibility of relocation and insisted on their right to the government's protection, hoping that their patriotism would continue to secure a subsidy in France for them.

96 *Resistant Virtue in Flight*

According to Mangion, "They relied on their English identities as well as their status as French subjects to meet their objectives."[28]

English nuns were very aware of the possibility of returning to England if dispersed. At the age of 70, Lady Anastasia Stafford, known as Sister Mary Ursula in religious life with the English Benedictines from Cambrai, wrote to her cousin, William Jerningham, in August of 1792 that, "It is hard for me at my age to be abandoned in her own house." Even earlier in September of 1789, Dame Anselma Ann wrote to her nephew in England, Alexander Knight, "if we are turn'd out we may meet at your House. I hope it won't happen and all will end in talk, I have nothing to recommend my self to you but that I can knit & spin, & teach your little ones to read & work, jesting aside I hope we shall not come to it, it would be a long journey for me at my age."[29] With humor and humility, she was considering her situation at 74 years of age and suggesting the possible social contributions she could make to the family. As historian Olwen H. Hufton notes, the average age of French nuns in contemplative houses was older, making "reintegration into society through marriage" unlikely: "all they could hope for was to fill the role of maiden aunt in a brother's dwelling." Unfortunately, Dame Anselma Ann would not return to teach her nieces, expiring in the prison of Compiègne in January of 1794.[30]

The British press, also concerned with the plight of English nuns and their political and economic status, praised the French for their treatment of English nuns in the December 1, 1792 issue of *Woodfall's Register*:

> At Gravelines, and at Dunkirk, the English nuns have been left unmolested in their convents, although all the other religions, of both sexes, have been driven out. Whether this distinction be made on account of their helpless situation as foreigners, or because their monasteries were founded and endowed by Englishmen, I know not. Perhaps it proceeds from a combination of these two motives; but be it as it may, it is honourable to the justice of the French nation.[31]

Yet the situation changed in 1793 after Britain joined the war. Considered a double threat, as both Catholic nuns and British nationals, these "enemy aliens" were either imprisoned in their own convents, which were now under government sequestration, or taken to other prisons. The *London Evening Post* for October 22–24, 1793, reports that with the imminent arrest of British nationals in France (Helen Maria Williams is listed in the article as one such suspect), "The Convents of the English Blue Nuns . . . are by this Decree abolished, notwithstanding they were excepted in the late general one for the suppression of the religious houses."[32] The Benedictines in Cambrai, for example, thought they would be able to stay in their property even after it was seized by the state, but instead were taken to Compiègne in October of 1793, where they were imprisoned alongside sixteen French Carmelite nuns who were executed in 1794.[33] Similarly, the English Augustinians, Benedictines, and Blue Nuns in Paris were put under house arrest in October of 1793, receiving additional prisoners within a month; all three were later put under the same roof

in 1794 at the convent of the Augustinians on the rue des Fossés St Victor. These transfers took a toll on the community: five nuns perished before the group's transfer to the Augustinians' convent and two more deaths quickly followed.[34] The first rush of migrations of English nuns occurred during the uncertainties of 1794. English communities outside of Paris traveled to England, including the Carmelites from Antwerp and Lierre, the Augustinians from Bruges and Louvain, the Benedictines in Ghent and Brussels, the Dominicans from Brussels, the Sepulchrines from Liège, and the Franciscans from Bruges.[35]

During the shift of power from the Jacobins to the French Directory in 1795, English nuns remaining in France were released and allowed to return to or stay in their convents, although they no longer maintained the rights to their property. Rather than risk further losses, the majority of the remaining English nuns returned to England in 1795, including the Benedictines in Paris, Dunkirk, and Cambrai, the Poor Clares in Aire, Dunkirk, Rouen, and Gravelines, and the Carmelites in Hoogstraten.[36] While the Blue Nuns sent three members and a novice to England at this point (only two of whom would rejoin the community in England, albeit temporarily), the rest stayed in Paris. As Anastasia Stafford wrote to her cousin Lady Jerningham in 1795, "The Nation has restored our Town House Rents, and our old rotten houses to us." While they technically retained possession of their property, the convent remained under sequestration until 1799 when the Directory decreed the confiscation of all English establishments in France. Unless nuns had funds to buy the building once more, they had few alternatives. The Blue Nuns' convent was sold at auction to a Mr Gillett from Brussels. As their biographer, Margaret J. Mason, puts it, "Napoleon had returned, and given them passports to England instead of their convent."[37]

At the onset of the Revolution there had been nineteen members. Now, with only six members remaining in France, the Blue Nuns sailed to England in January of 1800.[38] They came to England five years after all but one English community had returned. The women had held out as long as possible in France, conceding perhaps too much to make their transition successful. English nuns had returned reluctantly because they believed that "a vocation was possible only in a Catholic country and that distance from England was an advantage."[39] By the end of 1795, the year Williams's writings on "English nuns" appeared in print, 16 houses of English nuns had migrated to England, destitute and exhausted from their sojourns through war-torn France and with limited means of survival.

Resistant Virtue: Nuns and Other Heroines in Williams's *Letters from France*

While nuns were taking flight from the Continent to England, Helen Maria Williams, a well-known poet in England in the 1780s, positioned herself in the center of Revolutionary drama in Paris in the 1790s, taking on the role of "foreign correspondent" and arguably becoming one of the most prominent international women writers from the period. A prolific writer, as evidenced by her eight-volume series of epistles, collectively referred to as *Letters from France* (1791–1796),

98 *Resistant Virtue in Flight*

Williams was widely read and esteemed by her contemporaries, including the then aspiring poet William Wordsworth, who reported composing "On Seeing Miss Helen Maria Williams Weep" (1787) after reading her sonnet "To Twilight."[40] Yet as a British woman who was engaged in the public debates surrounding the Revolution, Williams was subject to a variety of attacks against her virtue, political ideas, and ability to relate historical events with accuracy and understanding. As critic David Simpson argues, Williams's "detailed and complex" writings on the Revolution did not easily fit into the "extreme distinctions" between conservative and liberal views that British politicians were making.[41] Her decision to live in France during and after the Revolution, devoting most of her literary endeavors to an exploration of the progress of the new French Republic, diminished her popularity in England over the next 150 years. As critic William Beloe writes of Williams in 1817: "If she lives . . . she is a wanderer—an exile, unnoticed and unknown."[42] Yet, if Williams was nearly cast out of European literary culture, undergoing the fate of exile just as nuns did in Revolutionary France, critics and historians have now made significant inroads in recuperating her literary, political, and feminist contributions to the Romantic period.[43]

A brief look at Williams's biography provides insight into her political and religious affiliations. In the 1780s, Williams was an established poet and a well-known figure in radical politics.[44] Williams maintained an active profile as a leading intellectual in London, organizing gatherings at her salon in Portman Square with other writers, intellectuals, and politicians such as William Godwin, Hester Thrale Piozzi, Dr. Andrew Kippis, Anna Laetitia Barbauld, William Smith, and Benjamin Vaughan (both of whom were Members of Parliament).[45] As Anne Mellor demonstrates, women actively participated "in the discursive or literary public sphere . . . self-consciously defining themselves as the shapers of public opinion."[46] As a Dissenter and a Whig, Williams supported the abolition of the slave trade, criminal law reforms, and greater tolerance towards religious groups in England through the repeal of discriminatory legislation, such as the Test Act of 1673 and the Corporation Act of 1661, which kept non-Anglicans from public offices, including the military. These reform campaigns sought to widen anti-discriminatory legislation beyond that specifically geared towards English Catholics, such as the Catholic Relief Acts of 1778 and 1791.[47] While advocating for greater leniency towards minority religious groups in England, Williams's political circle was highly critical of the Catholic Church, particularly its involvement in the political structure of the *ancien régime* in France, a view she would maintain throughout her career, although she considered atheism as far more disruptive to national security than Catholic "superstition."[48]

After visiting France in 1790 and involving herself in revolutionary politics, Williams moved from sentimental poetry to epistolary prose, a form which, according to Mary Favret, became by the end of the century, the "the medium of collective political activity." The flexibility of the epistle made it a fluid and effective "instrument for political propaganda" during the Revolution.[49] Williams's *Letters Written in France*, published in four duodecimo volumes, and another four under the title *Letters Containing a Sketch of the Politics of France*, provided her British readers with

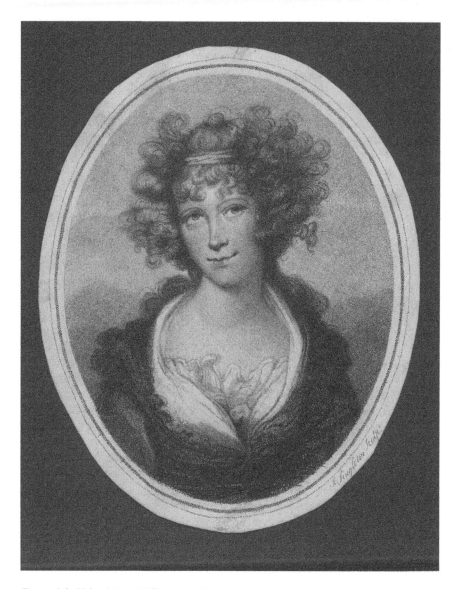

Figure 3.2 Helen Maria Williams (c. 1780–1800).

Source: The Trustees of the British Museum.

Print by Joseph Singleton after Ozias Humphrey, *Helen Maria Williams*, 11 × 8.9 cm, stipple and etching on paper, c. 1780–1800, British Museum, London.

100 *Resistant Virtue in Flight*

eyewitness accounts of the Terror, including her imprisonment in the Luxembourg prison and the convent of the Blue Nuns. Reproduced in a variety of contemporary sources, including newspapers, reviews, and miscellanies, all eight volumes of Williams's *Letters*, according to Gary Kelly, "were widely read, influential, and even plagiarized" in their own time and influenced male Romantic portraits of the Terror.[50] As Thrale Piozzi complained after obtaining her copy of volume three of *Letters Written in France*, "The entire neighbourhood borrows Helen's latest publication from me, such that I have hardly had time to read it myself."[51]

Letters Written in France, which covers events from 1790 through the first half of 1792, generated positive appraisals in England from liberal circles, while also alarming some of her closest friends, such as Thrale Piozzi, who felt Williams's safety was at risk and that her support for the Revolution was misguided.[52] Laetitia Hawkins, in the advertisement to her *Letters on the Female Mind, its Powers and Pursuits: Addressed to Miss H.M. Williams, with Particular Reference to her Letters from France* (1793), a pointed response to Williams's work, called for a "candid renunciation of your political principles," explaining that "many of your former connections will be shy of entering with you on your favourite topic— French Liberty."[53] Conservative reviewers were quick to point out the impropriety of Williams's focus on politics; a review in the *Gentleman's Magazine*, for example, claims: "She has debased her sex, her heart, her feelings."[54] Her continued support of the ideals of the French Republic resulted in a degree of notoriety and the eventual loss of her friendships with Thrale Piozzi and Hawkins, although her next four volumes, *Letters Containing a Sketch*, written after her final return to Paris in 1792, reveal a distinct shift away from Jacobin politics.[55]

However, though Williams's reputation in England was compromised because of her engagement in radical political discourse, she was soon to become the center of an elite intellectual culture again, hosting soirées at her Paris apartment and making friends with Mary Wollstonecraft who admired "the *simple* goodness of her heart."[56] Indeed, Williams's biographer claims that as early as 1791 Williams was "the most famous English woman residing in France." As the Jacobin-generated violence in France escalated, Williams aligned herself with French intellectuals, politicians, writers, and members of the moderate Girondin faction, including Madame de Genlis, Nicolas Chamfort, Jean-Marie and Manon Roland, the Venezuelan revolutionary General Francisco de Miranda, Pierre Victurnien Vergniaud, Jaques-Henri Bernardin de Saint-Pierre, and Jacques-Pierre Brissot.[57]

In spite of intentionally distancing herself from the working class women directly involved in Revolutionary violence, Williams and other "female politicians" ran the risk of being identified with them. A popular cartoon by James Gillray, based on the 1791 stripping and beating with brooms of several Sisters of Charity by the market women of *la Halle*, a conservative but no less salacious take on the French print, *La Discipline patriotique or le fanatisme corrigé*, ("The patriotic discipline or fanaticism corrected"), was distributed in London in June of 1792. Gillray's spoof, Figure 3.3, is entitled "A Representation of the horrid barbarities practiced upon the nuns by the fish-women on breaking into the nunneries of France," a revision that shifts the problem from the incorrigibility of the nuns to

Resistant Virtue in Flight 101

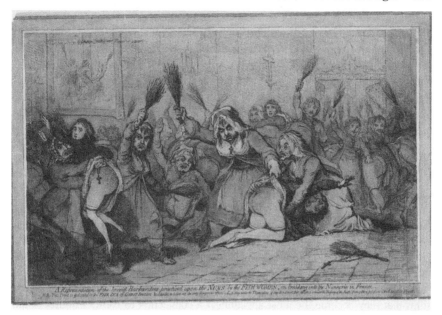

Figure 3.3 A representation of the horrid barbarities practised upon the nuns by the fish-women, on breaking into the Nunneries in France (Gillray, 1792).

Source: The Trustees of the British Museum.

James Gillray, *A representation of the horrid barbarities practised upon the nuns by the fish-women, on breaking into the nunneries in France*, 30 × 45 cm, hand-colored etching, 1792, British Museum, London.

the violence and shame perpetrated on them by the French market women. Below the title, Gillray adds: "This Print is dedicated to the Fair-Sex of Great-England, & intended to point out the very dangerous effects which may arise to Themselves, if they do not exert that influence to hinder the 'Majesty of the People' from getting possession of the Executive Power," which threatens similar violence upon British women, particularly those who "do not exert that influence" to resist the Revolution. As echoed later in the anonymous *Complete History of the Invasions of England* (1801), such rhetoric asserted that women were certainly capable of effecting political change passively or actively, but subject to censure—even punishment—if they represented the wrong party. Gillray's dedication takes British women writers in support of the Revolution to task and as Deborah Kennedy argues, makes women like Williams complicit in these events.[58] As Mary Jacobus suggests, Revolutionary violence "became associated with the body of the woman, onto which all the turbulence of revolution was conveniently projected and then disciplined."[59] For British women writers, the threat of negative reviews, censorship, even literary exile, might shame them into proper politics, just like the public caning of nuns.

102 *Resistant Virtue in Flight*

While in France, Williams encountered nuns and depicted their shifting status during the Revolution, along with her own shifting perceptions of their culture. Williams's critique of nuns in *Letters Written in France* illuminates her original distaste for monasticism, a position that is not surprising given her dissenting and liberal background, as well as her support of the anti-monastic legislation during the Revolution. According to Angela Keane, in the first volume of *Letters Written in France*, Williams is the "genteel, sentimental 'tourist,' guiding the reader through cultural highlights from Paris to Rouen."[60] With a perspective limited by her lack of access to conventual space, her initial views are similar to the first impressions of travel writers such as Radcliffe and Thrale Piozzi. Williams's visit to a Benedictine convent in Rouen is also reminiscent of Paterson's descriptions of nuns in *Another Traveller!* Upon her arrival at the grate, Williams notices a young man conversing with a young nun on the other side, and laments his "perilous situation; for where can a young woman appear so interesting, as when seen within that gloomy barrier, which death alone can remove?" The habit itself is "likely to affect a man of sensibility" because it is "so much at variance with youth and beauty," symbolizing "eternal renunciation of the world and all its pleasures." According to Matthew Bray, Williams's description "suggests that it is when women are the most oppressed by sublime power relationships that they become the most appealing," a connection to Burke's notion of the sublime—though the two writers represent two ends of the political spectrum—and which can also be applied to Williams's figuration of women's victimization during the Terror.[61] Williams and her sister, desiring to tour the interior spaces of the convent, and with the help of a French male accomplice, attempted to convince the Mother Superior that they were English Catholics seeking admittance into the community, a ruse that did not work. Limited by these restrictions, neither Williams nor her sister moved beyond the grate that separated them from the community of nuns.

Written with gothic appeal, Williams's narration of her visit to a Carmelite convent in Rouen echoes Thrale Piozzi's and Radcliffe's commentary on the rigid practices of the Poor Clares. Williams describes the scene as "the most gloomy horror" since the women cannot view their visitors, are separated by a double grate and curtain, and live a highly disciplined life: "they slept in their coffins, upon straw, and every morning dug a shovel full of earth for their graves; . . . they walked to their devotional exercises upon their knees." On the way home, Williams and her party encountered three nuns on the road who had been released from their vows as decreed by the National Assembly in 1790. These women claimed to have been "forced by their parents to take the veil." These episodes convinced Williams that nuns had not freely chosen such a life, a sentiment she shared with other progressives, such as Richard Price and Joseph Priestley, who reasoned that servitude, rather than liberty, defined monastic practice. In fact, she concluded her remarks by documenting that religious houses will soon be sold by the government, monks and nuns will receive pensions upon their departure, and the clergy will be able to marry, information that signals the devastating impact that the early years of the Revolution had on French conventual life.[62]

In volume two of *Letters Written in France*, Williams argues that the suspension of monastic vows in 1789 by the National Assembly allows young women

Resistant Virtue in Flight 103

the right of self-determination. In the supposedly factual story of Madelaine and Auguste, Madelaine's father places her in a convent, separating her from her lover. Luckily, the suspension of monastic vows releases Madelaine from the cloister, allowing her to reunite with her lover. As Nicola Watson comments, "the Revolution performs the part of a deus ex machina ... preserving Madelaine for the embraces of her now independent lover."[63] Williams's views mirror the popular press reports of nuns grateful for their release in the early years of the Revolution. The March 18th edition of the *Argus* ran a story of a French nun who, in her thanks to the National Assembly, declared she would use her body in the "practice of social virtues" rather than in the "bondage" of "superstition." The *English Chronicle* published a similar tale a month later, although at 75 years of age, the thankful ex-Carmelite nun would likely return to family rather than enter into society. These, however, are rare examples. According to Hufton, only one percent of nuns thanked the Assembly for their release.[64]

Williams's early commentary on women religious reflects ideas supported by both French and British propaganda that asserted that monks, nuns, and priests released from their vows would marry, thus transforming them into useful citizens. English nuns were acutely aware that public discourse was framing them as "such useless insignificant members of society," as Clare Knight, a Benedictine nun in Cambrai, wrote to her brother Alexander in December 28, 1789. The *London Chronicle* from August 11–14, 1792, reported that no member of clergy would lose his pension if he married and, furthermore, that while the pensions were not very generous, "that as the parties would throw two into one by marriage, they would be sufficient."[65]

The idea that released nuns would quickly marry ex-priests or monks also had a "strong visual presence" in French print culture, as Hufton notes. A French caricature, depicted monks and nuns throwing off their religious clothing and embracing long-lost lovers after the promulgation of the Decree of the National Assembly to dissolve religious orders on February 16, 1790 (Figure 3.4). The translation reads: "How happy is this day, my sisters! Yes, the peaceful names of 'mother' and 'wife' are much preferable to that of 'nun,' they give you all the Rights of Nature, thus to us."[66] Research indicates that only four and a half percent of clerical marriages were to ex-nuns and less than one percent of released nuns ever married. The Assembly did not consider that the average age in contemplative houses was over fifty, thus decreasing the likelihood of social reintegration via marriage.[67] The French commissioners in charge of dismantling religious houses believed that they were liberating women who had been imprisoned; instead, they were imprisoning women who believed that their liberty—indeed, their right to self-determination—was being taken away.

Nuns' petitions are among the surviving *cahiers de doléance*, the lists of grievances discussed in the convening of the Estates–General on May 5, 1789.[68] Engaging directly in the early political process of the Revolution, nuns continued to play an active role in protest, wielding the rhetoric of "liberty"—what the authorities thought nuns did not have—to argue against suppression.[69] As one nun wrote to the Ecclesiastical Committee, "Is it possible at a time when we hear the

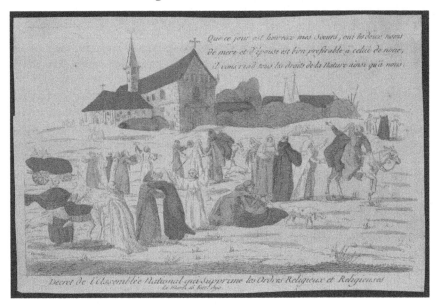

Figure 3.4 Decret de l'assemblee national qui supprime les ordres religieux et religieuses (1790).
Source: The Library of Congress Prints and Photograph Division, Washington, D.C.

Anonymous, *Decret de l'assemblee national qui supprime les ordres religieux et religieuses*, hand-colored etching, 1790, Library of Congress, Washington, D.C.

word 'liberty' sounding from every side, that we should be excluded from this privilege, in finding ourselves forced to quit a sanctuary that we chose in all freedom?" Another French nun could not believe that she was being asked to recant her public and sacred oaths made to God "at a time when oaths are being taken everywhere to be faithful to the Nation."[70] Emphasizing patriotism and utility to the nation, women religious were "careful to acknowledge the legitimacy of the Revolution," though they stubbornly refused to leave their communities voluntarily.[71] At this final clash between authorities and women religious, Williams was herself forced into conventual incarceration with the community of "English Nuns," where she witnessed from inside cloistered space the political dynamics nuns were facing.

Nestled in volume one of *Letters Containing a Sketch*, the tale of her imprisonment with the Blue Nuns is contextualized by Williams's withdrawal of support for the government with the ascendency of Robespierre whom she terms a "sanguinary despot." Noting her move away from Jacobin politics, the *Critical Review* opined that while her principles had remained constant, "her sentiments are corrected by that great teacher—experience. We no longer discern the wild enthusiasms of democracy." Williams's first letter of the volume announced that with the death of Robespierre on July 28, 1794, "Liberty, bleeding with a thousand

Resistant Virtue in Flight 105

wounds, revived once more," suggesting that the years of the Terror endangered the very concept that underwrote the French Revolution in the first place.[72] Like life-giving stigmata, Liberty's "thousand wounds" stand in for the thousands of victims who lost their lives and whose legacies Williams reinvigorates through her writings. As Kennedy writes, Williams's "Liberty is a woman of sensibility" and "a victim of male violence," a device that calls attention to the fact that women's status had not improved as had been anticipated at the beginning of the Revolution.[73]

Williams's account in volume one begins by describing her personal vulnerability during the political turbulence of 1793. With the announcement that British nationals would be arrested and their property sold, Williams questions how the Revolutionary commissaries will treat a "family of women," which included Williams's mother and sister who had accompanied her to France.[74] As journalism becomes autobiography, this episode frames Williams herself as "one of the victims of the jealous and impolitic cruelties of the monster Robespierre," as depicted in the *London Review*.[75] As an unwilling participant in the drama rather than a mere passive observer, Williams takes on the role of gothic heroine, according to Keane, "at turns incarcerated and in flight, only writing when in temporary repose," in these latter volumes. The *Critical Review* even reprinted the "interesting" story of Williams's arrest.[76] Positioned within a domestic female community, Williams argues that "neither sex nor age gave any claim to compassion," a lesson that is reinforced in her portraits of other women who have faced violence, mistreatment, and even death. During the arrest, two commissaries waited outside their home with "swords drawn," a threatening, visible reminder of these women's loss of agency and as potent a symbol as cannons pointed at convent doors. The women were led to the Luxembourg "pale and trembling" on October 9, 1793.[77]

In November of 1793, Williams and her family joined the Blue Nuns, one month after the community had been put under house arrest.[78] Williams describes the group as containing 23 members.[79] And, in contrast to the English and Irish monks who had "long since thrown off their habits," the "religious sisters" retained an "enthusiastic attachment to the external signs of their profession," a less-than-veiled critique of these women's adherence to religious traditions in spite of the changing times.[80] However, Williams also registers nuns' resistance to mandates that they dress in secular clothing and renounce their vows.

As quaint and sororal as Sarah Scott's community of matrons in *Millenium Hall* (1762), the nuns immediately put Williams and her fellow prisoners at ease.[81] This episode represents a kind of homecoming in the middle of the Terror for Williams. Although prisoners themselves, the nuns' hospitable reception of British nationals provides a model for refugee assistance. The nun who welcomes them embraces and greets them in English:

> [She] begged we would be comforted, since she and the other nuns who were to have the charge of us were our countrywomen and our sisters. This soothing sympathy, expressed in our native language, formed such a contrast to the

106 *Resistant Virtue in Flight*

rude accents of inspectors of police, that it seemed as if some praying angel had leaned from heaven to comfort us. The kindness with which we were received by our amiable country-women, contributed to reconcile us to our chamber.[82]

Familiarity underwrites Williams's introduction to the community as she considers them "amiable country-women." Phrases such as "native language," "praying angel," and "soothing sympathy" further reinforce ties of gender and nation over religious differences, domesticating nuns for British readers schooled in the exoticism of gothic conventions.

Beyond merely a picturesque episode of domestic harmony, Williams goes several steps further, refiguring conventual space as truly democratic: "There were no rich amongst us . . . those who had any resources left, shared all their little luxuries and indulgences with those that had none. The young succoured the old, the active served the infirm, and the gay cheered the dejected." Sympathy is manifested in financial and emotional actions, creating an environment that alters one's perception of captivity: "One circumstance tended to make our situation tolerable, which was that true of spirit of fraternity that prevailed in our community, consisting of about forty female prisoners besides the nuns. Into how happy a legion would the world be transformed if that mutual forbearance and amity were to be found in it which had power to cheer even the gloom of a prison!"[83] In calling attention to the prior claims that religious orders have to concepts such as fraternity and equality, embedded in their vows of poverty, Williams places conventual social management on equal par with Revolutionary ideals. Just as nuns themselves were emphasizing their patriotism to the new government and claiming the term "liberty" for their own purposes, Williams emphasizes the very "spirit of fraternity" deployed by religious women who supposedly pose a threat to the government.

Williams's representation of egalitarian practices within the sororal space of the convent recalls Thrale Piozzi's discussion of the ways in which women of very different social classes negotiated space together during her visit with the Blue Nuns in 1775:

> Surely a Convent is [women's] safest Refuge from the Shafts of Poverty & the Corrosions of Care. It was very pleasing today to see Lady Lucy Talbot, Sister to an Earl, & whose Fortune (for she brought 10,000 lb with her) has hitherto supported the House; serving the Nuns at Table as her duty demanded because it was her Week of waiting—& running to the Kitchen to heat a little Cabbage for Sister Simson, who had been a Maid Servant in Mrs. Strickland's Family.—To see all distinctions thus thrown down by Religion is so lovely that I felt myself very much penetrated by the Sight which made a deep Impression—as I told them—Oh, said Lady Abbess, Women of Quality here must learn to wait & Cook too.[84]

That "Religion," rather than secular ideals, liberates women from social and economic "distinctions" calls attention to the ways in which female religious orders

put *egalité* into practice. Although a former maid and lay sister with "a weak understanding," Sister Benedict Simpson had risen to the status of a choir nun: "I saw a Woman of very different Rank *in the World* but the same *in a Cloyster*." Such a move from lay sister to choir nun would have been rare (the Blue Nuns, in fact, maintained a strict hierarchy); however, Thrale Piozzi is quick to point out Simpson's equality in the cloister as evidence that the social divisions so entrenched in society are more easily erased in religious community.[85] Similarly, Williams emphasizes the potential for women to meet on terms of equality in religious life, while leaving off an examination of the very hierarchal practices at work within it.

While the Blue Nuns struggled to maintain themselves upon their return to England, trying unsuccessfully to run a day school and then turning their attention to handiwork such as sewing, bookmarks, and purses "lest we should appear indolent and unwilling to help ourselves in the eyes of the world," as Abbess Green writes to Lady Jerningham in 1801, their years of service within the community of the Faubourg St Antoine impressed Williams as a demonstration of their social utility.[86] Not only did the nuns show hospitality and sympathy towards the prisoners, but they also elicited help from the local inhabitants who were "accustomed from infancy to revere them, to have the wants of the poor supplied at the gate of the convent, and, while under the former government they were treated with neglect or disdain by others, to be there received with evangelical humility, felt that their esteem and veneration for the nuns had survived their own superstitious belief."[87] Far from converting to Catholicism herself, Williams separates the women's actions from their beliefs, assessing their social value in terms of their perceived social productivity in the community.

Williams's depiction of the Revolutionary Army's reaction to the nuns is particularly striking. As the embodiment of sensibility and benevolence, the nuns have the power to emasculate even the representatives of Revolutionary bloodshed: "The conquerors of the Bastille, the terror of aristocracy, and the vanguard of revolutions, laying aside their bloody pikes and bayonets, humbled themselves before these holy sisters, whom a sort of visible sanctity seemed to encompass."[88] Williams lauded these nuns' "visible sanctity" and the power that such resistant virtue wielded over officials, at least initially. Such commentary reflects how English communities used "selective compromise and accommodation" when dealing with officials;[89] it may also indicate the ways in which techniques such as "collective obstinacy," or isolating particular officials, as well as the manipulation of sexist stereotypes such as women's weakness, enabled nuns to survive in Paris during these turbulent years.[90]

Yet these strategies did not work in the long run. In another encounter with authorities, members of the police, whom Williams stated "were far less agreeable than those of our good commissaries," put a quick end to the routine of mutual aid and solicitude within the convent. One such policeman, referred to as "Brutus," a "ferocious pagan," unsuccessfully attempted to rip a veil from a nun's face, symbolizing his intent to uncover this nun's body without her permission. His "uncontrollable rage" left the nuns "trembling with horror" as he stomped on a

108 *Resistant Virtue in Flight*

cross in the garden, shouting obscenities at the prayer bell, which he exclaimed could be put to better use as a cannon. Because of this man's report, the bell was dismantled the following day, the crosses removed, and the nuns ordered to wear civilian clothing, over a year after the official mandates had been issued for nuns to abandon religious dress. According to Hufton, the sounding of a convent bell "pronounced to the outside world that Republican law was ignored in the community" and thus when seized, might be followed by a "rebellious peal" to announce to the community the persistent triumph against authorities.[91]

When the Blue Nuns were ordered to dress in secular clothes in November, according to Williams, "Nothing could exceed their despair . . . The convent resounded with lamentations, and the veils which were now to be cast off were bathed in tears." Afterwards, in a kind of sewing circle, Williams reported that the nuns and female prisoners collaborated to fashion new outfits for the nuns: "we all went to work, and in a few hours sweeping trains were converted into gowns, and flowing veils into bonnets. One charming young nun . . . begged that, if it were possible, her bonnet might shroud her face altogether; while another . . . hinted that she should have no objection to the decoration of a bow."[92] The relinquishment of religious for secular dress was not only a punishment exacted upon nuns by Revolutionary authorities, but also a disguise that enabled them to travel and eventually return to England more quietly. In fact, English nuns' friends and family members advised such a strategy.[93]

Williams's curtailed portrait leaves the nuns in flight, ready to brave their next encounter. Significantly, most English groups were relocating to England with the publication of Williams's account of the Blue Nuns. Indeed, Williams's open ending calls attention to the refugee status of nuns lately dismissed from their homes, although the Blue Nuns themselves would not embark for England for another five years. After they were barred from their convent, they temporarily resided in the home of their confessor, Father Shelley, before joining the English Augustinians in Paris.[94] Contemporary reviewers did not overtly focus on this episode—the *London Review* commented on the "enlightened society of her fellow-prisoners"—yet Williams's framing of refugee English nuns further normalized their presence in Britain. A full extract of Williams's incarceration episode appeared as "A Picture of the English Convent in Paris" in the 1797 edition of the *Britannic Magazine*, indicating readers' continued interest in the plight of English nuns, most of whom had already returned to their homeland.[95] Just like the universalizing title in the *Britannic Magazine*, "A Picture of the English Convent," Williams never named the specific house of "English nuns" with whom she resided, thus broadening the scope of her depiction in its application to multiple communities of "domestic" women religious in the process of migration.

Although Williams pointed to the convent as one expression of women's agency during the Terror, it is important to note that she did not end her narration with an endorsement of monasticism for women. Instead, she praised the "angelic purity" and "tender heart" of "Sister Theresa," a nun who inspired Williams to conclude that: "the revolution was a blessing, if it was only for having prohibited vows which robbed society of those who were formed to be its delight and ornament."[96]

Resistant Virtue in Flight 109

Worded more as an elaborate compliment to a beautiful nun than a critique of the monastic vocation, Williams suggests that this nun's virtues will not be utilized to their fullest extent within the convent. Interestingly, "Sister Theresa" was Anne Lonergan, an Irish woman who returned to England with two other nuns, Mary Anne Aston and Anne Duffield, after the Blue Nuns' release from incarceration in 1795.[97] Just as Williams does not name the specific convent, she also does not identify Sister Teresa as Irish, unifying rather than fracturing her portrait of "English" women religious who would need support from multiple sources in the years to come.

The positioning of the episode of Williams's incarceration with English nuns is notable, squeezed as it is between those of two of the most famous women executed on the scaffold, Charlotte Corday and Madame Roland. Williams commends these women side by side in her 1801 *Sketches of the State of Manners and Opinions in the French Republic*: "What Roman virtue was displayed by Charlotte Corday!—what more than Roman fortitude dignified the last moments of Madame Roland!"[98] Corday's assassination of John-Paul Marat in July of 1793, a leading figure in the Revolution who used his newspaper, *L'Ami du peuple* ("The Friend of the People"), to inculcate incendiary political views, resulted in her rapid execution. Preceding her portrait of the heroic Blue Nuns, Williams describes Corday's "majestic solemnity" and "composure" at receiving her sentence. Just as the commissaries of the Revolution are awed into submission by the "visible sanctity" of the nuns, so are the lower-class women who typically hurl insults at those on their way to the guillotine, "awed into silence by [Corday's] demeanor." Corday's virtuous legacy is evident even after death: "the moment she bent before the fatal stroke, she blushed deeply; and her head, which was held up to the multitude the moment after, exhibited this last impression of offended modesty."[99] Corday's post-mortem "blush" reveals her innocence and virtue, rudely taken from her and by extension, society. Through the phrase "offended modesty," Williams figures her death as a rape, pointing to the perversion of power by the Jacobins in their ability to take out of this world the very virtues of female heroism that she so admires.

The execution of Marie-Jeanne Phlippon Roland, known as Madame Roland, in November of 1793, follows Williams's depiction of the nuns. Roland and her husband, Jean-Marie Roland, supported the Revolutionary agenda before defecting in 1792 and joining the moderate Girondins. As an intellectual who engaged politically with and through her husband, Roland had an "ardent attachment to liberty, and the most enlarged sentiments of philanthropy," according to Williams who claimed the Rolands as part of her social circle. Roland's death, like Corday's, provides a model of "feminized heroism," as Keane states. In Williams's portrait, Roland's "placid resignation" to her fate is only contradicted by her occasional tears of "indignation" when asked questions by the tribunal "so injurious to her honor." Her "heroical firmness" during her trial mirrors her composure on the way to her execution. To symbolize that she is innocent of the charges leveled against her, Roland faces her death in a white dress and addresses Liberty directly: "Ah Liberty! How hast thou been sported with!" A "glorious martyr,"

110 *Resistant Virtue in Flight*

Madame Roland is the epitome of the "virtue in distress" motif that Williams threads throughout *Letters Containing a Sketch*.[100] Reviewers noted this focus on women's victimization. The *Monthly Review* pointed out Williams's highlighting of "the most conspicuous of her own sex, particularly that extraordinary female patriot, Madame Roland," while the *London Review* reprinted "the most interesting and pathetic" extracts, the "least known to the public," which included the tale of Madame Roland and Camille Desmoulins.[101]

These accounts further sublimated women's voices in the "paradigm of the young woman as consumable object."[102] Just as Williams's early commentary on nuns illustrates her concern that they cannot fulfill their procreative potential, in *Letters Containing a Sketch*, her portraits of the deaths of young women, forever barred from family or political life, shifts the blame from the convent to the government. Williams thus participates in the idealization of victimized women, perhaps attempting to appeal to a male readership. In depicting these executions, such as that of the 23-year-old Madame Desmoulins who displays the "serenity of an angel" and the beautiful 19-year-old daughter of Madame Saint Amaranth, Williams draws a parallel between "liberty," refigured in the New Republic as a young beautiful maiden, and the loss to families and society when young women of unequaled sensibility are murdered.[103] Describing these women as "angels in their flight to heaven," Williams gives them special status in her catalogue of martyrs. In its thirst for the "blood of women," the revolutionary tribunal directs its "fury" with "peculiar virulence against that sex whose weakness man was destined by nature to support."[104] While in several instances Williams compares women's fortitude to that of men, she further condemns violence against women by appealing to the natural role that men fulfill in protecting them. Through her minimal treatment of the trial of Marie Antoinette, Williams brings attention to the ways in which the Revolution compromises women's natural role as mothers: the charges of incest brought before the Queen "wrung from her bursting heart that affecting appeal to every mother that was present."[105]

When women enter into public debate willingly, their virtue is compromised, such as the young Cecile Renaud, a "heroic young woman" who after openly denouncing Robespierre as a tyrant, is ordered to take off her clothes and dress in rags, dying along with her family.[106] That the Blue Nuns do not face death in France does not mean that the integrity of their community has not been compromised, even if they are able to avoid the male gaze. While women like Cecile Renaud must uncover themselves in front of men, nuns and other British women prisoners work together to transform habits into dresses that serve not only to protect virtue, but also as safe cover. In placing English nuns within this iconic context, Williams suggests that British women—Catholic and Protestant—played a significant though perhaps unacknowledged role in political resistance, whether through active or passive modes, or in the swaying of public opinion through writing like Williams herself.

Though Williams identified with the Blue Nuns in this episode, it is important to note that she did not support the Catholic revival in Restoration France,

including the Charter of 1814, even though it allowed religious freedom. Consistent with her support of tolerating legislation in England in the 1780s, Williams's critical views on the restoration of Catholicism in France were primarily rooted in her ongoing concerns regarding religious freedom for Protestants.[107] In 1801, Williams commended the check to "paternal authority" that the new system in France affords, "which so often doomed the younger branches of noble families to wither in the gloom of convents, or with stern despotism disposed of the persons of females, without their choice or consent." In some ways recalling the anti-monastic sentiments retained from her early education, her focus shifted to women's ability to be self-determined, rather than serving the ends of the "stern despotism" of family members. Williams advocated for women's freedom from coercive practices, including the limits placed on women's education, the "gates of learning rudely barred against her entrance," a statement that looks forward to Virginia Woolf's arguments in *A Room of One's Own*. Williams's comments on women's education rephrased some of the central concerns voiced by Thrale Piozzi for single women in England without the option of a Protestant convent—the need for women to have an "honorable independence," free from the pressure to marry a "man whom her heart despises," and "supplied with the means of knowledge."[108]

Williams also advocated for women's full engagement in the roles of citizenship, including the right to vote. Her last and less well-known work, *Souvenirs de la Révolution française* (1827), lamented the re-masculinization of the French state under Napoleon Bonaparte, a development that left women little political effect in "those great issues where the interests of humanity are debated and decided" outside of "the narrow circle where men have enclosed them."[109] As evidence that women demonstrated full involvement in the public sphere, Williams looked back to the hospitality of heroic women like the Blue Nuns in her later writings: "It was women, who, in those days of horror, proved that sensibility has its heroism . . . [they] penetrated the depths of dungeons . . . were the ministering angels" to prisoners and "in defiance of captivity and death, fought the dwellings of tyrants covered with the blood of innocence, and pleaded the cause of the captive, with the irresistible eloquence which belongs to the inspiration of the heart." In her assessment of women's work during the Terror, both within and outside of religious communities, Williams criticized forms of institutionalized power that did not liberate women but constrained their agency. Even when coerced, women used "irresistible eloquence," "defiance" of authority, and physical courage to fight for themselves and their dependents.[110]

Williams's treatment of women religious must be seen in the context of her general interest in examining the role of women in the public sphere, whether married, single, or cloistered. Her experience with the Blue Nuns is one example of how Catholic religious women worked as a collective unit during a time when women's professional and public involvement was discouraged. Employing Enlightenment rhetoric to endorse conventual management and criticize the treatment of the government towards the Girondins, French clergy, and nuns, Williams engaged the very terms at issue in public debate, just as nuns did to

112 *Resistant Virtue in Flight*

justify their position in France. In aligning British women with iconic French heroines who refused to capitulate to authorities, Williams's writings suggested that heroism and agency were possible for women on many levels and from different positions.

Williams's episode constitutes one way that women religious entered into public discourse in Britain, easing tensions posed by religious difference and engaging readers in the lives of migrants in the process of relocation. In her sentimental and heroic depiction of English nuns fighting against terrible odds, Williams played an important but since overlooked role in championing women whose compromised positions threatened to silence them—like Corday and Roland—forever.

Reluctant Returns: English Nuns in England

Softening anti-Catholic prejudice at the height of nuns' migrations to England in 1794 and 1795 with her genteel depiction of "domestic" women in religious community, Williams could not have anticipated that the Blue Nuns would not survive into the next millennium.[111] Arriving in 1800 when the earlier influx of migrating women religious was nearly a memory, the Blue Nuns entered into a tentative political and social climate in which the government questioned the long-term status of nuns in England, their nationalities, and their political affiliations. Lady Jerningham supported them handsomely as she had the French Benedictines of Montargis and the English Augustinians of Bruges. She also took an active role in revising, finishing, and preserving their collective history, an example of the high level of access and trust the religious community granted to her as a benefactor.[112] The vulnerability of migrating women religious to the designs and desires of patrons only added additional challenges to an already resource-poor situation. Catholic benefactors, on the other hand, faced the task of assisting cloistered relatives returning in variously sized groups.

As historian Kirsty Carpenter asserts, in spite of some tension, the British sympathized with and supported the refugees.[113] However, the refugees who arrived in 1794 and 1795 also had much to overcome. Beyond finding lodging, work, and negotiating religious dress, they had to focus on public relations, nurturing ties to local communities and their Catholic and Anglican benefactors in spite of anti-Catholic prejudice. Contemplative nuns also had to prove themselves socially useful while negotiating their enclosed orientation, another strategic move that would further secure their positions in England in the following century. In addition, contemporary legislation specified that Catholic nuns were not allowed to wear their habits in England, nor could they legally profess new members. Thus, in 1792 Alexander Knight advised his sister, Ann Joseph Knight, a Benedictine nun in Cambrai, to "put on secular clothes" for the women's journey to England.[114] The group did return in secular dress, although not until 1795, after an 18-month imprisonment in Compiègne. They disguised themselves in the peasant clothing discarded by the French Carmelite nuns who went to the scaffold in their habits in 1794. The Benedictines arrived destitute and met with a "cautious welcome" in England. Consequently, they did not fully resume the habit until 1823.[115] Once

Figure 3.5 Mrs. Jerningham as Hebe (1809).

Source: The Trustees of the British Museum.

Print by Henry Meyer after John Hoppner, *Mrs. Jerningham as Hebe*, 43.1 × 29.5 cm, stipple and etching on paper, 1809, British Museum, London.

114 *Resistant Virtue in Flight*

in England, the Blue Nuns wore their habits primarily on feast days; to please patrons they exhibited the distinctive white gown with sky blue mantle and black veil. The image of Mary on their scapular and sky blue mantle, "circled about with Sun-Beames, and crowned with stars"[116] must have seemed sufficiently exotic and Continental to the women's Protestant visitors.

Records indicate that upon migration nuns were recovering from their traumatic experiences of the war, finding proper accommodations, and figuring out how to become financially independent.[117] Opening a girls' school offered one means of acquiring social acceptance and downplaying the contemplative nature of many refugee communities.[118] With such support from the start, groups such as the Benedictines of Cambrai were able to begin the business of making money within months of their arrival in 1795. The Benedictine priest, Dr. John Brewer, who had served as the confessor to the Benedictine branch in Paris from 1771 to 1776, took an active role in the nuns' transition. Having worked in England since 1776 on behalf of the Catholic mission, he secured 43 Woolton Street where the nuns staffed a Catholic school with 11 students already enrolled. The nuns also benefited from the expertise of Miss Crilly, a lay teacher who later joined the Benedictines as a choir nun. Within two months, advertisements appeared in local papers, announcing the school's opening and its target audience: "Catholic Young Ladies" under the management of "English Nuns lately escaped from Compiègne, formerly of Cambray." The nuns adjusted to teaching young students, ranging in age from 5 to 13. Over the 12 years at Woolton, the school serviced over 150 students. In 1807 the nuns moved to Salford Hall at Abbots Salford in Warwickshire to obtain lodgings that complemented their contemplative orientation; by 1835 the group moved again, this time to Stanbrook Hall near Worcester.[119] Thus, Woolton provided an initial location where the nuns could build up their resources, solicit assistance from the surrounding community, and recover from the trauma they had experienced in France.[120]

In contrast, Lady Jerningham did not secure permanent lodgings for the Blue Nuns until nearly four months after they had arrived, a task perhaps made more difficult as fears regarding the establishment of monastic institutions were surfacing in the House of Commons. Staying in the Jerninghams' Bolton Row home the first few months, a kind of salon where the "Cats" (Lady Jerningham's term for the English Catholics) and French nobility gathered in London, the Blue Nuns next traveled to the Jerninghams' country estate in Cossey awaiting final preparations for their new home in Norwich. Lady Jerningham's enthusiasm for the nuns is laced with possessiveness, as seen in a letter to her daughter Charlotte on April 25, 1800: "You will have seen my good nuns at Cossey, and you can, I am sure, but be satisfied with them . . . I do not put their Light under a Bushel."[121] They finally settled into a home on Magdalen street in St George's Colegate in Norwich, an oddly urban location for a contemplative house with an overt Marian and French flavor. This is where the poet Amelia Opie encountered them and whose verse sentimentally framed them as victims of the Revolution. The nuns tried to establish a school, received regular visitors, and made purses and bookmarks.[122] Yet having waited so long and lost so many, the group suffered in numbers, needing both

to care for the eldest members and establish a stable source of income. Because they lost time in establishing a student body in the already competitive market of Catholic education, the Blue Nuns could not recruit enough students to run a modest day school. Two of three nuns who had been sent ahead to England in 1795 rejoined the community in 1800. Williams's beloved Sister Teresa Lonergan, one of the three, opted to stay in Ireland.[123]

After the nuns were settled in Norwich, Mother Mary Bernard Green entrusted Jerningham with the work of updating the community's *Diary* since the French Revolution had interrupted its continuation. Green wrote to Jerningham that "there are passages not proper for everyone to see." Jerningham seems to have marked out text that called the group's reputation into question; however, her most active role was in the reconstruction of the nuns' obituaries from 1792 to 1810.[124] Jerningham was herself a prolific letter-writer with an interest in managing the community's image on record. As both a former student and cousin to one of their own members, the former Abbess Mary Ursula or Lady Anastasia Stafford, Jerningham had a personal interest in taking care of the women and their story. First, Jerningham's husband William was the heir to the Stafford barony, which had passed to Lady Stafford in 1769. At the time of the Blue Nuns' departure from Paris and in a move of ultimate resistance, Stafford did not return but stayed with a French Augustinian community, *les Orphelines de l'Enfant Jesus*. This choice may have strained Stafford's relationship to her kin though the Jerninghams made it a priority to stay in contact with Stafford. Second, the line claimed a Catholic martyr: Stafford's great grandfather, Viscount Stafford, had been executed during the Popish Plot.[125] Thus, the family's recusant legacy was a significant part of their identity as English Catholics. Finally, Jerningham knew that her family's reputation would be tied to the history of the groups she assisted just as these groups' successful transplantation to England reflected benefactors' efforts.

Hence, Lady Jerningham drew upon conventional sentimental tropes in her obituary entries in the Blue Nuns' *Diary*, emphasizing the nuns' opposition to the Revolution and the community's slow deterioration by means of the "violence of Revolutionary Mania," the agent of destruction in the narrative, much like Matilda Betham's elegy to Catherine Dillon and Opie's reprisal in "Lines for the Album at Cossey."[126] While Sister Joseph Clare (Mary Bell), a "great support" to the Choir with her "fine voice," fell victim to "a nervous Decline, that Extinguished Life" in October of 1794, Sister Frances Agatha (Margaret Whiteside), who made her vows the day after the fall of the Bastille, caught "the seeds of a Consumptive disorder . . . from the damp Parlours, she was made to inhabit." The entry for Mother Winifred Joseph (Elizabeth Stock), the last "to dye in the Convent where she had Engaged to Remain," voices these women's attachments to conventual space and the eventual loss of their properties.[127]

Jerningham colonizes the obituary entries twice with assertions of her discovery of a home for the nuns. William Jerningham was "happy to give them an asylum at his House in Bolton Row," and later they were "comfortably settled in a Convenient House" in Norwich as arranged by Lady Jerningham, although how convenient such a location was or how comfortable contemplative nuns were

116 *Resistant Virtue in Flight*

in their small urban lot in the middle of Norwich can only be surmised. Jerningham's second reference to her assistance in securing a home for the women, which is found in the final obituary entry for Mother Mary Bernard Green, is self-congratulatory and misleading. Jerningham depicts Green as a gentle matron leading the "Remainder of her Reduced Community safely to England, and to the asylum [sic] Prepared for them at Norwich." However, the purchase of the Norwich home was not finalized until Easter week, several months after their arrival in England; the nuns did move in until July.[128] Jerningham constructs the Norwich "asylum" as a space of reassembling a broken community fleeing from the terror of Revolution. Like Opie and Williams, Jerningham presents the nuns as faithful adherents to their community in the face of complete disintegration.

The impact of a member's death could be profound, particularly one revered for her leadership. Mother Mary Augustine (Mary Lloyd), "this most Valuable member of our expiring Community," known for her superior management of students and the convent, had shepherded the group to England "in the cold month of January 1800" at 84 years of age. Living through a decade of Revolution, she died only four years after leaving France. Mason's research documents that Lloyd's death initiated the collapse of the community. Two nuns left to join other English religious groups and two defected altogether.[129] After the four members left, Jerningham solicited the Dunkirk Benedictines to take in the three remaining women. As Jerningham wrote to Abbess Prujean at her flourishing school in Hammersmith, "I will own that it is with great regret I see them giving up all hope of remaining together; but they seem to be persuaded of the necessity of it." Abbess Prujean denied the request.[130] Sister Mary Joseph (Elizabeth Edwards), one of the two nuns who joined other communities, recorded in 1805 in the archives of the Franciscan nuns at Winchester that the Blue Nuns "were forced to break up . . . Not being a sufficient number, nor having other necessary means to practice their religious observances they were obliged to a separation."[131] Only Sister Frances Agatha and Sister Benedict Simpson remained in Norwich with Mother Bernard Green. Sister Frances Agatha died in 1806, while Sister Benedict Simpson nursed Mother Bernard Green for four more years before the latter died; Simpson returned to her own family in Lancashire until her death in 1822.[132] Mother Bernard Green's "Decease was the sad moment of Dispersion," Jerningham writes, finalizing the narrative to reflect what little integrity the remaining two survivors maintained, just as she had white-washed evidence of dissension during their earlier years in France.[133] That she co-opted their story speaks to the ways in which Jerningham's family's reputation was also at stake, and by extension, that of the elite Catholic minority that had shouldered many of the practical concerns that refugee communities had brought with them.

Ultimately, Jerningham inherited the *Diary*, which was used as evidence in the Stafford Peerage case in 1807. She also created her own version of the *Diary*, which she called the "Archive Book."[134] After some convent property was restored with the restoration of Louis XVIII, Anne Duffield, surviving ex-member and abbess "by right of age and rotation," obtained the *Diary* from Lady Jerningham after the document was used as evidence to support her son Edward's claim to the Stafford

Resistant Virtue in Flight 117

barony. From there, the *Diary* went through a series of owners, including William Pickering and John Gage Rokewode. In 1839 Rokewode published excerpts from it in a paper he wrote to the Antiquarian Society, bringing the nuns' stories to the attention of Victorian readers. Joseph Gillow rediscovered the work in 1906.[135] Jerningham's attempts to gloss over a much more fragmented reality indicates the value she placed upon preserving a portrait of positive benefactor–refugee relations for the next generation.

That the public image of nuns in England was as fragile as their communities is revealed in the discussions surrounding the Monastic Institutions Bill of 1800. Sir Henry Mildmay brought the bill forward to the House of Commons on May 22, 1800, only one month after the Blue Nuns had settled in Norwich. The Bill's supporters were concerned with the permanency and proselytizing impact of monastic groups in England, as Mildmay voiced on May 22 and June 23, 1800. The Bill proposed to protect religious if they agreed not to recruit young women into their ranks and did not teach Protestant children. In order to secure these agreements, the government would regulate Catholic schools if the bill passed. The Bill drew on the rhetoric of nationalism, suggesting that Papist schooling was also French schooling.[136]

A major talking point among politicians was whether religious were French or English. If "the subject might be transitory," then would not the Aliens Act of 1793, which banned the formal establishment of foreign-based monasteries in England, as well as the recruitment of members, be sufficient? If British, anti-papal legislation was still in effect in the event that religious groups violated their boundaries.[137] Certainly groups like the Blue Nuns challenged a simplistic distinction between French and English communities—how should repatriated religious be categorized or supervised?

The Bill's opponents, emphasizing toleration, thought it alarmist in nature and presented at "a most unseasonable moment": nuns were a dying breed rather than a threat to Protestant communities. Mr Hobhouse, for example, concluded that convents were "in a state of diminution": "death had made more ravages than vows had replaced." While Lady Jerningham's obituaries serve as one rare example of complete communal dissolution, the Parliamentary records also provide evidence of the belief among politicians that this fate would befall other groups: "assaulted by the cruel rage of persecution, the greater part of them would fly together in quest of a peaceful asylum, and therefore few were left to join them since their settlement in Great Britain."[138] With so few remaining, how could nuns pose a threat?

The question of "the usefulness of monastic institutions" underwrote some of the debate. Opposing the Bill, Mr Windham, argued, "why [were] monks considered worse than the gentlemen of that House, who live on their estates without labour"? Utilizing the stereotype of the parasitic religious orders, Mr Windham defended nuns on the basis of England's support of the superfluous upper-class: "Might not a society of ancient ladies be as usefully employed in a convent as if they were distributed in parties at different card tables?" The Bishop of Rochester suggested that "it would be martyrdom to these retired, sober women, to be compelled to lay aside the cowl and simple habit of their order, to besmear their

118 *Resistant Virtue in Flight*

cheeks with vermillion ... with elbows bared to the shoulder, to sally forth to the pleasures of the midnight rout." In response to fears that Protestant women might become Catholic nuns, the Bishop asserted that the temperaments of "my fair countrywomen ... [are] not bent towards retirement and seclusion."[139] Thus, the counter-argument asserted that because nuns were depleted in numbers and did not present a compelling lifestyle choice for English women, religious groups did not need governmental supervision: nuns were essentially a relic of the past.

The nation's historical complicity in the problem was also broached: "It would seem as if these poor Catholics possessed all their former wealth, and that all their lands and goods had not been turned over with the cathedrals to our Church—as if Harry 8th had never stripped them of anything," argued Mr Sheridan. The Bishop of Rochester argued along similar lines in the House of Lords, clarifying that the subjects in question were indeed English, who having settled in France or Flanders "because they could make no such settlement in their own country," were now, after having had "their property plundered, their persons harrassed," obliged to fly "into the arms of their mother-country in the hope of finding a shelter."[140] Like Opie's "cloistered virgin, forced to fly," the Bishop of Rochester's rhetoric drew on a decade's worth of literary and cultural representations of nuns struggling to survive the Revolution. In the end, such sentimental framing of nuns worked: the bill was defeated in the House of Lords. The Parliamentary debates, which were picked up in the press, reveal, according to Ralph Washington Sockman, "a pretty fair cross-section of English opinion on the subject of monasteries. It shows the English still unreconciled to the monastic idea," but also the assumption of its "harmlessness."[141]

The politicians defending religious institutions completely underestimated the agency of nuns, both English and foreign, whose communities flourished in the nineteenth century, a reality that underscores that the demise of the Blue Nuns was rather unique.[142] Politicians also discounted the impact that migrating nuns had on writers, readers, patrons, and other local community members who worked to disseminate and preserve their stories. Jerningham's intercessory work in making coherent the traumatic narrative of the Blue Nuns' sojourn to and settlement in England provides one example of how multiple stakeholders worked to secure the legacies of religious groups at a time when communal integrity—indeed, survival itself—was at stake. Helen Maria Williams, another such writer, domesticated refugee nuns to a British readership while inserting them into a larger narrative of women's active engagement in politics, a public role that Williams herself claimed as an historian of the period. However, Williams was by no means alone in linking women's work with that of women religious. As early as 1793 British women writers had begun to self-consciously co-opt the social role of nuns in the public labor of émigré aid and education, an act of identification that continued well into the nineteenth century.

Notes

1 *The Diary of the Blue Nuns: An Order of the Immaculate Conception of our Lady at Paris, 1688–1810*, eds Joseph Gillow and Richard Trappes-Lomax (London, 1910); Margaret J. Mason, "The Blue Nuns in Norwich: 1800–1805," *Recusant History*, 24/1

(1998): p. 114; Amelia Opie, "Lines for the Album at Cossey," in *Poems by Mrs Opie*, 3rd edn (London, 1804), pp. 77–84.

2 Janet E. Hollinshead, "From Cambrai to Woolton: Lancashire's First Female Religious House," *Recusant History*, 25 (2001): p. 481.

3 Dominic Aidan Bellenger, "France and England: The English Female Religious Reformation to World War," in Frank Tallett and Nicholas Atkin (eds), *Catholicism in Britain and France Since 1789* (London, 1996), p. 6; Bernard Ward, *The Dawn of the Catholic Revival in England, 1791–1803* (2 vols, London, 1909), vol. 2, p. 116.

4 Helen Maria Williams, *Letters Containing a Sketch of the Politics of France, from the Thirty-first of May 1793, till the Twenty-eighth of July 1794, and of the Scenes which have passed in the Prisons of Paris* (4 vols, London, 1795), vol. 1, pp. 182–93.

5 Avtar Brah, *Cartographies of Diaspora: Contesting Identities* (London, 1996), p. 193.

6 Dominic Aiden Bellenger, "The Brussels Nuns at Winchester 1794–1857," English Benedictine Congregation History Commission Symposium (1999), p. 4; see also Ward, vol. 2, pp. 69–70; Hollinshead, p. 481.

7 Opie, pp. 77–84.

8 *Diary of the Blue Nuns*, pp. 269–74.

9 Ralph W. Sockman, *The Revival of the Conventual Life in the Church of England in the Nineteenth Century* (New York City, 1917), pp. 35–6; *The Parliamentary History of England from the Earliest Period to the Year 1803* (London, 1819), vol. 35, pp. 340–86.

10 Hollinshead, pp. 477–8; *A History of the Benedictine Nuns of Dunkirk*, ed. by the Community (London, 1958), pp. 137–8. Hollinshead, in her research on the Benedictines of Cambrai, insightfully yet briefly contrasts the experience of the Blue Nuns to that of the Benedictines, a contrast that inspired my own investigation into these communities' social histories. See Hollinshead, p. 481.

11 *A History of the Benedictine Nuns of Dunkirk*, p. 127; Claire Walker, *Gender and Politics in Early Modern Europe: English Convents in France and the Low Countries* (New York, 2003), pp. 20–21, 76–7, 94, 124–8. For more on the education of Catholic children during the seventeenth and eighteenth centuries, see G. Holt, "The Education of Catholics from the Act of Uniformity to the Catholic Relief Acts," *Recusant History*, 27/3 (2005): pp. 346–58.

12 Walker, pp. 18–19, 123. The group sent to England returned to the Continent in 1650.

13 *Diary of the Blue Nuns*, pp. ix, xii. Widdrington would later enter the Benedictine cloister in Cambrai where her sister was a nun. Walker, p. 95.

14 *Diary of the Blue Nuns*, pp. ix–xii.

15 Walker, p. 122; *Diary of the Blue Nuns*, pp. 13–14, 17–18, 23–4.

16 *Diary of the Blue Nuns*, pp. 133–89; Walker, p. 93.

17 John Gage Rokewode, "A Brief History of the late English Convent at Paris of the Order of the Conception, commonly called the Blue Nuns, communicated to the Society of Antiquaries" (London, 1839), p. 197.

18 *The Jerningham Letters 1780–1843*, ed. Egerton Castle (2 vols, London, 1896), vol. 1, p. 5; Walker, p. 93; *The English Convents in Exile, 1600–1800*, eds Caroline Bowden, Carmen M. Mangion, Michael Questier, et al. (6 vols, London, 2012–2013), vol. 1, p. xxv.

19 Caroline Bowden, "The English Convents in Exile and Questions of National Identity C. 1600–1688," in David Worthington (ed.), *British and Irish Migrants and Exiles in Europe, 1603–1688* (Leiden, 2010), p. 307.

20 Valerie Irvine, *The King's Wife: George IV and Mrs Fitzherbert* (London, 2005), p. 7.

21 *Diary of the Blue Nuns*, pp. xiii, 14–15, 41, 45–6; Mason, p. 95; Walker, p. 73.

22 Walker, pp. 76–7; Williams, *Letters Containing a Sketch*, vol. 1, p. 182.

23 Carmen M. Mangion, *Contested Identities: Catholic Women Religious in Nineteenth-Century England and Wales* (New York, 2008), p. 33; Elizabeth Rapley, *A Social History of the Cloister: Daily Life in the Teaching Monasteries of the Old Regime* (Montreal, 2001), pp. 104–5. Nigel Aston, *Religion and Revolution in France*

120 *Resistant Virtue in Flight*

1780–1804 (Washington, D.C., 2000), pp. 182, 232. English convents shared in part the experiences of the French teaching monasteries (which were not outlawed until 1792), and the Hospital orders that worked on a provisional basis as late as 1793. Olwen H. Hufton, *Women and the Limits of Citizenship in the French Revolution* (Toronto, 1992), pp. 81–2.

24 Carmen M. Mangion, "Avoiding 'rash and imprudent measures': English Nuns in Revolutionary Paris, 1789–1801," in Caroline Bowden and James E. Kelly (eds), *Communities, Culture and Identity: The English Convents in Exile, 1600–1800* (Aldershot, 2013), p. 250. This is a small number compared to the 55,500 French women religious cited by Claude Langlois, *Le catholicisme au féminin: les congrégations françaises à supérieure générale au XIXe siècle* (Paris, 1984), p. 78.

25 Aston, p. 233; Bellenger, "The Brussels Nuns at Winchester," p. 3, argues that "English-speaking exiles" were targeted by the government, particularly after France declared war on England. Yet English convents had clear advantages over French communities during the early years of the Revolution. See Mangion, "Avoiding 'rash and imprudent measures.'"

26 "Memorial of the English Nuns, Settled at Paris, in the Rue des Fossés, Saint Victor," in *Extract from the Proceedings of the Board of Administration of the District of Douay on the Fourteenth of December*, 1791 (London, n. d.), pp. 15–17.

27 Joan Landes, *Women and the Public Sphere in the Age of the French Revolution* (Ithaca, 1988), p. 107. Landes discusses the irony behind women religious orders' petitions: "they seem to straddle a desire to restore the old system of moral justice and an impulse to assert women's rights within the new system of legal representation." However, aristocratic women exerted political influence in the Old Regime and thus the language of "rights" may not have seemed contradictory to their requests. Landes, pp. 17–38. John G. Alger discusses the Blue Nuns' petition in *Englishmen in the French Revolution* (London, 1889), p. 162.

28 Mangion, "Avoiding 'rash and imprudent measures,'" p. 263. The English Benedictines and Augustinians in Paris petitioned for their pensions after release.

29 *Diary of the Blue Nuns*, p. xvii; Knight Correspondence, DAA to AK, September 21, 1789. Stanbrook Abbey. Wass, Yorkshire.

30 Hufton, pp. 57–8; Cecilia Heywood, "Records of the Abbey of our Lady of Consolation at Cambrai 1620–1793," in Joseph Gillow (ed.), *Catholic Record Society* (London, 1913), p. 27.

31 *Diary or Woodfall's Register*, December 1, 1792, p. 2.

32 *London Evening Post*, October 22–24, 1793, p. 3. The same information is repeated in the *Public Advertiser*, October 24, 1793, p. 5, and the *Star*, October 24, 1793, p. 5.

33 Heywood, pp. 20–31. For more on the Carmelites of Compiègne, see William Bush, *To Quell the Terror: The True Story of Carmelite Martyrs of Compiègne* (Washington, D.C., 1999).

34 *Diary of the Blue Nuns*, pp. xiv–xv, 269–70; Alger, p. 309. The convent prison held over 130 prisoners. Mangion, "Avoiding 'rash and imprudent measures,'" p. 250. See also Dom Denis Agius, "Benedictines Under the Terror 1794–1795," English Benedictine Congregation History Commission (1982), pp. 4–9.

35 *English Convents in Exile*, vol. 6, p. xi.

36 *English Convents in Exile*, vol. 6, pp. xi, 293.

37 *Diary of the Blue Nuns*, pp. xv, xvii, 271; Mason, p. 89.

38 *Diary of the Blue Nuns*, pp. xiii–xv; Mason, pp. 89, 92, 96–7.

39 *Diary of the Blue Nuns*, p. xvii; Mangion, *Contested Identities*, p. 35; Hollinshead, p. 481. As Mangion states, "despite the 1778 and 1791 Catholic Relief Acts, the English nuns were not preparing to return to England any time soon." *English Convents in Exile*, vol. 6, p. 291.

40 Mary Favret, *Romantic Correspondences: Women, Politics and the Fiction of Letters* (Cambridge, 1993), p. 54. With letters of introduction from Charlotte Smith, Wordsworth attempted to visit Williams in Paris in 1791, but she was not at home. It

Resistant Virtue in Flight 121

was not until 1820 that Wordsworth and his sister Dorothy met Williams, a meeting arranged by Crabb Robinson. Angela Keane, *Women Writers and the English Nation in the 1790s* (Cambridge, 2000), p. 49.

41 David Simpson, *Romanticism, Nationalism, and the Revolt Against Theory* (Chicago, 1993), p. 121. Favret comments that Williams was considered "a fallen woman" because of her notoriety. *Romantic Correspondences*, p. 54. Kelly discusses the critical reception of Williams, including criticism of her "inaccuracies." Gary Kelly, *Women, Writing, and Revolution 1790–1827* (Oxford, 1993), p. 78.

42 William Beloe, *The Sexagenarian* (1817). Qtd. in Favret, *Romantic Correspondences*, p. 55.

43 Deborah Kennedy, *Helen Maria Williams and the Age of Revolution* (London, 2002). Book chapters on Williams are found in Keane, pp. 48–80; Favret, *Romantic Correspondences*, pp. 54–95; Kelly, pp. 192–233; Anne Mellor, "English Women Writers and the French Revolution," in Sara E. Melzer and Leslie W. Rabine (eds), *Rebel Daughters: Women and the French Revolution* (New York, 1992), pp. 255–72; Deborah Kennedy, "Benevolent Historian: Helen Maria Williams and Her British Readers," in Adriana Craciun and Kari E. Lokke (eds), *Rebellious Hearts: British Women Writers and the French Revolution* (Albany, 2001), pp. 317–36. Articles include Deborah Kennedy, "Spectacle of the Guillotine: Helen Maria Williams and the Reign of Terror," *Philological Quarterly*, 73/1 (1994): pp. 95–113; Vivien Jones, "Femininity, Nationalism and Romanticism: The Politics of Gender in the Revolution Controversy," *History of European Ideas*, 16/1–3 (1993): pp. 299–305; Mary Favret, "Spectratice as Spectacle: Helen Maria Williams at Home in the Revolution," *Studies in Romanticism*, 32/2 (1993): pp. 273–95.

44 For more on Williams's poetry of sensibility, see Anne Mellor, *Mothers of the Nation: Women's Political Writing in England, 1780–1830* (Bloomington, 2000), p. 10.

45 Kennedy, *Helen Maria Williams*, p. 52.

46 Mellor, *Mothers of the Nation*, p. 9. Jurgen Habermas's *The Structural Transformation of the Public Sphere*, first published in 1962, neglected to analyze the critical role that women played in the development of the public sphere, as feminist critics note. Habermas, *The Structural Transformation of the Public Sphere*, trans. Thomas Burger (Cambridge, 1991). For example, Mellor states that Habermas's "conceptual limitation of the public sphere in England between 1780 and 1830 to men of property is historically incorrect." Mellor, p. 2.

47 Kennedy, *Helen Maria Williams*, pp. 52–3. The campaign to repeal the Test and Corporation Acts, led by dissenting reformers such as the minister Dr Andrew Kippis, did not gain support in Parliament; the Bill was voted down in 1787, 1789, and 1790. For a discussion on the ways in which pro-Catholic legislation reduced restrictions for Catholics in England while continuing to limit their involvement in civil society, see Michael Tomko, *British Romanticism and the Catholic Question: Religion, History and National Identity, 1778–1829* (New York, 2010), pp. 16–22.

48 Williams, *Letters Containing a Sketch*, vol. 2, p. 174.

49 Favret, *Romantic Correspondences*, pp. 30, 24.

50 Keane, p. 49; Kelly, p. 78. See also Robert D. Mayo, *The English Novel in the Magazines, 1740–1815* (Evanston, 1962), p. 259. Mayo claims that Williams was "perhaps the best-known contemporary author to magazine writers of her generation."

51 Hester Thrale Piozzi, "To Penelope Pennington," November 4, 1793, in ed. Oswald Knapp, *The Intimate Letters of Hester Piozzi and Penelope Pennington, 1788–1821* (London, 1914), p. 92. I will be following Williams's sequencing with both titles and volumes.

52 Favret, *Romantic Correspondences*, pp. 54, 24–5, 63.

53 Laetitia Hawkins, *Letters on the Female Mind, its Powers and Pursuits: Addressed to Miss H.M. Williams, with Particular Reference to her Letters from France* (2 vols, London, 1793), vol. 2, pp. 182–3.

54 Janet Todd, "Introduction," in Janet Todd (ed.), *Letters from France* (2 vols, Delmar: 1975), vol. 1, p. 7.

122 *Resistant Virtue in Flight*

55 Kennedy, *Helen Maria Williams*, p. 116; Favret discusses Hawkins's renunciation of Williams in *Romantic Correspondences*, p. 54. See *Critical Review*, 14 (1795): p. 361.

56 Mary Wollstonecraft, "December 24, 1792," in Ralph M. Wardle (ed.), *The Collected Letters of Mary Wollstonecraft* (Ithaca, 1979), pp. 225–6.

57 Kennedy, *Helen Maria Williams*, p. 94.

58 *A Complete History of the Invasions of England* (London, 1801); Kennedy, "Benevolent Historian," pp. 325–6; Kennedy, *Helen Maria Williams*, pp. 115–16.

59 Mary Jacobus, "Incorruptible Milk: Breast-Feeding and the French Revolution," in Sara E. Melzer and Leslie Rabine (eds), *Rebel Daughters: Women and the French Revolution* (New York, 1992), p. 63.

60 Keane, p. 5.

61 Helen Maria Williams, *Letters Written in France in the Summer of 1790, to a Friend in England: Containing Various Anecdotes Relative to the French Revolution; and Memoirs of Mons. and Madame DuF——*, 2nd edn (4 vols. London, 1792), vol. 1, p. 113; Matthew Bray, "Helen Maria Williams and Edmund Burke; Radical Critique and Complicity," *Eighteenth Century Life*, 16/2 (May 1992): p. 12.

62 Williams, *Letters Written in France*, vol. 1, pp. 118–20; Kennedy, *Helen Maria Williams*, p. 61; Bray, p. 7, discusses this episode as a commentary on pre-Revolutionary France.

63 Williams, *Letters Written in France*, vol. 2, pp. 122–3; Nicola Watson, "Novel Eloisas: Revolutionary and Counter-Revolutionary Narratives in Helen Maria Williams, Wordsworth and Byron," *Wordsworth Circle*, 23/1 (1992): p. 19. Favret discusses this section in terms of Williams's evocation of Pope's "Eloisa," languishing for her lover Abelard, and the nun in the *Lettres portugaises*, two depictions that accord with Williams's sense that women's natural sphere is in the world. *Romantic Correspondences*, p. 76. Kelly describes Williams's narrative agenda in these terms: "Specific Revolutionary legislation enables the subjective absolute of romantic love to triumph over social 'prejudice' produced by a false political and social structure." Kelly, p. 46.

64 *Argus*, March 18, 1790, p. 3; *English Chronicle or Universal Evening Post*, April 27–29, 1790, p. 2; Hufton, p. 61.

65 Knight Correspondence, DC to AK, December 28, 1789. Stanbrook Abbey. Wass, Yorkshire; *London Chronicle*, August 11–14, 1792, p. 4. The same is reported in the *Star*, August 13, 1792, p. 2.

66 Hufton, p. 56.

67 Hufton, pp. 57, 164; Gérard Cholvy, "Revolution and the Church: Breaks and Continuity," *Concilium*, 201/1 (1989): p. 53.

68 Landes, p. 107.

69 Gemma Betros, "Liberty, Citizenship and the Suppression of Female Religious Communities in France, 1789–90," *Women's History Review*, 18/2 (2006): pp. 315–17.

70 Quoted in Rapley, *A Social History of the Cloister*, p. 101.

71 Mita Choudhury, *Convents and Nuns in Eighteenth-Century French Politics and Culture* (Ithaca, 2004), p. 167.

72 *Critical Review*, ed. Tobias Smollett, 14 (1795): p. 362; Williams, *Letters Containing a Sketch*, vol. 1, p. 2. The scholarly focus on Williams's first series, *Letters Written in France*, has obscured her positive commentary on women religious and the attention from reviewers that her next series elicited. See *Universal Magazine*, 97 (1795): pp. 51–5; *English Review*, 28 (1796): pp. 142–3; *Monthly Review*, eds Ralph Griffiths and G.E. Griffiths, 21 (London, 1796): pp. 325–6; *Analytical Review*, 22 (London, 1796): pp. 137–45.

73 Kennedy, *Helen Maria Williams*, p. 110.

74 Williams, *Letters Containing a Sketch*, vol. 1, p. 7.

75 *European Magazine and London Review*, ed. John Bannister, 28 (1795): pp. 39–44.

76 Keane, p. 75; *Critical Review*, ed. Tobias Smollett, 14 (London, 1795): pp. 362–5.

77 Williams, *Letters Containing a Sketch*, vol. 1, p. 8.

Resistant Virtue in Flight 123

78 While Williams was imprisoned until the end of November, the Blue Nuns were removed to the Augustinian convent in Paris on November 14, suggesting that the British nationals at the convent of the Blue Nuns remained longer than the nuns themselves. *Diary of the Blue Nuns*, p. xv.

79 *Diary of the Blue Nuns* reports only nineteen members at this time, although the novice, Elizabeth Barrow, may be part of Williams's count, as well as female boarders. *Diary*, p. xiv. The Augustinians were the only English nuns who remained in their Paris home through the war. They also presented their case to the National Assembly, arguing that their estate had been purchased as a private establishment. See the "Memorial of the English Nuns," pp. 15–18.

80 Williams, *Letters Containing a Sketch*, vol. 1, pp. 182–3.

81 Sarah Scott, *Millenium Hall*, ed. Gary Kelly (Ontario, 2001).

82 Williams, *Letters Containing a Sketch*, vol. 1, pp. 184–5.

83 Williams, *Letters Containing a Sketch*, vol. 1, pp. 185–6.

84 Hester Thrale Piozzi, *French Journal, 1775*, in Moses Tyson and Henry Guppy (eds), *The French Journal of Mrs Thrale and Doctor Johnson* (Manchester, 1932), pp. 136–7.

85 Mason, p. 99; Thrale Piozzi, p. 105, emphasis hers; Walker, p. 61; See Walker, p. 30 for more information on nuns' socio-economic status.

86 Mason, p. 101.

87 Williams, *Letters Containing a Sketch*, vol. 1, p. 183.

88 Williams, *Letters Containing a Sketch*, vol. 1, pp. 183–4.

89 Mangion, "Avoiding 'rash and imprudent measures,'" p. 247.

90 Choudhury, p. 170; Hufton, p. 115.

91 Williams, *Letters Containing a Sketch*, vol. 1, p. 183; Hufton, p. 125. Other English houses experienced similar disruptions. See Mangion, "Avoiding 'rash and imprudent measures.'" The Benedictines in Paris, located nearby the Bastille, cautiously maintained their daily routines, offering refreshments to groups of citizens surrounding their convent in order to mitigate the possibility of violence. In 1793 authorities searched the premises for "French writings" and concealed priests. On October 3, the commissioners made a fourth visit, putting the nuns under arrest and accusing them of "holding assemblies." By November 8, most of the convent's valuables were taken and another visit at the end of the month resulted in the destruction of crosses, artwork, shrines, and other ornaments. Although they were promised that only aristocratic females would be lodged at their convent, this promise was soon broken. The nuns continued to make do, "appearing in . . . religious dress" until December 29. The following July these women were imprisoned at the Castle of Vincennes, and finally were incarcerated at the convent of the English Augustinians in the rue des Fossés St Victor. Upon their release in 1795, the Benedictines sold off their remaining valuables and left for England, eventually settling at Colwich in Staffordshire. Alger, pp. 301–9.

92 Williams, *Letters Containing a Sketch*, vol. 1, pp. 190–92.

93 Knight Correspondence, AK to DAJ, December 14, 1792. Stanbrook Abbey. Wass, Yorkshire.

94 *Diary of the Blue Nuns*, pp. xiv–xv.

95 *European Magazine and London Review* 28 (1795): p. 39; *Britannic Magazine; or Entertaining Repository of Heroic Adventures and Memorable Exploits*, 5/58 (1797): pp. 48–50.

96 Williams, *Letters Containing a Sketch*, vol. 1, p. 192.

97 While Duffield and Aston rejoined the community upon its arrival in England in 1800, only to leave again around 1805, Lonergan never returned, choosing rather to resettle with her family in Ireland until her death in 1838. Mason, pp. 96–7, 111. Gillow and Trappes-Lomax are inconsistent in their treatment of Lonergan, stating that she returned to England both in 1794 and 1795 in *Diary of the Blue Nuns*, pp. xv, 384. They also state that Duffield did not rejoin the community in England, p. 350,

124 *Resistant Virtue in Flight*

 although Mason indicates she did, pp. 96–7. Although she did not rejoin the order, Lonergan outlived all of the professed nuns, even those who joined other groups in the tumultuous years of the Revolution and emigration. Mason, pp. 96, 118.

98 Williams, *Sketches of the State of Manners and Opinions in the French Republic* (London, 1801), vol. 1, p. 65.

99 Williams, *Letters Containing a Sketch*, vol. 1, pp. 133–5, 184.

100 Williams, *Letters Containing a Sketch*, vol. 1, pp. 195–201; Kennedy, *Helen Maria Williams*, pp. 117–18.

101 *Monthly Review*, 19 (1796): p. 336; *European Magazine and London Review*, 28 (1795): pp. 40–41. Catalogued under "History" in the *Analytical Review*, after excerpting Williams's story of Madame Roland, a review appears of Roland's *An Appeal to Impartial Posterity*, a collection of writings by Roland in prison and assembled by her daughter, a positioning that suggests that the editors knew what readers would want to pursue after having read the Madame Roland excerpts reprinted from Williams's work. *Analytical Review*, 22 (1796): pp. 137–52.

102 Madelyn Gutwirth, "The Engulfed Beloved: Representations of Dead and Dying Women in the Art and Literature of the Revolutionary Era," in Sara E. Melzer and Leslie W. Rabine (eds), *Rebel Daughters: Women and the French Revolution* (New York, 1992), pp. 198–227. Gutwirth discusses the popularity of the dead and dying young woman in men's artistic representations during the French Revolution.

103 Williams, *Letters Containing a Sketch*, vol. 2, pp. 35, 70–72.

104 Williams, *Letters Containing a Sketch*, vol. 1, pp. 121, 214. Keane suggests that Williams's "character sketches and execution reportage" are styled "after the iconography of martyrdom," p. 74.

105 Williams, *Letters Containing a Sketch*, vol. 2, p. 13–14.

106 Williams, *Letters Containing a Sketch*, vol. 2, pp. 66–9.

107 Kennedy, *Helen Maria Williams*, p. 196.

108 Helen Maria Williams, *Sketches of the State of Manners and Opinions* (2 vols, London), vol. 2, pp. 54, 56. In *Souvenirs* Williams lists her own gains on the front of the Revolution, one of which was her effective persuasion of a young girl not to enter a cloister after the Restoration. Kelly, p. 224.

109 Helen Maria Williams, *Souvenirs de la Révolution française*, trans. Charles Coquerel (Paris, 1827), p. 72. For more on Williams's sense of the setbacks women incurred during the Revolution, see pp. 121–2.

110 Williams, *Sketches of the State of Manners and Opinions*, pp. 59, 63.

111 Only the Augustinians in Paris, the community with which Thrale Piozzi spent the majority of her time, actually remained in France during and after the Revolution. The Augustinians of Bruges were also able to solidify their resources and return to Belgium in 1803. Mother Bernard Green, in constant contact with the English Augustinian nuns in Paris, states that the purchaser of their convent paid off the French government, allowing the nuns to buy back the property. The Blue Nuns, on the other hand, could not buy back their convent since Mr Gillett was in debt, according to the convent's tenants. Mason, pp. 93–4.

112 Mason, p. 104; *Diary of the Blue Nuns*, pp. vii, xi.

113 Kirsty Carpenter, *Refugees of the French Revolution: Emigrés in London, 1789–1802* (New York, 1999), p. 34. Mangion asserts that "the so-called tolerance of catholicity may have reflected more an antipathy for the French government and the revolutions in France than an acceptance for Catholicism or religious life." *Contested Identities*, p. 34.

114 Knight Correspondence, AK to DAJ, December 14, 1792. Stanbrook Abbey. Wass, Yorkshire.

115 Heywood, pp. 30–31; Hollinshead, pp. 461, 465; *In a Great Tradition: The Life of Dame Laurentia McLachlan, Abbess of Stanbrook by the Benedictines of Stanbrook* (New York, 1956), p. 42.

116 Mason, pp. 89, 95. For a description of their habit in their rule, see *Diary of the Blue Nuns*, pp. 310–11. The sky blue mantle represented "the soul of the Glorious Virgin,

Resistant Virtue in Flight 125

being chosen to be the singular Bed-chamber of the King of glory, and was from her first creation made wholly Celestial."

117 See Hollinshead, pp. 89–122; for a list of benefactors who provided accommodations, see Ward, vol. 2, pp. 116–18, 121–6, 128–9.

118 Bellenger, "Brussels Nuns at Winchester," p. 5.

119 Hollinshead, pp. 468–81.

120 Mark Bence-Jones, *The Catholic Families* (London, 1992), pp. 88–9; Hollinshead, pp. 476–7, 481; Sister Scholastica Jacob, Stanbrook Abbey, Wass, Yorkshire (Personal Communication, June 29–30, 2011).

121 *The Jerningham Letters*, vol. 1, p. 170.

122 Mason, pp. 89–90, 101. Lady Jerningham did not secure their home in Norwich until Easter, at which time she took them to Cossey Hall while the house was being prepared. They did not inhabit the home until July. *Diary of the Blue Nuns*, pp. xv–xx.

123 Mason, p. 96–7; *Diary of the Blue Nuns*, p. 384.

124 Mason, pp. 95, 104.

125 Mason, pp. 91–2, 104; Irvine, p. 7; Bence-Jones, p. 51. The French Augustinian community with which Stafford remained was also known as *Les Filles Orphelines*. Rokewode, p. 204.

126 Matilda Betham, *Poems and Elegies*, ed. Donald H. Reiman (New York, 1978), pp. v–vii; Opie, pp. 77–84.

127 *Diary of the Blue Nuns*, pp. 269–72.

128 *Diary of the Blue Nuns*, pp. 271–4; Mason, p. 90.

129 *Diary of the Blue Nuns*, pp. 271–2; Mason, pp. 111–12.

130 *Diary of the Blue Nuns*, p. xix.

131 Mason, pp. 96–7, 110–11, 117–18. Sister Mary Joseph (Elizabeth Edwards) went to the Franciscan community at Winchester in 1805; Sister Mary Catherine (Ann Kirby), went to the Bridgettines in Lisbon. Sister Anne Duffield and Sister Lawrence Aston, who had returned to England in 1795, rejoined the Blue Nuns' community in 1800 and left around 1805.

132 Mason, pp. 111–14; Sister Simpson lived until 1822, resettling with her nephew in Woolton, Lancashire, near the Benedictine nuns from Cambrai. The 1822 *Liverpool Mercury* recorded her death at the age of 80, noting she was "one of only four survivors of the community." *Liverpool Mercury*, March 29, 1822. Cited in Hollinshead, p. 481

133 Mason, pp. 95, 104; *Diary of the Blue Nuns*, pp. 273–4.

134 *Diary of the Blue Nuns*, pp. vii, xi; Rokewode, p. 203.

135 *Diary of the Blue* Nuns, pp. vii, xv–xx, 350–51; Rokewode.

136 *Parliamentary History of England*, vol. 35, pp. 341–4, 383–4; Elizabeth Lady Holland, *The Journal of Elizabeth Lady Holland* (1791–1811), ed. Earl of Ilchester (2 vols, London, 1908), vol. 2, p. 79.

137 *Parliamentary History of England*, vol. 35, pp. 360, 364, 369–70, 373–5.

138 *Parliamentary History of England*, vol. 35, pp. 356–7.

139 *Parliamentary History of England*, vol. 35, pp. 350, 377–8.

140 *Parliamentary History of England*, vol. 35, pp. 366, 373–4.

141 Sockman, p. 36. Sockman's discussion of the Bill is found on pp. 31–6. Sockman states that Catholics took an active role in persuading the House of Lords to defeat the Bill. For press coverage, see *The Times*, June 24, 1800; *The London Packet or New Lloyd's Evening Post*, June 23–25, 1800, p. 1, which covered the House of Commons debate; *The Times*, July 11, 1800, p. 2, which picked up the House of Lords debate. See also Ward, vol. 2, pp. 201–10.

142 Susan O'Brien, "Religious Life for Women," in V. Alan McClelland and Michael Hodgetts (eds), *From Without the Flaminian Gate: 150 Years of Roman Catholicism in England and Wales 1850–2000* (London, 1999), p. 112; Susan O'Brien, "Terra Incognita: The Nun in Nineteenth-Century England," *Past and Present*, 121 (1988): p. 120.

4 Refugee Resources and Competitive Curricula

Frances Burney, Charlotte Smith, and the Augustinians of Bruges

> Driven from house and home, despoiled of dignities and honours, abandoned to the seas for mercy, to chance for support, some old, some infirm, all impoverished? With mental strength alone allowed them for coping with such an aggregate of evil!
>
> Frances Burney, *Brief Reflections Relative to the Emigrant French Clergy*, 1793

Frances Burney's impassioned call for assistance on behalf of religious refugees calls attention to the struggles that made migration so challenging, struggles that are threaded throughout refugee accounts: dependency on others for direct support, old age, sickness, and poverty. The story of the Blue Nuns represents a striking example of the collision of such forces, which ultimately resulted in the demise of their community. Although they had floundered in their attempts to open a school out of their Norwich home, other refugee groups successfully supplemented their limited incomes by opening schools for girls. In 1794, the English Augustinians of Bruges opened their doors to students a mere month after settling into Hengrave Hall near Bury St Edmunds in Suffolk.[1] Similarly, the English Benedictines of Dunkirk, installed in the Hammersmith convent in 1795, were enrolling students within the next year.[2] In fact, priests and nuns quickly entered the competitive market for children's schooling: they opened schools, recruited students, and advanced a variety of curricular options.[3] By the end of the century, nuns' educational and religious endeavors had sparked national concerns about their potential recruitment of both working class and Protestant students, as well as young women into the convent's novitiate.[4]

As refugees used their skills as educators to sustain themselves, women writers wove the project of refugee aid into educational agendas for young women. Frances Burney and Charlotte Smith promoted young women's engaged reflection upon the religious and political histories informing current social problems. Drawing on a legacy of women's work in social aid and inspired by the migration of thousands of French exiled clerics to Great Britain, Burney's *Brief Reflections Relative to the Emigrant French Clergy* (1793) advocates girls' inclusion in the public work of refugee relief.[5] Burney's plea to mothers explicitly frames this

Refugee Resources and Competitive Curricula 127

work as imitative of religious sisters, a bold move that puts Protestant women and their daughters into a comparative civic role as Catholic religious.

Smith, a political radical and an unlikely advocate for Catholic priests, followed Burney's lead with a work of young adult fiction, *Rural Walks: In Dialogues. Intended for the use of Young Persons* (1795).[6] In this text, Smith puts the process of young adult education into dialogue with the contemporary political crisis of the French Revolution: women educators are given responsibility for broadening girls' education to include an historical understanding of the political processes that initiate and intensify poverty. Smith's socially responsive curriculum emphasizes a deeper understanding of the types of social and political unrest that cause displacement of groups and individuals, inquiry typically reserved for boys.[7]

Smith, in contrast to Burney, proposes sustainable methods of refugee aid by promoting the employment of émigré priests as tutors for young women and children, and suggesting that collaboration with refugees is mutually beneficial. *Rural Walks* represents refugees as active participants in England's work force. Beyond this, Smith depicts émigré priests advancing English Protestant children's education, the very thing that opponents of Catholic schooling feared. Whether they were debilitated (as Burney viewed them) or employable (as Smith posited), the presence of migrants raised serious concerns about how the nation could support them when so many native Britons were impoverished: would refugees provide a new labor market or further drain the country's resources?[8] Furthermore, although Smith's portrayal of an émigré priest points to their resourcefulness in gaining employment, it is important to realize that they were entering into direct competition with a variety of other educators—including foreign and English nuns—almost as soon as they arrived in England.

Burney's and Smith's texts explore these contemporary dilemmas in relation to the Gordon Riots and the monastic dissolution during the English Reformation, respectively. Smith complicates the study of history by delineating the differences between the French Revolution and the English Reformation, whereas Burney argues that the deaths and injuries inflicted upon British Catholics during the Gordon Riots of 1778 compel her readers to assist French religious in the present. Both writers' emphasis on historical analysis and reflection challenged eighteenth-century norms for girls' education, in which social deportment was valued over critical thinking.[9]

While writers took on the work of social advocacy through their pens, nuns put their own resources to work. They were facing the challenges of social integration in a Protestant country and, since they wished to maintain enclosure as much as possible, this was a delicate negotiation. Despite their presence in England, nuns appear only at the periphery of Burney's text—their agency a thing of the past, their communities dispersed—and they are altogether invisible in Smith's narrative. However, the impact of nuns' work coordinating refugee assistance during the Revolution and contributions to British education upon immigration should not be overlooked.

128 *Refugee Resources and Competitive Curricula*

Frances Burney and Resources for Refugees

Although several communities of nuns had already arrived by 1794, French clerics were by far the most visible refugee group in Britain.[10] An estimated 1,500 French priests lived in London alone; by 1800, over 5,000 priests resided in England, some 4,000 of them receiving government aid. The Emigrant Relief Committee—the administrative bureaucracy necessary to priests' survival—also became a means of surveilling their behavior and curtailing their movement within England, provoking what Dominic Aidan Bellenger has described as an isolationist mentality among exiles. Indeed, after the Concordat of 1801 and the restoration of the French monarchy in 1815, the vast majority of these priests returned to their homeland.[11]

Nuns, although also recipients of some state aid, were dependent upon private patronage; they utilized their social networks to whatever advantage they could. Public attention, particularly following the spectacularly bloody September Massacres of 1792, was focused primarily on the thousands of priests who arrived over the course of the next year (priests' rates of migration dipped and swelled several times over the course of the decade).[12] Less visible than priests, nuns also elicited far less attention, enabling more freedom of movement and time to reestablish their lives in ways that minimized the likelihood of their return to the Continent.

Burney's investment in the plight of émigrés was personal: befriending a group of French aristocratic exiles who were leasing Juniper Hall near the village of Mickleham, Burney took French lessons from a dashing career soldier, Alexandre d'Arblay, who hailed from Joigny, Burgandy. These "French *papishes*," as William Locke, who lived nearby in Norbury Park referred to them, included the ex-Minister of War, Louis de Narbonne, Germaine de Staël (whose reputation raised the eyebrows of Burney's family), and d'Arblay with whom Burney fell in love and married in July of 1793. The match met with the disapproval of Burney's father due to d'Arblay's politics, reduced economic prospects, and Catholicism.[13]

With their young son, the d'Arblays moved to France in 1802, where they sojourned for a decade.[14] Afterward, Burney wrote *The Wanderer* (1814), a novel depicting the plight of an English Protestant woman who is exiled from the Continent during the Revolution and returns to Britain only to find herself in a position of economic and social marginalization very similar to that of the refugee nuns for whom she is mistaken.[15] Given her personal history, it is perhaps unsurprising that Burney's writings, both before and after *Brief Reflections*, demonstrate a sustained concern for the struggles of refugees, both men and women.

Burney's highly political position threatened her reputation as a writer. As Margaret Anne Doody points out, publishing *Brief Reflections* was an especially daring move in light of Burney's marriage to d'Arblay, which had already thrown her Protestant leanings into question. Considered a "charity sermon" by reviewers, it was her only written "entry into public life, into . . . the political arena." Because contributions to the Wilmot Committee had dwindled by 1793, Burney

Figure 4.1 Madame d'Arblay (1840).
Source: The Trustees of the British Museum.
Print by Charles Turner after Edward Francis Burney, *Madame d'Arblay*, 27.9 × 22.6 cm, mezzotint etching on paper, 1840, British Museum, London.

took on the challenge of amassing aid for French priests, writing her pamphlet on behalf of a committee of women under the direction of Mrs. Crewe.[16] Burney's *Brief Reflections* promoted "FEMALE BENEFICENCE" as an overlooked but significant "resource" for the French emigrants. Susan Wolfson describes this "beneficence" as a kind of "chivalric maternal compassion."[17]

130 *Refugee Resources and Competitive Curricula*

In *Brief Reflections*, Burney harnesses the same rhetoric of lawful ownership found in Edmund Burke's *The Case of the Suffering Clergy in France* (1792), asking whether priests' "violated rights [will] terminate in the death of hunger?" Burney's argument that the concerns of the "most retired part of mankind" penetrated even "domestic peace," filling "mothers, wives, and children with solicitude irresistible," illustrates the enormous hold that the refugee crisis had upon the popular imagination of the time. Burney called upon women—a hitherto untapped resource—to donate to the cause of the French emigrants in the place of "heads of houses and masters of families," because many families had already given monetary contributions to the Wilmot Committee.[18] She thus directly engages women in the national project of émigré aid, asking them to consider themselves as active citizens and to share in the struggles brought on by the Revolutionary Wars.

Condemning philanthropy that is "the short-lived offspring of curiosity," a kind of giving that springs from "novelty" rather than a deep commitment to the amelioration of social ills, Burney outlines two pathways for Britain in the hopes of spurring readers to social action. The first—the path of inaction—is possible only in an uncivilized and ungenerous nation. The other involves the active participation of Burney's readers during the crisis.[19] Confident that the government will soon provide "more permanent provision for these pious fugitives," Burney proposes that, in the meantime, women become "participating citizens," assuaging the interim needs of refugees.[20] Burney encourages women to inhabit more fully their unique mothering role in the public sphere, calling upon them to nurture the exiles with "Philanthropy–that *soft milk of human kindness*, that benign spirit of social harmony . . . and receiving in bosom-serenity all solace."[21] Women play a central role in the national project of offering mental and physical rehabilitation for refugee priests.

Dispersal and integrity are two concepts that Burney weaves throughout the work, recalling Barruel's interest in assembling a coherent narrative of refugee exile after expulsion from France and positive reception in Britain. The object of her pamphlet, "to preserve" the French clergy, casts Britain, and British women in particular, into the role of mitigating émigrés' losses. Furthermore, drawing on the trope of corporeal dissolution, as a metaphor for communal dispersal, Burney declaims: "Come forth, then, O ye Females, blest with affluence! Spare from your luxuries, diminish from your pleasures, solicit with your best powers; and hold in heart and mind that, when the awful hour of your own dissolution arrives, the wide-opening portals of heaven may present to your view these venerable sires, as the precursors of your admission." Reunited in heaven, the "venerable sires" will testify to British women's charity to them during the tumultuous years of the Revolution.[22]

Burney invokes the "dissolution" of the human body in a very literal way, lamenting the fate of French clerical prisoners, approximately 230 of whom were slaughtered at the *L'Eglise des Carmes* in Paris at the onset of the September Massacres of 1792.[23] Burney calls attention to this particular episode in order to evoke the compassion of her readers, imagining how England might have been a Heaven-on-earth for these deceased priests:

Refugee Resources and Competitive Curricula 131

[H]ad pitying Heaven but spared the final blow, and snatching them from their dread assassins, cast them, despoiled, forlorn, friendless, on this our happy isle, with what transport would we have welcomed and cherished them! Sought balm for their lacerated hearts, and studied to have alleviated their exile, by giving to it every character of a second and endearing home. Our nation would have been honoured by affording refuge to such perfection; every family would have been blessed with whom such pilgrims associated; our domestics would have vied with each other to shew them kindness and respect; our poor would have contributed their mite to assist them; our children would have relinquished some enjoyment to have fed them.[24]

Burney's hypothetical portrayal of the warm reception these men could have enjoyed in England is framed by her gruesome and detailed depiction of the slaughter of this "pious fraternity"—"sufferers whose story we could not read without tears, martyrs that remind us of other days"—at the hands of men who, with "fiend-like ferocity," commit sacrileges that "invade the sacred abode," leaving "Mangled carcasses strew[n upon] the sacred ground." The violent penetration of sacred space, a trope also used by Barruel and Williams, is the equivalent of death: the complete loss of integrity, both personal and communal. Certainly, since the nation itself was in danger of similar invasions, it should work to preserve the lives of these "banished men."[25]

Writers seeking assistance on behalf of refugees tended to compliment readers' sympathy for the refugees, bringing readers directly into the narrative of public assistance, since, according to Doody, migrating French clergy were not warmly received by most; only in special circles were they regarded highly. There was always a degree of suspicion among the British that French spies could be posing as emigrants. Burney "flatters her readers while arguing them out of national prejudice and English chauvinism," Doody explains.[26] Choosing poverty over protection in refusing to take the Constitutional Oath while yet in France, priests have now arrived in a sympathetic "asylum" to "rest [their] weary limbs," to "Calm . . . [their] harassed spirits, repose [their] shattered frames."[27] England is the space for such rest, though perhaps not for rejuvenation.

Remembering history to imagine the future, Burney's work uses reflective mechanisms to advocate positive change: "Already we look back on the past as on a dream . . . wild in its horrors . . . [t]he future—the consequences—what judgment can pervade? The scenery is so dark, we fear to look forward." Burney reminds her readers of the "murdered martyrs" in England—most likely a reference to the Gordon Riots of 1780, a backlash against the Catholic Relief Act of 1778.[28] The Gordon Riots initiated a series of violent episodes in London, which targeted Catholics and those who supported the Relief Act. Appealing to her readers' consciences, Burney suggests that righting the wrongs done to the French clergy would absolve Britain of its former wrongdoings. She thus actively appeals to women's sense of justice in recalling a recent example of unjust treatment of British Catholics by fellow Britons.

132 *Refugee Resources and Competitive Curricula*

In prompting such historical reflection, Burney challenges her readers to contemplate their role in ameliorating the contemporary refugee crisis. If the nation can be a safe haven for exiles, it is up to readers to ensure that French priests will not find Britain "an inhospitable and hard-hearted place," the "wrong country," according to Doody.[29] Burney thus asks a central question: how will women—and all citizens—write this national narrative? In a footnote that nearly swallows the page, Burney further gives women the agency to answer this question. She justifies women's public involvement in philanthropy by comparing their work to that of French religious sisters who "had the happiness, in former and better times, of exercising a charity as decisive for life or death as that which the females of Great Britain are now conjured to perform."[30] Though the agency of women religious is currently disabled, like that of their clerical brethren, Burney draws quite purposefully on such a legacy of women's collaborative philanthropy.

Significantly, in the footnote, Burney references the Daughters of Charity, a women's congregation founded in 1633 by St Vincent de Paul and Louise de Marillac. De Paul instituted the Foundling Hospital of Paris to care for, educate, and nurse French orphans.[31] Burney makes it clear that just as de Paul's sorority had the power to determine the fate of orphaned children, so do British women hold in their hands the fortunes of the orphaned French émigrés. Burney quotes de Paul himself: "You are their judges—pronounce, then, their fate; do you ordain them to live? Do you doom them to die?" Thus, British women, single and married, should choose to inhabit an analogous civic position to that once occupied by their Catholic counterparts abroad.[32]

In addition to explicitly comparing the work of British women's charity towards émigrés to that of women religious, Burney positions her appeal and women's work on behalf of the clergy as acts worthy of national remembrance: "female tradition will not fail to hand down to posterity the formers and protectresses of a plan which, if successful, will exalt for ever the female annals of Great Britain." And beyond simply passing down to subsequent generations a national legacy of female benevolence (much like the more personal legacy that Lady Jerningham wished to create of her family's kindness towards the Blue Nuns), Burney also claims that benefactors' "accounts . . . will be settled elsewhere"; indeed, the "happy donors" who support this plan will be admitted to heaven by the very clergy they are assisting. To address donors' more mundane concerns, Burney reassures them that though the money will "be paid into foreign hands," it will be spent entirely in Britain.[33]

Burney's dual interest, training girls in charitable giving towards the poor and promoting historical reflection, was shared by other educational theorists, although the degree to which girls needed to understand history was a matter up for debate. Hester Chapone's *Letters on the Improvement of the Mind Addressed to a Young Lady*, first published in 1773, went through 16 editions by 1800. It directs young women to learn economic management, including charitable giving; it also outlines appropriate ways for girls to acquire languages and geography, but encourages only a basic knowledge of history. According to Chapone, the study of history informs judgment, provides material for conversation, and widens

Refugee Resources and Competitive Curricula 133

one's views of human nature. But, she explicitly warns that girls should not study several different histories at once since this only "distracts and confounds" the memory. Instructing girls that they "will not read with a critical view, nor enter deeply into politics," Chapone envisions a carefully controlled educational environment designed to turn young women into wives and moralists, rather than critical thinkers performing a public service.[34]

In general, social deportment was highly emphasized in school curricula for girls, and learning the value of charitable practices was one aspect of proper sociability.[35] Chapone shared Burney's conviction that girls should engage in charitable practices and in *Letters on the Improvement of the Mind* she highlights one group particularly worthy of girls' benevolence: "they who are fallen into indigence from circumstances of ease and plenty."[36] Mary Wollstonecraft, highly impressed with Chapone's work, lists "forbearance and liberality" as key features of girls' education in benevolence in *Thoughts on the Education of Daughters* (1787). Wollstonecraft states that "children should be taught everything in a positive way; and their own experience can only teach them afterwards to make distinctions and allowances." Mothers should lay out a "fixed stipend" for girls to engage in acts of charity so that "the short-lived emotions of pity [are] continually retraced 'till they grow into habits."[37]

Likewise, Hannah More explicitly links the education of girls in philanthropic practice to refugee assistance in *Considerations on Religion and Public Education* (1794), first published under the title *Remarks on the Speech of M. Dupont, on the Subjects of Religion and Political Education* (1793). In this text, More appeals to the nation at large to bestow its sympathy upon and donate monies to the impoverished French clerics.[38] Her commitment to ameliorating social ills had led More and her sister Patty into the field of girls' elementary education: in the 1790s, they opened multiple schools in the Mendips in Somerset. Their aim was to spread literacy and Evangelical Christianity, while protecting children from the supposed dangers of radical political thought.[39]

More targets women and girls specifically in the first section of *Remarks on the Speech of M. Dupont*, titled *A Prefatory Address to the Ladies, &c. of Great Britain and Ireland, In Behalf of the French Emigrant Clergy*. This text encourages the reader to reconsider her domestic expenditures on food and entertainment: "by retrenching one costly dish from her abundant table, the superfluities of one expensive dessert, one evening's public amusement, she may furnish at least a week's subsistence to more than one person." But More's proposals do not end with this mere appeal that women forgo some portion of their domestic luxuries; she suggests that the condition of the French clergy should lead to a reconsideration of the entire household economy, including the material goods of daughters:

> Even your young daughters, whom maternal prudence has not yet furnished with the means of bestowing, may be cheaply taught the first rudiments of charity, together with an important lesson of economy: They may be taught to sacrifice a feather, a set of ribbons, an expensive ornament, an idle diversion. And if they are thus instructed, that there is no true charity without self denial,

134 *Refugee Resources and Competitive Curricula*

they will *gain* more than they are called upon to *give*: For the suppression of one luxury for a charitable purpose, is the exercise of two virtues, and this without any pecuniary expense.[40]

Thus More directs mothers to inculcate in their daughters a philanthropic sensibility and sympathy for others, encouraging the perpetuation of a culture of female-initiated philanthropy. Wolfson identifies More's dominant tropes: "Maternal care is the national example, to daughters and to the world, . . . Christian Britain . . . will be famed for mothering the orphans of France."[41] In figuring priests as orphans, More renders it acceptable for women to help them through domestic retrenchments, while neutralizing the potential political dangers involved in working with Catholic priests in person. More's pamphlet was successful in earning money for the distressed emigrants: her appeal brought in £240 on behalf of the relief efforts of the Wilmot Committee.[42]

More's and Burney's political pamphleteering asks young women to assume a kind of public work. To achieve her ends, Burney juxtaposes the current émigré crisis with a recent example of anti-Catholic violence in Britain; she also places middle- and upper-class British women in a service role equivalent to that of nuns. Smith pushes these issues even further, depicting ways that citizens could collaborate with the socially useful émigrés who were entering into Britain's work force. She also explores means of providing young women with a more comparative and nuanced understanding of the social forces—historical and political—that underwrite refugee displacement.

Charlotte Smith: Reciprocal Aid as Innovative Curricula

A political radical, Smith initially supported the Revolution, though, like other Romantic writers, such as William Wordsworth and Helen Maria Williams, she modified her views after the escalation of revolutionary violence and the subsequent French immigration to England. In response to the French government's targeting of clerics, Smith wrote: "It seems to me wrong for the Nation entirely to exile and abandon these Unhappy Men." Smith also sheltered, housed, and fed a group of émigrés in 1792 whom she considered "very agreeable Men [who] find some consolation in the society my small book room affords them of an evening."[43] In 1793, Smith's son, in battle against the French, lost his lower leg, an event that surely affected the family's perspective on the war.[44] That same year, Smith's daughter, Augusta, married the émigré Alexandre Marc-Constant de Foville. Smith supported the marriage, although she did discuss the matter with Charles Burney in reference to his own daughter's recent marriage to d'Arblay.[45]

According to Jacqueline Labbe, Smith identified with the notion of "exile," because of her own "sense of marginality, personal and cultural." She supported her children financially with her writing, a move that garnered unwelcome criticism. Smith also experienced migration herself: in 1784, accompanied by all of her nine children, she traveled to Normandy to join her husband Benjamin, who had just been released from King's Bench Prison and was living in France as a debt-exile.[46]

Figure 4.2 Mrs. Charlotte Smith (1808).
Source: The Trustees of the British Museum.
Print by Samuel Freeman after John Opie, *Mrs. Charlotte Smith*, 16.3 × 11.4 cm, stipple and etching on paper, 1808, British Museum, London.

136 *Refugee Resources and Competitive Curricula*

Though she was not politically conservative, Smith made use of the refugee migration to rally Britons from across the political spectrum to join in assisting émigrés. Her poem "The Emigrants" (1793), in which she reflects on the plight of the émigrés in light of her own struggles, demonstrates a political bipartisanship described by Wolfson as Smith's "sequential alternations of sympathy and political review."[47] By "publicly distanc[ing] herself from radical politics in defending the exiles of the ancient regime," Susan Zimmerman claims that Smith is able to criticize war as "patriarchal militarism," a move that puts Romantic women poets in the role of political commentators.[48]

Smith's interest in émigré aid is woven into works in several genres designed for both children and adults. *Rural Walks* (1795), a two-volume collection of educative "dialogues" interspersed with Smith's poetry, was followed by the sequels *Rambles Farther: A Continuation of Rural Walks* (1796), and *Minor Morals, Interspersed with Sketches of Natural History, Historical Anecdotes, and Original Stories* (1798).[49] The fact that, in *Rural Walks*, she "wished to unite the interest of the novel with the instruction of the school-book, by throwing the latter into the form of dialogue, mingled with narrative," distinguished her contribution to the field of conduct literature and was intended to appeal to the burgeoning readership of girls aged 12 to 16, as well as readers "farther advanced in age." In addition, Smith is careful to embed her narrative within the more socially acceptable domestic rather than public setting for girls' education.[50]

In her Preface to *Rural Walks*, Smith downplays the radical nature of the curriculum she was setting forth for young British women. She states that her work is "confined . . . to what are called *les petites morales*," citing behavioral objectives, such as to "repress discontent" (which may have diverted attention away from her earlier support of revolutionary movements), "check that flippancy of remark, so frequently disgusting in girls of twelve or thirteen," and "give them a taste for the pure pleasures of retirement." She emphasizes the book's usefulness in making young women compliant rather than reactionary, self-sufficient rather than dependent. Thus, Smith's Preface attempts to reframe her implicit pedagogical aims, conforming them to conventional expectations for conduct literature, as well as those for women writers.

Contemporary reviews of *Rural Walks* replicate the Preface's assertions that the book does not move beyond traditional curricula for girls. The *Analytical Review*, for example, describes the narrative as a "course of easy lessons on temper and manners, interspersed with pleasing information on subjects of natural history, and lively descriptions of characters in human life."[51] Reviews also praise Smith's poetry, the *New Annual Register* calling them "elegant pieces," and reproducing a "pleasing sonnet," the "production of her own elegant pen."[52] *The Monthly Review* deems the work "entertaining and generally instructive," a compliment disguised in understatement, while the *British Critic* lauds Smith's "active imagination towards the entertainment and improvement of rational children." As an example of Smith's ability to meld captivating story-telling with lessons in charity and good-neighborliness, the reviewer transcribes highlights from Smith's tale of Eupheme who, in search of protection and traveling with her ill mother, boldly

ventures into a seemingly haunted gothic mansion only to find stores of food guarded by an "old miser and not a sorcerer."[53] Overlooking much of what made Smith's text so progressive, the reviews provided a solid base for marketing the book; its ensuing success reflects both the popularity of this form during the late eighteenth century and Smith's reputation as an established writer.[54]

In contrast to the mainstream didactic literature of the period, such as More's *Considerations on Religion and Public Education* and Wollstonecraft's *Thoughts on the Education of Daughters*, which teach socially-acceptable modes of charitable practices, Smith's *Rural Walks* examines the social causes of poverty and criticizes structures that limit the agency of marginalized groups, including émigrés, the poor, women, and children.[55] In fact, Smith explicitly asserts that the study of history and the development of historical reasoning is essential for women and girls in the Preface to her politically charged novel, *Desmond* (1792):

> Have [women] no interest in the scenes that are acting around them, in which they have fathers, brothers, husbands, sons, or friends engaged?—Even in the commonest course of female education, they are expected to acquire some knowledge of history; and yet, if they are to have no opinion of what is passing, it avails little that they should be informed of what has passed, in a world where they are subject to such mental degradation; where they are censured as affecting masculine knowledge if they happen to have any understanding; or despised as insignificant triflers if they have none.[56]

In *Desmond*, Smith echoes Wollstonecraft's convictions of the 1790s: that education for girls should be expanded and deepened, allowing them to explore a fuller range of studies, including traditionally masculine disciplines.[57] Indeed, teachers in *Rural Walks* play a pivotal role in transforming pupils from passive recipients of knowledge into active participants in their own educational process. In addition, both teachers and students are agents of social change.[58] Unlike earlier pedagogical theorists, who warned against juxtaposing historical time periods, Smith models just such an approach, suggesting that such an exercise strengthens students' abilities to make historical distinctions and construct more nuanced meanings that have the potential to inform current social problems.

In the text, Mrs. Woodfield is the teacher and mother of two of the students (Elizabeth and Henrietta) and aunt of the third (Caroline Cecil). The tale is directly linked to More's and Burney's earlier texts advocating refugee assistance when Mrs. Woodfield references "the just and beautiful sentiment of Mrs. Hannah More . . . enforced by the pathetic exhortation of the authoress of *Evelina* and *Cecilia*." Smith thus ostensibly positions her own work in the same tradition, aligning the relationship between donor and recipient with contemporary treatments, rather than showcasing the highly collaborative mode of exchange between parties found within the actual narrative.[59]

To provoke a wider consideration of the ways that political forces affect individuals, Smith's *Rural Walks* employs three primary narrative techniques designed to "train readers to see the social structures that create and exacerbate poverty,"

138 *Refugee Resources and Competitive Curricula*

according to Elizabeth Dolan. First, Smith introduces the figure of the teacher-as-ethnographer of local culture; second, she encourages experiential learning via dialogue; and third, she divides the narrative into episodes that allow readers to explore differing perceptions of self and other through comparison and discussion.[60] Additionally, in Dialogue Three, "The Ruined Abbey," (an episode Dolan does not address), Smith squares her broader educational agenda for young women with the ongoing refugee crises of the 1790s, allowing readers to imagine how sustainable social aid could be mutually beneficial to recipients and donors.

In this Dialogue, a hike to the fictional "Heardly Abbey," the "beautiful ruins" of a former Dominican monastery, combines physical with mental exercise for Mrs. Woodfield's pupils. Mrs. Woodfield begins her impromptu lesson with a brief summary of the loss of "religious societies" during the English Reformation, then outlines the story of Dominican brothers and their erstwhile home, describing the community's final inhabitants: "a superior, twelve brethren, and four lay brothers."[61] How Mrs. Woodfield acquired such antiquarian knowledge of this pre-Reformation religious brotherhood is difficult to ascertain, but sites like the old abbey in Smith's tale were frequently toured and ethnographic studies, such as T.D. Fosbroke's *British Monachism or Manners and Customs of Monks and Nuns of England*, published in 1817, were underway.[62]

Smith's fictional Dominican brotherhood faced challenges similar to those experienced by actual contemporary religious: "at the Reformation," Mrs. Woodfield explains, "this was, with other religious societies, dissolved, and the lands belonging to it were seized by the crown." Mrs. Woodfield's depiction of this monastic brotherhood prompts her youngest daughter, Henrietta, to question the forces that led to the Reformation: "Was it a revolution, such as people are always talking about now?" Discouraging simple comparisons between the causes of the French Revolution and those of the English Reformation, Mrs. Woodfield delineates the motives behind Britain's break with Rome as "the caprice of the sanguinary tyrant, Henry the Eighth," rather than "any regard he had to the real interests of religion." A character sketch of Henry follows: "impatient of control, though still a superstitious bigot, [he] threw off the yoke, and emancipated his people from the impositions which had, till then, been fastened on them, in the abused name of religion."[63] It should be noted that Mrs. Woodfield's view of the English Reformation in no way signals her support of Catholicism or its religious orders: by referring to the people's "emancipation" from the imprisoning bonds of religion, she is invoking Enlightenment, even revolutionary, rhetoric. Yet the impacts of such "emancipation"—the displacement of religious populations, for example—reverberate across time and find their way into the present.

Later in the narrative, Mrs. Woodfield resumes the historical dialogue initiated upon the group's arrival at Heardly Abbey, describing "those events that had driven the clergy of France to seek a refuge in England."[64] King Louis's economic policies provoked fomentation and rebellion from the people, which ultimately resulted in the creation of a new political order, Mrs. Woodfield explains. The Revolution, she argues, was a legitimate movement to free the French people from the economic tyranny of the Crown and the Church. Nonetheless, according

Refugee Resources and Competitive Curricula 139

to Mrs. Woodfield, the clergy's enforced exile speaks to their resistance to new forms of political oppression, as well their steadfast religious commitments, making them worthy recipients of British charity. Haydon White has observed that the impulse to create narrative "is intimately related to, if not a function of, the impulse to moralize reality, that is, to identify it with the social system that is the source of any morality we can imagine."[65] Mrs. Woodfield's historical discussion functions in just this way, making sense of two monastic dissolutions and the cultural and political contexts that precipitated them.

Historical and political reflection segues directly to the project of refugee social aid when the second daughter, Elizabeth, notices a "gentleman . . . surveying the ruins." This French émigré, "sitting there on a piece of the broken wall . . . a mass of broken stone," brings the present into history and frames the foreigner within the domestic. The "broken wall" provides a meditative spot for "the venerable figure of a man near seventy," signaling the vulnerability of both refugees and religious ideologies. When Mrs. Woodfield suggests that Caroline approach the cleric to practice her French, the girl demurs and Mrs. Woodfield herself models bilingual benevolence in action. Suspecting that the cleric is residing at "W—" (a reference to the King's House in Winchester, an English Royal estate that had been renovated to accommodate over 500 displaced French clergy in 1793), Mrs. Woodfield explains to her charges that he is in England "because he would not relinquish his principles."[66]

Although Burney had suggested that the King's House be outfitted for a hospital, the idea of turning it into a refuge for priests most likely came from the Marquis of Buckingham, and had the support of Edmund Burke and George III. Lauded in the local community as an example of "English hospitality," the King's House was looked after by a supervisory committee, set up by the Emigrant Relief Committee, which was responsible for inspecting the site and examining residents in order to grant residence certificates—a means of keeping tabs on the priests—as prescribed by the conditions of the Aliens Act of 1793.[67] The large number of French clerics in the Winchester community, not to mention the English Benedictine and Franciscan nuns residing nearby, evoked feelings of patriotism in the populace, but also caused local unrest. Some priests suffered insults and many remained in semi-isolation; some engaged, at times tenuously, in trade and employment relationships with locals. Priests supplemented their meager existence at the King's House by various means: offering tutoring in French, writing books, preparing medicine, manufacturing tapestries, and doing manual labor.[68]

Residents at the King's House subsisted on a diet of bread, cheese, and beer for breakfast; meats such as mutton, veal, or lamb for other meals; and peas and salt fish on Fridays. The priests were also provided with clothing and dormitory-style housing. According to Frederick George Lee, the enterprise was a "marvel of economy." The King's House served over 1,000 residents before it closed in 1796, when, so as not to alarm locals, priests were dispersed in groups.[69] Bellenger points out that this dispersal was initiated by rumors of proselytism by the priests, as well as by the need to use the King's House as a military barracks, an idea that had been in circulation since November of 1793.[70]

140 *Refugee Resources and Competitive Curricula*

Abbé Bernard, the fictional priest in *Rural Walks*, is not at Winchester, though. He is being housed by an Anglican chaplain and his situation is tenuous at best: as Bernard says of his host, "I cannot submit to be burdensome to him, who is himself only the almoner and chaplain to the absent Lord D*****." Without the support of an aristocratic benefactor or government-sponsored housing, the abbé—having spent three years in Rome perfecting his Italian—seeks employment as a French or Italian language instructor.[71]

In the real world, clerical refugees frequently marketed themselves as instructors and tutors in England, creating competition among educators, as well as new opportunities for parents who wished to fill gaps in their children's education.[72] In Smith's story, Mrs. Woodfield arranges to have the abbé work with her daughters and niece in language tutoring twice a week. A family's geographic location could limit the range of instruction available for children's education, an issue Mrs. Woodfield articulates in her approval that the abbé will provide "knowledge which she had despaired of finding for them in their present situation."[73]

Although the abbé faces a three mile walk to the Woodfield residence, he "was yet healthy, and, amidst all his misfortunes, cheerful and resigned."[74] Smith thus recasts the elderly figure of the refugee as an employable and useful member of the community rather than as a social burden. As Callum Whittaker explains, there was some "popular distrust and sense of hostility" towards the French refugees, not only because they were French, and, hence, possibly pernicious in their influence, but also because national aid was directed towards them. However, as Whittaker also observes, other Britons argued that new immigrants could teach valuable skills to native workers and increase commerce in England.[75] Smith participates in this national discussion by recuperating the refugee as a social agent who contributes to Smith's broader feminist agenda of expanding girls' educational options.

That those individuals who aid and employ refugees also play a significant part in integrating them within the community at large is suggested in the artistic lesson that concludes the episode in *Rural Walks*. Upon the group's arrival home, Caroline says that she had sketched Heardly Abbey while listening to her aunt converse with Abbé Bernard. Praising Caroline's industry and skill, Mrs. Woodfield calls the sketch "Very free and well-drawn," before commenting that the completion of the composition nevertheless requires "A little more broken pieces about this side, and a few larger masses of stones, half mantled with shrubs and ivy, in the fore-ground." Responding to this somewhat imposing feedback, Caroline wonders if she might also include a "human figure." Incorporating a drawing tutorial into the historical, linguistic, and philanthropic lessons of the day, Mrs. Woodfield suggests that his "figure, on paper, be made to represent the effect on [him] of the melancholy reflections which, I have no doubt, occupied him at that moment; when, from the recent destruction of religious houses in his own country, he was led, by accident, to contemplate the dilapidation of such buildings, which was effected, many years since, in ours."[76] This aesthetic exercise thus reinforces the day's other lessons and places the history of the displaced cleric in thoughtful juxtaposition to that of England's monastic dissolutions. The creation of this

visual tableau can be seen as signifying the importance of situating contemporary social crises within a framework of broader historical inquiry and analysis.

In drawing attention to political crises that exacerbate poverty, Smith also connects women's vulnerability in patriarchal culture to that of other marginalized groups.[77] As Toby Benis argues, "perceptions of the period's exiles played in ongoing debates . . . including the nature of British identity and women's rights."[78] Mrs. Woodfield, a widow, has been forced by financial hardship to "retire" to a rural village with her two daughters. Because of this, her daughters' education involves preparing them to live modestly and support themselves. According to Dolan, Mrs. Woodfield exists "on a continuum" with the poor characters in the other episodes of *Rural Walks*; thus, one of the functions of the narrative is to expose and address social ills, taking into account factors such as gender, class, and age.[79] Like immigrants and the poor, young women are often financially dependent upon others. Caroline Cecil, for example, is without a mother and has been left with Mrs. Woodfield by her brother, Colonel Cecil. A strain on her reduced family, Caroline is lucky to have Mrs. Woodfield as a resource. Caroline's predicament highlights the important role that women educators played in inculcating "self-reliance" in their charges, as well as enacting "social interdependence" in their communities.[80]

Smith's focus on the mutually beneficial relationship between hosts and refugees obscures the very real competition among educators that the influx of teachers and tutors was creating in England. Indeed, Smith's resourceful priest has more in common with the actual refugee nuns and clerics than with the helpless victims who populate Burney's dire depictions of monastic annihilation in France. The next section of this chapter begins to illuminate the broader historical realities that undergird Smith's fiction. As seen in her treatment of Abbé Bernard, Smith registers many of the very real exigencies faced by refugees, including finding suitable accommodations, negotiating relationships with patrons, and acquiring employment.[81] Yet well before women writers, British donors, benefactors, or the government took up the cause of social relief for native and foreign migrants, English nuns were helping their own by providing hospitality for displaced religious in the late eighteenth century. And refugees themselves, using what little resources they had, opened schools and found work as tutors almost as quickly as they arrived in England, becoming key players in a highly competitive educational arena.

Refugee Resourcefulness, Social Integration, and Catholic Schooling

During the crisis of the Revolution, English nuns in France and Belgium provided temporary and long-term relief for wandering Continental migrants. According to the history of the English Augustinian Canonesses of Bruges, convents housed religious and some non-religious refugees, as well as coordinated refugee movement between religious houses.[82] The September Massacres of 1792 increased the migration of displaced persons across national borders and that month the Augustinian convent in Bruges saw the arrival of a French curé from Longuenisse and an

142 *Refugee Resources and Competitive Curricula*

English "Capuciness" from the Jesuit College at St Omer. In October, the convent housed four Benedictines of Montargis, one of them Catherine Dillon, the sister of Lady Jerningham. The Benedictines of Montargis had stopped in Bruges temporarily; they were on their way to the English Benedictines in Brussels, where they were hoping to arrange a temporary space for their entire community. They did not want to leave the Continent, preferring to stay closer and eventually return to their French convent. The Augustinians' annals document the traveling women's diversity: "They were of four different nations—viz., English, Irish, Scotch, and Flemish."[83] Three of the Benedictine nuns passed through the Augustinian convent again in November, after being advised by their own prioress, Madame de Lèvi de Mirepoix, that accommodations awaited them in England. Dillon, however, did not agree that the group should settle there and delayed almost two months before finally migrating. On the way to England, she stayed again with the Augustinians of Bruges on December 27, 1792, accompanied by Lady Jerningham, along with Jerningham's daughter Charlotte and son Edward (who were visiting their brother William, who had enlisted in the Austrian army in Brussels).[84]

Convents opened their doors not only to a diversity of nuns, but also to a variety of displaced religious across categories of class, gender, nationality, and ethnicity. Nevertheless, although they managed to shelter a French Augustinian nun from Paris, nine French priests, and individual nuns from the Benedictine, Dominican, Capuchin, and Annonciade orders, the Augustinians of Bruges could provide sanctuary for only so long and to only so many, especially while Bruges faced the threat of imminent invasion by the French army. As C.S. Durrant charitably puts it, Mother Mary Augustina More "was obliged to send away two of the nuns from other Orders who had sought refuge with them," leaving "with great regret."[85] Nuns were, at times, forced to choose to maintain the integrity of their communities rather than provide safe haven to those in need. The Poor Clares of Rouen, for example, could not accommodate the rest of the Benedictines of Montargis's community en route to either England or Brussels.[86]

In 1794, after learning that the French had taken Ypres, the Augustinians of Bruges removed the majority of their community to England, leaving behind only a small group, most of them elderly. A first-person account from one departing nun describes her heart-breaking farewell to Sister Mary Baptist Barton, who was sickly and decided to remain behind. An arthritic lay sister who chose to stay in Bruges confessed that she would prefer the guillotine to the pains of travel. Beneath the tears of such partings, however, there also lay strategy: the rumor was that elderly nuns "were left unmolested," unlike younger nuns. Besides, as long as the convent was occupied the nuns stood a greater chance of retaining it. The capable and brave Sister Olivia Darrell stayed with her elderly sisters to manage convent business and "deter looters."[87]

Those who left traveled with an Ursuline nun and two priests. They sought shelter with other nuns struggling to retain communal integrity, arriving first at the convent of the English Benedictines in Ghent.[88] Moving next to Antwerp, they lodged with the English Carmelites, although in order to accommodate other migrants, the Augustinians had to separate into two groups. Nine of

Figure 4.3 Mother Mary Augustina More (1772).
Source: Convent of Nazareth Archives

Heylbrouck, *Mother Mary Augustina More*, 112 × 86 cm, oil on canvas, 1772, Convent of Nazareth, Bruges.

them went on to the English Carmelites at Lierre to make room at the Antwerp convent for nuns from Ghent. Ironically, working together sometimes meant forming alliances with others, breaking up into smaller groups, and shifting locations to enable protection for all. In this case, the Augustinians of Bruges,

144 *Refugee Resources and Competitive Curricula*

the Carmelites of Antwerp, one nun from Lierre, several priests, and five La Trappe monks formed a party of 73, endured a "harrowing voyage" to Wapping, England aboard a Hamburg trader, finally arriving on July 12, 1794.[89] They were greeted by the English with the term "French devils," however when it was clarified that they were "English ladies seeking refuge from the French in their own country, the temper of the crowd quickly changed, and they were shown every kindness and consideration."[90]

Further shuffling ensued after their arrival. Benefactors received as many of the nuns as they could accommodate at once. Four cousins of William Jerningham— Ann (Sister Ann Teresa), Elizabeth (Sister Mary Agnes), Edwardina (Sister Francis Joseph), and Frances Henriette (Sister Mary Francis of Sales)—went directly to Cossey Hall.[91] Mrs. Wright (Lucretia Havers), the wife of the community's banker, took in about 12 nuns including Prioress More, while others stayed with Mrs. Julia Bryan and Mrs. Mary d'Evelin Franklin, the daughter-in-law of Benjamin Franklin. "We were not to be Seen Such Sight our Relations was ashamed of us [sic]" one community member wrote, going on to reveal that Mrs. Wright laid out the expenses for proper clothing for the refugee Augustinians.[92]

The need for a more permanent lodging was quickly addressed. By August, nuns arrived at Hengrave Hall, located near Bury St Edmunds in Suffolk, to prepare the house for habitation. According to Francis Young, the idea of renting Hengrave Hall originated with Mr. Wright, in response to the prioress's desire to find "a retreat that was discreet, permanent and secure." It met the group's needs and possessed a medieval design that Prioress More thought simulated a "convent by having cloisters below and galleries above." If the nuns thought they could better stay out of the public eye at this location, they would find that remaining discreet would prove impossible. Meanwhile, to assist with preparations for the community's installment at Hengrave Hall, More and four other nuns moved to the home of Sir Thomas and Lady Gage in nearby Bury St Edmunds.[93]

Nuns relied on Catholic and Protestant benefactors, both lay and religious, not only to obtain suitable housing and recruit students, but also to negotiate the cultural politics that made their transitions difficult.[94] Donations in particular were essential to the struggling communities and came from a variety of sources, including local gentry, both Protestant and Catholic. For the Augustinians of Bruges, donations included everything from liturgical materials, furniture, and textiles, to cookware (such as a tin tea kettle that doubled as a tea pot) and food (such as wine, fresh fish, and a hogshead). The household accounts of the Benedictines of Cambrai, settled in Woolton in 1795, list exotic gifts of pineapples, plums, a pound of chocolate, and green tea, as well as more homely offerings such as a "fat goose" and a "suckling pig." The Augustinians document receiving black silk and blue damask to make vestments, some church linens, and "an English Martyrology." Families such as the Talbots, the Jerninghams, and the Tauntons also gave monetary contributions to the Augustinians; the Jerninghams were particularly generous just as they had been towards the French Benedictines of Montargis and the English Blue Nuns, supplying not only essentials (money, food, and shelter), but also students.[95]

Like other religious refugees, the Augustinians diversified their sources of income to gain financial stability. They opened a school around the end of August, starting with only two pupils, one of whom had traveled with the nuns all the way from Bruges. They also crafted embroidered muslin turbans, needle books, pin-cushions, work bags, and artificial satin flowers, all of which were typically sold to outsiders in spite of the order's injunction not to "do any work for secular persons."[96] Enamored by the nuns' religious dress, visitors convinced the sisters to outfit dolls in the habit of their order, which they did for "many," and "which [they] had pleasure in doing," possibly receiving compensation for their efforts.[97] In fact, artistry in needlework and artificial flower making was put to good use in several communities. The English Benedictines of Cambrai, for example, "had acquired a great reputation," according to Bishop Milner, for both skills, as well as for "cutting out upon vellum various ornaments and devices with the most exquisite taste and execution." By means of this artistic experimentation (possibly similar to an early form of decorative collage practiced by few contemporaries), the Benedictine nuns combined creativity with highly skilled work to bring in extra money.[98]

Forming connections in the local community and working with patrons and their expectations required delicate negotiations. To appease a patron, nuns might play up aspects of their culture such as dressing in full habits. The Duke of Clarence, intrigued by the Benedictines of Cambrai and their stories from revolutionary France, encouraged them, despite their objections, to "Wear your dress, and *I* will see that it is all right; wear your dress, and you *shall* be protected by Government." Nuns also tried to remain out of the public eye by concealing overt markers of social difference, particularly after the clamor surrounding the Monastic Institutions Bill of 1800. For example, the English Benedictines from Brussels, settled in Winchester, wore their habits only in the morning when outsiders had little opportunity to see them.[99] Benis suggests that exiles "perform[ed] a variety of personae, to manipulate public perception." The exile became a "composite of others' fears, prejudices and distractions."[100]

Furthermore, the politics of social acceptability were different in different communities and also shifted within communities. For example, upon the Augustinians' arrival at Hengrave Hall, "the Country people were at first afraid we were French Men in disguise, but this apprehension soon vanished, and they became very fond of us."[101] Opening a school in London even before settling at Bodney Hall, the French Benedictines of Montargis wore their habits and accepted their first pupil, Fanny Fallon, in 1792, although public sentiment, mixed as it was, induced the young Fallon to answer callers because "some people look at the Sisters and say rude things."[102] Nuns walked a narrow line between invisibility and visibility: people who lived in surrounding communities could be either indignant or curious, generous or suspicious.

Local interest in the Augustinians at Hengrave Hall made many of them lament that they could not maintain enclosure and remove themselves further from the public eye. "We were never an Hour secure of being alone for all sorts of persons Flocked to see us, as they would have done to see some Foriegne [sic] Christians," one nun complained, while acknowledging that "all were very Civil" and were very generous to them generally. The nuns' seeming Continental exoticism, Catholic religious services, and traditional dress fascinated patrons and tourists. In fact, by 1794,

146 *Refugee Resources and Competitive Curricula*

the Augustinians at Hengrave Hall were replete in their white habits and perform-
ing liturgical services just as they had in Bruges, although now they had to contend
with throngs of curious attendees. The nuns had gained permission to wear their
habits from the Archbishop of Canterbury and two members of Parliament, achieved
through Lady Gage's networking. Local Protestant clergy and gentry remained eager
to witness the Augustinian community and experience a "high mass" on St Augus-
tine's Day, August 28, 1795. Since the attention from outsiders failed to wane on its
own, the nuns decreased the number of services that included musical accompani-
ment in order to discourage large groups from attending.[103]

How were nuns able to open schools and recruit students in this complex and not
always friendly environment? English nuns on the Continent were already well-
known in Britain for their educational facilities by the late eighteenth-century and,
as discussed in Chapter 1, had been teaching Catholic and, less frequently, Prot-
estant children there for some time. These Continental schools were mostly small,
serving classes of about 12 or 15 students, although the Paris communities (the
English Blue Nuns, English Benedictines, and English Augustinians), due to their
central urban location, brought in between 15 and 30 students apiece, primarily
from French and English parents. While convent schools abroad aimed to attract
recruits for religious profession, many girls were also educated and conditioned
for life outside of the cloister.[104]

Caroline Bowden, discussing English nuns' Continental schools, notes that
though the "quality of teaching provided must have varied widely," there is evi-
dence that nuns developed curricula, built classrooms, provided books, and taught
"feminine accomplishments." The Augustinians of Bruges and the Sepulchrines
in Liège had a more extensive curriculum than most, teaching languages, history,
drawing, arithmetic, embroidery, and dancing. The convent school of the English
Blue Nuns in Paris functioned more as a finishing school than a novitiate, refining
girls' accomplishments and boarding them for periods as short as a single term.[105]
Bellenger states that convent schools run by English nuns provided a more "profi-
cient" education for girls than non-Catholic English schools (although schooling
for Catholic boys was even more rigorous). Girls attending convent schools bene-
fited from the "wide culture of the European cities" that their expatriate education
provided.[106] In addition, Gabriel Glickman suggests that an "education spent in
exile" fostered a transnational awareness in English children and functioned as a
"rite of separation" from parents and into a broader Catholic community.[107]

This "rite" would no longer be necessary after educators' migration to Eng-
land, however. There, nuns would rely on the reputations of their schools abroad,
Catholic families and friends who wanted their children educated traditionally,
and employment of lay teachers to manage or assist at the new schools in England.
The Benedictines at Bodney Hall, for example, boasted in an advertisement in the
1794 *Laity Directory*, that "their reputation for instruction is so well established,
not only in France, but with many families in England, that it needs no further
eulogium. Nuns' migrations to England and years of difficult survival in France
had taken a toll on women religious and for some, such as the Benedictines of
Cambrai, organizing a school and teaching students was felt to be burdensome;

hence, nuns used available and outside labor, such as Protestant teachers and supervisors to fill gaps in curriculum and staffing.[108] It is also likely that even these few employment positions for local teachers helped to further positive relationships between nuns and the surrounding communities.

In fact, nuns' advertisements for their schools expose their status as victims of the Revolution; nuns' savvy use of their harrowing stories to gain recruits is notable. For example, the French Benedictines at Bodney Hall state openly that "the present history of the ladies of Montargis cannot be unknown to any one the least conversant with public affairs." And the English Benedictines at Woolton advertised their school for the "education of Catholic Young Ladies by the English Nuns lately escaped from Compiègne, formerly of Cambrai."[109] This framing, much as Smith's depiction of the displaced Abbé Bernard, melds émigré assistance with educational objectives and seems designed to elicit the sympathy of parents who were eager to aid refugee women.

The nature of girls' Protestant schooling in England was even more variable, ranging from instruction at home, or in small cohorts under the direction of a governess or teacher, to residential programs in variously sized boarding schools, which were often criticized as being at once too regimented and too unregulated. Charity or "dame" schools served children from the working classes with a curriculum focused more on religious conversion and preparation for employment than on academic rigor.[110] Nuns' schools thus filled several niches in English education, providing education to Catholics at an affordable price and without the travel expenses of sending children abroad. Many Catholic families patronized particular convents by enrolling multiple children in one school. For example, five of Lady Jerningham's granddaughters were attending the school at Bodney Hall by 1806; Sir Thomas Gage had four grandchildren enrolled at the convent school at Hengrave Hall.[111]

Beyond bringing in extra income, convent schools also provided nuns with a "veneer of respectability," according to Bellenger, because "a girls' school was more socially acceptable than a convent of enclosed nuns."[112] However, convent schools were and always had been potential portals into the novitiate, a point amplified in anti-Catholic propaganda of the time. Although a rather uncommon practice in the early years of their British stay, Catholic nuns in England did in fact recruit novices from amongst their students, staff, and local communities. The French Benedictines of Montargis, newly settled at Bodney Hall, brought in one novice in 1794 and a second, Mary Stourton, in 1796. Stourton was courted literally at the grate by Lady Jerningham's youngest son Edward, who thought she was "much too pretty" to be a nun."[113]

Some groups of nuns were not well received in local communities. The English Benedictines of Brussels, settled at Winchester, "caused uneasiness," as did the Augustinians of Louvain who were in Amesbury in Wiltshire by 1795.[114] A daughter of Mr. Weld, who supported the La Trappe monks residing at Ludworth, was professed in full ritual at the Franciscan community in Winchester in 1795, and several professions had also been made among the Augustinians, calling unwanted attention to the women refugees. According to Dr. Douglass, vicar apostolic of the

148 *Refugee Resources and Competitive Curricula*

London district, skits targeting the Augustinians in Amesbury surfaced in newspapers.[115] Their landlord, the Duke of Queensbury, was frequently lampooned in the papers for his overt interest in nuns. And although it took the mainstream press twelve months to even notice that "a society of English nuns from the Continent" had taken up residence in the neighborhood, follow-up reports indicated that the women were not only financially secure with an income of £1,700, but also "so far comfortable, that they are increasing their numbers by converts from the neighbourhood, till they had notice to abstain from such activity in the cause of celibacy and seclusion."[116] These kinds of rumors had the potential to dislodge nuns again; in particular, Weld's profession and new recruits in the English Franciscan community in Winchester were cited as reasons for Parliamentary action in 1800. It turned out, however, that Sir Henry Mildmay, who proposed the Monastic Institutions Bill that year, had leased and then sold Abbey House to the Franciscans, serving as a kind of patron to them, and had thus undermined his own credibility.[117]

A convent's reputation was difficult to manage: if local Catholics believed a religious group was thriving and self-sufficient—the very qualities that might make non-Catholics suspicious—the numbers of students and novices could increase, which in turn could and often did exacerbate the opposition's outrage. There is no doubt that women religious risked their community's security by covertly or openly taking in novices or professing nuns. But recruitment depended upon word-of-mouth; thus, currying favor with local and long-time patrons was central to establishing a student body and ultimately, novitiates.[118] In the 12 years that the Benedictines of Cambrai lived in Woolton, they recruited seven new members, four of whom had been students. One notable recruit, a "Miss Crilly" who managed the Woolton school in the first year of the Benedictines' stewardship (she had been a teacher there when the nuns arrived), left to pursue another educational venture, only to return later and join the community as a novice. Sister Teresa Mary Clare Crilly, professed in 1799, led the school for years afterwards.[119]

In addition to fears that nuns would recruit both students and novices, there was a general concern about the ways in which the new force in education represented by refugee nuns and priests would impact existing English schools. The profession had been overcrowded since the 1780s, and teachers and schoolmasters flooded the market following the emigration from Europe. An early example of this phenomenon can be found in the *St James's Chronicle* of September 22 of 1972: "We shall now have the swarm of seminaries in the neighbourhood of London cheaply and promptly supplied with teachers." Catholic schools sought students in an already highly competitive market and drove both wages and tuition prices down. As Kirsty Carpenter suggests, "Emigrés not only provided an unprecedented number of teachers for British educational institutions but they also provided a new market with numbers of French émigré children being sent to British schools." New schools in England even advertised in French newspapers, seeking students from aristocratic French emigrants.[120]

For priests, such as Smith's Abbé Bernard, tutoring within gentry or middle-class households was another alternative. Some French priests assimilated into

Refugee Resources and Competitive Curricula 149

academic circles at Oxford, offering courses in French to the undergraduates, and generally incurring the good favor of their colleagues.[121] That 1,000 priests stayed in Britain after 1802, many of them working as private tutors, indicates the high degree of integration experienced by many exiles. French clergy also worked in Protestant schools, some with long-term success, teaching Latin, Greek, and French, although Carpenter notes that they were not always treated respectfully.[122]

New Catholic schools were developed and backed by a variety of interested parties. In April of 1796, Edmund Burke, using government relief money, opened the Penn School near Beaconsfield along with Abbé Maraine, who had worked in a seminary college in Rouen for 20 years before immigrating to Britain in 1791. Many of the boys who attended the school belonged to families of the aristocratic French elite and although the school suffered financial problems and mismanagement, it remained open until 1820. Disagreements over school curricula may not have been uncommon and are evident in Burke's Penn project: he wanted the French pupils to receive a "good dash" of English education, while the Bishop of St Pol de Léon, who had recommended Abbé Maraine to direct the school, wanted only French teachers employed.[123] Working across Protestant-Catholic lines meant compromising and taking into consideration the ethnic and national biases of both teachers and financial backers.

The Marquise de MacNamara, a Catholic lay woman, worked with the Emigrant Relief Committee to open a school in Hammersmith for émigré girls which ran until 1801, creating competition for students with the Benedictines of Dunkirk, who ran a small school in their Hammersmith convent. The Marchioness of Buckingham, who also played a central role in establishing the King's House at Winchester for refugee priests, was behind this venture, desiring that emigrant girls learn essential skills for their roles as Christian mothers. The curriculum there included grammar, English, geography, embroidery, sewing, and some "gentle arts" such as music and painting.[124]

In 1797, Mary Russell Mitford attended a Catholic school in Chelsea run by lay émigrés, learning French, history, geography, some science (a discipline not typically offered to girls), as well as Italian, drawing, dance, and music from finishing masters who were assisted by the lay teacher Miss Rowden, the daughter of a local Anglican clergyman.[125] Abbé Carron, in 1796, established very successful boys' and girls' day schools in Somerstown, enrolling 60 boys and 40 girls in the first year; students came from Ireland and England, as well as the U.S. and India, and were taught by a team of "the best talents the French community could provide for teachers," according to Carpenter. The schools' success continued: by 1801, 70 students were enrolled in each.[126]

Though varying from house to house, curricula in nuns' schools generally challenged students to develop individual talents in writing, language, music, and the arts, as well as work collaboratively and demonstrate some knowledge in religion, geography, and history. Courses ranged from the traditional offerings for girls, such as reading, writing, French, arithmetic, grammar, geography, and religion—the staples of an education with the Benedictines of Cambrai at Woolton in 1795—to more innovative subjects, including student-directed theatricals and

150 *Refugee Resources and Competitive Curricula*

history.[127] In 1814 at the English dame school at Winchester, Dame Agnes Whelan personally assembled "a library of well-chosen books," revising the curriculum to emphasize "a course of solid reading."[128]

The French Benedictines at Bodney Hall took a more traditional approach, which appealed to many parents. Teaching girls proper behavior, religion, and rigorous self-application to their studies, the Benedictines' focus was on utility, morality, and the social graces. The prioress's 1794 advertisement in the *Laity Directory* proposed to instruct "young ladies in every branch of useful knowledge becoming the delicacy of their sex." National rhetoric is woven into this advertisement and within it we can see the community's goal of social utility mirroring its pedagogical objectives: "ambitious of being useful to the nation so generous, who received them in their distress with such unbounded charity and benevolence." The Benedictines' wish to inculcate the same utility into their charges that they themselves embody is threaded throughout the advertisement. Rather than sitting idle, eating "their bread with thankfulness," they are "happy to tender their services to the British people." At their school, subjects such as French, English, needlework, and drawing accompanied instruction in singing, and performing "suitable tragedies," including those based on biblical stories, such as Racine's *Esther*. They recruited French, Irish, and English Catholic girls, teaching around 166 students between 1793 and 1811.[129]

The Catholic Relief Acts of 1788 and 1791 had not lifted the restrictions outlawing the education of children with Protestant fathers; thus, there are very few examples of Protestant children enrolled in these schools at the end of the eighteenth century, whereas by the mid-nineteenth century Catholic schools were frequently utilized for the education of British children.[130] In 1800 the Benedictines of Montargis at Bodney Hall boarded two Protestant Swinburne sisters, although the community also turned away an Irish Protestant girl related to Lord Besborough. Lady Jerningham, involved in their affairs, thought this a double standard. But that same year they turned away another Protestant applicant as well, explaining that they did not admit Protestants—particularly if they wanted to convert to Catholicism. These seeming inconsistencies may have been motivated by the perception that their community's stability was put at risk by the introduction of the Monastic Institutions Bill in 1800.[131]

The Monastic Institutions Bill highlighted concerns that refugee schools were recruiting Protestant and working-class children. Indeed, in addition to providing education to paying Catholic customers, repatriated nuns such as the English Benedictines at Winchester (from Brussels) and the English Poor Clares at Haggerston (from Rouen)—as well as French priests—established charity schools for children in financial need, whether their parents were émigrés or English. By offering schooling to both paying and non-paying students, nuns and priests managed to serve the larger community while at the same time keep their own doors open.[132] The increasing numbers of educational options provided by Catholics fueled anti-Catholic sentiment. One critic complained that French priests and nuns were offering not only free education, but also clothing and food to the poor. The *Bath Journal*, for example, carried this "protest" against the encroachment of Catholic

institutions in Britain: "Are not Languages, Painting, Drawing, Music, and other Employments usurped by Foreigners to the Ruin of our own Countrymen? . . . Surely this is another *Norman Conquest* by *insidious* attack."[133] There was the sense that, while they might be counter-revolutionists, the French émigrés could not but help importing semi-Jacobin schemes to educate the working classes.

The Monastic Institutions Bill offered conditions to Catholic religious: if it passed, the government would protect current religious so long as they did not recruit new members "in useless inactivity and seclusion," and did not "seduce the children of Protestant parents." Mildmay accused Catholic schools of offering the public a bribe—free education—implying that in doing so, and widening their student base, religious were making it more difficult to regulate not only who was enrolled in their schools, but also what was being taught there. If the Bill passed, Catholic schools would be forced to submit to some form of regulation. The Bill's opponents argued that was an intrusive and biased measure, since the government did not interfere in the curricula at dissenting schools, which were more likely teaching the principles of Jacobinism than Catholic nuns, many of them English in origin. This argument diverted attention from nuns to the disruptive potential of liberal Protestant schooling. In addition, opponents lauded the benefits of Catholic institutions for Catholic families, which now had the option of educating their children in England rather than sending them abroad, a situation highly preferable to exposing British children to French principles.[134]

In attempting to pin down the location of insidious "French" ideas, either at home or abroad, legislators were revealing their ethical and political biases. Yet identifying the origins of these ideas—whether Catholic religious had imported a French element into British education or if this element already existed at home—was a matter of great contention. Private schools run by Dissenters, particularly those that followed Joseph Priestley's rationalist approach (a curriculum based on Rousseau's educational philosophies), were thought to inculcate atheism and radical political thought, possibly spurring a future revolution in England.[135]

The Bill was dismissed in the House of Lords. Yet concerns surrounding the education of Protestant and working class children in Catholic émigré or repatriated schools continued to surface. Abbé Carron, for example, was called to the Bow Street magistrates' court, as Bishop Douglass records in his 1805 diary, to "answer to some charges made against him for receiving children of Protestant parents into his charity school." The abbé, whose "modesty" in responding earned him a reprieve, claimed that he only accepted those Protestant students whose parents had petitioned him. As for adults who explicitly desired reception in the Catholic Church, he could "not refuse to instruct" them.[136] That same year, the French Benedictines at Bodney Hall relinquished Miss Blackburn, whose Protestant father had threatened to make a complaint against the community at the Alien Office. Lady Jerningham was brought in by Bishop Milner to mediate and she effected Miss Blackburn's return home.[137]

Because recruitment of novices and Protestant students by nuns were central issues underlying the Monastic Institutions Bill, in order to "ward off the blow," Mr. Charles Butler, a Catholic lawyer, solicited information from the Augustinians

152 *Refugee Resources and Competitive Curricula*

of Bruges, now at Hengrave Hall, about the composition of their membership and their recruiting practices. Butler asked Prioress More to identify the number of professed members and their date of profession, the number of pensioners at the establishment and their religious orientation, and whether any children were being educated there for free.[138] The fact was that four women had been professed at Hengrave Hall before 1800, in addition, three more were in the novitiate.[139] Certainly within the context of a highly politicized environment, the nuns must have been uneasy about the visibility and potential viability of their community in England.

Troubled by the Monastic Institutions Bill and the questions it had raised, the Augustinians at Hengrave Hall discussed the matter with Lady Gage, one of their benefactors. Sister Mary Agnes proposed returning to their convent in Bruges, exclaiming that "then Lady Gage . . . would clap [her] hands with joy, meaning from public report that convents and nuns are evils in the nation." Unfortunately, Lady Gage misinterpreted the remark to mean that Sister Mary Agnes "wanted [Lady Gage] to go." Disgruntled perhaps at the notion that the nuns were considering abandoning both Hengrave Hall (which had been developed for their use), and their work as teachers (they had taught four of the Gages' grandchildren), Lady Gage disparaged Sister Mary Agnes to the other nuns, leaving her "rattled." Such miscommunications between benefactors and nuns illuminate how widely even co-religionists' goals could differ. Concerned as they were with the political movement in England to regulate activity within convents, the Augustinians went so far as to consider migrating to the U.S. where they had connections.[140]

Back on the Continent, Sister Olivia Darrell, left in charge of the convent in Bruges, had worked tirelessly to retain that space, using all available resources to buy the convent and its appurtenances back from private owners and the government between 1797 and 1800. Her successful efforts serve as a prime example of the tenacity with which some English nuns held on to their Continental properties.[141] In fact, changing political activity on the Continent was opening alternative pathways for some religious. With the Peace of Amiens settled on March 27, 1802, and following the unexpected deaths of Sister Olivia Darrell and Sister Martha Ferguson in January, the Augustinians at Hengrave Hall took a crucial vote to determine their future. It was prompted by the sense that their survival as a community in England was anything but certain, despite the fact that they were repatriated citizens. Out of 25 women—choir nuns and lay sisters—a decisive majority of 20 voted to return to Bruges.[142]

In October of 1802, the last of the Augustinians at Hengrave Hall boarded boats sailing for Bruges, embarking on the final leg of their journey to reclaim their convent and reunite their community once and for all.[143] Their sojourn in England was over: they were returning home.

Notes

1 Margaret J. Mason, "The Blue Nuns in Norwich: 1800–1805," *Recusant History*, 24/1 (1998): pp. 94, 97; Francis Young, "Mother Mary More and the Exile of the Augustinian Canonesses of Bruges in England 1794–1802," *Recusant History*, 27/1 (2005): p. 90.

Refugee Resources and Competitive Curricula 153

2 The building, originally a medieval convent, was owned by the Institute of the Blessed Mary, which was founded by Mary Ward in the early seventeenth century. Essentially an undercover Catholic boarding school for girls, the Hammersmith convent had been well regarded and was known in the eighteenth century as "The Ladies' School." *A History of the Benedictine Nuns of Dunkirk: Now at St Scholastica's Abbey, Teignmouth, Devon*, ed. by the Community (London, 1958), pp. 132, 138.

3 Kirsty Carpenter, *Refugees of the French Revolution: Emigrés in London, 1789–1802* (New York, 1999), pp. 100–103, 106; T.H. Plumb, "The New World of Children in Eighteenth-Century England," *Past & Present*, 67 (1975): p. 77.

4 *The Parliamentary History of England from the Earliest Period to the Year 1803* (London, 1819), vol. 35, pp. 340–86; Ralph W. Sockman, *The Revival of the Conventual Life in the Church of England in the Nineteenth Century* (New York City, 1917), pp. 35–6.

5 Frances Burney, *Brief Reflections Relative to the Emigrant French Clergy* (London, 1793).

6 Charlotte Smith, *Rural Walks: In Dialogues. Intended for the use of Young Persons* (Dublin, 1795).

7 Elizabeth Dolan, *Seeing Suffering in Women's Literature of the Romantic Era* (Aldershot, 2008), pp. 172, 188. For the classic model of enlightened education for boys and domestic education for girls, see Jean Jacques Rousseau, *Emile, Julie and other Writings*, ed. R.L. Archer (Woodbury, 1964).

8 Callum Whittaker, "La Généreuse Nation!" Britain and the French Emigration 1792–1802," M.A. Dissertation (York, 2012), pp. 47–8; Dominic Aidan Bellenger, *The French Exiled Clergy* (Bath, 1986), p. 20.

9 Plumb, p. 72.

10 Bellenger, *French Exiled Clergy*, p. 67.

11 Bellenger, *French Exiled Clergy*, pp. 3, 14–17, 20.

12 Bellenger, *French Exiled Clergy*, pp. 3–4.

13 Claire Harman, *Fanny Burney: A Biography* (New York, 2001), pp. 228–46.

14 Michael Wiley, *Romantic Migrations: Local, National, and Transnational Dispositions* (New York, 2008), p. x.

15 Frances Burney, *The Wanderer; or, Female Difficulties* (London, 1814). For an examination of Burney's internationalism in *The Wanderer*, see Maria Jerinic's "Challenging Englishness: Frances Burney's *The Wanderer*," in Adriana Craciun and Kari E. Lokke (eds), *Rebellious Hearts: British Women Writers and the French Revolution* (Albany, 2001), pp. 63–84.

16 Margaret Anne Doody, *Frances Burney: The Life and Works* (Cambridge, 1988), pp. 203–5; *Monthly Review*, 12 (1793), p. 475. Doody states that "French Roman Catholic priests were not objects of charity appealing to the population at large."

17 Burney, *Brief Reflections*, p. 4; Susan Wolfson, "Charlotte Smith's Emigrants: Forging Connections at the Borders of a Female Tradition," in Anne K. Mellor, Felicity Nussbaum, and Jonathan F.S. Post (eds), *Forging Connections: Women's Poetry from the Renaissance to Romanticism* (San Marino, 2002), p. 91.

18 Edmund Burke, "Case of the Suffering Clergy of France," *The Evening Mail*, September 17–19, 1792; Burney, *Brief Reflections*, p. 2–4. Burke states that French clergy have been "robbed of their legal property"; of nuns, Burke comments: "they have been deprived of their estates, and expelled from their houses, in which they had purchased a property by the portions given to them by their parents."

19 Burney, *Brief Reflections*, p. 15–17.

20 Burney, *Brief Reflections*, p. 3; Angela Keane, *Women Writers and the English Nation in the 1790s* (Cambridge, 2000), p. 7.

21 Burney, *Brief Reflections*, p. 13.

22 Burney, *Brief Reflections*, pp. 26–7.

23 Nigel Aston, *Christianity and Revolutionary Europe c 1750–1830* (Cambridge, 2002), p. 200.

154 Refugee Resources and Competitive Curricula

24 Burney, *Brief Reflections*, p. 25.

25 Burney, *Brief Reflections*, pp. 14, 22–6.

26 Doody, pp. 204–25.

27 Burney, *Brief Reflections*, p. 17.

28 Burney, *Brief Reflections*, pp. 11, 14, 26.

29 Burney, *Brief Reflections*, p. 11; Doody, p. 204.

30 Burney, *Brief Reflections*, pp. 7–8.

31 B. Randolph, "Sisters of Charity," *The Catholic Encyclopedia* (New York, 1914). Retrieved 29 July 2014. In addition to working with orphans, the Daughters of Charity opened girls schools for the poor, served as nurses both on the battlefield and in hospitals, hosted soup kitchens, and visited prisoners. Silvia Evangelisti, *Nuns: A History of Convent Life* (New York, 2007), pp. 224–30.

32 Burney, *Brief Reflections*, pp. 7–8. In "Challenging Englishness," p. 75, Jerinic interprets Burney's remarks on de Paul as encouraging British women to model their actions on de Paul himself, rather than on his female followers.

33 Burney, *Brief Reflections*, pp. 5–6, 17–19, 21.

34 Hester Chapone, *Letters on the Improvement of the Mind Addressed to a Young Lady* (London, 1773), pp. 177, 210, 227.

35 Plumb, p. 72.

36 Chapone, p. 156.

37 Mary Wollstonecraft, *Thoughts on the Education of Daughters* (London, 1787), pp. 138–40.

38 Hannah More, *Considerations on Religion and Public Education with Remarks on the Speech of M. Dupont* (Boston, 1794).

39 Anne Stott, "Evangelicalism and Enlightenment: The Educational Agenda of Hannah More," in Mary Hilton and Jill Shefrin (eds), *Educating the Child in Enlightenment Britain: Beliefs, Cultures, Practices* (Aldershot, 2009), p. 41.

40 More, p. 4.

41 Wolfson, pp. 93.

42 Mona Scheuermann, *In Praise of Poverty: Hannah More Counters Thomas Paine and the Radical Threat* (Louisville, 2002), p. 13.

43 Charlotte Smith, *The Collected Letters of Charlotte Smith*, ed. Judith Phillips Stanton (Bloomington, 2003), pp. 49, 62.

44 M.O. Grenby, "'Surely There Is No Boy or Girl Who Has Not Heard of the Battle of Waterloo!' War and Children's Literature in the Age of Napoleon," in Elizabeth Goodenough and Andrea Immel (eds), *Under Fire: Childhood in the Shadow of War* (Detroit, 2008), p. 47.

45 Loraine Fletcher, *Charlotte Smith, A Critical Biography* (London, 1998), pp. 196–201; Toby Benis, *Romantic Diasporas: French Emigrés, British Convicts, and Jews* (New York, 2009), p. 27.

46 Jacqueline Labbe, *Charlotte Smith: Romanticism, Poetry and the Culture of Gender* (Manchester, 2003), p. 122. As Labbe points out, "Her awareness of the connotations of her own publicity creates the paradox that Smith's self-declared marginality becomes central to her work," p. 123; Fletcher, p. 5.

47 Charlotte Smith, "The Emigrants," in Stuart Curran (ed.), *The Poems of Charlotte Smith* (Oxford, 1993); Benis, p. 28; Wolfson, p. 106.

48 Susan Zimmerman, *Romanticism, Lyricism, History* (New York, 1999), p. 57; Anne Mellor, "The Female Poet and the Poetess: Two Traditions of British Women's Poetry, 1780–1830," *Studies in Romanticism*, 36 (1997): p. 266.

49 Charlotte Smith, *Rambles Farther: A Continuation of Rural Walks* (London, 1796); *Minor Morals, Interspersed with Sketches of Natural History, Historical Anecdotes, and Original Stories* (London, 1798).

50 Smith, *Rural Walks*, pp. 3–4; Sophia Woodley, "'Oh Miserable and Most Ruinous Measure': The Debate between Private and Public Education in Britain, 1760–1800,"

in Mary Hilton and Jill Shefrin (eds), *Educating the Child in Enlightenment Britain: Beliefs, Cultures, Practices* (Aldershot, 2009), p. 22.

51 *Analytical Review*, 21 (London, 1795), p. 548.

52 *New Annual Register*, eds Andrew Kippis and William Godwin (London, 1795), p. 282; *Analytical Review*, 21 (1795), p. 549. The *British Critic* also described Smith's poetry as "pleasing," "original," and "elegant." *British Critic and Quarterly Theological Review*, 5 (London, 1795), p. 553. See also *Critical Review*, 18 (London, 1796), pp. 445–6, for reproductions of a sonnet and an episode from the work.

53 *Monthly Review or Literary Journal*, eds Ralph Griffiths and G.E. Griffiths, 17 (London, 1795), p. 350; *British Critic and Quarterly Theological Review*, 5 (London, 1795), p. 553.

54 For examples of episodic narratives for young adults and children, see Sarah Trimmer's *Fabulous Histories, Designed for the Instruction of Children, Respecting their Treatment of Animals* (London, 1786); Anna Letitia Barbauld and John Aiken's *Evenings at Home, or the Juvenile Budget Opened* (London, 1792–96); and Mary Wollstonecraft's, *Original Stories from Real Life, Calculated to Regulate the Affections, and form the Mind to Truth and Goodness* (London, 1788). Dolan discusses Smith's and Wollstonecraft's works as radical departures from mainstream young adult literature in *Seeing Suffering*, pp. 165–93.

55 Mary Wollstonecraft explored these issues later in *Maria: Or The Wrongs of Woman. A Posthumous Fragment*, ed. William Godwin (Philadelphia, 1799).

56 Charlotte Smith, *Desmond* (3 vols, London, 1792), vol. 1, p. iii.

57 Mary Wollstonecraft, *A Vindication of the Rights of Woman: With Strictures on Political and Moral Subjects* (London, 1792).

58 Dolan, *Seeing Suffering*, pp. 166, 171, 191–2.

59 Smith, *Rural Walks*, p. 70.

60 Dolan, *Seeing Suffering*, p. 167

61 Smith, *Rural Walks*, p. 66.

62 T.D. Fosbroke, *British Monachism: or, Manners and Customs of the Monks and Nuns of England* (London, 1816). A new edition of Dugdale's *Monasticon Anglicanum* was available by 1817. William Dugdale, Roger Dodsworth, John Stevens, et al., *Monasticon Anglicanum: A History of the Abbies and other Monasteries, Hospitals, Frieries, and Cathedral and Collegiate Churches, with their Dependencies, in England and Wales* (6 vols, London: Longman, Hurst, Rees, Orme & Brown, 1817–1830).

63 Smith, *Rural Walks*, pp. 66–7.

64 Smith, *Rural Walks*, p. 70.

65 Haydon White, *The Content of Form: Narrative Discourse and Historical Representation* (Baltimore, 1987), p. 14.

66 Smith, *Rural Walks*, pp. 66–8.

67 Bellenger, *French Exiled Clergy*, pp. 73–6. For more on the purposes of surveillance and control that the Aliens Act imposed on refugees, see Whittaker, pp. 54–8.

68 Bellenger, *French Exiled Clergy*, pp. 73–8; Bellenger, "The Brussels Nuns at Winchester 1794–1857," English Benedictine Congregation History Commission Symposium (1999), pp. 4–5.

69 George Frederick Leigh, "The French Clergy Exiles in England, A.D. 1792–1797," *National Review*, 12/69 (London, 1888): p. 356.

70 Bellenger, *French Exiled Clergy*, pp. 73–9.

71 Smith, *Rural Walks*, p 69.

72 Bellenger, *French Exiled Clergy*, pp. 3, 70–71; Carpenter, pp. 100–115.

73 Smith, *Rural Walks*, pp. 69–70.

74 Smith, *Rural Walks*, pp. 69–70.

75 Whittaker, pp. 48–50.

76 Smith, *Rural Walks*, pp. 71–2.

77 Dolan, *Seeing Suffering*, p. 172.

156 *Refugee Resources and Competitive Curricula*

78 Benis, p. 2.
79 Smith, *Rural Walks*, p. 1; Dolan, *Seeing Suffering*, pp. 168, 192.
80 Smith, *Rural Walks*, p. 2–3; Elizabeth Dolan, "Collaborative Motherhood: Maternal Teachers and Dying Mothers in Charlotte Smith's Children's Books," *Women's Writing*, 16/1 (2009): p. 111.
81 For examples see Janet E. Hollinshead, "From Cambrai to Woolton: Lancashire's First Female Religious House," *Recusant History*, 25 (2001): pp. 461–86; *A History of the Benedictine Nuns of Dunkirk*; *In a Great Tradition: The Life of Dame Laurentia McLachlan, Abbess of Stanbrook by the Benedictines of Stanbrook* (New York, 1956); Margaret J. Mason, "Nuns of the Jerningham Letters: The Hon. Catherine Dillon (1752–1787) and Anne Nevill (1754–1824), Benedictines at Bodney Hall," *Recusant History*, 23/1 (1996): pp. 34–78. In future references, this essay is cited as "Benedictines at Bodney Hall."
82 For more history on the movement of English groups leaving France and the Netherlands, see Bernard Ward, *The Dawn of the Catholic Revival in England, 1791–1803* (2 vols, London, 1909), vol. 2, pp. 82–94.
83 Durrant, p. 360; Young, p. 88.
84 Durrant, pp. 360–61; Margaret J. Mason, "Nuns of the Jerningham Letters: Elizabeth Jerningham (1727–1807) and Frances Henrietta Jerningham (1745–1824), Augustinian Canonesses of Bruges," *Recusant History*, 22/3 (1995): p. 352. In future references, this essay is cited as "Augustinian Canonesses."
85 Durrant, pp. 361, 363–7.
86 See Chapter 1; Mason, "Benedictines at Bodney Hall," pp. 34–40; Bellenger, *French Exiled Clergy*, pp. 91–2.
87 Durrant, p. 367; Young, p. 88; "An Account of the Austin Nuns Travels from Bruges to England—the year 1794," in *The English Convents in Exile, 1600–1800*, eds Caroline Bowden, Carmen M. Mangion, Michael Questier, et al. (6 vols, London, 2013), vol. 6, p. 374. Young states that nine nuns were left behind, while Durrant puts the number at 10. The unknown author of "An Account of the Austin Nuns" cites 11.
88 Young, p. 89.
89 Durrant, pp. 368–70; Young, p. 89.
90 P.C.P.W., *Lanherne, The Oldest Carmel in England* (Bodmin, 1945–49?), p. 18.
91 Mason, "Augustinian Canonesses," pp. 351–2.
92 Young, pp. 89–90; "An Account of the Austin Nuns," p. 375
93 Young, pp. 89–90; "An Account of the Austin Nuns," p. 375; Mason, "Augustinian Canonesses," p. 353.
94 As Ward makes clear, the "greater part of the burden fell upon the representatives of the old Catholic families." For a list of benefactors who provided housing, see Ward, *Dawn of the Catholic Revival*, vol. 2, pp. 116–18, 121–6, 128–9.
95 Young, p. 91; "An Account of the Austin Nuns," p. 376; Mason, "Augustinian Canonesses," p. 352; Account Book, Stanbrook Abbey Archives, 1795–1803. Stanbrook Abbey. Wass, Yorkshire.
96 Young, p. 92; Mason, "Augustinian Canonesses," p. 353–4. Mason states the school opened in September. Young dates the opening in August.
97 "An Account of the Austin Nuns," p. 376.
98 *In a Great Tradition*, p. 33. For more on this art form, see Molly Peacock's *The Paper Garden: Mrs Delany [Begins Her Life's Work] at 72* (New York, 2011).
99 Ward, *Dawn of the Catholic Revival*, vol. 2, pp. 118, 123–6. The Benedictines of Louvain, who settled first in Hammersmith and then Amesbury, wore their habits, as did the Sepulchrines from Liège who settled at Holme Hall in Yorkshire. The English Benedictines of Ghent chose secular attire upon arrival, "yet caused some attention, and led to inquiries which were at times disquieting to the nuns."
100 *In a Great Tradition*, pp. 48–9. Benis, pp. 35–6.
101 "An Account of the Austin Nuns," p. 376.

Refugee Resources and Competitive Curricula 157

102 Frideswide Stapleton, *The History of the Benedictines of St Mary's Priory, Princethorpe* (1930), pp. 90–91; Mason, "Benedictines at Bodney Hall," pp. 38–9.

103 Mason, "Augustinian Canonesses," p. 353; "An Account of the Austin Nuns," p. 376.

104 Claire Walker, *Gender and Politics in Early Modern Europe: English Convents in France and the Low Countries* (New York, 2003), pp. 93, 120.

105 *English Convents in Exile*, vol. 1, p. xxv.

106 Dominic Aidan Bellenger, "France and England: The English Female Religious Reformation to World War," in Frank Tallett and Nicholas Atkin (eds), *Catholicism in Britain and France Since 1789* (London, 1996), p. 4.

107 Gabriel Glickman, *The English Catholic Community, 1688–1745: Politics, Culture, Ideology* (Rochester, 2009), pp. 9, 76.

108 Hollinshead, p. 478–80; Stapleton, p. 94; *A History of the Benedictine Nuns of Dunkirk*, p. 137–8. The English Benedictines of Hammersmith employed Maura Carrington and the Misses Kirwans, former pupils, as secular teachers in 1796; Carrington became a choir nun. The Benedictines of Cambrai, after settling at Stanbrook Abbey in 1838, continued to staff masters and teachers to assist the nuns; *In a Great Tradition*, p. 85.

109 Stapleton, p. 94; Hollinshead, p. 476.

110 Carol Percy, "Learning and Virtue: English Grammar and the Eighteenth-Century Girls' School," in Mary Hilton and Jill Shefrin (eds), *Educating the Child in Enlightenment Britain: Beliefs, Cultures, Practices* (Aldershot, 2009), pp. 80, 86–7; Mary Clare Martin, "Marketing Religious Identity: Female Educators, Methodist Culture, and Eighteenth-Century Childhood," in Mary Hilton and Jill Shefrin (eds), *Educating the Child in Enlightenment Britain: Beliefs, Cultures, Practices* (Aldershot, 2009), pp. 65–9. Mary Bosanquet, a Methodist preacher and educator, opened a home-based boarding school in Leytonstone for impoverished girls, which was criticized in 1765 on the grounds that its rigid practices were training children to be nuns. Martin, p. 70.

111 Mason, "Benedictines of Bodney Hall," p. 68; Young, p. 92.

112 Bellenger, "Brussels Nuns at Winchester," p. 5.

113 Mason, "Benedictines at Bodney Hall," p. 42. Around 25 women were professed by 1800 in the English convents. *Who Were the Nuns?* database, <http://wwtn.history.qmul.ac.uk/> accessed Feb. 9, 2016.

114 Bernard Ward, *Catholic London a Century Ago* (London, 1905), p. 167.

115 Ward, *Catholic London a Century Ago*, p. 167; Ward, *Dawn of the Catholic Revival*, vol. 2, pp. 115–16, 125; Who Were the Nuns? database, <http://wwtn.history.qmul.ac.uk/> accessed Feb. 9, 2016.

116 *St James's Chronicle*, December 26–29, 1795, p. 1; *Star*, December 28, 1795, p. 3. The Augustinians from Louvain first took their lodgings with Mrs Molineux in Bolton Row, Piccadilly, London, removing next to King Street, Hammersmith before moving on to Amesbury. The Hammersmith convent, which had served as the Institute of the Blessed Virgin Mary, and was founded by Mary Ward in the seventeenth century, would later house the Benedictines from Dunkirk who ran a successful school there from 1795 to 1863. *A History of the Benedictine Nuns of Dunkirk*, pp. 131–2, 140–55.

117 Ward, *Dawn of the Catholic Revival in England*, vol. 2, pp. 202–4, 206. Mildmay's involvement in the Bill was more likely motivated by disagreements with the Winchester clergy, rather than his displeasure with religious professions.

118 Mason, "Augustinian Canonesses," pp. 354–5; Hollinshead, pp. 477–8; "Benedictines at Bodney Hall," pp. 35, 40; Ward, *Dawn of the Catholic Revival*, vol. 2, p. 124.

119 Hollinshead, pp. 478–80.

120 Plumb, p. 77; *St James's Chronicle*, September 22, 1792; Carpenter, pp. 100–103, 106.

121 Bellenger, *French Exiled Clergy*, pp. 78, 70, 31.

122 Carpenter, pp. 108, 111–12.

158 *Refugee Resources and Competitive Curricula*

123 Carpenter, pp. 107–9. Another school, directed by the Abbés Rozaven and Broglie suffered from similar disruptions in finances, staffing, and discipline even though it boasted a "wide curriculum." See Bellenger, *French Exiled Clergy*, pp. 70–71.
124 Carpenter, pp. 104–5.
125 Mary Russell Mitford, Alfred Guy Kingan L'Estrange, and William Harness, *The Life of Mary Russell Mitford* (3 vols, London, 1870), vol. 2, p. 11; Carpenter, p. 106.
126 Carpenter, pp. 112–14.
127 Hollinshead, p. 477; Carpenter, p. 106.
128 Bellenger, "Brussels Nuns at Winchester," p. 5.
129 Stapleton, p. 94; Bellenger, *French Exiled Clergy*, p. 92; Mason, "Benedictines at Bodney Hall," p. 40. Once at Princethorpe Priory, the French Benedictines devoted some of the curriculum to both lengthy and short dramatic performances, which were integrated into liturgical feasts. Stapleton, p. 110.
130 Susan O'Brien, "French Nuns in Nineteenth-Century England," *Past and Present*, 154 (1997): p. 179; Michael Tomko, *British Romanticism and the Catholic Question: Religion, History and National Identity, 1778–1829* (New York, 2011), pp. 16–22.
131 Mason, "Benedictines at Bodney Hall," pp. 51–3, 66; Bellenger, *French Exiled Clergy*, p. 92.
132 Bellenger, "Brussels Nuns at Winchester," p. 5; A.M.C. Forster, "The Chronicles of the English Poor Clares of Rouen—II," *Recusant History*, 18/2 (1986): p. 159; M.D.R. Leys, *Catholics in England 1559–1829: A Social History* (New York, 1961), pp. 160–61; Ward, *Catholic London a Century Ago*, pp. 170–80.
133 Whittaker, p. 41; *Bath Journal*, September 5, 1796, quoted in Carpenter, p. 107.
134 *Parliamentary History of England*, vol. 35, pp. 353, 343, 384, 374–5.
135 Woodley, p. 35. Hannah More was one educator opposed to Priestley's views. Stott, p. 44.
136 Carpenter, p. 114.
137 Mason, "Benedictines at Bodney Hall," pp. 51, 66.
138 Durrant, p. 389.
139 Mason, "Augustinian Canonesses," pp. 356, 367; *Who Were the Nuns?* database, <http://wwtn.history.qmul.ac.uk/> accessed Feb. 9, 2016.
140 Mason, "Augustinian Canonesses," p. 356; Young, p. 92.
141 Mason, "Augustinian Canonesses," p. 357.
142 Young, p. 94; Mason, "Augustinian Canonesses," pp. 357–8.
143 Young, pp. 94–7; Mason, "Augustinian Canonesses," p. 358.

Epilogue

> Notwithstanding our happy retirement we don't forget with gratitude our kind reception in dear old England in [the] time of our exile and to our kind and benevolent relations who was so charitable to us we daily pray for that God may bless and preserve that good and charitable country. We was blamed by many for coming back but the retirement was what we sighed after and our house.
>
> Sister Mary Francis of Sales to Lady Frances Jerningham, January 3, 1803

> [T]hose who survive the anarchy for which they are desolated . . . will still be strangers to repose, even at the natal home for which now every earthly sigh is heard, till, with their restituted property, they have cleared their dignity of character from every possible aspersion of calumny, and returned—not to their benefactors—whose accounts, far more nobly, will be settled elsewhere!—but to the poor of the kingdom at large, that bounty which has sustained them in banishment and woe.
>
> Frances Burney, *Brief Reflections Relative to the Emigrant French Clergy*, 1793

The travails of refugee nuns during the last decade of the eighteenth century were of wide interest to Romantic-era readers. Today, less is generally known about these women, but even during that time period, English nuns' migration to Britain, and their subsequent struggles at home and abroad, were not well understood. This book has focused on writers—many of them British—who advocated for the causes of religious refugees, and who wrote about the lives of these migrants within various genres, including historical nonfiction, fiction, letters, journalism, poetry, children's literature, travel writing, essays, and pamphlets.

Significantly also, nuns' own social histories illuminate the actual experiences of migrating religious, but these narratives have heretofore only been partially accounted for in historical or literary studies in Romanticism. This research pays close attention to the literature about and the social histories of migrating nuns, and dispels some of the more gothicized myths with which women religious are too often associated in the literary and cultural imaginations of the British eighteenth and nineteenth centuries. Problematically, a lopsided scholarly focus on anti-Catholic literature has obscured the reality that contemporary writing was actually quite diverse in its treatment of Catholic women religious. In recovering Romantic-era writings about and by nuns, I hope also to have recovered the

160 *Epilogue*

historical and literary interchanges between religious groups and British Protestants and Catholics, as well as the ways in which such interactions shaped perceptions of religious refugees in British society during this time. Ultimately, the "monastic invasion" (historian Peter F. Anson's term for the influx of religious refugees to England during the French Revolution), both in and outside of community formations, also set an important precedent for the Victorians, who experimented with a variety of Catholic and Protestant same-sex communities.[1]

The survival and success of refugee communities depended upon a number of factors and entailed the collaborative efforts of many, including nuns themselves, Catholic and Protestant supporters, relief committees, and British and French writers. In calling religious groups' adaptations to extremely challenging and life-threatening historical crises "successful," I am not implying that such a history ultimately made their lives better. The loss of community members, resources, property, and, in the case of English nuns, some portion of their Continental identities (both on communal and individual levels), impacted these groups for many decades to come. However, representations of nuns as courageous victims—found in many genres of the period—played an important role in temporarily softening British anti-Catholic and anti-conventual prejudices during nuns' difficult transitions to England.

The epigraphs above, by Frances Burney and Sister Mary Francis of Sales (Frances Henriette Jerningham), give voice to some of the issues this study has explored, and that were critically at stake in the interactions between destitute nuns and British society.[2] Writing in the early years of the Revolution and migration, Burney constructed refugee priests as "strangers to repose," drawing on sentimental imagery of helpless clergy to persuade readers to assist religious during their "temporary" exile from France. Although the visibility of priests—both in print culture and society—was far greater than that of nuns, both groups shared a sense of isolation and displacement; neither the British government nor Burney imagined that some French priests would find permanent settlement in England. And ironically, although Burney's migrants' "natal home" is France (the country for "which now every earthly sigh is heard"), England was for English nuns both their homeland and their place of exile. Furthermore, this state of exile invests their narratives with a kind of double awareness of juxtaposed loyalties, responses, and identities. For example, although English herself, Sister Mary Francis described nuns' displacement from the Continent to England as the "time of our exile," a trope that finds its way into modern-day community histories.[3]

Beyond their initial displacement, however, repatriated nuns underwent a series of relocations well into the nineteenth-century, further complicating and diversifying their individual and collective connections to "place." Nuns' relationships to cloistered space, including the Continental convents they left behind, are important aspects of nuns' experiences that should not be overlooked. As Sister Mary Francis affirms in her letter to Jerningham, the Augustinians, while in England, sighed after their "house" in Bruges. In late Romantic and early Victorian literature, nuns pop up in all sorts of unexpected places, reflecting perhaps their various attempts to settle themselves in an oft-times hostile environment.

Epilogue 161

This book has only begun to examine the complex relationships that existed between hosts and refugees. Religious and familial ties, shared or differing agendas among co-religionists, and national loyalties all inflected such relationships. Nuns arrived financially, physically, and psychologically exhausted; they depended upon the patronage of wealthy families to supply material goods, students, and housing. Beyond simply expressing their gratitude, nuns were expected to follow their benefactors' agendas. Sister Mary Francis's statement is telling: "[W]e was blamed by many for coming back [to Bruges]." Though necessary to survival, the financial and familial relationships between benefactors and religious communities were also problematic in ways that Catholic historiography has not always recognized. Lady Jerningham, for example, had an unprecedented involvement in the construction of the written legacy of the Blue Nuns; her sense of entitlement leaves us pondering how other benefactors perceived their roles, to what extent they involved themselves intimately in the affairs of the nuns, and to what ends. Romantic literary figurations of the nun as both heroic and vulnerable reinforced the idea that nuns needed outside help to preserve their communal legacies, their memories of war and migration, their traditional cultural practices, and even their lives.

Writers other than benefactors were also interested in the dual projects of refugee assistance and cultural preservation. Burney, for example, called upon middle- and upper-class British women to aid émigré priests, reassuring her audience of reward by God himself. In newspapers and pamphlets, poems and fiction, writers from across the political spectrum deployed a national rhetoric to reassure their readers that the destitute migrants were worthy recipients of charity. Texts during this time categorized nuns in a variety of ways—living or dead, resourceful or needy, exotic or domestic—to sentimentalize the refugees' struggles and integrate them into a national narrative of British charitable assistance. Some women writers, such as Williams and Smith, were seeking not only to help refugees, but also to promote British women's engagement in public and political work.

Despite being in crisis, nuns exerted tremendous agency in the political landscapes of France, Belgium, and England; they were also active agents in constructing others' perceptions of them. By identifying as "English," nuns temporarily eschewed their more truly international identities to gain support for themselves in England, and consequently helped ease the political tensions that defined Anglo-French relations during this time. Produced after the Augustinians' return to Bruges, Sister Mary Francis's letter to Jerningham more than once employs a topos of gratitude towards the English nation (it is a construct seen frequently in nuns' writings): "We daily pray for that God may bless and preserve that good and charitable country." The letter effuses over "our kind reception in dear Old England," as well as "our kind and benevolent relations," (a reference to the letter's recipient, Jerningham herself). In both France and England, nuns often asserted national loyalties when to do so was in their self-interest, and claims of national identity, origins, or preference by English nuns must be seen in this context. In contrast, English nuns' international identities played a significant role in the minds of the nuns themselves, and continued to impact their religious practices throughout the nineteenth century.

162 *Epilogue*

Victorian Anti-Catholicism and the Anglican Sisterhoods

The Victorian period saw the proliferation of religious orders in England, and with it came diverse ways to practice religion and, in literary culture, to depict it. This proliferation was a result of large-scale political and religious changes in the nineteenth century, and Victorian era portrayals of nuns and religious sisters must thus be situated within the larger religious and cultural transformations that were underway between 1830 and 1850. Some of these changes include the Irish immigration, conflicts between various groups of Protestants, the resurgence and legalization of Catholicism, and the High Church movement in Anglicanism.[4]

The increased Catholic presence in Britain grew out of the Catholic Emancipation Act of 1829, the infusion from 1830 until the end of the century of apostolic women's orders from Ireland, France, and Belgium, and the restoration of the Catholic hierarchy in England in 1850.[5] By 1850, some refugee religious communities had been in England for nearly 60 years, but newer migrant groups had arrived as well, including the over 2,000,000 people from Ireland escaping the potato famine in the 1840s and 1850s. Continental refugees appeared in England after the revolutions that reverberated across Europe in the 1830s and 1840s.[6] Revolution in Ireland had been warded off by the passing of the Catholic Emancipation Act of 1829, which removed many of the existing legal barriers against Catholics, including the penal laws.[7] Anti-Catholic sentiment increased throughout this period, not only in response to new Catholic populations, but also as the Oxford Movement within the Church of England made religious life possible for Protestant men and women.

The development of the Anglican Sisterhoods represent women's initiatives after the Tractarian agitations of the 1830s led by the forerunners of the Oxford Movement, John Keble, Edward Pusey, and John Henry Newman. Their work resulted in the recuperation of Catholic doctrines and practices for use among Anglicans, including the development of religious orders and a celibate priesthood with a shared mission of service to the poor.[8] Anglican Sisterhoods, the first of which was founded in 1845, aroused varying degrees of support and resistance. Their existence motivated a rather critical backlash among co-religionists, because the Sisterhoods represented the infiltration of Catholic monasticism into the Church of England and, hence, into Protestant bourgeois society.[9]

However, anti-Sisterhood propaganda—which primarily recycled eighteenth-century stereotypes about nuns—must also be seen within the context of the broader religious and social changes that threatened heteronormative, religious, and gendered cultural assumptions.[10] Nineteenth-century conventual escape narratives heightened the sense that abuses of power were endemic to convent life.[11] Opponents argued that convents undermined the father's authority within the family, just as the re-emergence of confession in the Tractarian branch of the Church of England was criticized as allowing male clergy access—like Catholic priests—to the inner thoughts of wives and daughters.[12] Jenny Franchot posits that, in the U.S., this fear was a symptom of the general loss of religious belief in the nineteenth century, and was absorbed within the "drama of Protestant male interest

Epilogue 163

in female incarceration."[13] In Britain, the tradition of changing one's name after profession also roused the indignation of defenders of "the family"—seen particularly as an affront to the father, and as an act both disloyal and "unEnglish," even though giving up one's paternal name after marriage was expected. Likewise, as Maria LaMonaca notes, Roman Catholicism was thought to "undermine the primacy and integrity of the English family" because it plucked women out of their homes and planted them into celibate religious communities.[14] In Victorian art, the state of celibacy was also often conflated with death, since women religious were denying their procreative function.[15]

The issue of women's leadership without male supervision divided those who grappled with ways to further reform female religious orders. Critics questioned whether mother superiors had the innate capability to organize and lead other women. Drawing on a recent 1851 census that reported that Great Britain contained more than half a million more women than men, Anna Jameson in her *Sisters of Charity* (1855) proposed the immediate formation of male-headed groups of "sisters" for active service in the world.[16] Her disapproval of women's leadership in the Anglican Sisterhoods is implicit but obvious. Previously, Abbess Lydia Sellon, the founder of Ascot Priory in 1848, had been criticized by both Anglican leaders and other Protestants such as Jameson for the position of authority she assumed, and for the rigid Rule that she set forth for her community.[17] Jameson believed that women living and working alone were as "unstable as water."[18]

Drawing on the same trope of women's mental or emotional weakness, however, Dinah Mulock Craik argued in "On Sisterhoods" (1883) that the Sisterhoods might "have saved many a woman from a lunatic asylum . . . for diseased self-absorption is the very root of madness."[19] Craik imagined the convent as a space of community and agency for mentally and emotionally unstable single women. Newman asserted that "foundations for single females" provided women with physical, moral, and economic protection, arguments that echo Thrale Piozzi, who saw in French and English convents a viable alternative to the supposedly "weaker" state of singlehood.[20]

Florence Nightingale, a proponent of women's work, considered developing a reformed women's religious community modeled after the Deaconess order at Kaiserswerth in Germany, which staffed hospitals, libraries, facilities for the deaf, and a school.[21] She also briefly trained with the Sisters of Charity in Paris, and yet Nightingale struggled in her relationships with other women authority figures. She was in charge of 10 Catholic nuns and 14 Anglican sisters during her administration of Scutari military hospital during the Crimean War (1853–1856). This was a difficult role because the nuns and sisters did not always concede to Nightingale's authority, but sometimes to their mother superior's instead.[22] Disagreements about the roles of women and their leadership capabilities reveal just how gendered nineteenth-century society was. And that the Church of England did not officially sanction Anglican Sisterhoods until the early twentieth century makes evident that the male episcopate was highly uncomfortable with female-centered leadership throughout the nineteenth century.[23]

164 *Epilogue*

Legislative attempts to regulate convents, albeit unsuccessful, also continued throughout the nineteenth century. Agitation to implement mandatory inspections of women's convents was initiated in 1852 by Charles Newdegate, a Conservative MP, and continued for decades, but such inspections were not effectuated.[24] The Anglican Convent Inquiry Society, founded in 1889, was never able to enact convent inspections on the Parliamentary level, although attempts continued until 1912.[25] In response to grumblings in the 1870s that Parliament should regulate convents, Prime Minister William Gladstone insisted that nuns' privacy would be maintained. He also lauded the Benedictine Rule as the "the epitome of civilization."[26] Perhaps over-optimistically, the historian Edward Norman asserts that an increasing tolerance towards Catholicism among the educated characterized the late nineteenth century in general.[27]

Ultimately, although anti-Catholic sentiment characterizes some of what we know about cultural responses to nuns, the real experiences of women religious, and the ways in which Victorian writers encountered, depicted, or secularized nuns and/or their cultural practices, tell a much more nuanced story.

Revisiting the Nun in Victorian Literature and Culture

Burney's agenda in *Brief Reflections*—to secularize the work of nuns—obtained tremendous traction during the Victorian period.[28] The explosion of active religious communities in nineteenth-century England testifies to the period's reformist sensibility. The partial secularization of women's monasticism meant that multiple yet unique communities could cater to a wider variety of women seeking alternatives to domesticity. Rather than incarcerating women into a life of drudgery and superstition, women's religious communities, Catholic and Anglican, provided women with alternatives. By 1850, the active sister, engaging within the community, had become the normative image of contemporary women religious.[29] Performing the public work of educating the young, nursing the sick, and aiding marginalized populations, nuns enabled changing women's roles in the Victorian period because they challenged the dominant notion that women belonged at home raising children and taking care of families or husbands. Indeed, in addition to schools and convents, Catholic and Anglican women religious founded hospitals, orphanages, asylums, houses of reform for "fallen" women, and provided a variety of services to the community that were both duplicative and unique to each religious house.[30]

The movement of women's apostolic congregations from France, Ireland, and Belgium to England as early as 1830 brought a new internationalism to women's religious culture.[31] Next, the restoration of the Catholic hierarchy in England in 1850 created ecclesiastical support for bringing experienced French "worker nuns" to England, in order to best train new Irish postulants.[32] By 1887, 32 of 62 apostolic congregations in Britain were French; five were Belgian. According to Susan O'Brien, "they transferred something of the diversity and expertise which had developed out of a more confident, elaborate and larger Catholic culture to the relatively small English Catholic subculture."[33] Blending the corporate

Epilogue 165

models from the enclosed teaching orders—the Ursulines and the Daughters of Charity—apostolic nuns also recruited members from Catholic and non-Catholic gentry and middle-class families, whose daughters preferred to join non-native English congregations where class hierarchies were better maintained and where professional training, and eventually attending university, was made possible for working-class women.[34]

The perceived notion that French nuns knew better what was "properly Catholic and properly feminine," conferred upon them an authority in Catholic circles, as O'Brien observes.[35] By the end of the century around 10,000 women had participated in some version of religious life in Britain.[36] The large numbers of nuns and women religious in this period might cause us to question whether the notion of domesticity became more firmly entrenched, or was further unhinged, by the popularity of such communities. Although O'Brien is speaking here from a purely historical perspective, similar things can be said of representations of nuns in literature. She notes:

> Religious sisters aroused a wider range of reactions and emotions than has been represented in the historical literature. For reasons as yet unclear, convents wove themselves into the fabric of towns and cities all over England more easily and rapidly than we have realized. Our concentration on the literature of anti-Catholicism has led us to overlook experience at the local level where there was often a marked change in the public's attitude from initial antipathy to respect, and occasionally, to protectiveness.[37]

Recovering a literary history of the "nun" that does not rely upon anti-Catholic stereotypes is of particular interest in Victorian studies. Some relevant writers include Elizabeth Gaskell, Anna Jameson, Rhoda Broughton, and George Eliot, who flouted the nun-as-icon to laud women's public work in both domestic and celibate cultures.[38] These "later-born Theresas," as Eliot terms such women in *Middlemarch* (1871–1872), exemplify a domestic version of women's sainthood, though forced to confront changed historical circumstances without the "coherent social faith and order" that gave the sixteenth-century Spanish nun, Theresa of Avila, a framework to enact her own monastic reforms for women. Jameson's highly popular *Legends of the Monastic Orders* (1850), reprinted multiple times throughout the nineteenth century, recovers women religious as depicted in Western art, cementing their legacies in a visual history of women's intellectual advancement and social utility. Her feminist claims concerning life in the cloister illuminate Jameson's rethinking of monastic culture: "The protection and better education given to women in these early communities; the venerable and distinguished rank assigned to them . . . did more, perhaps, for the general cause of womanhood than all the boasted institutions of chivalry."[39]

Eschewing "institutions of chivalry" altogether, some writers went even further, positing communities of women as the ideal mode of social reform, and connecting Romantic-era concepts of national hospitality to women's work. For example, Eliot's *Romola* (1862) concludes with a portrait of an Italian Renaissance matron

166 *Epilogue*

who, possessed of the resources to take care of the motley group of women and children left in her charge, runs her household as if it were a religious sisterhood, performing social service functions such as care of the elderly, the young, and fallen women. Elizabeth Gaskell's *My Lady Ludlow* (1858) depicts a kind of Protestant abbess who designs her estate to care for young women with economic or physical disabilities.[40] As a staunch English conservative, Lady Ludlow faces the potential revolutionary impact of educating the lower classes. Thus, Gaskell's text brings into discussion two kinds of social reform—literacy for the working classes and social services for middle class women—against the historical backdrop of the French Revolution.

In addition to nineteenth-century fiction writers, Catholic historians also recovered the histories of nuns, bringing their stories to contemporary readers. In 1839, for instance, John Gage Rokewode published a version of the Blue Nuns' fatal history. "A Brief History of the late English Convent at Paris of the Order of the Conception, commonly called the Blue Nuns" was based upon the copy of the *Diary of the Blue Nuns* bequeathed to ex-Blue Nun Anne Duffield (and which contained Jerningham's additions and revisions). And John C. Alger's *Englishmen in the French Revolution* (1889), which capitalized on the continuing fascination with the Revolution and its violent outcomes, included in lengthy appendices the Revolutionary-era narratives of the English Benedictines in Paris and the English Benedictines in Cambrai.[41] Shortly thereafter, Bernard Ward published his *Dawn of the Catholic Revival 1791–1803* (1909), recounting the harrowing experiences of English nuns during the Revolution, as well as their travails in England. Finally, Peter Guilday's *The English Catholic Refugees on the Continent, 1558–1795* (1914) summarized English nuns' Continental histories, beginning the work of creating a coherent narrative of two very different experiences of exile.[42]

English nuns in the nineteenth century were not just subjects of historical inquiry, however. What of the actual fate of English contemplative houses that had returned during the French Revolution? How did they fare within this pied landscape of religious women's life in print and culture?

Conclusion: Repatriated Nuns in England

Contemplative nuns' histories in the Victorian period and beyond, including those of the first refugee migrations in the 1790s, are less visible than those of active women religious whose open work furthered the institutionalization of social services in nineteenth-century British society. However, contemplative groups were busy fostering productive social networks to secure patronage, recruits (students and novices), and property. They were managing schools, participating in artisan industry, buying and selling property, and engaging in scholarship. They also expanded: The Augustinians of Bruges sent a filiation to England in 1886, which settled at Haywards Heath in Sussex. The Stanbrook Abbey Benedictines assisted in efforts to found a community in Jambaroo, Australia in 1849, and, from 1900 to the present, they have contributed to the development of communities in Nigeria

(2012), the U.S. (1984) India (1970), and Uganda (1960).[43] The French Benedictines of Montargis at Princethorpe Priory sent nuns to Sydney, Australia in 1847; they opened a school there in 1851, which continued for 70 years.[44]

In the nineteenth century, finding suitable housing was an ongoing challenge for repatriated religious. For example, though both the Benedictines of Cambrai and the Benedictines of Montargis flirted with the idea of returning to France, it was not to be.[45] After two earlier moves, the English Benedictines bought Stanbrook Abbey in 1835 through the "ample dowers" of several wealthy postulants; it would remain their home until 2009.[46]

The French Benedictines also took several detours after living and working at Bodney Hall. First, they moved to Heath Hall in Yorkshire in 1813. Next, because their student enrollment had increased, they sought a larger house, buying Orrell Mount near Wigan in 1821. They soon discovered that coal mines around the property rendered the construction of a foundation for a monastery—so that the nuns could live again in enclosure—impossible.[47] Finally, they moved to Princethorpe, Warwickshire in 1835, reopened their school, and commissioned the building of Princethorpe Priory, a monastery designed on the model of their

Figure E.1 Abbey of Our Lady of Consolation, Stanbrook 1838.
Source: Stanbrook Abbey Archives.
Print by W.H. Wood, *A View of Charles Day's New Monastery Buildings of 1835–38*, Stanbrook Abbey, Wass.

168 *Epilogue*

convent in Montargis, and the first convent erected in England since the English Reformation.[48] The Augustinians of Bruges, though they migrated and returned to Belgium in 1803, arguably experienced fewer transitions than other groups: they reoccupied their Bruges convent, thrived over the course of the nineteenth century, and exist to this day. In 1843, Queen Victoria and King Leopold I of Belgium visited the convent accompanied by Lady Jerningham's daughter, Lady Charlotte Bedingfeld, whose daughter (Lady Jerningham's granddaughter) had been professed as Sister Mary Agnes in 1824. The Queen, according to the convent's annals, "seemed altogether pleased and expressed her admiration of the richness and precision of the children's singing."[49] The Queen's visit signaled not only the ongoing concrete relationship between English convents—whether at home or abroad—and the British state, but also the abstract notion that English convents were "British."

Nonetheless, just as during the French Revolution, Catholic nuns were still considered curiosities in British culture. A prime example of this occurred after the Catholic Emancipation of 1829, when the French Benedictines at Bodney Hall decided to make a more permanent settlement by having a convent built in Warwickshire. The 1832 ceremony that formalized the foundation of Princethorpe Priory drew a large group of Protestant spectators, and while the cloister walls and dormitories were under construction, "hundreds and thousands of visitors . . . pressed in to see this very curious house." With 500 workmen, the site, according to one spectator, "appeared to be alive, by reason of the number of people there." Sunday evening witnessed as many as 800 visitors eager to see the architectural monument to refugee survival. A local woman capitalized on the tourist traffic by charging a shilling to peep at a pasteboard model of the priory, which was kept behind a window. Even after the nuns were finally installed at Princethorpe Priory in 1835, they encountered a "mob, anxious to assure themselves that nuns were human beings, and not animals." To keep visitors at bay (who were accustomed to pop in at all hours to survey the building), a shop was opened to divert their passage and encourage them to purchase the nuns' extraordinary needlework.[50]

In contending with outsiders' fetishization of nuns and convents, the Benedictines of the 1830s were dealing with the same concerns as the religious who first disembarked in England almost thirty years before: as Chapter 4 of this book documents, the 1794 arrival at Hengrave Hall of the Augustinians of Bruges was met with a throng of curious bystanders and spectators. Though a continuing challenge, this domestic tourism was tolerated and even sometimes encouraged by nuns, because it made some small income for them, just as convent tourism in the eighteenth century had.

Contemplative nuns promoted the intellectual and entrepreneurial growth of members and the community through scholarship, artisan industry, and expansionist enterprises. By 1820, the English Poor Clares were settled at Scorton Hall in Yorkshire, and were well known for their fine work in "elegant needlework" and church vestments in gold, silk, and lace.[51] The Benedictines at Princethorpe Priory also gained a reputation for their needlework.[52] At Stanbrook Abbey, Dame Laurentia McLachlan excelled in scholarly work on plainchant, publishing (among other works) *Gregorian Music* (1897), *Grammar of Plainsong* (1905),

Epilogue 169

and the *Worcester Antiphoner* (1922).[53] Stanbrook Abbey was gifted with a print-ing press in 1876 by Father Laurence Shepherd, the local vicar, who wanted to "develop the spiritual, intellectual, and artistic lives of nuns," according to com-munity records. The Stanbrook Abbey Press published numerous religious works, both original and translated, into the late twentieth century.[54]

Recruiting novices in Britain was no longer a matter of simply attracting stu-dents and catering to rich Catholics, as it had once been on the Continent. By 1832, English houses, as well as the French Benedictines of Princethorpe Priory, recruited English and Irish novices. This is one early example of the easy reciproc-ity between Irish and English orders that would exist throughout the century. In addition, convent schools were well regarded and provided a significant source of income.[55] Nuns participated in social aid and institution-building through teach-ing, property acquisition, school and conventual administration, and refugee assistance throughout the nineteenth-century.

"Female subcultures were liberating places," Carmen M. Mangion argues, and the histories of refugee contemplative orders provide ample evidence of the ways in which nuns maintained their independence despite clerical pressures toward institutional conformity.[56] "Adjustments" recommended by apostolic vicars could be interpreted by nuns as encroachments. For example, when Vicar Apostolic John Milner suggested that the French Benedictines serve an "English" break-fast, some sisters insisted "no change, no change, no breakfast" and refused to concede. Moreover, the written and oral cultures of the French Benedictines at Princethorpe Priory retained many French characteristics, and although, as the century progressed, they were advised by clergy to use the English vernacular in their titles, terminology, and daily conversation, they continued to maintain their written annals in French until 1862, and had French superiors until 1860.[57]

Male clergy envisioned nuns fulfilling the church's agenda, rather than their own. When Cardinal Manning presided over the abbatial election at the English Benedictines at Stanbrook Abbey in 1887, for example, he emphasized his own role in legitimizing and making official the nuns' doings: "By delegating me, the Holy See has touched *directly* your venerable Abbey, for it is truly venerable, your flittings from place to place being only as it were stages in the passage through life." While minimizing nuns' movements as "flittings," rather than as multiple displacements, Manning also managed to analogize the indissolubility of Rome to the nuns' stone abbey, rather than to their stability as a group. Manning described the papal "touch" as "the bond which binds you to her still closer—and rendered you more pontifical, more papal than ever."[58] Increasingly absorbed into a sys-tem that was being shaped in England by Ultramontanism, the Benedictines may well have wondered how they had survived for over a century so loosely tethered to Rome.[59]

The re-institutionalization of the Catholic Church in England also gave nuns easier accessibility to Rome, and allowed them to formally memorialize their own histories. In 1897, the beatification of the French Carmelites of Compiègne (a pro-cess undertaken by the English Benedictines at Stanbrook Abbey) was authorized by the Vatican. The remains of the Carmelites' peasant clothing, which had been

170 *Epilogue*

given to the English Benedictines by prison officials after the sixteen members were sent to the scaffold wearing their habits in 1794, were authenticated as holy relics in a ceremony at Stanbrook in 1906.[60] In this case, English nuns had recovered and made permanent the legacy of French nuns with whom they had shared incarceration in the Compiègne prison over a century before. It is perhaps telling that only a few of these peasant clothes are currently still possessed by the community because, as Sister Scholastica Jacob notes, the nuns gave away many of the relics—perhaps out of a sense of obligation—to patrons.

Refugees no longer, nineteenth-century repatriated nuns were inserted into a national narrative of Britain's kind hospitality towards political outcasts during the French Revolution. Although they were less conspicuous in Victorian British culture than active women religious, they integrated into local communities, providing quality education for British children, offering new avenues for scholarly and financial betterment for their communities, and drawing postulants from new groups of women. Contemplative nuns negotiated enclosure with the expectations that nuns should be socially useful. In any event, the difficulty of finding properties that enabled complete separation from the world did not always make strict enclosure possible.[61]

The tricky position of contemplative nuns in late eighteenth- and nineteenth-century England has yet to be fully explored; so do the connections between nuns' lives and their representations in literature. Their Continental heritage introduced new elements into British religion, and was germane to an emerging multicultural landscape in the English Catholic Church. Wherever they went, nuns carried with them a powerful legacy of survival. Their narratives reveal the tenacity and courage with which women religious approached times of crisis, utilized social networks, and negotiated the demands of others. The overwhelming difficulties nuns surmounted during the French Revolution and into the nineteenth century bring to their collective stories—and the stories others wrote about them—a poignancy that continues to fascinate us today. There is still much to discover about the ways in which these early refugee communities responded to the changes brought on by industrialization, worked around (or in spite of) anti-Catholic attitudes, interacted with or impacted writers, politicians, other women religious, clergy, and local communities, all the while keeping their traditions alive in a rapidly changing society.

Notes

1 The connection between Catholic religious refugees in England and the development of Protestant-based religious communities has been proposed by Peter F. Anson and Ralph W. Sockman. Anson, *The Call of the Cloister: Religious Communities and Kindred Bodies in the Anglican Communion* (S.P.C.K., 1964); p. 25. Sockman, *The Revival of the Conventual Life in the Church of England in the Nineteenth Century* (New York City, 1917), pp. 36–7.

2 Frances Burney, *Brief Reflections Relative to the Emigrant French Clergy* (London, 1793), pp. 18–19. Sister Mary Francis's letter is quoted in Margaret J. Mason, "Nuns of the Jerningham Letters: Elizabeth Jerningham (1727–1807) and Frances Henrietta

Epilogue 171

Jerningham (1745–1824), Augustinian Canonesses of Bruges," *Recusant History*, 22/3 (1995): p. 359.

3 See for instance *The History of Darlington Carmel from the Foundation of Lierre Carmel 1648* (Darlington, Carmel, 1982), p. 25, where the author states that the Carmelite nuns removed some remains from their convent in Lierre "in order not to be separated from them during their 'exile' in England though they were in fact now returning providentially, to their homeland."

4 See John Wolffe, *The Protestant Crusade in Great Britain, 1829–1860* (Oxford, 1991), pp. 6–27.

5 Michael Tomko, *British Romanticism and the Catholic Question: Religion, History and National Identity, 1778–1829* (New York, 2010), p. 183; Susan O'Brien, "Religious Life for Women," in V. Alan McClelland and Michael Hodgetts (eds), *From Without the Flaminian Gate: 150 Years of Roman Catholicism in England and Wales 1850–2000* (London, 1999), pp. 113–14.

6 Mary Hilton, *Women and the Shaping of the Nation's Young: Education and Public Doctrine in Britain 1750–1850* (Aldershot, 2007), p. 185; See also Sabine Freitag, *Exiles from European Revolutions: Refugees in Mid-Victorian England*, ed. Sabine Freitag (New York, 2003).

7 Tomko, p. 183; O'Brien, "Religious Life for Women," p. 113.

8 For more on the Oxford Movement, see John Shelton Reed, *Glorious Battle: The Cultural Politics of Victorian Anglo-Catholicism* (Nashville, 1996); for the development of the Anglican Sisterhoods see Susan Mumm, *Stolen Daughters, Virgin Mothers: Anglican Sisterhoods in Victorian Britain* (London, 1999).

9 Susan O'Brien, "French Nuns in Nineteenth-Century England," *Past and Present*, 154 (1997): p. 178.

10 For reactions to Catholic convents and Anglican Sisterhoods in popular culture see Mumm, pp. 166–206; Reed, pp. 186–209; Dennis G. Paz, *Popular Anti-Catholicism in Mid-Victorian England* (Stanford, 1992); Susan P. Casteras, "Virgin Vows: The Early Victorian Artists' Portrayal of Nuns and Novices," *Victorian Studies*, 24/2 (1980–81): pp. 157–84; Contemporary sources include Dinah Mulock Craik, *On Sisterhoods*, in Elaine Showalter (ed.), Christina Rossetti *Maude* and Dinah Mulock Craik *On Sisterhoods* and *A Woman's Thoughts about Women* (New York, 1995); "Sisterhoods," *Pall Mall Gazette*, September 22, 1866, pp. 4–6; [Anthony Trollope], "The Sisterhood Question," *Pall Mall Gazette*, September 14, 1865, p. 338; W.M. Colles, *Sisters of Mercy, Sisters of Misery: or Miss Sellon in the Family* (London, 1852); "On Sisterhoods," *The Victoria Magazine*, August, 1863, pp. 289–301; Charles Walker, *Three Months in an English Monastery* (London, 1864); Lydia Sellon, *Reply to a Tract by the Rev. J. Spurrell* (London, 1852); J.M. Ludlow, *Women's Work in the Church: Historical Notes on Deaconesses and Sisterhoods* (London, 1865); Charles Kingsley, *Yeast, A Problem* (New York, 1864).

11 A well-known example of this genre is Maria Monk's *Awful Disclosures of the Hotel Dieu Nunnery* (New York, 1836), which was actually written by the Protestant minister J.J. Slocum. For a narrative relating to the Anglican Sisterhoods, see Margaret Goodman's, *Experiences of an English Sister of Mercy* (London, 1861).

12 Reed, p. 200.

13 Jenny Franchot, *Roads to Rome: The Antebellum Protestant Encounter with Catholicism* (Berkeley, 1994), p. 118. Franchot links American narratives of conventual escape to Indian captivity narratives—both register young peoples' rebellion from the parental roof.

14 Maria LaMonaca, *Masked Atheism: Catholicism and the Secular Victorian Home* (Columbus, 2008), p. 14. The most publicized claims regarding young women supposedly abused in Anglican Sisterhoods were made by fathers whose daughters apparently left home in an act of rebellion against parental authority. Reed, pp. 203–7; Mumm, pp. 172–90. Mumm articulates several key arguments against Sisterhoods in the period, including the presumed incapacity of women to self-govern, the concern that sisters

172　*Epilogue*

were in the public sphere, and that middle- and upper-class ladies were performing domestic work.

15　Casteras, pp. 157–84.
16　Anna Jameson, *Sisters of Charity, Catholic and Protestant and the Communion of Labor* (Boston, 1857). In "French Nuns," p. 143, O'Brien states that in the nineteenth-century, apostolic or active sisters working in public ministries "came to dominate the church's thinking about women religious and the popular image of nuns as never before."
17　Mumm, p. 60.
18　Jameson, *Sisters of Charity*, p. 141. See also Pauline Nestor, *Female Friendships and Communities: Charlotte Bronte, George Eliot, Elizabeth Gaskell* (Oxford, 1985), pp. 7–27.
19　Craik, pp. 54–5, 47–58.
20　Casteras, p. 159.
21　Florence Nightingale, *The Institution of Kaiserswerth on the Rhine* (London, 1851).
22　Val Web, *Florence Nightingale: The Making of a Radical Theologian* (St Louis, 2002), pp. 37, 78–9. Nightingale did maintain a good relationship with Mother Mary Clare of the Bermondsey Sisters of Mercy. Mary C. Sullivan, *The Friendship of Florence Nightingale and Mary Clare Moore* (Philadelphia, 1999).
23　Mumm, pp. 164–5.
24　For more on the convent inspection agitations, see Rene Kollar, *A Foreign and Wicked Institution? The Campaign against Convents in Victorian England* (Eugene, 2011); and "Allegations of Convent Violence, the Campaign against Sisterhoods in Victorian England, and the Response of Parliament," *Studia Monastica*, 50/2 (2008): pp. 255–73; Walter L. Arnstein, *Protestant versus Catholic in Mid-Victorian England: Mr Newdegate and the Nuns* (Columbia, 1982).
25　Carmen M. Mangion, "Women, Religious Ministry, and Female Institution-Building," in Sue Morgan and Jacqueline deVries (eds), *Women, Gender and Religious Cultures in Britain, 1800–1940* (London, 2010), p. 79; Kollar, "Allegations of Convent Violence," pp. 270–72.
26　Frideswide Stapleton, *The History of the Benedictines of St Mary's Priory, Princethorpe* (Hinckley, 1930), pp. 129–30; for more on Gladstone and religion, see D.W. Bebbington, *William Ewart Gladstone: Faith and Politics in Victorian Britain* (Grand Rapids, 1993).
27　Edward Norman, *Anti-Catholicism in Victorian England* (London, 1986), p. 20.
28　See Jill Rappoport, *Giving Women: Alliance and Exchange in Victorian Culture* (Oxford, 2012).
29　Carmen M. Mangion, "The 'Mixed Life': Challenging Understandings of Religious Life in Victorian England," in Laurence Lux-Sterritt and Carmen M. Mangion (eds), *Gender, Catholicism, and Spirituality* (New York, 2011), p. 169.
30　Susan O'Brien, "Terra Incognita: The Nun in Nineteenth-Century England," *Past and Present*, 121 (1988): pp. 116, 140; Carmen M. Mangion, "Women, Religious Ministry, and Female Institution-Building," pp. 79–80; Barbara Walsh, *Nuns in England and Wales: A Social History 1800–1937* (2002), p. 2; Mumm, pp. 93–134.
31　O'Brien, "Terra Incognita," p. 129. Before 1850, there were fewer than 50 convents, including the new congregations and the older contemplative houses. Congregations included the Faithful Companions of Jesus (1830); Presentation Nuns (1836); Sisters of Mercy (1839); Good Shepherd Nuns (1841); Society of the Sacred Heart (1842); and the Sisters of Notre Dame of Namur (1845).
32　O'Brien, "Terra Incognita," p. 111.
33　O'Brien, "Religious Life for Women," p. 114; O'Brien, "French Nuns," pp. 155–6. O'Brien argues that "convent development in England was profoundly influenced by the French connection," p. 146.
34　O'Brien, "Terra Incognita," pp. 135, 138.

Epilogue 173

35 O'Brien, "French Nuns," p. 173.
36 Mangion, "The 'Mixed Life,'" p. 168.
37 O'Brien, "French Nuns," p. 177.
38 Anna Jameson, *Legends of the Monastic Orders* (London, 1850); Rhoda Broughton, *Not Wisely, But Too Well* (London, 1867); George Eliot, *Middlemarch*, ed. Rosemary Ashton (London, 1994); *Romola*, ed. Dorothea Barrett (London, 1996); Elizabeth Gaskell, *Ruth*, ed. Angus Easson (London, 1997), and *Cranford*, ed. Patricia Ingham (London, 2008). Scholarly work includes Joseph Ellis Baker, *The Novel and the Oxford Movement* (London, 1932); Susan Greenstein, "A Question of Vocation: From *Romola* to *Middlemarch*," *Nineteenth-Century Fiction*, 35/4 (1981): pp. 487–505; Alison Booth, "The Silence of Great Men: Statuesque Femininity and the Ending of *Romola*," in Alison Booth (ed.), *Famous Last Words: Changes in Gender and Narrative Closure* (Charlottesville, 1993), pp. 110–34; Tonya Moutray McArthur, "Unwed Orders: Religious Communities for Women in the Works of Elizabeth Gaskell," *Gaskell Society Journal*, 17 (2003): pp. 59–76.
39 Eliot, *Middlemarch*, p. 3; Jameson, *Legends of the Monastic Orders*, p. xx.
40 George Eliot, *Romola*, ed. Dorothea Barrett (London, 1996); Elizabeth Gaskell, *My Lady Ludlow and Other Stories* (Oxford, 1989).
41 John Gage Rokewode, "A Brief History of the late English Convent at Paris of the Order of the Conception, commonly called the Blue Nuns, communicated to the Society of Antiquaries" (London, 1839); John G. Alger, *Englishmen in the French Revolution* (London, 1889), pp. 300–332.
42 Bernard Ward, *The Dawn of the Catholic Revival in England, 1791–1803* (2 vols, London, 1909); Peter Guilday, *The English Catholic Refugees on the Continent, 1558–1795* (New York, 1914).
43 Stanbrook Abbey, "A 21st Century Community Rooted in Christ," (Stanbrook Abbey, 2015). Accessed May 8, 2015. www.stanbrookabbey.org.uk/page-ourroots.html.
44 C.S. Durrant, *A Link Between Flemish Mystics and English Martyrs* (London, 1925), p. 412; Stapleton, pp. 114–15.
45 *In a Great Tradition: The Life of Dame Laurentia McLachlan, Abbess of Stanbrook by the Benedictines of Stanbrook* (New York, 1956), p. 46. The Brussels nuns at Winchester also desired to return. Dominic Aidan Bellenger, "The Brussels Nuns at Winchester 1794–1857," English Benedictine Congregation History Commission Symposium (1999), p. 5.
46 The Community of Saint Mary, formerly from Cambrai, relocated to Wass, York, in 2009.
47 The Benedictines at Heath Hall stayed with the English Augustinians in Paris for six months. Margaret J. Mason, "Nuns of the Jerningham Letters: The Hon. Catherine Dillon (1752–1787) and Anne Nevill (1754–1824), Benedictines at Bodney Hall," *Recusant History*, 23/1 (1996): p. 70; Stapleton, pp. 99–100.
48 Stapleton, pp. 100, 102–3.
49 Margaret J. Mason, "Nuns and Vocations of the Unpublished Jerningham Letters: Charlotte Bedingfield, Augustinian Canoness 1802–1876, Louisa Jerningham, Franciscan Abbess (1808–1893), and Clementina Jerningham, Marquise de Ripert-Monclar (1810–1864)," *Recusant History*, 21/4 (1993): p. 533.
50 Stapleton, pp. 103–6.
51 O'Brien, "Terra Incognita," p. 116; A.M.C. Forster, "The Chronicles of the English Poor Clares of Rouen—II," *Recusant History*, 18/2 (1986): pp. 160–1. Members from the Poor Clares of Aire joined the Poor Clares residing in Scorton, bringing with them their knowledge of pill and snuff making to assist the communities.
52 Stapleton, p. 106.
53 *In a Great Tradition*, pp. 122–4.
54 Benedictines of Stanbrook Abbey, *The Stanbrook Abbey Press* (Worcester, 1970), pp. 9–10.

174 *Epilogue*

55 Dominic Aidan Bellenger, *The French Exiled Clergy* (Bath, 1986), p. 93; O'Brien, "French Nuns," pp. 151, 163; this exchange is evident particularly in women's congregations.

56 Mangion, "Women, Religious Ministry, and Female Institution-Building," p. 73. Though Mangion focuses primarily on active religious groups, she broadly argues that "these female-governed structures functioned relatively independently although they were under the supervision of male clergy who, at times, attempted to limit their authority and subjugate their governmental structures."

57 Bellenger, *French Exiled Clergy*, pp. 92–3; Stapleton, pp. 127, 130. Milner was Apostolic Vicar of the midlands region from 1803 to 1826.

58 *In a Great Tradition*, pp. 145–6.

59 Paz, p. 82; See also Mary Heimann, *Catholic Devotion in Victorian England* (Oxford, 1995).

60 *In a Great Tradition*, p. 148.

61 *In a Great Tradition*, pp. 50, 54.

Bibliography

Primary Sources

Addison, Joseph. *Remarks on Several Parts of Italy, &c. In the Years 1701, 1702, 1703* (Hague, 1718).

"An Account of the Austin Nuns Travels from Bruges to England—the year 1794," in Caroline Bowden, Carmen M. Mangion, and Michael Questier, et al. (eds), *English Convents in Exile, 1600–1800* (6 vols, London: Pickering and Chatto, 2012–2013), vol. 6, pp. 373–6.

An Accurate Description of the Principal Beauties, in Painting and Sculpture, belonging to the Several Churches, Convents, &c. in and about Antwerp (London, 1765).

Andrews, John, *Remarks on the French and English Ladies, in a Series of Letters; Interspersed with Various Anecdotes* (Dublin, 1783).

Antonini, Annibale. *A View of Paris: Describing all the Churches, Palaces, Publick Buildings, Libraries, Manufactures, and Fine Paintings; Necessary for the Observation of Strangers: by the Abbot Antonin* (London, 1749).

Astell, Mary. *A Serious Proposal to the Ladies*, 4th edn (New York: Source Book Press, 1970).

Bacon, Francis. "Of Travel," in *Bacon's Essays* (New York: Carlton House, 1930s).

Barbauld, Anna Letitia and John Aiken. *Evenings at Home, or the Juvenile Budget Opened* (London: J. Johnson, 1792–1796).

Barker, Jane. *The Galesia Trilogy and Selected Manuscript Poems*, ed. Carol Shiner Wilson (New York: Oxford University Press, 1997).

Barruel, Augustin. *Histoire du clergé pendant la Révolution françoise; oubrage dédié à la nation angloise* (3 vols, London: J.P. Coghlan, 1793).

———. *The History of the Clergy During the French Revolution* (3 vols, London: J.P. Coghlan, 1794).

———. *Abstract of the History of the Clergy During the Revolution* (London: J. Nichols, 1794).

———. *Memoirs, Illustrating the History of Jacobinism* (4 vols, London: T. Burton and Co., 1797–1798).

Behn, Aphra. *The Rover* (London, 1677).

———. *The History of the Nun: or, The Fair Vow-Breaker* (London, 1689).

Beloe, William. *The Sexagenarian* (1817).

Betham, Matilda. *Poems and Elegies*, ed. Donald H. Reiman (New York: Garland Publishing, Inc, 1978).

Brontë, Charlotte. *The Poems of Charlotte Brontë*, ed. Victor A. Neufeldt (New York: Garland Publishing, Inc., 1985).

176 *Bibliography*

———. *Villette*, ed. Tony Tanner (New York: Penguin, 1985).

Broughton, Rhoda. *Not Wisely, But Too Well* (London: Tinsley, 1867).

Burke, Edmund. *Reflections on the Revolution in France*, 5th edn (London: J. Dodsley, 1790).

———. "The Case of the Suffering Clergy of France," *The Evening Mail*, September 17–19, 1792.

Burney, Frances. *Brief Reflections Relative to the Emigrant French Clergy* (London: T. Davison, 1793).

———. *The Wanderer; Or, Female Difficulties* (London: Longman, 1814).

Cavendish, Margaret. *The Convent of Pleasure and Other Plays*, ed. Anne Shaver (Baltimore: John Hopkins University Press, 1999).

Centlivre, Susanna. *The Wonder: A Woman keeps a Secret: A Comedy* (London, 1714).

Chapone, Hester. *Letters on the Improvement of the Mind Addressed to a Young Lady* (London, 1773).

Chateaubriand, François-René. *Atala/René*, trans. Irving Putter (Berkeley: University of California Press, 1952).

Cole, William. *A Journal of my Journey to Paris in the year 1765* (New York: Richard R. Smith, Inc, 1931).

Colles, W.M. *Sisters of Mercy, Sisters of Misery: or Miss Sellon in the Family* (London: T. Hatchard, 1852).

A Complete History of the Invasions of England (London: J. Skirven, 1801).

Craik, Dinah Mulock. *On Sisterhoods*, in Elaine Showalter (ed.), Christina Rossetti *Maude* and Dinah Mulock Craik *On Sisterhoods* and *A Woman's Thoughts about Women* (New York: New York University Press, 1995).

The Diary of the Blue Nuns: An Order of the Immaculate Conception of our Lady at Paris, 1688–1810, eds Joseph Gillow and Richard Trappes-Lomax (London: J. Whitehead & Son, 1910).

Diderot, Denis. *The Nun*, trans. Russell Goulbourne (Oxford, Oxford University Press, 2005).

Discours de Madame de Lévi de Mirepoix, abbesse des religieuses bénédictines de Montargis, âgée de vingt-sept ans; en réponse aux officiers du district de cette ville, entrant par force dans sa maison (n.p., n.d.).

Dryden, John. *The Assignation: Or, Love in a Nunnery* (London, 1673).

Dugdale, William, Roger Dodsworth, John Stevens, et al. *Monasticon Anglicanum: A History of the Abbies and other Monasteries, Hospitals, Frieries, and Cathedral and Collegiate Churches, with their Dependencies, in England and Wales* (6 vols, London: Longman, Hurst, Rees, Orme & Brown, 1817–1830).

Eliot, George. *Middlemarch*, ed. Rosemary Ashton (London: Penguin, 1994).

———. *Romola*, ed. Dorothea Barrett (London: Penguin, 1996).

Essex, James. *Journal of a Tour through part of Flanders and France in August, 1773*, ed. W.M. Fawcett (Cambridge: Deighton, Bell & Co, 1888).

Fosbroke, T.D. *British Monachism: or, Manners and Customs of the Monks and Nuns of England* (London: J. Nichols, 1816).

Gaskell, Elizabeth. *My Lady Ludlow and Other Stories*, ed. Edgar Wright (Oxford: Oxford, 1989).

———. *Ruth*, ed. Angus Easson (London: Penguin, 1997).

———. *Cranford*, ed. Patricia Ingham (London: Penguin, 2008).

The Gentleman's Guide, in a Tour through part of France and Flanders (London, 1768).

Goodman, Margaret. *Experiences of an English Sister of Mercy* (London: Smith, Elder, and Co., 1861).

Bibliography 177

Hawkins, Laetitia. *Letters on the Female Mind, its Powers and Pursuits: Addressed to Miss H.M. Williams, with Particular Reference to her Letters from France* (2 vols, London: Hookham and Carpenter, 1793).

Haywood, Eliza. *Love in Excess*, 2nd edn, ed. David Oakleaf (Toronto: Broadview, 2000).

Hesmivy d'Auribeau, Pierre d.' *Extraits de quelques écrits de l'auteur des Mémoires pour servir à la histoire de la persécution françoise* (1814).

Heywood, Cecilia. "Records of the Abbey of our Lady of Consolation at Cambrai 1620–1793," in Joseph Gillow (ed.), *Miscellanea*, 8 (London: The Catholic Record Society, 1913), pp. 20–35.

Jameson, Anna. *Sisters of Charity, Catholic and Protestant and the Communion of Labor* (Boston: Ticknor and Fields, 1857).

———. *Legends of the Monastic Orders* (Boston: Ticknor and Fields, 1866).

Jerningham, Frances Dillon. *The Jerningham Letters (1780–1843)* (2 vols, London: R. Bentley and Son, 1896).

Johnson, Samuel. *Rasselas* in Bertrand H. Bronson (ed.), *Poems, and Selected Prose*, 3rd edn (New York: Harcourt Brace Jovanovich College Publishers, 1971).

Kingsley, Charles. *Yeast, A Problem* (New York: Harper & Brothers Publishers, 1864).

Laclos, Pierre Ambroise François Choderlos de. *Dangerous Liaisons*, trans. and ed. Helen Constantine (London: Penguin, 2007).

Les Lettres portugaises, Lettres d'une péruvienne, et autres romans d'amour par lettres, eds Bernard Bray and Isabelle Landy-Houillon (Paris: Flammarion, 1983).

Lewis, Matthew. *The Monk*, ed. Christopher Maclachlan (London: Penguin, 1998).

"Memorial of the English Nuns, Settled at Paris, in the Rue des Fossés, Saint Victor," in *Extract from the Proceedings of the Board of Administration of the District of Douay on the Fourteenth of December, 1791. Trans. from the French.* (London, n. d.).

Milton, John. *Animadversions* in Don M. Wolf (ed.), *Complete Prose Works* (8 vols, New Haven: Yale University Press, 1953–82), vol. 1.

Monk, Maria. *Awful Disclosures of the Hotel Dieu Nunnery* (New York, 1836).

Monsanto, Antonio. *A Tour from England, thro' part of France, Flanders, Brabant, and Holland* (London, 1752).

Montagu, Mary Wortley. *Letters* (New York: Alfred A. Knopf, 1992).

Montesquieu, Charles-Louis de Secondat de. *Persian Letters*, trans. C.J. Betts (London: Penguin, 1993).

More, Hannah. *Considerations on Religion and Public Education with Remarks on the Speech of M. Dupont* (Boston: Weld and Greenough, 1794).

Nightingale, Florence. *The Institution of Kaiserswerth on the Rhine, for the Practical Training of Deaconesses* (London: London Ragged Colonial Training School, 1851).

———. *Ever Yours, Florence Nightingale Selected Letters*, eds Martha Vicinus and Bea Nergaard (Cambridge: Harvard University Press, 1990).

Nugent, Thomas. *The Grand Tour; or, a Journey through the Netherlands, Germany, Italy, and France* (4 vols, London, 1778).

"On Sisterhoods," *The Victoria Magazine*, August, 1863, pp. 289–301.

Opie, Amelia. "Lines for the Album at Cossey," in *Poems by Mrs Opie*, 3rd edn (London: Garland Publishing, Inc., 1804).

Paterson, Samuel. *Another Traveller!: or, Cursory Remarks and Tritical* (sp) *Observations made upon a Journey through part of the Netherlands in the latter end of the year 1766 by Coriat Junior* (London: J. Johnson & J. Payne [etc], 1767–1769).

The Parliamentary History of England from the Earliest Period to the Year 1803 (London: Longman, 1819), vol. 35, pp. 340–86.

178 *Bibliography*

Piozzi, Hester Thrale. "To Penelope Pennington," November 4, 1793, in Oswald Knapp (ed.), *The Intimate Letters of Hester Piozzi and Penelope Pennington, 1788–1821* (London: John Lane, 1914).

———. *Mrs Thrale's French Journal, 1775*, in Moses Tyson and Henry Guppy (eds), *The French Journals of Mrs Thrale and Doctor Johnson* (Manchester: Manchester University Press, 1932).

———. *Thraliana: The Diary of Mrs Hester Lynch Thrale (Later Mrs Piozzi), 1776–1809*, ed. Katherine C. Balderston (2 vols, Oxford: Clarendon Press, 1951).

———. *Observations and Reflections Made in the Course of a Journey Through France, Italy, and Germany*, ed. Herbert Barrows (Ann Arbor: University of Michigan Press, 1967).

Pope, Alexander. "Eloisa to Abelard," in Aubrey L. Williams (ed.), *Poetry and Prose of Alexander Pope* (Boston: Houghton Mifflin, 1969).

Radcliffe, Ann. *A Journey Made in the Summer of 1794, through Holland and the Western Frontier of Germany, with a Return down the Rhine: to Which Are Added Observations during a Tour to the Lakes of Lancashire, Westmoreland, and Cumberland*, 2nd edn, (2 vols, London: G. G. and J. Robinson, 1795).

———. *The Mysteries of Udolpho* (Oxford: Oxford University Press, 1998).

———. *The Italian, or, the Confessional of the Black Penitents*, ed. Robert Miles (London: Penguin, 2000).

Richardson, Samuel. *The Works of Samuel Richardson* (19 vols, London, 1825).

Rokewode, John Gage. "A Brief History of the late English Convent at Paris of the Order of the Conception, commonly called the Blue Nuns, communicated to the Society of Antiquaries" (London: J.B. Nichols and Son, 1839).

Rousseau, Jean Jacques. *Emile, Julie and other Writings*, ed. R.L. Archer (Woodbury: Barron's Educational Series, Inc., 1964).

Sade, Marquis de. *Juliette*, trans. Austryn Wainhouse (New York: Grove, 1968).

Sand, George. *The Convent Life of George Sand*, trans. Maria Ellery McKay (Chicago: Cassandra Editions, 1977).

Scott, Sarah. *Millenium Hall*, ed. Gary Kelly (Ontario: Broadview Press, 2001).

Sellon, Lydia. *Reply to a Tract by the Rev. J. Spurrell, vicar of Great Shelford, containing certain charges concerning the Society of Sisters of Mercy in Devonport and Plymouth* (London: Joseph Masters, 1852).

"Sisterhoods," *Pall Mall Gazette*, September 22, 1866, pp. 4–6.

Smith, Charlotte. *Desmond* (3 vols, London: G.G.J. and J. Robinson, 1792).

———. *Rural Walks: In Dialogues. Intended for the use of Young Persons* (Dublin, 1795).

———. *Rambles Farther: A Continuation of Rural Walks* (London, 1796).

———. *Minor Morals, Interspersed with Sketches of Natural History, Historical Anecdotes, and Original Stories* (London, 1798).

———. "The Emigrants," in Stuart Curran (ed.), *The Poems of Charlotte Smith* (Oxford: Oxford University Press, 1993).

———. *The Collected Letters of Charlotte Smith*, ed. Judith Phillips Stanton (Bloomington: Indiana University Press, 2003).

Smith, Adam. *Theory of Moral Sentiments* (Indianapolis: Liberty Fund, 1982).

Sousa-Botelho, Adélaïde de. *Oeuvres de Madame de Souza* (Paris: Charpentier, 1845).

Southey, Robert. *Sir Thomas More, or, Colloquies on the Progress and Prospects of Society* (2 vols, London: Murray, 1831).

Thicknesse, Philip. *Observations on the Customs and Manners of the French Nation: in a Series of Letters, in which that Nation is Vindicated from the Misrepresentation of some Late Writers* (London: R. Davies, 1766).

Bibliography 179

———. *A Year's Journey through France, and part of Spain* (2 vols, Bath: R. Cruttwell, 1777).

A Tour of Spa, through the Austrian Netherlands, and French Flanders (London, 1774).

A Tour through part of France and Flanders (London, 1768).

Trimmer, Sarah. *Fabulous Histories, Designed for the Instruction of Children, Respecting their Treatment of Animals* (London, 1786).

[Trollope, Anthony]. "The Sisterhood Question," *Pall Mall Gazette*, September 14, 1865, p. 338.

Venus in the Cloister; Or, the Nun in her Smock (London: Edmund Curll, 1725).

Walker, Charles. *Three Months in an English Monastery* (London: Murray and Co., 1864).

Walpole, Horace. *The Castle of Otranto* (Oxford: Oxford University Press, 1998).

Williams, Helen Maria. *Letters Written in France in the Summer of 1790, to a Friend in England: Containing Various Anecdotes Relative to the French Revolution; and Memoirs of Mons. and Madame DuF—*, 2nd edn (4 vols, London, 1792).

———. *Letters Containing a Sketch of the Politics of France, from the Thirty-first of May 1793, till the Twenty-eighth of July 1794, and of the Scenes which have passed in the Prisons of Paris* (4 vols, London, 1795).

———. *Sketches of the State of Manners and Opinions in the French Republic towards the close of the eighteenth century. In a series of Letters* (2 vols, London: J. Crowder, 1801).

———. *Souvenirs de la Révolution française*, trans. Charles Coquerel (Paris: Dondy-Dupré, père et fils, 1827).

Wollstonecraft, Mary. *Thoughts on the Education of Daughters* (London, 1787).

———. *Original Stories from Real Life, Calculated to Regulate the Affections, and form the Mind to Truth and Goodness* (London: J. Johnson, 1788).

———. *A Vindication of the Rights of Woman: With Strictures on Political and Moral Subjects* (London: J. Johnson, 1792).

———. *An Historical and Moral View of the Origin and Progress of the French Revolution* (2 vols, London: J. Johnson, 1794).

———. *Maria: Or The Wrongs of Woman. A Posthumous Fragment*, ed. William Godwin (Philadelphia: James Carey, 1799).

———. "December 24, 1792," in Ralph M. Wardle (ed.), *The Collected Letters of Mary Wollstonecraft* (Ithaca: Cornell University Press, 1979).

Archives

Account Book, Stanbrook Abbey Archives, 1795–1803. Stanbrook Abbey. Wass, Yorkshire.

Knight Correspondence, 1789–1792. Stanbrook Abbey. Wass, Yorkshire.

Personal Communication

Sister Scholastica Jacob, June 29–30, 2011. Stanbrook Abbey. Wass, Yorkshire.

Newspapers

Argus, 1790.

Bath Journal, 1796.

Diary or Woodfall's Register, 1792.

English Chronicle or Universal Evening Post, 1790.

180 *Bibliography*

Evening Mail, 1792, 1799.
Gazetteer, 1793.
Gazetteer and New Daily Advertiser, 1792.
General Evening Post, 1792.
Liverpool Mercury, 1822.
Lloyd's Evening Post, 1792.
London Chronicle, 1792.
London Evening Post, 1793.
London Packet or New Lloyd's Evening Post, 1797, 1800.
Morning Post, 1793.
Morning Post and Fashionable World, 1797.
Observer, 1793.
Public Advertiser, 1792–1793.
Star, 1792–1793, 1795.
St James's Chronicle, 1792, 1795.
Times, 1800
World, 1792.

Periodicals

Analytical Review, 1794–1796.
Britannic Magazine; or Entertaining Repository of Heroic Adventures and Memorable Exploits, 1797.
British Critic and Quarterly Theological Review, 1795.
Critical Review, 1766, 1768, 1777, 1795–1796.
English Review, 1796.
European Magazine and London Review, 1795.
Gentleman's Magazine, 1766.
Gentleman's Magazine and Historical Chronicle, 1794.
London Magazine or Gentlemen's Monthly Intelligencer, 1768
Monthly Review or Literary Journal, 1766, 1768, 1777, 1794–1796.
Monthly Magazine, 1809.
Monthly Repository 2nd ser. 9, 1835.
New Annual Register, 1795.
Universal Magazine, 1795.

Secondary Sources

Acosta, Ana M. "Hotbeds of Popery: Convents in the English Literary Imagination," *Eighteenth-Century Fiction*, 15 (2003): pp. 615–42.
Adams, Hannah. *A View of Religion in Two Parts* (2 vols, Boston: Manning & Loring, 1801).
Adolphus, John. *The History of England from the Accession to the Decease of George the Third* (7 vols, London: John Lee, 1845), vol. 7.
Agius, Dom Denis. "Benedictines Under the Terror 1794–1795," English Benedictine Congregation History Commission (1982), pp. 4–9.
Alger, John G. *Englishmen in the French Revolution* (London: Sampson Low, Marston, Searle & Rivington, 1889).

Bibliography 181

Amory, Thomas. *Memoirs: Containing the Lives of Several Ladies of Great Britain* (London, 1755).

Anson, Peter F. *The Call of the Cloister: Religious Communities and Kindred Bodies in the Anglican Communion* (S.P.C.K., 1964).

———. *Building up the Waste Places* (Leighton Buzzard, Faith Press, 1973).

Applewhite, Harriet B. and Darline G. Levy. *Women and Politics in the Age of the Democratic Revolution* (Ann Arbor: University of Michigan Press, 1993).

Arnstein, Walter L. *Protestant versus Catholic in Mid-Victorian England: Mr Newdegate and the Nuns* (Columbia: University of Missouri Press, 1982).

Aston, Nigel. *Religion and Revolution France 1780–1804* (Washington, D.C.: Catholic University of America Press, 2000).

———. *Christianity and Revolutionary Europe c 1750–1830* (Cambridge: Cambridge University Press, 2002).

Baker, Joseph Ellis. *The Novel and the Oxford Movement* (London: Oxford University Press, 1932).

Baldensperger, Fernand. *Le Mouvement des idées dans l'émigration française, 1789–1815* (2 vols, Paris: Plon, 1924).

Barker-Benfield, G.J. *The Culture of Sensibility: Sex and Society in Eighteenth-Century Britain* (Urbana: University of Chicago, 1992).

Battigelli, Anna and Stevens, Laura M. (eds). "Eighteenth-Century Women and English Catholicism," *Tulsa Studies in Women's Literature*, 31/1–2 (2012): pp. 1–26.

Beales, Derek. *Prosperity and Plunder: European Catholic Monasteries in the Age of Revolution, 1650–1815* (Cambridge: Cambridge University Press, 2003).

———. "Edmund Burke and the Monasteries of France," *Historical Journal*, 48/2 (2005): pp. 415–36.

Bebbington, D.W. *William Ewart Gladstone: Faith and Politics in Victorian Britain* (Grand Rapids: W.B. Eerdman's Publishing Co., 1993).

Bellenger, Dominic Aidan, "The French Revolution and the Religious Orders. Three Communities 1789–1815," *Downside Review*, 98/330 (1980): pp. 25–32.

———. *The French Exiled Clergy* (Bath, England: Downside Abbey, 1986).

———. "France and England: The English Female Religious Reformation to World War," in Frank Tallett and Nicholas Atkin (eds), *Catholicism in Britain and France Since 1789* (London: Hambledon Press, 1996), pp. 3–11.

———. "The Brussels Nuns at Winchester 1794–1857," English Benedictine Congregation History Commission Symposium (1999), pp. 1–7.

———. "'Fearless Resting Place': the Exiled French Clergy in Great Britain, 1789–1815," in Kirsty Carpenter and Philip Mansel (eds), *The French Emigrés in Europe and the Struggle against Revolution, 1789–1814* (New York: St Martin's Press, 1999), pp. 214–29.

Bence-Jones, Mark. *The Catholic Families* (London: Constable & Robinson Ltd., 1992).

Benedictines of Stanbrook Abbey. *The Stanbrook Abbey Press* (Worcester: Stanbrook Abbey Press, 1970).

Benis, Toby. *Romantic Diasporas: French Emigrés, British Convicts, and Jews* (New York: Palgrave Macmillan, 2009).

Betros, Gemma. "Liberty, Citizenship and the Suppression of Female Religious Communities in France, 1789–90," *Women's History Review*, 18/2 (2006): pp. 311–36.

The Bible. Old and New Testaments in the Authorized King James Version (Charlotte, North Carolina: Stampley Enterprises, Inc., 1985).

Black, Jeremy. *Natural and Necessary Enemies: Anglo-French Relations in the Eighteenth Century* (Athens: University of Georgia Press, 1987).

182 *Bibliography*

————. *The British Abroad: The Grand Tour in the Eighteenth Century* (New York: St Martin's, 1992).

Booth, Alison. "The Silence of Great Men: Statuesque Femininity and the Ending of *Romola*," in Alison Booth (ed.), *Famous Last Words: Changes in Gender and Narrative Closure* (Charlottesville: University Press of Virginia, 1993), pp. 110–34.

Bowden, Caroline. "The English Convents in Exile and Questions of National Identity C. 1600–1688," in David Worthington (ed.), *British and Irish Migrants and Exiles in Europe, 1603–1688* (Leiden: Brill, 2010), pp. 297–314.

Brah, Avtar. *Cartographies of Diaspora: Contesting Identities* (London: Routledge, 1996).

Bray, Matthew. "Helen Maria Williams and Edmund Burke; Radical Critique and Complicity," *Eighteenth Century Life*, 16/2 (May 1992): pp. 1–24.

Buck, Charles. *A Theological Dictionary* (Philadelphia: W. Hill Woodward, 1818).

Bush, William. *To Quell the Terror: the Mystery of the Vocation of the Sixteen Carmelites of Compiégne Guillotined July 17, 1794* (Washington, D.C.: ICS Publications, 1999).

Carpenter, Kirsty. "London: Capital of Emigration," in Kirsty Carpenter and Philip Mansel (eds), *The French Emigrés in Europe and the Struggle against Revolution, 1789–1814* (New York, 1999), pp. 43–62.

————. *Refugees of the French Revolution: Emigrés in London, 1789–1802* (New York: St Martin's Press, 1999).

Casteras, Susan P. "Virgin Vows: The Early Victorian Artists' Portrayal of Nuns and Novices," *Victorian Studies*, 24/2 (1980–1981): pp. 157–84.

Certeau, Michel de. *The Practice of Everyday Living*, trans. Steven Rendall (Berkeley: University of California Press, 1984).

Chard, Chloe. *Pleasure and Guilt on the Grand Tour: Travel Writing and Imaginative Geography, 1600–1830* (New York: Manchester University Press, 1999).

Cholvy, Gérard. "Revolution and the Church: Breaks and Continuity," *Concilium*, 201/1 (1989): pp. 51–60.

Choudhury, Mita. *Convents and Nuns In Eighteenth-Century French Politics and Culture* (Ithaca: Cornell University Press, 2004).

Colley, Linda. *Britons: Forging the Nation 1707–1837* (New Haven: Yale University Press, 1992).

Corens, Liesbeth. "Catholic Nuns and English Identities. English Protestant Travellers on the English Convents in the Low Countries, 1660–1703," *Recusant History* 30 (2011): pp. 441–59.

Daniel-Rops, Henri. *The Church in an Age of Revolution, 1789–1870*, trans. John Warington (J.M. Dent: London, 1965).

Dolan, Elizabeth. *Seeing Suffering in Women's Literature of the Romantic Era* (Aldershot: Ashgate, 2008).

————. "Collaborative Motherhood: Maternal Teachers and Dying Mothers in Charlotte Smith's Children's Books," *Women's Writing*, 16/1 (2009): pp. 109–25.

Dolan, Frances E. *Whores of Babylon: Catholicism, Gender, and Seventeenth-Century Print Culture* (Notre Dame: University of Notre Dame Press, 2005).

Doody, Margaret Ann. *Frances Burney: The Life and Works* (Cambridge: Cambridge University Press, 1988).

Durrant, C.S. *A Link Between Flemish Mystics and English Martyrs* (London: Burns, Oates and Washbourne Ltd., 1925).

Edwards, Bela Bates and George Palmer Tyler, *An Encyclopedia of Religious Knowledge*, ed. John Newton Brown (Brattleboro: J. Steen & Co., 1844).

Bibliography 183

The English Convents in Exile, 1600–1800, eds Caroline Bowden, Carmen M. Mangion, Michael Questier, et al. (6 vols, London: Pickering and Chatto, 2012–2013).

Evangelisti, Silvia. *Nuns: A History of Convent Life* (New York: Oxford University Press, 2007).

Fabian, Johannes. *Time and the Other: How Anthropology Makes its Object* (New York: Columbia University Press, 1983).

Fanning, William. "Augustin Barruel," *The Catholic Encyclopedia* (2 vols, New York: Robert Appleton Co., 1907).

Favret, Mary. "Spectratice as Spectacle: Helen Maria Williams at Home in the Revolution," *Studies in Romanticism*, 32/2 (1993): pp. 273–95.

———. *Romantic Correspondences: Women, Politics and the Fiction of Letters* (Cambridge: Cambridge University Press, 1993).

Fletcher, Lorraine. *Charlotte Smith, A Critical Biography* (London: Macmillan,1998).

Forster, A.M.C. "The Chronicles of the English Poor Clares of Rouen—II," *Recusant History*, 18/2 (1986): pp. 149–91.

Franchot, Jenny. *Roads to Rome: The Antebellum Protestant Encounter with Catholicism* (Berkeley: University of California Press, 1994).

Freitag, Sabine. *Exiles from European Revolutions: Refugees in Mid-Victorian England*, ed. Sabine Freitag (New York: Berghahn Books, 2003).

Glickman, Gabriel. *The English Catholic Community, 1688–1745: Politics, Culture, Ideology* (Rochester: Boydell Press, 2009).

Gosse, Philip. *Dr. Viper: The Querulous Life of Philip Thicknesse* (London: Cassell & Company Ltd., 1952).

Greenstein, Susan. "A Question of Vocation: From Romola to Middlemarch," *Nineteenth-Century Fiction*, 35/4 (1981): pp. 487–505.

Grenby, M.O. "'Surely There Is No Boy or Girl Who Has Not Heard of the Battle of Waterloo!' War and Children's Literature in the Age of Napoleon," in Elizabeth Goodenough and Andrea Immel (eds), *Under Fire: Childhood in the Shadow of War* (Detroit: Wayne State University Press, 2008), pp. 39–58.

Grundy, Isobel. "Women's History? Writings by English Nuns," in Isobel Grundy and Susan Wiseman (eds), *Women, Writing, History: 1640–1740* (Athens: University of Georgia Press, 1992).

Guilday, Peter. *The English Catholic Refugees on the Continent, 1558–1795* (New York: Longmans, Green, and Co., 1914).

Gutwirth, Madelyn. "The Engulfed Beloved: Representations of Dead and Dying Women in the Art and Literature of the Revolutionary Era," in Sara E. Melzer and Leslie W. Rabine (eds), *Rebel Daughters: Women and the French Revolution* (New York: Oxford University Press, 1992), pp. 198–227.

———. "*Citoyens, Citoyennes*: Cultural Regression and the Subversion of Female Citizenship in the French Revolution," in Renée Waldinger, Philip Dawson and Isser Woloch (eds), *French Revolution and the Meaning of Citizenship* (Westport: Greenwood Press, 1993), pp. 19–28.

Habermas, Jurgen. *The Structural Transformation of the Public Sphere*, trans. Thomas Burger (Cambridge: MIT Press, 1991).

Hallett, Nicky. *The Senses in Religious Communities 1600–1800* (Aldershot: Ashgate, 2013).

Harman, Claire. *Fanny Burney: A Biography* (New York: Alfred Knopf, 2001).

Harrison, J.F.C. *The Second Coming: Popular Millenarianism, 1780–1850* (London: Routledge & Kegan Paul, 1979).

184 *Bibliography*

Haydon, Colin. *Anti-Catholicism in Eighteenth-century England, 1714–80: A Political and Social Study* (New York: St Martin's Press, 1993).

Heimann, Mary. *Catholic Devotion in Victorian England* (Oxford: Clarendon Press, 1995).

Hill, Bridget. "A Refuge from Men: The Idea of a Protestant Nunnery," *Past and Present*, 117 (1987): pp. 107–30.

Hilton, Mary. *Women and the Shaping of the Nation's Young: Education and Public Doctrine in Britain 1750–1850* (Aldershot: Ashgate, 2007).

Hind, Elphege. "Princethorpe Priory," *Ampleforth Journal*, 11 (1905): pp. 192–204.

A History of the Benedictine Nuns of Dunkirk: Now at St Scholastica's Abbey, Teignmouth, Devon, ed. by the Community (London: Burns & Oates, 1958).

The History of Darlington Carmel from the Foundation of Lierre Carmel 1648 (Darlington, Carmel, 1982).

Hofman, Amos. "Opinion, Illusion, and the Illusion of Opinion: Barruel's Theory of Conspiracy," *Eighteenth-Century Studies*, 27/1 (Fall, 1993): pp. 27–60.

Holland, Elizabeth Lady. *The Journal of Elizabeth Lady Holland* (1791–1811), ed. Earl of Ilchester (2 vols, London: Longmans, Green, and Co., 1908).

Hollinshead, Janet E. "From Cambrai to Woolton: Lancashire's First Female Religious House," *Recusant History*, 25 (2001): pp. 461–86.

Holt, G. "The Education of Catholics from the Act of Uniformity to the Catholic Relief Acts," *Recusant History*, 27/3 (2005): pp. 346–58.

Hufton, Olwen H. *Women and the Limits of Citizenship in the French Revolution* (Toronto: University of Toronto Press, 1992).

In a Great Tradition: The Life of Dame Laurentia McLachlan, Abbess of Stanbrook by the Benedictines of Stanbrook (New York: Harper and Brothers, 1956).

Irvine, Valerie. *The King's Wife: George IV and Mrs Fitzherbert* (London: Palgrave Macmillan, 2005).

Isambert, François. *Recueil général des anciennes lois françaises depuis l'an 420 jusqu'à la révolution de 1789* (29 vols, Paris: Belin-Le-Prieur, 1821–1833).

Jacobus, Mary. "Incorruptible Milk: Breast-Feeding and the French Revolution," in Sara E. Melzer and Leslie W. Rabine (eds), *Rebel Daughters: Women and the French Revolution* (New York, 1992), pp. 54–75.

Jerinic, Maria. "Challenging Englishness: Frances Burney's *The Wanderer*," in Adriana Craciun and Kari E. Lokke (eds), *Rebellious Hearts: British Women Writers and the French Revolution* (Albany: State University of New York Press, 2001), pp. 63–84.

Johns, Alessa. *Women's Utopias of the Eighteenth Century* (Urbana: University of Illinois Press, 2003).

Jones, Chris. "Helen Maria Williams and Radical Sensibility," *Prose Studies*, 12 (1989): pp. 3–24.

Jones, Vivien. "Women Writing Revolution: Narratives of History and Sexuality in Wollstonecraft and Williams," in Stephen Copley and John Whale (eds), *Beyond Romanticism: New Approaches to Texts and Contexts 1780–1832* (London: Routledge, 1992), pp. 178–99.

———. "Femininity, Nationalism and Romanticism: The Politics of Gender in the Revolution Controversy," *History of European Ideas*, 16/1–3 (1993): 299–305.

Keane, Angela. *Women Writers and the English Nation in the 1790s* (Cambridge: Cambridge University Press, 2000).

Kelly, Gary. *Women, Writing, and Revolution 1790–1827* (Oxford: Clarendon Press, 1993).

Kennedy, Deborah. "Benevolent Historian: Helen Maria Williams and Her British Readers," in Adriana Cracium and Kari E. Lokke (eds), *Rebellious Hearts*: *British Women*

Bibliography 185

Writers and the French Revolution (Albany: State University of New York Press, 2001), pp. 317–36.

———. *Helen Maria Williams and the Age of Revolution* (London: Rosemont Publishing & Printing Corp., 2002).

Kennedy, Emmet. *A Cultural History of the French Revolution* (New Haven: Yale University Press, 1989).

King, Kathryn. *Jane Barker, Exile: A Literary Career, 1675–1725* (Oxford: Clarendon Press, 2000).

Kinsley, Zoe. *Women Writing the Home Tour, 1682–1812* (Burlington: Ashgate, 2008).

Kollar, Rene. "Allegations of Convent Violence, the Campaign Against Sisterhoods in Victorian England, and the Response of Parliament," *Studia Monastica*, 50/2 (2008): pp. 255–73.

———. *A Foreign and Wicked Institution? The Campaign against Convents in Victorian England* (Eugene: Pickwick, 2011).

Labbe, Jacqueline. *Charlotte Smith: Romanticism, Poetry and the Culture of Gender* (Manchester: Manchester University Press, 2003).

Lagrave, Christian. *La Vie et l'oeuvre du R.P. Augustin Barruel de la Compagnie de Jésus*, in Barruel's *Mémoires pour servir à l'histoire du jacobinisme* (4 vols, Vouille: *Diffusion de la penseé française*, 1973), vol. 1, pp. 9–25.

Lamb, Susan. *Bringing Travel Home to England: Tourism, Gender, and Imaginative Literature in the Eighteenth Century* (Newark: University of Delaware Press, 2009).

LaMonaca, Maria. *Masked Atheism: Secularism and the Secular Victorian Home* (Columbus: University of Ohio Press, 2007).

Landes, Joan. *Women and the Public Sphere in the Age of the French Revolution* (Ithaca: Cornell University Press, 1988).

Langlois, Claude. *Le catholicisme au féminin: les congrégations françaises à supérieure générale au XIXe siècle* (Paris: Cerf, 1984).

Latz, Dorothy L. *Neglected English Literature: Recusant Writings of the 16th–17th Centuries* (Institut Für Anglistik Und Amerikanistik Universität Salzburg, 1997).

Leigh, George Frederick. "The French Clergy Exiles in England, A.D. 1792–1797," *National Review*, 12/69 (London: W.H. Allen & Co, 1888): pp. 350–60.

Leys, M.D.R. *Catholics in England 1559–1829: A Social History* (New York: Sheed and Ward, 1961).

Lough, John, *The Encyclopédie of Diderot and D'Alembert: Selected Articles* (Cambridge: Cambridge University Press, 1954).

———. *The Encyclopédie in Eighteenth-Century England* (Newcastle upon Tyne, England: Oriel Press Limited, 1970).

Ludlow, J.M. *Women's Work in the Church: Historical Notes on Deaconesses and Sisterhoods* (London: Alexander Strahan, 1865).

Mangion, Carmen M. *Contested Identities: Catholic Women Religious in Nineteenth-Century England and Wales* (New York: Manchester University Press, 2008).

———. "Women, Religious Ministry, and Female Institution-Building," in Sue Morgan and Jacqueline deVries (eds), *Women, Gender and Religious Cultures in Britain, 1800–1940* (London: Routledge, 2010), pp. 72–93.

———. "The 'Mixed Life': Challenging Understandings of Religious Life in Victorian England," in Laurence Lux-Sterritt and Carmen M. Mangion (eds), *Gender, Catholicism, and Spirituality* (New York: Palgrave Macmillan, 2011), pp. 165–79.

———. "Avoiding 'rash and imprudent measures': English Nuns in Revolutionary Paris, 1789–1801," in Caroline Bowden and James E. Kelly (eds), *Communities, Culture*

186 *Bibliography*

and Identity: The English Convents in Exile, 1600–1800 (Aldershot: Ashgate, 2013), pp. 247–63.

Martin, Mary Clare. "Marketing Religious Identity: Female Educators, Methodist Culture, and Eighteenth-Century Childhood," in Mary Hilton and Jill Shefrin (eds), *Educating the Child in Enlightenment Britain: Beliefs, Cultures, Practices* (Aldershot: Ashgate, 2009), pp. 57–75.

Mason, Margaret J. "Nuns and Vocations of the Unpublished Jerningham Letters: Charlotte Bedingfield, Augustinian Canoness (1802–1876), Louisa Jerningham, Franciscan Abbess (1808–1893), and Clementina Jerningham, Marquise de Ripert-Monclar (1810–1864)," *Recusant History*, 21/4 (1993): pp. 503–55.

———. "Nuns of the Jerningham Letters: Elizabeth Jerningham (1727–1807) and Frances Henrietta Jerningham (1745–1824), Augustinian Canonesses of Bruges," *Recusant History*, 22/3 (1995): pp. 350–69.

———. "Nuns of the Jerningham Letters: The Hon. Catherine Dillon (1752–1787) and Anne Nevill (1754–1824), Benedictines at Bodney Hall," *Recusant History*, 23/1 (1996): pp. 34–78.

———. "The Blue Nuns in Norwich: 1800–1805," *Recusant History*, 24/1 (1998): pp. 89–122.

Maunu, Leanne. *Women Writing the Nation: National Identity, Female Community and the British-French Connection, 1770–1820* (Lewisburg: Bucknell University Press, 2007).

Mayo, Robert D. *English Novel in the Magazines, 1740–1815* (Evanston: Northwestern University Press, 1962).

McNamara, Jo Ann Kay. *Sisters in Arms: Catholic Nuns through Two Millennia* (Cambridge: Harvard University Press, 1996).

Mellor, Anne. "English Women Writers and the French Revolution," in Sara E. Melzer and Leslie W. Rabine (eds), *Rebel Daughters: Women and the French Revolution* (New York: Oxford University Press, 1992), pp. 255–72.

———. "The Female Poet and the Poetess: Two Traditions of British Women's Poetry, 1780–1830," *Studies in Romanticism*, 36 (1997): pp. 261–76.

———. *Mothers of the Nation: Women's Political Writing in England, 1780–1830* (Bloomington: Indiana University Press, 2000).

Melzer, Sara E. and Leslie W. Rabine, *Rebel Daughters: Women and the French Revolution* (New York: Oxford University Press, 1992).

Mitford, Mary Russell, Alfred Guy Kingan L'Estrange, and William Harness. *The Life of Mary Russell Mitford* (3 vols, London: R. Bentley, 1870).

Moretti, Franco. *Atlas of the European Novel 1800–1900* (London: Verso, 1998).

Moutray McArthur, Tonya. "Unwed Orders: Religious Communities for Women in the Works of Elizabeth Gaskell," *Gaskell Society Journal*, 17 (2003): pp. 59–76.

———. "Jane Barker and the Politics of Catholic Celibacy," *Studies in English Literature 1500–1900*, 47/3 (2007): pp. 595–618.

———. "Peregrinations to the Convent: Hester Thrale Piozzi and Ann Radcliffe," in Dorothy Medlin and Katherine Doig (eds), *British-French Exchanges in the Eighteenth Century* (Cambridge: Cambridge Scholars Press, 2007), pp. 116–30.

Mumm, Susan. *Stolen Daughters, Virgin Mothers: Anglican Sisterhoods in Victorian Britain* (London: Leicester University Press, 1999).

NewKirk, Terrye. "The Mantle of Elijah: The Martyrs of Compiègne as Prophets of Modern Age" (Washington, D.C.: Institute of Carmelite Studies Publications, 1995).

Norman, E.R. *The English Catholic Church in the Nineteenth Century* (Oxford: Oxford University Press, 1985).

Bibliography 187

———. *Anti-Catholicism in Victorian England* (London: George Allen and Unwin Ltd., 1986).

Notter, Marie-Thérèse. "*Les contrats de dot des religieuses à Blois (1580–1670),*" *Revue Mabillon*, 63 (1991): pp. 241–66.

Nussbaum, Felicity A. The Autobiographical Subject: Gender and Ideology in Eighteenth-Century England (Baltimore: Johns Hopkins University Press, 1989).

O'Brien, Susan. "Terra Incognita: The Nun in Nineteenth-Century England," *Past and Present*, 121 (1988): pp. 110–40.

———. "French Nuns in Nineteenth-Century England," *Past and Present*, 154 (1997): pp. 142–80.

———. "Religious Life for Women," in V. Alan McClelland and Michael Hodgetts (eds), *From Without the Flaminian Gate: 150 Years of Roman Catholicism in England and Wales 1850–2000* (London: Darton, Longman, and Todd, 1999), pp. 108–41.

———. "A Survey of Research and Writing about Roman Catholic Women's Congregations in Great Britain and Ireland (1800–1950)," in Jan DeMaeyer, Sophie LaPlae, and Joachim Schmiedl (eds), *Religious Institutes in Western Europe in the Nineteenth and Twentieth Centuries* (Belgium: Leuvan University Press, 2004), pp. 91–116.

Paz, Dennis G. *Popular Anti-Catholicism in Mid-Victorian England* (Stanford: Stanford University Press, 1992).

P.C.P.W. *Lanherne, The Oldest Carmel in England* (Bodmin: George W.F. Ellis Ltd., 1945–1949?).

Peacock, Molly. *The Paper Garden: Mrs Delany [Begins Her Life's Work] at 72* (New York: Bloomsbury, 2011).

Peck, Walter Edwin. "Shelley and the Abbé Barruel," *PMLA*, 36/3 (1921): pp. 347–53.

Percy, Carol. "Learning and Virtue: English Grammar and the Eighteenth-Century Girls' School," in Mary Hilton and Jill Shefrin (eds), *Educating the Child in Enlightenment Britain: Beliefs, Cultures, Practices* (Aldershot: Ashgate, 2009), pp. 77–98.

Pestana, Carla Gardina. *Protestant Empire: Religion and the Making of the British Atlantic World* (Philadelphia: University of Pennsylvania Press, 2009).

Plumb, T.H. "The New World of Children in Eighteenth-Century England," *Past & Present*, 67 (1975): pp. 64–95.

Pohl, Nicole and Rebecca D'Monté (eds). *Female Communities, 1600–1800* (New York: St Martin's, 2000).

Pohl, Nicole and Brenda Tooley (eds). *Gender and Utopia in the Eighteenth Century: Essays in English and French Utopian Writing* (Burlington: Ashgate, 2007).

Porter, Dennis. *Haunted Journeys: Desire and Transgression in European Travel Writing* (Princeton: Princeton University Press, 1991).

Rapley, Elizabeth. *The Dévotes: Women and Church in Seventeenth-Century Convents* (Montreal: McGill University Press, 1990).

———. *A Social History of the Cloister: Daily Life in the Teaching Monasteries of the Old Regime* (Montreal: McGill-Queen's University Press, 2001).

———. *The Lord as Their Portion: The Story of the Religious Orders and How They Shaped Our World* (Cambridge: William B. Eerdmans, 2011).

Rapley, Elizabeth and Robert Rapley. "An Image of Religious Women in the *Ancien Régime: the Etats de religieuses* of 1790–91," *French History*, 11 (Fall 1997): pp. 387–410.

Rappoport, Jill. *Giving Women: Alliance and Exchange in Victorian Culture* (Oxford: Oxford University Press, 2012).

Randolph, B. "Sisters of Charity," *The Catholic Encyclopedia* (New York: The Encyclopedia Press, 1914). Retrieved July, 29, 2014.

188 *Bibliography*

Reed, John Shelton. *Glorious Battle: The Cultural Politics of Victorian Anglo-Catholicism* (Nashville: Vanderbilt University Press, 1996).

Rees, Christine. *Utopian Imagination and Eighteenth-Century Fiction* (New York: Longman, 1995).

Rendall, Jane. *The Origins of Modern Feminism: Women in Britain, France, and the United States 1780–1860* (London: Macmillan, 1985).

Riquet, Michel. "*Un Jesuit Franc-Maçon, historien du jacobinisme,*" *Archivum Historicum Societatis Iesu*, 43 (1974): pp. 157–61.

Rivers, Christopher. "Safe Sex: The Prophylactic Walls of the Cloister in the French Libertine Convent Novel of the Eighteenth Century," *Journal of the History of Sexuality*, 5/3 (1995): pp. 381–402.

Roberts, J.M. *The Mythology of the Secret Societies*, 2 edn (St Albans: Paladin, 1974).

Rogers, Katherine. "Fantasy and Reality in Fictional Convents of the Eighteenth Century," *Comparative Literature Studies*, 22 (1985): pp. 297–316.

Ryan, Robert. *The Romantic Reformation: Religious Politics in English Literature, 1789–1824* (Cambridge: Cambridge University Press, 1997).

Scheuermann, Mona. *In Praise of Poverty: Hannah More Counters Thomas Paine and the Radical Threat* (Louisville: University Press of Kentucky, 2002).

Schilling, Bernard N. *Conservative England and the Case Against Voltaire* (New York: Columbia University Press, 1950).

Shell, Alison. *Catholicism, Controversy and the English Imagination* (Cambridge: Cambridge University Press, 1999).

Simpson, David. *Romanticism, Nationalism, and the Revolt Against Theory* (Chicago: University of Chicago Press, 1993).

Sockman, Ralph W. *The Revival of the Conventual Life in the Church of England in the Nineteenth Century* (New York City: W.D. Gray, 1917).

Stanbrook Abbey, "A 21st Century Community Rooted in Christ," (Stanbrook Abbey, 2015). Accessed May 8, 2015. www.stanbrookabbey.org.uk/page-ourroots.html.

Stapleton, Frideswide. *The History of the Benedictines of St Mary's Priory, Princethorpe* (Hinckley: Samuel Walker, 1930).

Stott, Anne. "Evangelicalism and Enlightenment: The Educational Agenda of Hannah More," in Mary Hilton and Jill Shefrin (eds), *Educating the Child in Enlightenment Britain: Beliefs, Cultures, Practices* (Aldershot: Ashgate, 2009), pp. 41–55.

Sturman, M.W. "Gravelines and the English Poor Clares," *London Recusant*, 7 (1977): pp. 1–8.

Sullivan, Mary C. *The Friendship of Florence Nightingale and Mary Clare Moore* (Philadelphia: University of Pennsylvania Press, 1999).

Todd, Janet. "Introduction," in *Letters from France* by Helen Maria Williams (2 vols, Delmar: Scholars' Facsimiles & Reprints, 1975).

Tomko, Michael. *British Romanticism and the Catholic Question: Religion, History and National Identity, 1778–1829* (New York: Palgrave Macmillan, 2010).

Tooley, Brenda. "Gothic Utopia: Heretical Sanctuary in Ann Radcliffe's *The Italian*," in Nicole Pohl and Brenda Tooley (eds), *Gender and Utopia in the Eighteenth Century: Essays in English and French Utopian Writing* (Burlington: Ashgate, 2007), pp. 53–68.

Traub, Valerie. *The Renaissance of Lesbianism in Early Modern England* (Cambridge: Cambridge University Press, 2002).

Turner, Katherine. *British Travel Writers in Europe 1750–1800: Authorship, Gender, and National Identity* (Aldershot: Ashgate, 2001).

Van Strien, C.D. "Recusant Houses in the Southern Netherlands as Seen by British Tourists, c. 1650–1720," *Recusant History* 20 (1991): pp. 495–511.

Bibliography 189

Vicinus, Martha. *Independent Women: Work and Community for Single Women, 1850–1920* (Chicago: University of Chicago Press, 1985).

Vovelle, Michelle. *La Révolution Française: Images et Récit 1789–1799* (5 vols, Paris, 1986).

Walker, Claire. "Prayer, Patronage, and Political Conspiracy: English Nuns and the Restoration," *Historical Journal*, 43/1 (2000): pp. 1–23.

———. *Gender and Politics in Early Modern Europe: English Convents in France and the Low Countries* (New York: Palgrave Macmillan, 2003).

Walsh, Barbara. *Roman Catholic Nuns in England and Wales, 1800–1937* (Dublin: Irish Academic Press, 2002).

Ward, Bernard. *Catholic London a Century Ago* (London: Catholic Truth Society, 1905).

———. *The Dawn of the Catholic Revival in England, 1791–1803* (2 vols, London: Longmans, Green, and Co., 1909).

———. *The Eve of the Catholic Emancipation, 1812–1820* (3 vols, London: Longmans, Green, and Co., 1911).

Watson, Nicola. "Novel Eloisas: Revolutionary and Counter-Revolutionary Narratives in Helen Maria Williams, Wordsworth and Byron," *Wordsworth Circle*, 23/1 (1992): pp. 18–23.

Weaver, Elissa B. *Convent Theatre in Early Modern Italy: Spiritual Fun and Learning* (Cambridge: Cambridge University Press, 2007).

Web, Val. *Florence Nightingale: The Making of a Radical Theologian* (St Louis: Chalice Press, 2002).

Weiner, Margery. *The French Exiles 1789–1815* (London: Unwin Brothers Limited, 1960).

Wheeler, Michael. *The Old Enemies: Catholic and Protestant in Nineteenth-Century English Culture* (Cambridge: Cambridge University Press, 2006).

White, Haydon. *The Content of Form: Narrative Discourse and Historical Representation* (Baltimore: John Hopkins University Press, 1987).

Whittaker, Callum. "La Généreuse Nation!" Britain and the French Emigration 1792–1802," M.A. Dissertation (York: University of York, 2012).

Who Were the Nuns? A Prosopographical Study of the English Convents in Exile 1600–1800, Queen Mary University of London and the Arts and Humanities Research Council, http://wwtn.history.qmul.ac.uk/.

Wiley, Michael. *Romantic Migrations: Local, National, and Transnational Dispositions* (New York: Palgrave Macmillan, 2008).

Wolfson, Susan. "Charlotte Smith's Emigrants: Forging Connections at the Borders of a Female Tradition," in Anne K. Mellor, Felicity Nussbaum, and Jonathan F.S. Post (eds), *Forging Connections: Women's Poetry from the Renaissance to Romanticism* (San Marino: Huntington Library, 2002), pp. 81–118.

Woodley, Sophia. "'Oh Miserable and Most Ruinous Measure': The Debate between Private and Public Education in Britain, 1760–1800," in Mary Hilton and Jill Shefrin (eds), *Educating the Child in Enlightenment Britain: Beliefs, Cultures, Practices* (Aldershot: Ashgate, 2009), pp. 21–39.

Woshinsky, Barbara. *Imagining Women's Conventual Spaces in France*, 1600–1800 (Aldershot: Ashgate, 2010).

Young, Francis. "Mother Mary More and the Exile of the Augustinian Canonesses of Bruges in England 1794–1802," *Recusant History*, 27/1 (2005): pp. 86–102.

Zimmerman, Susan, *Romanticism, Lyricism, History* (New York: State University of New York, 1999).

Index

Note: Page numbers with *f* indicate figures; those with *t* indicate tables.

Acosta, Ana M. 22
Addison, Joseph 63
Alcott, Bronson 25
Alembert, Jean le Rond D' 62
Alger, John C. 166
Aliens Act of 1793 12, 117, 139
Amory, Thomas 25
Andrews, John 42
Anglican Convent Inquiry Society 164
Anglican Sisterhoods 162–4 (*see also*
 Victorian women religious); anti-
 monastic sentiment towards 111; Sellon,
 Lydia Marie 163; social services and
 166; women's leadership and 163
Ann, Dame Anselma 96
Another Traveller! (Paterson) 49, 52, 102
Anson, Peter F. 10
April Riots 72–3
Arblay, Alexandre d' 128
Astell, Mary 24–5
Aston, Mary Anne 109
Aston, Nigel 69
Augustinian Nuns (see also individual
 listing); English Augustinians of
 Bruges 14, 18, 19, 141–52; English
 Augustinians of Louvain 97, 147;
 English Augustinians of Paris 14, 43,
 47, 53, 54, 95, 108

Bacon, Francis 38–9
Barbauld, Anna Laetitia 98
Barker, Jane 25
Barker-Benfield, G.J. 51
Barruel, Augustin Abbé 3, 11, 16; April
 Riots and 72–3; the British Nation and
 16, 61, 68–9; conspiracy theories of 68;
 French Benedictines of Montargis and

68–76, 80; French émigré diaspora and
 migration 16, 68, 75, 132; *Histoire du
 clergé pendant la Révolution françoise*
 61; *History of the Clergy* 68, 69, 74;
 *Memoirs, Illustrating the History of
 Jacobinism* 68; *Reflections on the
 Revolution in France* 70; relationships
 between nuns and priests 147, 160;
 representation of nuns 3, 61; reviews of
 History of the Clergy 68, 69, 74, 76, 78,
 83; September Massacres of 1792
Bedingfeld, Charlotte 81, 82, 168
beguines and *beguinages* 7, 51; in relation
 to enclosed nuns 7
Behn, Aphra 21
Bellenger, Dominic Aidan 12, 80, 91, 128
Beloe, William 98
Benedictine monks 47
Benedictine nuns 13, 44, 103, 112, 142,
 145 (see also individual listing); English
 Benedictines of Brussels 147; English
 Benedictines of Cambrai 12, 14, 17, 19,
 20, 90, 92, 114, 144, 145, 146, 148, 149,
 167; English Benedictines of Dunkirk
 126, 149; English Benedictines of Ghent
 33n76, 156n99; English Benedictines
 of Louvain 33n76, 156n99; English
 Benedictines of Paris 97, 166; French
 Benedictines in Ardres 48; French
 Benedictines of Calais 48; French
 Benedictines of Gravelines 41; French
 Benedictines of Montargis 11, 16, 19,
 20, 26, 61, 76–83, 112, 144, 145, 147,
 167; French Benedictines of Rouen 102
Benis, Toby 4, 141
Betham, Matilda 81–2
Betros, Gemma 8, 67

Index 191

Black, Jeremy 39
Blue Nuns of Paris 12, 17, 19, 43, 54, 90
 (*see also* English Blue Nuns); Bodney
 Hall 81–3
Bonaparte, Napolean 111
Bowden, Caroline 6, 94, 146
Brah, Avtar 92
Bray, Matthew 102
Brewer, John 114
Bridgettine nuns (*see* English Bridgettines
 of Lisbon)
*Brief Reflections Relative to the Emigrant
 French Clergy* (Burney) 10, 18, 126–7,
 128–30, 164
Brissot, Jacques-Pierre 100
*British Monachism: or, Manners and
 Customs of the Monks and Nuns in
 England* (Fosbroke) 12, 138
Brontë, Charlotte 1
Brook Farm 25
Broughton, Rhoda 165
Brydone, Patrick 50
Burke, Edmund 60, 68, 69, 130, 149
Burney, Frances 3, 10, 18, 129*f*, 160;
 *Brief Reflections Relative to the
 Emigrant French Clergy* 126–7,
 128–30; d'Arblay and 128; Daughters
 of Charity and 132; depiction of French
 priests as martyrs 131, 141; female
 beneficence and 129; girls' education
 and 127, 133; Gordon Riots and
 131; historical reflection and 132–3;
 religious refugees and 126; resources
 for refugees and 128–34; September
 Massacres of 1792 and 130–31;
 Wanderer, The 128
Butler, Charles 151–2

cahiers de doléance 8
Carmelite Nuns 48, 76, 96, 112 (*see also*
 individual listing); English Carmelites
 of Antwerp 97, 144; English Carmelites
 of Hoogstraten 76, 97; English
 Carmelites of Lierre 97, 143, 144;
 French Carmelites of Compiègne 20, 64,
 169; French Carmelites of St. Denis 64;
 French Carmelites of Rouen 102
Carpenter, Kirsty 10, 69, 112, 148
Carron, Abbé 149, 151
*Case of the Suffering Clergy in France,
 The* (Burke) 130
Castle of Otranto, The (Walpole) 22
Catholic Emancipation Act, 1829 26, 162
Catholic Record Society 5

Catholic Relief Act: 1778 13, 98, 150;
 1791 13, 98, 150
Catholic schooling 127, 141–52;
 convent boarding schools 48, 90, 147;
 conversion of Protestant students and
 151; curriculum and 147; English
 convents and 6, 12, 15; for English
 Catholic families 48, 146, 147; free 7,
 150, 151, 152; French teaching orders
 and 64, 67, 165; Monastic Institutions
 Bill and 14, 92, 145, 148, 150, 151, 152;
 Victorian period and 164, 166
Cavendish, Margaret 21
Centlivre, Susanna 21
Certeau, Michel de 26
Chamfort, Nicolas 100
Chapone, Hester 132–3
Chard, Chloe 41
Charter of 1814, 111
Chateaubriand, François-René 22
Choudhury, Mita 64
Civic Oath 71, 72
clausura 20, 42; legislated by Trent 20;
 limitations created by 42; nuns' desire
 for 20, 42; protection by means of
 20, 42
clergy; constitutional 70, 72; non-juring
 or refractory 72, 94; tax exemptions
 of 69; involvement with nuns 65, 72;
 relationships with nuns in the nineteenth
 century 65, 72
cloister (*see* convents)
Clarissa (Richardson) 25
Coghlan, J. P. 61
Cole, William 15, 36; Catholic connections
 of 47; convent tourism 47; English
 Augustinians in Paris and 47; French
 nunnery at Port Royal 47; Miss
 Throckmorton and 47–8; monastic
 leanings of 47; travel writings of 46–8
Commission des secours 65; impact on
 18th-C women religious 65
companionate marriage 26
*Complete History of the Invasions of
 England* (anonymous) 74–5, 101
Conceptionist Nuns (*see* English Blue
 Nuns)
Concordat of 1801 128
Condé, Princess de 80
confraternities and congregations 8, 66, 73;
 (*see also* teaching orders)
*Considerations on Religion and Public
 Education* (More) 133, 137
constitutional church 72

192 *Index*

Convent of Pleasure, The (Cavendish) 21
convents 36 (*see also* nuns); access to by
 British tourists 38, 39, 43, 53; British
 tourists' access to 38, 39, 43, 53;
 boarders and 6, 49, 94; class structure
 of 7; Catholic schooling and 13, 18,
 114, 117, 127, 141, 148, 149, 150,
 151; compared to male monasteries 7,
 51, 62, 63; dowries and economics of
 65; education for women and 24–5;
 English convents abroad 6, 12, 38, 48,
 93; foreign travel pastime 38; impact
 of French Revolution upon 92–7;
 popularity of 15, 37, 48, 49; as property
 97; recruitment of novices and 14, 151;
 resettlement in England 13, 14, 20;
 taxation of 64; women's agency within
 20, 108
convent building: as property 97; as sacred
 space 9, 22, 91; use during French
 Revolution 92–7
convent literature: British gothic novels
 of 22, 24; French libertine fiction of
 22; incarceration literature of 20–21;
 non-fiction writings of 26; Protestant
 communal fiction of 25–6; Restoration
 drama/British amatory fiction of 21–2;
 travel writings about 36, 40, 41, 46
convent schools 36 (*see also* instruction
 of girls *and* education); advertisements
 114, 147; employment of lay teachers
 146; free 7, 150, 151, 152; Monastic
 Institutions Bill 14, 92, 145, 148,
 150, 151, 152; pre-Revolution 6, 14;
 Protestants and 13, 24, 25; Victorian
 period and 164, 166
convent tourism; Grand Tour 8, 38;
 patronage and 13, 15, 16, 19, 128, 166;
 popularity among British 15, 37, 48, 49;
 tourists' access to 7, 36, 37–40, 43, 47;
 urban vs. rural 39
Corday, Charlotte 91, 109–10
Cossey Hall 144 (*see also* the
 Jerninghams)
Coriat Junior 49 (*see also* Paterson,
 Samuel)
Craik, Dinah Mulock 163
Crilly, Teresa Mary Clare 148

Darrell, Olivia 152
Daughters of Charity 18, 66, 132
death; attitudes towards nuns' deaths 97,
 152; due to revolutionary violence 74,
 100, 101, 134; nuns' deaths in the 1790s

73; obituaries and 82, 83, 92, 115, 116,
 117; September Massacres of 1792 10,
 60, 68, 73, 128, 130, 141; women's
 martyrdom and Helen Maria Williams
 97–112
Desmond (Smith) 137
Desmoulins, Camille 110
Diary of the Blue Nuns 92, 115–17, 166
diaspora 2, 68, 75, 92, 93
Diderot, Denis 22, 37, 62
Dillon, Catherine (Sister François) 79,
 82–3, 142
Dominican Nuns 40, 97, 138, 142 (*see also*
 English Dominicans of Brussels)
D'Monté, Rebecca 26
Dolan, Elizabeth 138
Doody, Margaret Anne 128
Dryden, John 21–2
Duffield, Anne 109, 166
Durrant, C. C. 142

education 12, 37 (*see also* instruction
 of girls *and* convent schools); charity
 schools 72, 150, 151; girls vs boys
 curriculum 18, 126; nuns' education
 126; French teaching orders and 64,
 67, 165
Edwards, Elizabeth (Sr Mary Joseph) 116
Elegies and Other Poems (Betham) 82
Eliot, George 165–6
Émigré priests: migration to England 18;
 Catholic schooling and tutoring 127;
 refugee assistance and 127; suspicion of
 127, 131;
Emigrant Relief Committee149; (*see also*
 Wilmot Committee)
"Emigrants, The" (Smith) 136
Encyclopédie (Diderot and D'Alembert)
 62
English Augustinians of Bruges 14, 18,
 19, 141–52; British government and
 11, 12, 16, 75, 160; Catholic schooling
 and 146–51; Hengrave Hall and 126,
 144, 145, 146, 147, 152, 168; relief for
 wandering migrants 141–4; relationship
 to benefactors 132, 140, 141, 144,
 152; return to Bruges 144–5; social
 integration and 145–6; wearing of habits
 13, 170
English Augustinians of Louvain 97, 147
English Augustinians of Paris 43–4
English Benedictines of Brussels 147
English Benedictines of Cambrai 12, 13,
 14, 17, 19, 145 management of convent

Index 193

school 146–7; migration to England 17, 90, 147; relationship to the Carmelites of Compiègne 96, 112, 114, 147
English Benedictines of Dunkirk 126, 149; convent school at Hammersmith 92, 116, 126, 149
English Benedictines of Ghent 33n76, 156n99
English Blue Nuns 12, 16, 17, 20, 43, 54, 83 convent school of 93, 96, 146; *Diary* 17, 92, 94, 115, 116, 117; dispersal of 17, 18; distinctive habit of 13; financial support for 94; French Revolution and 17, 81; history of 92–7; imprisonment of 96–7; Jerningham and; migrations to England by 112–18; political authority and 92–3; property ownership and 94–5; reputation of; refusal to relocate 92; treatment of British nationals; Williams's writings of 91, 94, 97–112
English Catholic Refugees on the Continent, 1558-1795, The (Guilday) 166
English Carmelites of Antwerp 97, 144
English Carmelites of Hoogstraten 76, 97
English Carmelites of Lierre 97, 143, 144
English Conceptionists (*see* English Blue Nuns)
English Dominicans of Brussels 97
English Franciscans of Brussels 43; in Nieuport 43
Englishmen in the French Revolution (Alger) 166
English nuns (*see also* nuns); anti-Catholic sentiment and 2; benefactors and assistance 3; convent tourism and 168; British press and 3, 4, 10, 60, 69, 75, 76, 96; British government and 11, 12, 16, 75, 160; British Romantic writers and 2–3; Catholic schooling 13, 18, 114; and; class differences of 7; as contested figure in Victorian society 1–2; dispersal of during French Revolution 17; from English Reformation to French Revolution 5–10; history of exile 6–7; French Revolution and 2, 4; incarceration of 3, 9, 15, 17; Helen Maria Williams and 97–112; literary representations/lived experience, interplay between 3; literary works about 5; migrations to England by 9–10, 9t; national identities of 11–12; novices, recruiting of 14, 151; property ownership 93, 94; protest-writing of

103, 150; repatriated 166–70; reception in local communities 2, 10; religious dress of 14, 61, 112, 145; responsibilities of 7; self-mortification of 43; social networks of 6; recruiting students and 15, 18
English Nuns in Exile, 1600–1800 6
English Poor Clares of Aire 173n51
English Poor Clares of Dunkirk 97
English Poor Clares of Gravelines 41, 45, 54, 97
English Poor Clares of Rouen 97
English Reformation 5–10
Enlightenment, The 22, 24, 25, 62, 65, 70
Essex, James 51
Evangelisti, Silvia 6

Fabian, Johannes 39
Fantomina (Haywood) 21
Ferrars, Nicholas 24
Fitzherbert, Mrs 16, 36, 43, 79, 80
Fitzroy, Barbara 93
Fosbroke, T. D. 12, 138
Franciscan Nuns 116, 139 (*see also* English Franciscans of Nieuport)
French Benedictines of Ardres 48
French Benedictines of Calais 48
French Benedictines of Gravelines 41
French Benedictines of Montargis 16–17, 19; Barruel and 68–76, 80; Bodney Hall and 81–3; British press and 77–83; ethnic diversity of 142; dispersed migration to Belgium and England 16, 141, 161; French traditions and 19, 22, 41; history of 60–62; Princethorpe Priory and 167, 168, 169; royal reception in England of 2, 10, 14; recruitment of students and success of school 15, 18; social networks and 6
French Benedictines of Rouen 102
French Carmelites of Compiègne, martyrdom of 1794 20, 169–70; beatification of 20, 169
French Carmelites of St. Denis 64
French Carmelites of Rouen 102
French Journal 1775 (Thrale Piozzi) 37
French Revolution 2, 5; anti-monastic bias of 19; attitude towards the Catholic church 127, 168; British press and 76; British attitudes towards 53, 168; confiscation of monastic valuables during 19; nuns and 17, 81; the Terror and 92, 100; women and 5–10, 42

194 *Index*

Gage, John Rokewode 166
Gage, Thomas and Lady147
Gaskell, Elizabeth 165, 166
Gender and Politics in Early Modern
 Europe (Walker) 5
Genlis, Madame de 100
Gillow, Joseph 117
Gillray, James 100–101, 101*f*
Girondin 100, 109, 111
Gladstone, William 164
Glickman, Gabriel 38, 146
Godwin, William 98
Gordon Riots 13, 127, 131
Grand Tour 38
Green, Abbess Mary Bernard 115, 116
Guilday, Peter 166

habit 12, 49, 50, 102, 110, 112, 114, 145,
 146
handwork of nuns: bookmarks 107, 114;
 doll-making 145; embroidery 145, 146,
 149; lace production 168; purses 107,
 114; silk-flower making 51
Hawkins, Laetitia 100
Haywood, Eliza 21
Hengrave Hall 126, 144, 145, 146, 147,
 152, 168 (*see also* English Augustinians
 of Bruges)
Henry the VIII 6, 71
Historical and Moral View of the Origin
 and Progress of the French Revolution,
 An (Wollstonecraft) 63
History of the Clergy (Barruel) 68, 69, 74
Hollinshead, Janet 13
Hufton, Olwen H. 7, 65, 96, 103

inheritance 13, 70; nuns and monks 13
instruction of girls (*see also* education
 and convent schools); boarding
 schools 48, 90; Burney and 127,
 133; charity schools 72; compared
 to boys 18, 126; convent schools
 and 146; curriculum and 18; free 66;
 Protestant students and 126, 151;
 pedagogical writings and 136, 137,
 150; recruitment of students 126, 151;
 Smith and 18, 126
Italian, The (Radcliffe) 22, 46

Jacobins 70, 80, 97, 109
Jacobus, Mary 101
Jaucourt, Chevalier Louis de 62
James II 25, 47
Jameson, Anna 163, 165

Jerningham, Frances 16, 17–18, 20, 92,
 114–17, 142, 160–61; refugee assistance
 and 133; relationships to English
 convents 20
Jerningham, Frances Henriette (Sr Mary
 Francis de Sales) 144, 160, 161
Jerningham, William 16, 96
Johns, Alessa 25, 40
Johnson, Samuel 22
journalism 3, 61, 76, 105, 159 (*see also*
 press coverage); French Revolution and
 105; nuns and 3; refugee migration and 61
Journal of my Journey to Paris in the Year
 1765, A (Cole) 46
Journey Made in the Summer of 1794, A
 (Radcliffe) 44–5, 73–4

Keane, Angela 102
Keble, John 162
Kelly, Gary 100
Kennedy, Deborah 101
Kings House at Winchester 139
Kinsley, Zoe 40
Kippis, Andrew 98
Knight, Alexander 112
Knight, Ann Joseph 112
Knight, Clare 103

Labbe, Jacqueline 134
Laclos, Choderlos de 66
Landes, Joan 8, 95
La Religieuse (Diderot) 22, 37
Law Crash of 1720 64–5
lay sisters 7
Lee, Frederick George 139
Legends of the Monastic Orders
 (Jameson) 165
Leopold I of Belgium 168
Les Liaisons Dangereuses (de Laclos) 66
Letters Containing a Sketch of the Politics
 of France (Williams) 16, 17, 91, 92,
 100, 104–5, 110
Letters on the Female Mind, its Powers
 and Pursuits: Addressed to Miss H.M.
 Williams, with Particular Reference to
 her Letters from France (Hawkins) 100
Letters on the Improvement of the Mind
 Addressed to a Young (Chapone) 132–3
Letters Written in France (Williams) 98,
 100, 102–3
Les Lettres portugaises (French epistolary
 collection) 21
Lewis, Matthew 22, 24, 37
Leys, M.D.R. 13

Index 195

Little Gidding 24
Lloyd, Mary (Mary Augustine) 116
Locke, William 128
Lonergan, Anne 109, 115
Love in Excess (Haywood) 21
Louis of France, Princess 64
Louis XVI of France 67

Mangion, Carmen M. 11, 94, 96, 169
Manning, Cardinal Henry 1
Maraine, Abbé 149
Marat, John-Paul 109
Marillac, Louise de 132
Mary of Modena 93
Marie Therése, Queen of France 93
Mason, Margaret J. 97
McLachlan, Laurentia 168–9
McNamara, Jo Ann Kay 5
Mellor, Anne K. 26, 98
Memoirs, Illustrating the History of Jacobinism (Barruel) 68
Middlemarch (Eliot) 165
Mildmay, Henry 117, 148
Millenium Hall (Scott) 25
Milner, John 169
Milton, John 21
Minor Morals, Interspersed with Sketches of Natural History, Historical Anecdotes, and Original Stories (Smith) 136
Miranda, Francisco de 100
Mirepoix, Madame de Lèvi de 60, 67, 14
Mitford, Mary Russell 149
monastic communities (*see also* convents);as alternative to institution of marriage 7; clausura and; Continental convents, life in 7–8; economic/political forces and 7–8; French Revolution and 53, 63; male monasteries 7, 51, 62, 63
monastic economics, women religious in eighteenth- century France and 62–8; compared to male monasteries 7, 51, 62, 63; dowries and 7, 21, 64, 65; relationship to the Crown and 65, 138; taxation and 63, 64
Monastic Institutions Bill, 1800 14, 117–18, 145, 150–52 convent schooling and 152; depictions of refugees 145, 148, 150; English Augustinians of Bruges and 152; recruitment of novices and 151
monasticism (*see also* monks); anti-monastic propaganda 21, 64, 71;

consolidation of in eighteenth-century 3, 20; cultural impact of, during French Revolution 2; decline of male monasticism 7, 51, 62, 63; English Reformation to French Revolution 5–10; land holdings in France 70; public opinion of 68, 80, 91, 98, 110; relationship to the Crown 65, 138; social utility of 12, 62; taxation and 63, 64; vow of chastity 63
monks (*see also* monasticism); defection of during French Revolution 17, 81; in British culture 20, 39, 83
Monk, The (Lewis) 22, 24, 37
Montagu, Lady Wortley 40
More, Hannah 133–4
More, Prioress Mary Augustina 142, 143*f*
My Lady Ludlow (Gaskell) 166
Mysteries of Udolpho (Radcliffe) 22

Narbonne, Louis de 128
National Assembly
Newdegate, Charles 164
Newman, John Henry 162
Nightingale, Florence 1, 163
Norman, Edward 164
novices; Monastic Institutions Bill and nuns' recruitment of 151
nuns(*see also* English nuns *and* convents)age of 4, 12, 96; as counter-revolutionaries 16, 61; education of girls and 7, 18, 37, 133; eighteenth-century 2, 3; dispersal and eviction from France and Belgium of 16, 141, 161; "feminism" among 7, 25; lay sisters 6, 7, 94, 107; marriage and 20, 21; migration of English nuns during the French Revolution 9*t*; patriotism of 66, 95; press coverage of 3, 4, 10, 60, 69, 75, 76, 96; as public figures 60; political protest and 103, 150; reception of 2, 10; as seen by historians 2, 6, 7, 13; as seen by literary critics 2; social services and 3, 60, 66, 166; as victims of Catholic indoctrination 60–61; as victims of the French Revolution 2, 4, 98; Victorian period and 162, 164, 166
nuns' writings; anti-revolutionary writings 16, 61; benefactors' involvement with 3, 132, 140, 141, 144, 152; destruction of during the French Revolution 17, 81; *Diary of the Blue Nuns* 17, 92, 94, 115, 116, 117
nursing sisters 28n9, 31n43

196 *Index*

O'Brien, Susan 2, 3, 165
obituaries of nuns 82, 83, 92, 115, 116, 117
Observations and Reflections Made in the Course of a Journey Through France, Italy, and Germany (Thrale Piozzi) 53
Observations on the Customs and Manners of the French Nation (Thicknesse) 48
"On Sisterhoods" (Craik) 163
Opie, Amelia 12, 90, 92
Oxford Movement 162

Partington, Ann Teresa 13
Paterson, Samuel 15, 17, 36; change in perspective on women's monasticism 37; Coriat as narrator 49, 50; reviews of travel writings 49–52; sexualization of nuns 37–8; travel writings of 49–50, 50–52
Paul, St. Vincent de 132
Persian Letters (Montesquieu) 63
Petre, Robert 13
Pickering, William 117
Piozzi, Gabriel 53
Pohl, Nicole 26
Poor Clare Nuns 36, 41, 42 (*see also* individual listing); in Cologne 45, 46; English Poor Clares of Aire 173n51; English Poor Clares of Dunkirk 97; English Poor Clares of Gravelines 41, 42–3;
Pope, Alexander 21
poverty 42, 44, 64, 106, 126, 137, 141
press coverage (*see also* journalism); French Revolution and 76; nuns and 2, 4, 98; refugee migration and 10, 17
Price, Richard 102
Priestley, Joseph 102, 151
Prince of Wales 16, 60, 62, 78, 79, 80
Princethorpe Priory 167, 168, 169 (*see also* French Benedictines of Montargis)
property: bequeathed to nuns by benefactors 94; owned by nuns 94–5; seized from nuns 63, 69
Pusey, Edward 162

Radcliffe, Ann 7, 15, 36, 61–2; *Italian, The* 22, 46; *Journey Made in the summer of 1794, A* 44–5, 73–4; *Mysteries of Udolpho* 22; migrating Flemish nuns and 74; Poor Clares in Cologne visit 45–6; travel writings and

reviews of 38, 44–6; visiting nuns in Germany 44–6
Radcliffe, William 45
Rapley, Elizabeth 3, 5, 42, 62
Rasselas (Johnson) 22
Reflections on the Revolution in France (Burke) 70
refugee migration of religious groups to England 10–14; Emigrant Relief Committee 11, 128, 139, 149; émigré priests 16, 18, 26, 127, 161; permanent settlement prospects for 11–12, 14; reception of 10–13; suspicions of receiving government 12
Renaud, Cecile 110
Richardson, Samuel 25
Rivers, Christopher 50
Robespierre, Maximilien 104, 105, 110
Rogers, Katherine 22
Rokewode, John Gage 117
Roland, Jean-Marie 100
Roland, Marie-Jeanne Phlippon 91, 109–10
Romantic literature and nuns 2, 3, 4
Romola (Eliot) 165–6
Rover, The (Behn) 21
Rural Walks: In Dialogues. Intended for the use of Young Persons (Smith) 18, 127, 136–41
Ryan, Robert M. 26

Sand, George 43
Scott, Sarah 25, 105
Sellon, Abbess Lydia 163
September Massacres of 1792 10, 73, 128, 130–31, 141–2
Sepulchrine Nuns (*see* English Sepulchrines of Liege)
Serious Proposal to the Ladies, A (Astell) 24
Shell, Alison 38
Shelley, Percy Bysshe 68
sickness (*see also* trauma); caused by French Revolution 19, 114; nuns' trauma 20, 114, 118
Simpson, Sr Benedict 107, 116
Simpson, David 98
Sir Charles Grandison (Richardson) 25
Sir Thomas More: or, Colloquies on the Progress and Prospects of Society (Southey) 25
Sisters in Arms: Catholic Nuns through Two Millennia (McNamara) 5

Sisters of Charity 66, 72
"Sisters of Charity" (Jameson) 163
Sketches of the State of Manners and Opinions in the French Republic (Williams) 109–10
Smith, Amy Elizabeth 49
Smith, Charlotte 18, 135*f*; *Desmond* 137; "Emigrants, The" 136; girls' education and curriculum 18, 126; religious refugee aid/resourcefullness and 127, 134–41; reviews of works by 136–7; *Rural Walks* 127, 136–41; women's vulnerability and 141
Smith, William 98
Smollett, Tobias 49, 74–5
Social History of the Cloister 1600-1800, A (Rapley) 5, 42
Sockman, Ralph Washington 118
Southey, Robert 25
Souvenirs de la Révolution française (Williams) 111
Staël, Germaine de 128
Stafford, Anastasia Howard 96, 97
Stanbrook Abbey 19, 167*f*
Strickland, Cecilia 36, 41, 43, 44, 48, 106
Stephens, Edward 24–5
Stourton, Mary 147

teaching orders 64, 67, 165
Therése, Marie 93
Thicknesse, William 15; Catholic schooling of daughter 38; reviews of travel writings 36–44; travel writings of 36–40, 40–44, 53–4
Thoughts on the Education of Daughters (Wollstonecraft) 133, 137
Thrale, Henry 36, 53
Thrale Piozzi, Hester 3, 7, 15, 36, 98, 100, 111; access to English nuns; Blue Nuns/ Conceptionist visit 106–7; Catholicism and 36, 44; convent as model for English women 37; English Augustinian Nuns in Paris visit 43–4; French Benedictine of Saint-Louis visit 41–2; *French Journal 1775* 37; Poor Clares at Gravelines visit 41, 42; use of contrast by 37
Throckmorton, George 47
Thwaites, Elizabeth 42
Timperley, Anne 93
Trent, Council of (*see also* clausura)
trauma (*see also* sickness); caused by the French Revolution 19, 114; upon migration to England 118

travel narratives 15, 36, 37, 38, 39, 40, 41, 45, 49, 52, 53

Ursuline nuns 63, 76, 94, 142, 165

Vergniaud, Pierre 100
Victoria, Queen of England 168
Victorian anti-Catholicism 162; in literature/culture 164–6
Victorian women religious (*see also* Anglican Sisterhoods); active sister as normative image in society 164; Belgian and French 6, 19, 53; depictions of in literature 2, 3, 164–6; economic position of 15; growth of communities 46; involvement in girls' education 18, 127, 133; refugee communities in the Victorian period 162, 164, 166; relationship to clergy 162, 169; social services and 3, 60, 66, 166
vows 7, 8, 44, 51, 52, 63, 64, 65, 66, 80, 82, 102, 103, 105, 115, 117

Walker, Claire 5, 41, 93
Walpole, Horace 22
Walsh, Barbara 7
Wanderer, The (Burney) 128
Ward, Bernard 10, 166
Ward, Mary 42
Watson, Nicola 103
Wheeler, George 24–5
White, Haydon 139
Who Were the Nuns? (database) 5–6
Widdrington, Jane 93
Wiley, Michael 11
Williams, Helen Maria 3, 7, 16, 17, 97–112, 99*f*, 134; anti-monastic views; biography 98–100; convents in Rouen and travel writings 102; Catholic revival in Restoration France and 110–11; Charlotte Corday and 91, 109; *Convent Les Anglaises* 94; critics of 98, 100; as foreign correspondent 97; incarceration with the English Blue Nuns 91, 105–6; *Letters Containing a Sketch of the Politics of France* 91, 100, 104–5, 110; *Letters from France* 97–8; Madame Roland and 91, 109; Marie Antoinette and 110; political leanings of 91, 92; reviews and reputation of 100; Revolutionary violence against women and 100–101,

198 Index

101f; "Sister Theresa" writings 108–9; *Sketches of the State of Manners and Opinions in the French Republic* 109–10; *Souvenirs de la Révolution française* 111

Wilmot, John 11

Wilmot Committee (*see also* Emigrant Relief Committee) 11, 128, 130

Wollstonecraft, Mary 63, 100, 133

women's monasticism (*see* monastic communities, convents, monasticism, nuns)

Wordsworth, William 98, 134

Year's Journey through France, and part of Spain, A (Thicknesse) 49

Young, Francis 144

Zimmerman, Susan 136